ACROSS THE ART/LI

This edition first published in the UK in 2017 by
Intellect, The Mill, Parnall Road, Fishponds, Bristol, BS16 3JG, UK

This edition first published in the USA in 2017 by
Intellect, The University of Chicago Press, 1427 E. 60th Street,
Chicago, IL 60637, USA

A catalogue record for this book is available from the
British Library.

Copy-editor: Michael Eckhardt
Design: Aleksandra Szumlas
Cover image: Gelitin, *Blind Sculpture* (2010). Photo © Paula Court.
 Courtesy of the artists and Greene Naftali, New York.
Indexer: Róisín Nic Cóil
Production editor: Katie Evans
Typesetting: Contentra Technologies

Print ISBN: 978-1-78320-854-8
ePUB ISBN: 978-1-78320-855-5
ePDF ISBN: 978-1-78320-856-2

Printed and bound by Gomer, UK.

This is a peer-reviewed publication.

ACROSS THE ART/LIFE DIVIDE
PERFORMANCE, SUBJECTIVITY, AND SOCIAL PRACTICE IN CONTEMPORARY ART

MARTIN PATRICK

CONTENTS

INTRODUCTION

Painting relates to both art and life. Neither can be made. (I try to act in that gap between the two.)

—ROBERT RAUSCHENBERG, 1959[1]

Contemporary artists are not out to supplant recent art with a better kind; they wonder what art might be. Art and life are not simply commingled; the identity of each is uncertain.

—ALLAN KAPROW, 1966[2]

Across the Art/Life Divide: Performance, Subjectivity, and Social Practice in Contemporary Art argues that the most central defining feature of contemporary visual art and culture is the intensive and sustained interest shown by artists to the problematic and vexing relationship between art and life. In so doing, many artists have adopted and created more incorporative theories and new forms of practice, eroding the notion of a distinct border between the two realms. Artists have repeatedly challenged the notion that art must be a wholly unified, separate entity, and are consistently shifting their concentrated efforts towards creative methods that emphasize mutability, flux, and chance.

I drew my early inspiration from so many artworks and statements by artists, such as the ones cited by Rauschenberg and Kaprow. This project addresses the question of how and why so many vitally significant yet stylistically different artists of the contemporary period have sought to link and merge the disparate entities of art and life in a concerted fashion within their particular theories and practices. Moreover, it attempts to record how the history of "blurring boundaries" has led to increasingly diversified models for artistic practice. The artists examined here have moved between art and life concerns with the desire to keep those parameters flexible, never as rigid demarcations.

Across the Art/Life Divide proceeds more thematically than chronologically, with the intention of selectively investigating relevant examples of contemporary cultural production. The book can be viewed as a series of interrelated essays, although written in the hope that they will reinforce and support one another when read together. I came to research and write this book through my long-standing interest in performance art, conceptualism and interdisciplinary modes of art-making in which artists have so often annexed aspects of their daily life into their practice, questioning the separation between "art" and "life" as discrete, circumscribed areas of existence.

And while so many artists draw upon, are inspired by, and variously use their life experiences to nurture their practice, many artists wish to close the studio door, so to speak, keeping certain boundaries in place, neither transgressed nor muddled. Although it was initially my primary interest to discuss art/life practices of the mid-to-late twentieth century, it has instead become my intention here to explore the heritage and residual effects of those notions on

various trajectories of contemporary practice: performance and live art; public art and interventions; relational aesthetics; and autobiographical narratives. I became equally intrigued by how notions of blurred, indistinct categories have radically altered and reworked some existing assumptions concerning the roles of authorship and subjectivity, along with aspects of socially engaged art practices.

While the phrase "art and life" might indeed sound overly ambitious, perhaps even vague, or a historical box to be ticked, in *Across the Art/Life Divide* I explore a wide, lateral profusion of approaches – albeit selectively chosen – that might be reconsidered and unpacked in light of my initial premise. To perform, reenact, represent, and otherwise engage with lived existence in the context of art is a long-standing emphasis of practices that have now moved further into the forefront of both arts research and public awareness.

For this reason, the scope of critical investigation in *Across the Art/Life Divide* extends into a variety of fields of cultural production, including popular entertainment, art interventions, experimental writing, criticism and theory, performance art, and emergent media practices. If this short introduction is meant to sum up the book's approach, it is to some extent bound to fail, just as the examples discussed are arguably slippery and not readily categorized, but could conceivably provide some informative cues for readers and their own ongoing engagement with the world, whether easily decipherable as art or life. Bluntly stated, life *interferes* with art. The impulses to make certain gestures in art are not exactly the same as those that lead us to make certain decisions in daily life. Rauschenberg's claim to neither make life nor art, but work somehow in the interstices that are thereby opened up, in the so-called "gap between art and life", becomes not only a rhetorical device, but a still cogent and relevant explication of the predicament of the contemporary artist.

The artist David Hammons once remarked:

> I think the worst thing about galleries is, for instance, that there's an exhibition opening from 8–10 PM. The worst thing in the world is to say, "Well, I'm going to see this exhibition." The work should instead be somewhere in between your house and where you're going to see it, it shouldn't be at the gallery. Because when you get there you're already prepared, your eyes are ready, your glands, your whole body is ready to receive this art. By that time, you've probably seen more art getting to the spot than you do when you get there. That's why I like doing stuff better on the street, because the art becomes just one of the objects that's in the path of your everyday existence. It's what you move through, and it doesn't have any seniority over anything else.[3]

Hammons thus asserts the significance of the experiential factor in approaching the artwork. How might art compete with being taken unawares, shocked or disrupted by something seen on the street, or at least removed from the gallery context? Often this has occurred through the concerted efforts of artists to transport aspects of daily life into the gallery or, conversely, to move art out into the public sphere (both strategies we will encounter again and again within *Across the Art/Life Divide*).

With any work of written analysis and scholarship on contemporary art and visual culture, the expectation of the reader might be for the author to arrive at some clear conclusions, and to state from the outset the intentions of the written work itself. This is where I encounter considerable difficulty: just as artworks continue to challenge, so the writer must contend with both their specific aspects and broader assumptions. I consider this series of comments to be simply that: a performative trajectory that has its own problematic aspects, is both responsive to the artworks and notions chosen, and takes its own particular, idiosyncratic path in configuring such responses.

In a prescient proclamation written in the mid-1960s by Allan Kaprow, he states:

> I am convinced that the only human "virtue" is the continuous rebirth of the Self. And this is what a new art is. We today are not damned (as we have all been told); we are simply bored to death. If we seek salvation, it is still Baudelaire's ennui that we wish to be saved from. To be born not simply again, but again and again, is now our loftiest social obligation. As an artist, it means living in constant spiritual awe and inner disequilibrium. (This is perhaps the only real state of harmony; all the rest is undreaming sleep.) It means casting our values (our habits) over the edge of great heights, smiling as we hear them clatter to pieces down below like so much crockery – because now we must get up and invent something again.[4]

Such a near-constant discarding, embracing and recycling of potential selves has become much more widely manifest in recent contemporary art practice, and this will be returned to often in the themes treated throughout *Across the Art/Life Divide*. The notions Kaprow raises here are still relevant and challenging today, particularly the rebirth of artistic identities and the simultaneous maintenance of multiple creative "selves". The "inner disequilibrium" Kaprow mentions here refers to a creative instability that shows no sign of abating any time soon, even if the act of defining what "internal" and "external" subjective experience consists of is a very complicated matter. In everyday experience, one is constantly presented with the situation of "being oneself", so would it actually be that surprising to see contemporary artists investigating whether authenticity in this respect truly exists or might somehow be revealed, by taking on disorientating strategies of masking and merging identities.

The representation of self is often one of the most accessible aspects that viewers might look for in an artwork – that is, in terms of an authorial, biographical designation, to help decode it, make it legible. Even the notion of what to turn one's attention towards is built on nominal reputation and presumed status. The art historian and performance theorist Amelia Jones incisively remarked:

> The question of subjectivity – who we think the artist "is" or "was" or what she "expressed" in the work – is simply an in-built structure in relation to what we call art, which compels us to project *beliefs about* the artist's putative identity and subjectivity into our relationship with the work. There is no "object itself".[5]

The daunting question of how the subject is constituted is far from agreed upon, and even whether the self might be read as singular, plural, intersubjective and/or wholly constructed.

In the estimation of philosopher Jean-Luc Nancy, there is no singular self without implying the community to which it belongs and within which it interacts. Nancy applies the phrase "being singular plural":

> Being is *with*; it is *as the with* of Being itself (the cobeing of Being), so that Being does not identify itself *as such* (*as Being of the being*), but *shows itself* [se pose], *gives itself, occurs, dis-poses itself* (made event, history, and world) as its own singular plural *with*. In other words, *Being is not without Being.*[6]

So, if there is never "one" apart from "we", this correspondingly blurs, complicates and extends our readings of individual selfhood.

In an engaging study of theorist Félix Guattari's work on the production of subjectivity, writer/artist Simon O'Sullivan comments:

> Thinking ecologically we might see subjectivity in terms of a multiplicity: a complex aggregate of heterogeneous elements. Important here will be decentered relationships (i.e. no specialists, no priests, no teachers as such – no transcendent principle) and also relationships with architecture, with the group (however this is thought), with economic factors and always with an outside to whichever institutions and academies the individual happens to be "part of". Indeed an ecology of subjectivity will precisely emphasise this contact and communication with an outside (there are in this sense no closed systems, no completely isolated individuals).[7]

For artists to bleed over the edges of their creative selves, so to speak – in terms of actions and attitudes, forms and practices – is to contend with one of the most integral aspects of art-making: that cultural production depends upon and acts in relation to the surrounding life-world and cannot escape from it. So might the questions posed by many figures in this book emerge: *when* is my life art? Is any part of my existence *not* art? *What* is to be gained by acts of disguise and distortion to paradoxically get closer to discerning one's manifold identities? Moreover, perhaps there is indeed no "true self" except within the specific coordinates of certain historical psychoanalytical literature. Yet art gives a cause and motivation to voyage beyond ordinary perceptual limits that often assist in unduly containing a notion of self into more fluid and open-ended ranges of possibility.

The introductory chapter, "Art and How to Live It: Artists Performing Themselves (and Others)", treats a variety of artists who work within the realms of performance, photography, video, and other broadly interdisciplinary practices, but who use a number of tactics closely related to their artistic personae, conjured via masking, characterization, and spectacle. I examine multiple examples of how the emphasis on performing on various levels has become radically transformed since the "golden age" of 1970s live art, as artists continue to develop and refine their specific approaches to creating performative personae in novel and unexpected ways. These artists privilege in turn a kind of extended, transformative burlesque of artistic authenticity; a quest to show that what is real, authentic, truthful, must be gotten at through carefully elaborated yet patently absurd procedures, often incorporating intricate social relations, and with the artist occupying several roles simultaneously. Artists discussed

include Pawel Althamer, Bob Dylan, Gelitin, Rodney Graham, Ragnar Kjartansson, Nikki S. Lee, William Pope.L, Tony Tasset, Ronnie van Hout, and Gillian Wearing.

Chapter 2, entitled "Unfinished Filliou: On the Fluxus Ethos, Origins of Relational Aesthetics, and the Potential of a Non-Movement in Art", traces a lineage between the Fluxus movement and its ideals, the later artists associated with the notion of "relational aesthetics" and the residual impact of the Fluxus ethos. In this chapter, I pay close attention to, and take particular heed of, the life and legacy of the French artist Robert Filliou (1926–87), and his complex and entangled approach towards both his life and art. Today perhaps most famous for his oft-cited quote "art is what makes life more interesting than art", Filliou has only recently been gaining more acknowledgement for the immense significance of his art practice.[8] An understanding of his ideas serves as an important bridge between artists of his era who are discussed much more frequently, and the emphasis on dialogical, dispersed, and relational practices that has become increasingly pronounced since the 1990s. I also discuss Filliou's work in terms of its influence upon a number of contemporary artists, including Liam Gillick and Pierre Huyghe. The chapter also posits the notion of a Fluxus 2.0 today, as the notions of Fluxus gain more ground via social networking interfaces and a wider distribution of the original movement's playful ideas.

The primary focus of Chapter 3 – "Autobiographical Voices and Entangled Identities: On Monologues and Memoirs; Comedians, Celebrity, and Camouflage" – is the use of the first person, autobiographical monologue as a frequent narrative structuring device throughout late twentieth and early twenty-first century cultural production, whether in the form of performance art, stand-up comedy or television; memoirs created for the page, the cinema, or the video screen. Such cultural artefacts and their lingering influence tell us much about the art/life divide – that is to say, the crafting and merging of life experiences into creative practice – and this becomes the emphasis of this portion of the book. The artists, comedians, performers, and writers discussed include Dave Chappelle, Megan Dunn, Geoff Dyer, Bryce Galloway, Spalding Gray, Dick Gregory, John Haskell, Andy Kaufman, Chris Kraus, Glenn Ligon, Steve Martin, Richard Pryor, John Jeremiah Sullivan, and David Foster Wallace.

Chapter 4, "Intervals, Moments, and Events: Performative Tactics and the Reinvention of Public Space", examines a number of recent artists' projects that engage with the public space, and that have become more aligned with the temporal than the spatial. This shift away from traditional notions of public space has allowed for an increasingly elusive, radically dispersed number of intervals, moments, and events to occur. Projects incorporating site-specificity have also shown a greater preoccupation with so-called non-spaces and non-sites. Many such artworks can be characterized by their movement from the grandiose to the more intimate in scale. Practices rooted in institutional critique now foreground playfulness rather than pontificate, nevertheless maintaining a concertedly premeditated approach incorporating multiple angles, vantage points, and media. This chapter discusses a variety of these projects, including artworks by Francis Alÿs, Mark Boulos, Harrell Fletcher, Sharon Hayes, Toby Huddlestone, Maddie Leach, Tino Sehgal, Jane Tsong, and the Yes Men.

In the context of Chapter 5, "Reenactments, Remixing and Restaging the Contemporary", I investigate how artists have theatrically reenacted and restaged earlier events and works

from popular and visual culture. Within the current climate, the reconfiguration, recontextualization, revision, and reenactment of existing artistic materials has become both rampant and, upon reflection, profoundly significant. Topics addressed include the performative events/works of artists Tania Bruguera, Iain Forsyth and Jane Pollard, Elaine Sturtevant, Shannon Te Ao, Ant Farm and T.R. Uthco, Dick Whyte, and Our Literal Speed. In addition, the blurring of fact and fiction, and contemporary and historical source materials in recent art practice, is addressed in this chapter. If the concertedly recombinant, remixed, and hybridized is arguably more familiar to the viewer of the present than the ostensibly "whole", unitary, and cohesively legible, this in turn disrupts and questions long-standing assumptions of originality and authorship.

Chapter 6, "Social Practice and the Shifting Discourse: On Collaborative Strategies and 'Curating the Social'", examines contemporary art's involvement with so-called "social practices" over the past two decades. Moreover, the ways in which we are to regard this moment as social practice has been commented upon more widely, disseminated within critical and curatorial venues, and is still problematic and challenging in manifold respects. What happens when a micro-scaled, process-based work becomes subsumed within the global art economy? How can collectives take advantage of "group mind"? What are the distinguishing factors between symbolic representations and actual activism? How can social practices function within contemporary curatorial culture? Examples considered include Dan Peterman, John Preus, Temporary Services, Anthony Schrag, Theaster Gates, Paul O'Neill, SHOW gallery, The Suburban, and Kallio Kunsthalle.

In the final chapter, "Emergent Notions of Subjectivity and Authorship: How Might We Occupy the Present?", I consider three examples: (1) changing ideas and notions of address surrounding critical writing in the arts; (2) a reevaluation of the Fluxus score as a mode of writing and enacting performance as a charged social event; and (3) a consideration of Thomas Hirschhorn's views on "shared" authorship in his works, most specifically the *Gramsci Monument* of 2013. Questions raised in these discussions include: how might criticism matter? How might scores temporally distanced from us ignite the imagination again, acting both as texts and as live experiences? And what are we doing as authors? What might more expansive notions of authorship do for us?

My own formative experiences in art involved spending a considerable amount of time as an aspiring artist and photographer. Yet I became increasingly intrigued by the meta-conditions and contexts, whether aesthetic and conceptual, or social and political, surrounding the production of art. Over the course of my MFA degree, I undertook studies in both photography and transmedia, one of the earliest interdisciplinary areas in fine arts studies at the University of Texas at Austin, spanning installation, video, performance, and other expanded approaches to art-making. Working with artists Bill Lundberg, Linda Montano, and Bogdan Perzyński was enormously enriching and energizing in terms of my beginning to think through the rapidly expanding parameters of contemporary art practice.

I subsequently worked with such art historians as Linda Henderson, Ann Reynolds, and Richard Shiff at UT Austin, and Ann Gibson and Donald Kuspit at SUNY Stony Brook, and undertook a doctoral thesis under the supervision of Stephen Bann on the topic of Polish

conceptual and intermedial art of the Cold War era. This is all to say that engaging with a variety of notions around post-war art and its implications became hugely absorbing for me, as was how art is a vital, incorporative force, continually annexing the everyday. It is significant to note that this has become a widespread, global phenomenon, although the current study only hints to what extent.

Teaching art history, critical studies, and studio art while also writing short form criticism has deeply informed my approach to thinking about art, especially in the sense that one shares that experience with others, becoming a remarkably significant kind of interaction. However solitary the effort of writing might seem, it is always influenced by such exchanges and contact with others as adjacent interlocutors, and I would like to thank the many people I have been privileged to share ideas with, both those who have been namechecked in the acknowledgements, but also – and maybe even especially – those who have not. It has been a long, involved trajectory since I began this project, from considering some inchoate ideas years ago up to its current state. But even with the prolonged span of time leading up to its culmination, I would argue that the themes I am exploring here involving performance, subjectivity and the social have not lost their currency, and are as significant and crucial as ever.

CHAPTER ONE

Art and How to Live It:

Artists Performing Themselves (and Others)

What I'm trying to describe is that it's impossible to get out of your skin and into somebody else's. And that's what all this is a little bit about. That somebody else's tragedy is not the same as your own.

—DIANE ARBUS, C. 1970[1]

Becoming aware that the body is merely a tool of the soul is a great achievement. I feel like an astronaut in the spacesuit of my own body; I'm a trapped soul. [...] I think the Song of a Skin Bag by the Chinese Master Xu Yun, a treatise on the transience and fleeting nature of the body, made many things clear to me. The body serves as an outfit, an address.

—PAWEL ALTHAMER IN CONVERSATION WITH ARTHUR ZMIJEWSKI, 1997[2]

She is that outsider who experimentally drifts into other people's lives and slips on their skins.

—CRITIC GUY TREBAY ON ARTIST NIKKI S. LEE, 2004[3]

I've got to lose this skin I'm imprisoned in

Got to lose this skin I'm imprisoned in [...].

—"LOSE THIS SKIN", THE CLASH, 1980 (WRITTEN AND PERFORMED BY TYMON DOGG)[4]

Performance-related artworks that tested perceived limits and crossed numerous thresh-olds while generating a high amount of creative uncertainty (both on the part of the artist and the audience) became a characteristic approach within the visual arts throughout the 1960s–80s – from proto-psychedelic "happenings" to austere conceptual events to politi-cized art collectives. "Live art" became an elastic term not only signifying "live" (as in live performance), but art as a mode of *living* experience, subsequently framed, refined and (re-)produced for the art context – to *live* art. But this acted as an undercurrent to a prevailing emphasis (particularly in terms of the art market) upon objects, images and constructions.

Many artists emerging in the wake of postmodernism began to reinvent live art by strad-dling public and private realms, with increasing entanglement in late capitalist settings (for instance, the spectacular biennale exhibition and the burgeoning globalized art world). Mediation of the live event asserted itself even more strongly: video works (and now streaming video) since the 1990s bridged a gap between the original event and its later circulation and dissemination. The same period saw an increase in ambiguity concerning any political positioning or subjective locus of the artist's identity. In a climate shaped by both art as commodity and its filtering through virtual circuits, the constructed per-sona of the artist became a significant, foregrounded aspect of contemporary creative practice.

In this chapter, I argue that the performative approaches of a loose amalgam of artists since the 1990s are linked by a notion of the artwork as a well-documented temporal event, unfolding from constructed (and often reconstructed) personae deriving from a personalized hybrid of the artist's autobiography, aesthetic, and politics. The artists I am turning my attention towards enact an extended, transformative burlesque of artistic au-thenticity; a quest to show that what is meaningful must be gotten at through carefully elaborated yet often absurd procedures, often in dialogue with the surrounding public sphere. What does it mean to don a second skin, an artfully conceived carapace to forge ahead and contend with the world? The artists discussed here – Pawel Althamer, Bob Dylan, Gelitin, Rodney Graham, Ragnar Kjartansson, Nikki S. Lee, William Pope.L, Tony Tasset, Ronnie van Hout, and Gillian Wearing – ask this, as well as many other provocative questions.

Intriguingly, such actions coincided with artists also occupying several roles (and perhaps wearing several masks) at once. A common trait among many of these otherwise dissimilar artists from a diversity of backgrounds and artistic contexts is their hesitancy to make one singular, definitive project, but instead an inquisitive series of provisional statements, shrugs with exclamation points. In turn, these artists in their practices assert how an effective body of work may be comprised of multiple performative fragments rather than any assumed totality, thus acknowledging how partial and half-obscured our glimpses of the world tend to be. In the artists I examine, a wild humour and silliness often coexists with a faux madness and extreme, raucous behaviour.

In Mikhail Bakhtin's study *Rabelais and His World* (1984, first published 1965), the literary theorist writes: "Fear is the extreme expression of narrow-minded and stupid seriousness, which is defeated by laughter. [...] Complete liberty is possible only in the completely fearless world".[5] In his writing, Bakhtin details the historical power of the "grotesque" to transform "all that was frightening in ordinary life into amusing or ludicrous monstrosities".[6] While it might seem anachronistic to be inspired by theoretical material written to interrogate the literature of the Middle Ages and Renaissance in relation to my reading of various contemporary artists, many of Bakhtin's points are resonant with the chaotic climate of more recent years and the creative approaches of the artists under review here. Critic Gregory Volk has noted Bakhtin's influence on artist William Pope.L, for example:

> Importantly, carnival life does not seek to transcend normal life. Instead, both exist together, and one moves between the two, entering a "topsy turvical" (to borrow a term from Vladimir Nabokov) carnivalized situation in order to experience rampant eccentricity and radical freedom and then returning to one's normal life – perhaps shaken, perhaps deepened – with some sense of the wisdom that one gained.[7]

One weakness of the art of "identity politics" that emerged in the 1980s and 1990s was its pronounced reductive literalism, which tended to keep "identity" from being read as "identities"; multiple yet correspondingly involved in many interwoven textures, mixing vibrantly with the paths of other people and experiences. Identity was often represented as singular, bounded, and self-reflexive, without incorporating the exterior world except in an adversarial, confrontational way. This was undoubtedly highly significant in many instances, but left little room for continued pursuit of similar methodologies without a major rethink as surrounding contexts changed – and not always for the better. This is not to in any way dismiss many of the best artists and projects of that time, but to call attention to how comparatively fragile and combustible such uneasy aesthetic positioning became. The power of several of the artists discussed here is in their concerted reworking and reassessment of how to conduct an art which both enacts and questions the inexplicable, unstable, even unlocatable strangeness of identity.

Superman – in the form of an African American artist wearing a dishevelled version of the iconic garb – crawling slowly, flattened to the ground, along a busy avenue. An Icelandic pop musician and video artist hanging around in a gallery during the Venice Biennale, strumming a guitar, drinking lager and occasionally making an amateurish painting. A Korean émigré to the US has herself photographed as she all but melts into a number of highly circumscribed

subcultures. A Polish sculptor travels with selected groups wearing shiny gold spacesuits, jet passengers traversing assorted national borders.

Such an eclectic list is an intentional compression of some of the artistic approaches, projects and modalities to which I plan to turn my attention. While there is a marked diversity in terms of geographical locales, cultural backgrounds, and other demographic factors, the artists cited above add new relevance and revised meanings to one of the most integral themes of contemporary art: the blurring and questioning of the art/life divide. The attacks and skirmishes relating to this elusive borderline have occurred with such force and for so long that they have formed a ubiquitous and paradigmatic discourse throughout many histories of modern and contemporary art. From collectives to communes, one can, in a revisionist manner, turn over a lot of soil dating from the mid-to-late twentieth century to uncover the roots of the present.

I would argue that many aspects evident in recent contemporary artworks draw upon well-mapped historical trajectories, but have moved into a more difficult to define zone of experiences. By examining artists' construction of personae, which problematize notions of the individual and selfhood, and such characters' movement between fields of interrogation – performance and performativity, the carnivalesque and grotesquery, authorship and the mutability of identity – I assert the importance of such life/art practices in illuminating and recording experiential knowledge.

"Living Art": Artists Inhabiting the Gallery

Ragnar Kjartansson was Iceland's representative for the Venice Biennale in 2009. Recalling an earlier era of durational performance practice, he spent the course of the six-month-long exhibition in the pavilion space (off-site from the grandiose Giardini in a still grandiose palazzo) garbed in a bathrobe, strumming an acoustic guitar, chatting with visitors and making the occasional painting of fellow artist/model Pall Haukur Bjornsson amidst some formidable consumption of lager and cigarettes. Empty glass bottles cluttered the space; near an old-school turntable was a stack of LPs, not so current hits including *The Freewheelin' Bob Dylan* (1963).

During the exhibition, the artist commented, "I think, secretly, it's what every artist wants to do, just to sit and think and smoke and think".[8] As the retro kitschness of the set-up becomes almost too much to bear, it is also relevant to mention Kjartansson's parallel life as a contemporary pop musician (albeit of the cultish Icelandic sort), and further that Kjartansson's band, Trabant, in its very name harkened back to a less than supercharged vehicle manufactured in former East Germany.[9]

Just as pop music functions via a mix of novelty and the familiar, the art historical lineage from which Kjartansson's well-publicized work can be traced involves many artists who also chose to "live" in the gallery: from Ben Vautier to Linda Montano, Chris Burden to Tracey Emin. And in the Venice installation's knowingly portentous titling, *The End* (2009), one might ask: the end of *what*? Is this simply another staging of the slightly bloated finale of painting read both as farcical and as the beginning of something else; and, relatedly, does it offer up the performative event as the go-to genre of the scattered site/biennale circuit?

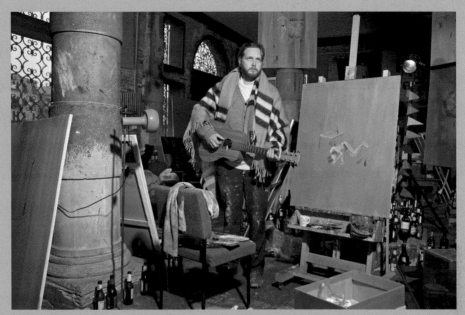

1.1 Ragnar Kjartansson, *The End – Venezia* (November 2009). Performed at the Icelandic Pavilion at the 53rd Venice Biennale, Italy, 14 June – 22 November, daily for six hours. Commissioned by the Center for Icelandic Art. Photo: Rafael Pinho.

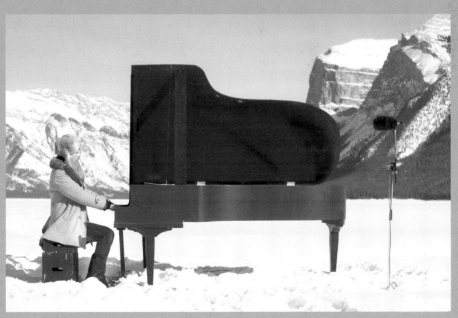

1.2 Ragnar Kjartansson, *The End – Rocky Mountains* (2009). Five-channel video. Duration: 30-minute loop. Commissioned for the Icelandic Pavilion at the 53rd Venice Biennale, Italy. Produced in collaboration with The Banff Centre, Canada, and the Stephan and Adriana Benediktson Fellowship for Icleandic Artists.

Such a mode of practice is a staple "post-medium" of these events, often in tandem with video works (which filled the anteroom of Kjartansson's installation).

Here the pictorial and the performative combine as a finely calibrated and premeditated conceptual attack, each part working in tandem to deftly produce a slacker art accessible for a visual arts and pop cultural savvy twenty-first century audience.

But the slacker character is simply another invented persona as Kjartansson is a highly industrious citizen of the international art circuit, preserving an outward impression that "I've just fallen into this cool gig". Kjartansson has taken on various guises in his performative videos: the dapper singer of the elongated phrase "sorrow conquers happiness" in front of an eleven-piece orchestra in the piece *God* (2007); or another performance entitled *Sounds of Despair* (2009), in which he screams/moans a loud chant while wearing a tuxedo and taped to a gallery pilaster. The atmosphere conjures some inside joke that viewers have been allowed to join in, perhaps not as equal participants but empathic onlookers. The eminently quotable artist commented: "Life is sad and beautiful, and my art is very much based on that view. I love life; I love the despair of it".[10] Whether made up as a Viking or a folk singer, Kjartansson cultivates a stance more reminiscent of television sketch comedies than the quasi-torturous rituals of artists like Marina Abramović or Vito Acconci.

Kjartansson is indebted to such figures as conceptual artist and gallerist Tom Marioni or the performance artist Linda Montano. A trained musician, Marioni's art has incorporated durational frameworks in both actual performances and performative drawings. For example, he has used the brushes of jazz drumming to repetitively create a soundscape from which emerges a highly distinctive residual image. He has also created performative works in which marks traced the acts of leaping and walking.[11] Marioni founded and operated the Museum of Conceptual Art (MOCA) in San Francisco.

An early alternative space, Marioni described its ethos in the following manner:

> It was simple no dance or theatre or painting or object sculpture. It's a long story. It was a one horse operation, no money changed hands and nothing was ever sold and it was open and free to the public. It was socialist because nothing that was installed into the building could be removed without its context being taken away. When I closed MOCA in 1984 and the building was destroyed the art went down with it. The art could not be owned.[12]

Marioni's most well-known projects today are his Wednesday afternoon salon-style gatherings, *Drinking Beer with Friends is the Highest Form of Art* (1970–) a work of "social sculpture" running on a regular basis in San Francisco for more than two decades. Marioni also participated in Linda Montano's early work *Handcuff* (1973) in which the two were locked together for three days as an example of what Montano has termed "living art". According to her personal remembrance of the 1960s and 1970s:

> It was an exciting time – street actions, long, drug-induced video trances and therapeutic disclosures were substituted for objects. The artist's inner environment was the

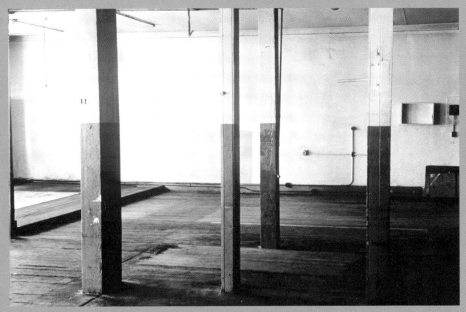

1.3 Tom Marioni, *Museum of Conceptual Art*, San Francisco, interior view, courtesy of the artist.

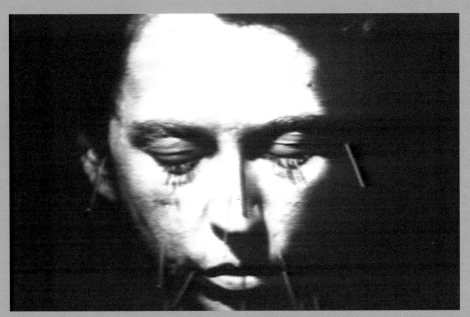

1.4 Linda Montano, *Mitchell's Death* (1977). Video (black and white, sound). Image copyright of the artist, courtesy of Video Data Bank, www.vdb.org, School of the Art Institute of Chicago.

15

source of the work. Criticism was hardly necessary because none had been developed for the genre; the audience was often the artists themselves and a small group of artist-friends (for example core groups such as the people associated with Tom Marioni's MOCA in San Francisco, The Judson Group in NYC and the Woman's Building in LA). Consciousness-raising and personal integrity were the priorities. Nothing could be bought or sold.[13]

However rosy Montano's view appears in hindsight, it exhibits a striking consistency with many other accounts from first-hand participants (such as Marioni's). Montano would go on to make many significant artworks, among them collaborations with the experimental musician Pauline Oliveros and fellow performance artist Tehching Hsieh. When Oliveros met Montano, she was performing the work *Three Day Blindfold/How to Become a Guru* (1975) in Los Angeles, and Montano joined Hsieh's *One Year Long Performance* in 1983–84 after having lived in a rural Zen retreat in upstate New York alongside Oliveros. Montano described the *Blindfold* piece as follows:

> In this event I blindfolded myself because I didn't want to react visually or socially and thought that I could alter my perceptions and therefore drop habituation and judg-ment. It was exhilarating and I was fearless [...] beyond society, acting intuitively. Pauline Oliveros became my guide for that time and we moved without guilt for those three days. I keep repeating similar experiments in other ways in order to become familiar with expanded body feelings. This piece was a vacation. It changed my life.[14]

Oliveros met Montano in March 1975 in the context of the vital California feminist art scenes, supported by artists such as Judy Chicago and Suzanne Lacy. In Oliveros' words:

> That was such a wonderful time [...]. Linda represented the first person who came along who understood what I was doing. She understood the meditation and spiritual aspect of the work that I was doing and gave me incredible emotional support at the time.[15]

Montano and Oliveros became partners in the mid-1970s. Around that time, Montano split with her husband, Mitchell Payne, who not long afterward was tragically shot in a robbery. In dealing with the aftermath of the event and all manner of intense emotions, Montano created the performance recorded on video as *Mitchell's Death* (1977).

It is a strange, startling and moving piece. Underpinning its intense subject matter are themes of spirituality and healing, and the video features Montano's droning, extended spoken-sung monologue, which owes much to both Oliveros' "deep listening" and the chanting of Tibetan Buddhism (of which both Montano and Oliveros had recently become initiates).

Mitchell's Death is also intriguing when viewed in comparison to Oliveros' musical perfor-mance *Rose Mountain Slow Runner* (1976), recorded by fellow composer Robert Ashley in his series of video profiles of experimental musicians. In this video documentation, over the course of a lengthy conversation with Ashley on her music, philosophy and other topics, Oliveros is "made-over" in a gaudy outfit decked in rainbows and leopard print, with a blonde wig and make-up, and subsequently plays the accordion and sings. *Rose Mountain Slow*

Runner exemplifies Oliveros' improvisatory approach, known by her term "deep listening", which owed much to John Cage's openness to ambient sound; similarly, Cage was influenced by Oliveros' approach in that it helped him reevaluate his antipathy towards harmony.

Oliveros and Montano collaborated throughout the 1970s, and one of Montano's first uses of the term "living art" is the following piece as described in her monograph *Art in Everyday Life* (1981):

> Living art: A complex theory which states that life can be art [...]. December 1975 [...]. Art: Pauline Oliveros and I lived in the desert for ten days and agreed that everything we did would be considered art. We documented the event. Life: Living art was incredibly exhilarating [...]. I thought that the life/art transference was finally made because I began interacting more truthfully and spontaneously. I called each day art and not life. I was happy and making art at the same time.[16]

Similar manifestations – whether projects, events, gatherings or strategies – by artists that intentionally blurred art/life distinctions in a generative manner had been widespread, if often overlooked, over the course of many years. Black Mountain College's retreats in rural North Carolina, emphasizing both experimental pedagogy and cross-disciplinary dialogue, were extremely important. The unscripted *Theatre Piece No. 1*, organized by John Cage and often called the first "happening", occurred there in 1952. Black Mountain offered an opportunity for many strands of modern cultural practice to coexist in the same temporal setting, including poets, abstract painters, Bauhaus veterans, and non-conforming visionaries such as the polymath designer and technologist Buckminster Fuller, dancer Merce Cunningham, and musician Cage.

Art historian Eva Díaz, in one of the most recent studies of Black Mountain's significance, has emphasized the crucial role of experimentation:

> [A] broad notion of experimentation in effect became a kind of glue binding the often-fragmented interdisciplinary discussions about the College. At the time the idea was used to rethink underlying assumptions that separated various disciplines into realms of discrete specialization. Prior interdisciplinary modernist explorations such as those practiced at the Bauhaus were revisited and expanded at Black Mountain: art merged with concerns of visual perception and environmental design; music composition flirted with arbitrary sounds and background noise; architecture and shelter design were pushed to redefine the conditions under which individuals, increasingly understood as members of wider communities, experienced space. Experimentation thus provided a shared terminology for College members to view their specific endeavors in relation to different although allied efforts in other disciplines. At Black Mountain, experimentation was professed to be a practice that could be shared by *all* creative producers.[17]

This notion of experimentation as a way of linking differing but searching approaches and attitudes towards art would continue throughout many other instances, including the concerts and performances held at Yoko Ono's Chambers Street loft in Manhattan from December 1960. For six months, a number of now renowned figures (such as Allan Kaprow, Robert

Morris, Henry Flynt and La Monte Young) conducted weekend events. According to Kaprow, in retrospect, due to the active participation of audiences in this setting, "the barrier between art and artist was removed".[18] Between 1963 and 1980, Charlotte Moorman, another central figure in the Fluxus group, organized the Avant-Garde Festivals, which incorporated experimental music and art. These were held at a number of sites throughout New York, including Central Park and the Judson Memorial Church in Greenwich Village, which was a pivotal location for showcasing mixed-genre practices from the 1960s onward.

Life and art in the subsequent decades have become increasingly intermingled with the marketing of "lifestyle" rather than the historic avant-garde, just as we have become as accustomed to interpreting text messages as decrypting theoretical texts. It seems telling that in one of Robert Rauschenberg's final exhibitions, *Synapsis Shuffle* (2000), held at the Whitney Museum, he collaborated with colleagues and celebrity "non-artists" such as the American home-decorating guru Martha Stewart. The brash, decorative patterning that had long characterized the artist's practice held a summit meeting with the "colour coordinator of cable television", as she was asked to "shuffle" his paintings on metal as if oversized playing cards. By the early twenty-first century, a magazine easily found on news stands titled itself *ReadyMade,* with the subtitle "for people who like to make stuff", again a conceptual touchstone of modern art rerouted into service as a marketing tool to entice fans of DIY projects, encompassing such categories as "home and garden, food and entertaining, design, craft, fashion and style, culture, travel and places, technology and work, and ice cold".[19] It is a long, strange trip from Duchamp's inscription of the inscrutable phrase, "In Advance of the Broken Arm", onto a snow shovel in 1915 to *ReadyMade*'s 2010 exhortation to have a "No Bummer Summer: Make Popsicles!"

Bearing relevance to this cultural push towards marketing DIY as creative, significant, and fun, along with the shifts in contemporary art practice toward durational projects, artist/writer Dave Beech, in an astringent essay, commented:

> The ideology of duration allows artists, curators, funders, and participants to affirm the monumentalisation of time in community projects as having a value in itself. We recognize this ethic from other fields, particularly from public relations, market research, the community investments of big business and the rise of consultancy within professional politics. The ideology of duration is not only a key normative element within contemporary realisations of the dematerialised monument; it is also deeply embedded in contemporary practices of *business management and social control.*[20]

To counterbalance in part the rather ominous tone underlying Beech's comments, there is the more affirmative appraisal of the variegated strands of durational art practice by theorist of performance and live art Adrian Heathfield:

> Contemporary Live Art now employs many different forms of experimentation with time: diminishing the "known" and rehearsed dynamics of performance by opening it to improvisation and chance, "employing actions in real time and space"; banishing, rupturing or warping fictional time and narration; scheduling works at "improper" times; creating works whose time is autonomous and exceeds the

spectator's ability to witness it; presenting the experience of duration through the body; deploying aesthetics of repetition that undo flow and progression; and radically extending or shrinking duration beyond existing conventions. Often these tactics are employed in combination.[21]

I am u r me: Artists and the Morphing Subject

Many of the artists I am considering here, while not necessarily explicitly derivative, are directly involved in acts of citation, satire, and the reworking of existing cultural material. Artist Nikki S. Lee, after an apprenticeship in fashion photography, portrayed within her *Projects* series (1997–2001) the outer representational signifiers or shell of a stereotype in order to more effectively disrupt it, to wrench it away from any type of straightforward meaning.

The people she acts, reenacts, and constructs her photographs with become on first glance the stereotypes themselves; yet as we look closer, we see they are collaborators in this process of disruption. This occurs by the de-authorization of the photographic process itself, so to speak, as Lee in her earliest works depended on a friend (Soo Hyun Ahn) to assist her in taking the images, and much of the charge of the photographs occurs via the posed actions for the camera rather than the reactions of the photographer.

Lee's *Projects* series is comprised of a number of discrete groupings, featuring the Korean artist striking poses and "transforming herself" in subcultural situations that feature denizens of the generally "non-Korean" American working/middle/upper class, among them punks, hip-hop crew, yuppies, skateboarders, and swing dancers. In the *Ohio Project* (1999), the artist is depicted with bleached blonde hair and faded blue jeans, as she hangs out in rural, working-class middle America, in which the reference points include the Confederate flag and hoisted guns, junk food, and muscle cars. As with so many of her pictures, Lee seems simultaneously to be totally at home here and completely out of synch, a misplaced persona.

Not unlike photographer Cindy Sherman, Lee presents a self-portraiture of that which is not exactly the self. As theorist Peggy Phelan writes:

> Sherman's work suggests that female subjectivity resides in disguise and displacement. She uses the self portrait to investigate the foundational otherness of women within contemporary Western representation. Taking the contradictory notion of white woman's representability very much to heart – that she is unrepresentable and yet everywhere imaged – Sherman made a series of photographs of herself disguised as film stars, housewives, young starlets, lost teenagers.[22]

The "otherness" present in Lee's work is an otherness involved in the turning of tables, an out-of-placeness that also explores being "out of time"; that is to say, Lee distinguishes herself by an act of masquerade, blurring without completely blending edges, the photographic act – the stilled moment – taken in the midst of staged partying, tourism, indolence. Differently than Sherman, Lee's photos depict her not as an individual within a studio context, but out in the world, in the midst of others.

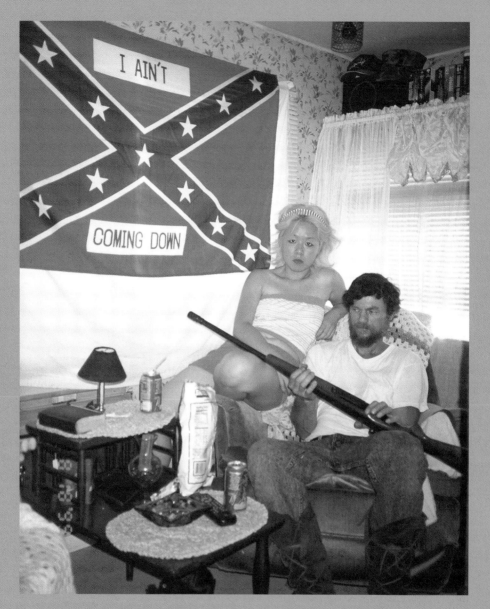

1.5 Nikki S. Lee, from the *Projects* series (1997–2001) Courtesy of the artist and Sikkema Jenkins and Co.

The poses struck gain their gravitas by being situated uneasily in-between art photography and the one-hour mini-lab mishap, as Lee preserves the look of everyday imagery, absent of the steps taken by so many fine art photographers to elevate and valorise the technical aspects of the work. Lee's perverse eloquence is in the set-up, the conceit, the pose, and its accompanying details. A distorting mirror is held up to our quotidian experience, making the underlying tensions behind the scene more apparent. Performance theorist Philip Auslander has categorized works like Lee's and Sherman's as "performed photography":

> [T]hese are cases in which performances were staged solely to be photographed or filmed and had no meaningful prior existence as autonomous events presented to audiences. The space of the document (whether visual or audiovisual) thus becomes the only space in which the performance occurs.[23]

According to Lee, she enjoys the generic look of her images; a dialogue not with mastery, but with boredom and superficiality. In a 2001 interview she states:

> What does it mean to go deeper? Taking pictures when you're more emotional or sorrowful, or having sex? I just want to have really boring snapshots – people just standing in front of a camera taking pictures with a smile. If people think it's boring, that's fine. But somehow it is emotional, because I do have an attachment with those people, although I never force it. I don't usually get really close to anyone's personal issues, but I don't consciously maintain a distance. I just open up to people, and if they come, I accept it. I don't force anyone to be close to me.[24]

This attitude recalls John Cage's well-known comment: "In Zen they say: if something is boring after two minutes, try it for four. If still boring, try it for eight, sixteen, thirty-two, and so on. Eventually one discovers that it's not boring at all but very interesting". Or Andy Warhol's "I like boring things".[25] Critic Mark Godfrey aptly stated: "Looking at Lee's photographs is like watching a dull film that suddenly becomes perplexing".[26] Lee's work indicates that life in full includes boredom when it is annexed into art; as such, she seeks an affectless photographic representation after much emotive performance leading up to those results. Boredom can also become a platform for breaking the routine, to introduce surprise and incongruity, and more than likely humour. In the midst of showing images of Lee's work to students, I have often encountered nervous laughter owing to her disruptive performative challenges to the wholly expected.

The "chameleon-like" strategy used by Lee brings to mind Woody Allen's 1983 film *Zelig*, which features the actor/director as a character named Leonard Zelig who, owing to his need for approval, develops the capacity to adopt the external attributes of anyone he encounters. *Zelig*, filmed in black-and-white documentary fashion and incorporating archival footage, is an incisive satire on America's societal conformity. Made on the verge of the digital revolution in filmmaking, much of the discussion at the time focused on the considerable technical "trickery" of the film itself, rather than its strength and complexity as a work of art. Another film of the same era, Wendell B. Harris Jr.'s *Chameleon Street* (1989), recounts the story of an African American man who impersonates – without actual training or credentials – members of a variety of professions, including a surgeon, a lawyer, and a journalist.

Lee's work extends into challenging territory, and for some critics, the work is too simplistic, folding too neatly into the identity politics that characterized much art practice of the early to mid-1990s. On a certain level, the notion of categorizing selected subgroups through her own representations can be read as an unfortunate gesture of reinscribing generalities, rather than engaging with the specifics of difference that might elicit richer contexts for understanding. However, Lee's images evoke an aura of positive empowerment around their multiply refashioned, shifting identities. The images incorporate hopefulness rather than alienation, as the bodies in the frame become more arbitrary; loud, untidy outer-coverings – punks, tourists, rednecks – overshadow some hidden temporal sequence of research, which presumably includes interesting dialogues to which we are not privy. Lee's mix of the "real world" and her microcosmic "Nikki S. Lee project world" work in tandem to build a new, complex hybrid entity.

The gestures of Lee may be contrasted tellingly with those of Canadian artist Rodney Graham, whose large-scale photographs and video works incorporate tropes drawn from anachronistic pop and so-called high culture, particularly referring to music and cinema. Distinct from Lee's approach, Graham as a "middle-aged white guy" appears able to fit neatly into so many stereotypical tableaux, steadfastly in control whether posed as a scientist or musician, criminal or pirate, inventor or artist. The very artificial inauthentic mode of representation that Graham enacts turns his Caucasian, normative status into a precisely photographed specimen facilitating our curious examination. In his video *How I Became a Rambling Man* (1997), the buckskin-clad artist roams on horseback around a bucolic landscape that references both Hollywood westerns and cigarette advertising, and riffs on the notion of the lone, wandering individual common to discussions of modern art. Graham as cowboy sings a melancholic ballad, but disappears on his nomadic travels once again.

Chicago-based artist Tony Tasset has also self-critically explored the quicksand atop which his own blonde, middle-class American subjectivity is uneasily perched in a series of videos, photographs, and sculptures. In the video *Better Me* (1996), a version of Tasset's life unfolds within a series of vignettes. Here, actor-surrogates who say all the right things replace the artist and his family unit. *Better Me* is an epic brilliantly laid out in just six-and-a-half minutes. Of note is the artist's double, a handsome and genial fellow whose presence immediately becomes cloying and unbearable, the artist as soap opera hero. We follow him through the following adventures: telling his partner before a glowing fire that she needn't work because money's not everything, and of course her art is more important; cut to Tasset's *doppelgänger* on the telephone, refusing a retrospective exhibition because his new work is all that counts; segue to Professor Tasset at the university being complimented by a young, attractive student for changing her life; and finally, a gleeful sword fight between pirate father and son.

The actor-Tasset (along with the others) is numbingly awful to watch. Do we truly believe such people, so familiar to us as types from countless television dramas, are somehow our betters, inhabitants of more perfect alternate world where everything's going to be all right? The production standard of *Better Me* is barely up to the level of a TV movie; we are thus witness to a dreamlike fantasy voiced in a manner that is both charmless and professional,

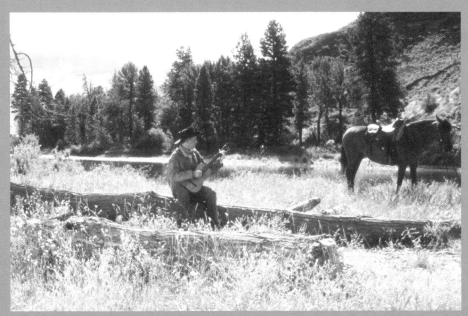

1.6 Rodney Graham, *How I Became a Rambling Man* (1997) © Rodney Graham. Courtesy the Artist and Lisson Gallery.

1.7 Tony Tasset, *I am u r me* (1998). Video still. Courtesy of the artist and Kavi Gupta Gallery, Chicago.

generic and frightening; a fantasy of a more perfect life, betraying us with its imperfect, artificial edges.

The digitized morphing in Tasset's *I am u r me* (1998) also presents a disorienting family portrait. Here, the actual Tasset family unit – father, mother, and son – sits eating breakfast around the table; the morning paper is poised on its edge, and a traffic report plays in the background. All of a sudden, the likeness of the father is "passed around" the table, as each family member is transformed: father into mother, son into father, mother into son. If viewed in a music video (as once featured in Michael Jackson's *Black or White* [1991]), this technique might elicit groans; but here Tasset dares to appropriate stylistic turns overly familiar from commercial media and integrate them into his work, adopting the syntax of television.

Works by Lee, Graham, and Tasset could all be read as exemplifying the postmodern notion of subjectivity. As art historian and theorist Gregory Minissale notes:

> The "postmodernist self" is viewed as entirely open to change and intersubjectivity, a conception that puts it in direct opposition to many psychological models of the self that posit – at the conceptual level as well as perceptual – a unified sense of self stemming from Enlightenment ideas and, later, liberal humanism where the self is associated with an autonomy and rationalism. The postmodernist self, which is a major theme in many contemporary artworks, represents (and in some cases succeeds in activating) a sense of selves in tension with self-doubt.[27]

Nonetheless, I think it bears remarking that philosophical and psychological fields view modernity and postmodernity using slightly different time frames, such that arguably contemporary art and visual culture is beginning to move into some area beyond or distinct from earlier definitions of postmodernism. Several models have been discussed, such as contemporaneity, globalism, and super-hybridity, but as of this writing, the jury is still out.

Pope.L: The Poet of Sensorial Unease

The singular name of African American artist [William] Pope.L refers to a mercurial amalgam of artistic selves and personae: artist, writer, performer, director. While most renowned for his achievements in the realm of performance, the scope of his practice is much wider than that alone. Pope.L's works speak in a multiplicity of tones and voices, consistently challenging the one-dimensional quality that too often characterizes our received assumptions around cultural and historical narratives, even when we might reassure ourselves that we are significantly revising our perspectives. There is no room for safety in Pope.L's practice, which is ever-shifting and sharply critical in unexpected and disarming ways. As the Chicago-based curator Hamza Walker writes, "Pope.L has forged an artistic practice that has nothing yet so much to do with race".[28]

His series of "crawl" works involve the artist crawling in a business suit or a Superman costume, the latter for the work *Great White Way* (1990), in which the artist bit by bit chose to

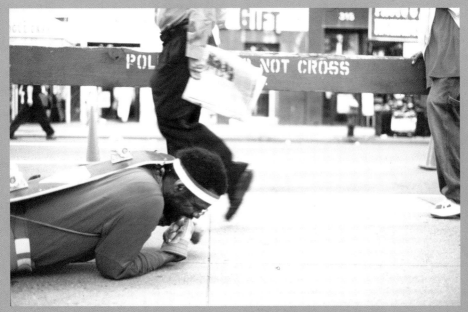

1.8 Pope.L *The Great White Way, 22 miles, 9 years, 1 street (Whitney version #2)* (1990). Video still © Pope.L. Courtesy of the artist and Mitchell-Innes & Nash, NY.

crawl from one end of Manhattan to the other along Broadway, a street whose midtown area was once nicknamed "The Great White Way" due to its early electric lighting.

It is also important to recall that while Superman is often considered emblematic of mainstream America (much like Coca-Cola or Mickey Mouse), he was invented in 1938 by two young Jewish men, Jerome Siegel and Joseph Shuster, such that the character they created could be read as a rejoinder and rejection of their own ascribed status of "otherness".

As the writer Maggie Nelson notes of one of Pope.L's crawls in which the artist wore a brown suit and carried a tiny house plant: "As the eccentric pathos of the potted plant might indicate, the Crawl pieces are not meant to provide an object lesson, but rather a peculiar public spectacle around which prejudices, sympathies, uncertainties, and other unpredictable emotions might swirl".[29] So, rather than harbouring any false pretence of resolving things, we are left with a deeply affecting, confounding impression of the world.

In Pope.L's practice, his investigation of the continuing entanglement of "whiteness", "blackness", and "otherness" is inescapably complex, offering a heightening and intensification of everyday experience via the poetic use of visual and textual language characterized by its creative generosity and critical sharpness. As performance theorist Shannon Jackson comments: "Less remarked – and if remarked, less analyzed – is the fact that Pope.L taught playwriting, avant-garde performance, and the performance of poetry in the Theatre and Rhetoric departments of Bates College for nearly two decades".[30] Playing counterpoint to Pope.L's brutal use in his performances of (as Jackson states) "food materials that filled his world of precarious consumption – hot dogs, Jell-O, white bread, mayonnaise, Pop Tarts, ketchup, and peanut butter" is his use of language that is subtly drawn and functions in performance – as narration in video works, incorporated into drawings, or presented within statements and writings.[31]

Art historian Darby English cites the "productive potential of apositionality" favoured by the artist in his insightful analysis of Pope.L's practice, commenting, "[a]lthough the play of differences weighs supreme in his work, it's never simply as a matter of one difference against the other, but more like a meditation on the impermanence that inheres in each: the play *in* differences".[32] That Pope.L has often been viewed as an "outsider" while simultaneously fulfilling "insider" roles is relevant to his work, as it reminds us that such categories are simply that – categories – which often serve as a means of officially according and sanctioning privileged or demeaning positions in the broader society.

In a passage representative of the artist's inventive and tactical wordplay, Pope.L writes:

> Blackness is a notion, a desert, a nothing [...]. And we all seem to have a use for nothing. It is the fantasy we tell ourselves to mark ourselves off from the world and put us to sleep at night. It is what we use to make money. To make people cry. It is our cereal, it is our milk. It is what we use to kill ourselves with. It is our blanky made out of vapor [...].[33]

The brand of poignant and distinctive humour evident throughout Pope.L's works draws upon a diversity of influences, among them the Fluxus movement's actions and objects (Pope.L was once a student of the Fluxus artist Geoff Hendricks), the stand-up comedy of

Richard Pryor, Samuel Beckett's existential absurdity, the anarchic impulses of Dada, and the multifarious activities of so many citizens who have not been afforded the designation "artist". Pope.L's use of the sensory, viscous properties of food, drink, bodily fluids, medications, and materials both recalls his worries over the trauma of a bare cupboard, and extends the influence of Fluxus' interest in artworks incorporating aspects of food and the body.

As dance historian Sally Banes notes:

> [The] Fluxus movement was particularly fascinated by bodily processes, from ingestion to excretion. The name Fluxus itself […] comes from the word "flux" – whose primary meaning is "a) a flowing or fluid discharge from the bowels or other part... b) the matter that is discharged".[34]

Pope.L's own works operate at the threshold between one thing and another. What are the discernible qualities of separateness, disunity, dissonance? How can challenges be encountered through the use of haptic, tactile means? How can an artist make mayonnaise, ketchup, Pop-Tarts®, industrially processed bread *do* things, fuck with our heads, irrevocably?

By inhabiting roles that may be perceived as contradictory, Pope.L portrays within the art context the conflicted situations that run through our own lives. In his *Reenactor* (2012), the artist is not the central character, as in his crawls and performance-actions, but the director:

> [*Reenactor* is] a film about how we costume and theatricalize time in order to make sense of our mortality. We dress reality up in history, documentary, biography, or art to restage and reorder the chaos of getting from one side of life to the other. *Reenactor* is a poor man's parallel universe; it is my way of haunting time. I call *Reenactor* my Civil War film but the war I'm referring to is any great trauma that marks the land and its people such that ghosts are spawned and made restless.[35]

These "ghosts", whether African American or Caucasian, could be the citizens of Nashville, Tennessee, wearing caricatured costumes as though dozens of Robert E. Lees were occupying and wandering through mundane settings such as convenience stores and lower-middle-class homes. In addition, it calls attention to the strange phenomena of Civil War reenactments that are considered a mainstream activity (at least in the American South), and are as teeming with underlying complexities and perversities as any works of performance art.[36]

Pope.L's web-based project *Distributing Martin* (2001–) presents similar contradictions to those of his performances, but taking the form of a hypertext-style site in which the reader may choose from a number of posts after encountering the following statement:

> 2025 I woke up today. Everyone is still black. Everyone has moustaches and can speak like a great orator. Everyone is kind and fierce. And dedicated. Everyone wears suits and has extramarital affairs whether they are married or not. People plan their assassinations while under hypnosis so that when they are awake they feel nothing more than that. On Sundays after preaching at church, everyone goes to their favorite Lorraine Motel and steps out onto the balconies for a breath of fresh air.[37]

In a 2002 interview, the artist described the origins of this project:

> I originally wanted to make a 10 foot by 30 foot billboard saying "This Is A Painting Of Martin Luther King's Penis From Inside My Father's Vagina," but the various sign companies I approached refused to make it, and my gallery in Harlem could not find a site willing to host it. As a result, I decided the billboard should remain purely conceptual but serve as a matrix for more dispersed activities. So the billboard text was made into thousands of postcards and flyers, rumors were spread, genetic material was inserted into supermarket fruit, and a website was created at http://distributingmartin.com. The goal of the project is to vaporize an encrusted monument called "the great black heroic father" into the wild air of everyday and everybody.[38]

Distributing Martin is an example of authorship becoming diffuse, distorted, and disorienting. It is hard to discern all the layers represented here, but the site points towards "the wild air of everyday and everybody", reinscribing Dr. King into the world, into "the air we breathe"; not in a wholly unproblematic fashion, but without the simplistic reverence that can (often unintentionally) undermine the enduring legacy of his thought and actions.

Pope.L's practice exemplifies a spectacular intersubjectivity; the artist conceives his work with the intention of the audience playing a crucial role, whether in viewing documentation at the time of the project in question or in a dialogical relation to the artist. As Pope.L commented in an interview with curator Lowery Stokes Sims:

> I like audience. I like giving good audience. I like people. My appreciation comes more from my background in theatre and rock bands than from being in the art world. [...] I also respect and fear the audience. Like my family, the audience is also bigger than me. I see my relation to audience as a kind of dance in which I must be sensitive to the ebb and flow of the choreography. This choreography is a collaboration. No one owns it. Its nature is mutually influencing. Bridges must be built and burnt viscerally.[39]

Along with the hard-core actuality of lived political situations, artistic practices intersect with aspects of dreaming, conjured worlds, and altered states, and these have been explored recently in curious parallel with the rise of so-called "social practice". Pope.L has stated that "there can be no innovation without the gangplank of dreaming".[40] As a starting point to elicit public participation in a project created for the *Prospect2* exhibition in New Orleans, Pope.L asked: "When you dream of New Orleans, what do you dream of? // When you wake up in the morning what do you see?"[41] The resultant work, entitled *Blink* (2011) collated more than 1000 images received by the artist into a film, which was projected onto the rear of an old four-ton ice cream truck, painted black and towed processional-style by volunteers through the streets of the city, from the Lower Ninth Ward to Xavier University.

In speaking of the work, Pope.L remarked:

> Blink is about sharing the struggle with the darkness with others. It's about dragging that darkness out into the daylight. It's also about the dream inside the darkness [...] We all have a hope that our dragging has a purpose, that's why we can't let go of the past.

> We're not done with it and it's not done with us. It's a puzzle we have to work out. But it's sometimes easier to figure a thing out if you have help.[42]

In relation to this emphasis on projected works, I recall a statement by Antonin Artaud, who although keenly aware of the extremes of the corporeal body, continually argued for a convincing language of dreams:

> So I demand phantasmagorical films [...]. The cinema is an amazing stimulant. It acts directly on the grey matter of the brain. When the savour of art has been sufficiently combined with the psychic ingredient which it contains it will go way beyond the theatre which we will relegate to a shelf of memories.[43]

Pope.L integrates autobiographical experiences into his practice; but they become so (re-)mixed in with his poetic allusions, performative tactics, and over-the-top rhetoric that to determine what is seemingly "real" versus entirely "theatricalized" is pointless. Pope.L appears to say that we all deal with the same spectral shit, and it is going to continue to haunt us in devastating ways unless we come to some acknowledgement of issues we rarely wish to face, involving race, class, and trust. His artistic approach, despite its often confrontational, highly stylized and excessive modes of operation, moves the viewer in the direction of more empathic and compassionate relations with other human beings.

"I'm Not There": Documentary Impulses and Surreal Transformations

British artist Gillian Wearing calls attention to the fact that most documentary-style work in film, video, and photography is actually a strange, unlikely construction. It may follow certain accepted rules, but it tends to become a theatrical rendering of reality nonetheless. Her inspired mixtures of in-the-street interrogations, documentary reconfigurations, and staged photographs and videos all tease borders between lived experience and artificiality. As a viewer, one can always speculate on the truth of a recorded event, however outlandish the claim (e.g. moon landings actually occurred in secret movie studios without any need for costly and dangerous space travel at all!). Wearing acknowledges this tendency and works it to her advantage. If we love both artifice and reality, why not have our proverbial cake served by the artist?

A key early work of Wearing's was *Signs that say what you want them to say and not Signs that say what someone else wants you to say* (1992–93), a series of modest portraits of people randomly chosen on the street presenting their own handwritten comments, scrawled in black felt-tip marker on sheets of white paper, directly to the camera.

Though snapshot-like, they accumulate into a powerful, larger grid of voices: "I will end this sentence but never my thoughts"; "I have been certified as mildly insane"; "I'm desperate"; "Everything is connected in life the point is to know it and unerstand [sic] it". In *Two into One* (1998), a mother of twins has her own voice and words transposed into their mouths, and vice versa, conjuring an uncannily disturbing and disorientating effect.

In Wearing's *Trauma* (2000), numerous people recount narratives of horrendous past experiences, revealing ways in which they were traumatized emotionally, sexually, violently.

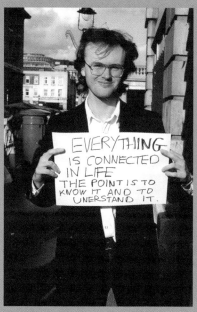

1.9 Gillian Wearing, *Signs that say what you want them to say and not Signs that say what someone else wants you to say* (1992–93). © Gillian Wearing. Courtesy of Maureen Paley, London, Tanya Bonakdar Gallery, New York, and Regen Projects, Los Angeles.

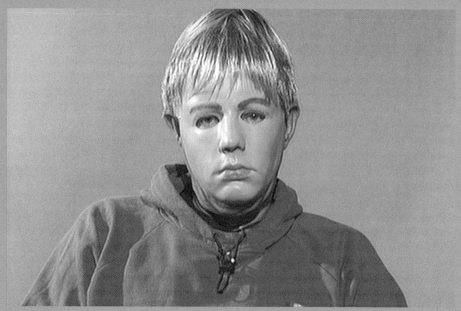

1.10 Gillian Wearing, *Trauma* (2000). Video still. © Gillian Wearing. Courtesy of Maureen Paley, London, Tanya Bonakdar Gallery, New York, and Regen Projects, Los Angeles.

Wearing sought out volunteers for her project via a newspaper advertisement reading, "Negative or traumatic experience in childhood or youth and willing to talk about it on film. Identity will be concealed".[44] The subjects wear grotesque masks disguising their identities. *Trauma* is a deceptively calm work that becomes ever more excruciating. Voices and "faces" don't match, as they relate tales of repression, angst, and horror. As a viewer, one can become addicted to hearing such awful incidents. Nevertheless, many of the now ubiquitous reality TV programmes pale by comparison.

While Wearing has concerned herself with layers and masks worn by others, she has also included herself in her work, especially when she donned masks modelled on family pictures to pose for recreations of her own family album, as well as homages to her artistic influences: Diane Arbus, Robert Mapplethorpe, and Claude Cahun. Wearing addresses the return to something that may never have existed. Who is to say that the traumatic events her subjects recount occurred, and what amount of transformation emerged in the act of retelling? Who were the aforementioned photographers in their daily lives in relation to the iconic images she exactingly mimics? What is it to reconstruct passing moments seen on the street as new events; or, family portraits and snapshots as eerie reconstructions?

Polish artist Pawel Althamer is fascinated by costuming and off-kilter constructions, vehicles for transcendental experience: astral projection, dream states, drugs, flight, pilgrimages, travelling, telepathy, fantasy, and the pastoral. His projects frequently address groups and collectivity, although the earliest works involved the artist becoming a live, temporal sculpture himself, as when he took a bus to the outskirts of Warsaw to shed his clothes and disappear into the landscape, or wore a spacesuit mounted with a video monitor relating what his camera-eye was "seeing".

Althamer's art practice derives from a variety of formative experiences, such as his studies in the Warsaw Academy of Fine Arts in the late 1980s and early 1990s, and the influence of artists such as Oskar Hansen, the post-war architect and sculptor who developed a notion of "open form", which informed Althamer's teacher artist Grzegorz Kowalski. In addition, Althamer emerged with other distinctive artists of his generation (including Katarzyna Kozyra and his frequent collaborator Artur Zmijewski), and from the late 1990s became recognized widely in part due to the support of the historically significant Foksal Gallery Foundation in Warsaw, and via his inclusion in such major exhibitions as *documenta X,* Kassel (1997).

Althamer's *Common Task* (2009) involved the artist's travels to diverse locations, including art exhibitions, along with residents of Brodno, his home neighbourhood in Warsaw. Notably, the participants in the artist's project – who donned shiny golden spacesuits as if they had just beamed in from a distant planet instead of Central Europe – were generally not fellow artists.

Another destination was a return to Mali, where Althamer had travelled in 1991 as part of an anthropological expedition, making a huge impact on his artistic development.

1.11 Pawel Althamer, *Wspólna sprawa/Common Task* (2009). Photo: Krzysztof Kozanowski. Courtesy of the artist and Foksal Gallery Foundation, Warsaw.

1.12 Pawel Althamer, *Wspólna sprawa/Common Task* (2009). Photo: Krzysztof Kozanowski. Courtesy of the artist and Foksal Gallery Foundation, Warsaw.

Curator Suzanne Cotter writes:

> In Althamer's case, art is life as self-realization. Self-reflective and seemingly unbounded in their generosity, the possibilities he alerts us to in the world seem imperfectly and optimistically endless. The potential is in each encounter; a question of singular moments that come together within a common sphere of experience.[45]

The apex of *Common Task* was transporting 160 people to Brussels in a 737 Boeing jet, customized with a coat of gold paint and coinciding with the anniversary of Poland's first free elections in 1989. Like many artists who have reached a certain notoriety, Althamer's project both derived from earlier efforts and has become much more spectacular in scale. The "self-realization" spoken of by Cotter becomes less central to a huge managerial project lacking in the quieter charm of the artist's early works, including building a tree house in a gallery courtyard. In Althamer's practice, the tensions between public space and private experience become more evident, as the artist moves into a role as an established citizen of the international art world.

Althamer's practice inherits particular features of Polish post-war art theory and practice. These would include examples drawn from academy professors such as Grzegorz Kowalski's assignment to his students to investigate public and private spaces, or the influence of the conceptually focused Foksal Gallery that has represented Althamer's work. From the 1960s, Foksal was associated with creating a "non-gallery" to archive artists' documents and writings, as well as to create a "place" to exhibit work both by Polish artists and international figures like Daniel Buren and Lawrence Weiner. Althamer's works of figurative sculpture and early puppets were influenced by Tadeusz Kantor, dramatist and creator of the first Polish happenings, just as his interest in altered states of consciousness recalls Stanislaw Witkiewicz (or "Witkacy"), the iconoclastic pre-war playwright and artist.

Broadly speaking, what can be regarded as the phenomenological attitude toward the process of art in Poland has influenced its more recent examples, including that of Althamer. As curator Pawel Polit writes with regard to Polish conceptual art created between 1965–75:

> The destruction of art and lack of reference to the artist's "inner self," the lack of inspiration or, more broadly, the impossibility of art opens the way for impossible art. "Poetry should link up with the impossibility to think, which is a thought," wrote Maurice Blanchot about Antonin Artaud. Something similar was experienced by conceptual artists in Poland; it was enough to have a change of optics. They worked on the border-line or in the space of resonance between the impossibility of art and impossible art.[46]

In a revealing 2002 interview with art historian Sven Spieker, Althamer described his own process of art-making:

> Sometimes I feel that there is no system. It's like I talk with the secret guy behind me, or inside me, or around me to discuss possibilities. That's why I use the term "schizophrenia" to describe it; it's as if to ask which material would be perfect for this impression, how to fix such an impression, how to communicate. And then, sometimes through

very irrational means you can find answers, such as ready-mades or traditional sculp-
tures. You are full of possibilities and have no clear strategy on how to fix such emo-
tional pressure, your own pressure to fix something. I think that is one of the interesting
things in art for me. When you have no borders for your activities, no systems, then it's
really interesting. Sometimes you can feel like a lost child, like being in a deep forest, but
you have freedom to go everywhere.[47]

In the same interview, Althamer privileged irrational procedures over strategic manipulation,
and valorized the more emotional and playful aspects of the work. It becomes evident in
reading the artist's comments made over the past two decades that his ideas have shifted
considerably, becoming more systematic and strategic.

Art highlighting the provocative and the performative can be totally excessive and ludi-
crous, precariously poised on the brink of falling apart. This is frequently the case with the
Austrian artists Wolfgang Gantner, Ali Janka, Florian Reither, and Tobias Urban, known
collectively under the name Gelitin. This artist collective has been actively establishing
their international profile since the 1990s. Gelitin tends to represent their projects from
a childlike, often scatological perspective. Whether costumed or bare naked in absurdly
choreographed actions and events, often involving other collaborators and participants,
Gelitin's comments about their work function as comic routines that deflect and redirect
standard notions of the interviewed subject. Projects have included visitors participat-
ing in filling a large waterbed-like seat with urine, or pissing off a building in sub-zero
Moscow to make a giant icicle.

Slapstick conceptual ridiculousness combines with alchemical transformation in the above
works, and Gelitin's fascination with bodily fluids and excreta returns us to the following
remarks by Bakhtin:

> We must not forget that urine (as well as dung) is gay matter, which degrades and re-
> lieves at the same time, transforming fear into laughter. If dung is a link between body
> and earth (the laughter that unites them), urine is a link between body and sea. [...]
> Dung and urine lend a bodily character to matter, to the world, to the cosmic elements,
> which become closer, more intimate, more easily grasped, for this is the matter, the
> elemental force, born from the body itself. It transforms cosmic terror into a gay carni-
> val monster.[48]

If Gelitin's tactics might seem contrived, they also provide closer examinations of the phys-
ical, perceptual, and psychic coordinates that graph our daily existence, which are often
just as arbitrary, scattershot, and surreal as any art process. In the durational performance
Blind Sculpture (2010), the artists and their "assistants" (including 45 invited artists, musical
accompaniment by Schuyler Maehl [pictured on front cover], and ongoing support by Salva-
tore Viviano) constructed an installation over the course of ten days from an assortment of
basic cast-off, ready-made, and makeshift materials.

The restrictive process resembles simultaneously a conceptual art stance in which the visual
is elided, and a kindergarten setting of playful, intuitive gaudiness.

1.13 Gelitin, *Blind Sculpture* (2010). Performance at Greene Naftali, New York. Photo © Paula Court. Courtesy of the artists and Greene Naftali, New York.

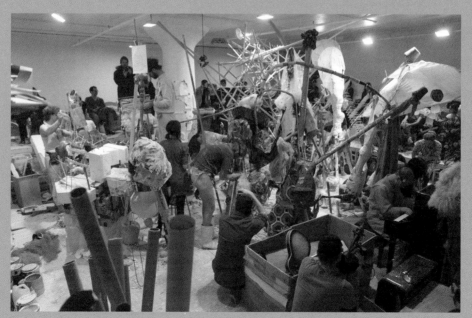

1.14 Gelitin, *Blind Sculpture* (2010). Performance at Greene Naftali, New York. Photo © Paula Court. Courtesy of the artists and Greene Naftali, New York.

The subtitle of the exhibition, "A Happening by Gelitin with a little help of their friends", references key 1960s touchstones, Kaprow and the Beatles. It is quite likely that *New York Times* critic Roberta Smith's queasy response was the sort the artists were seeking: "Visitors could observe from bleachers, though watching made me itchy. It looked messy, exhausting and mildly offensive, since the artists wore high heels and skimpy cocktail dresses, underwear optional".[49] But Smith's typecasting of the artists as "bad boys" avoids interrogation of the strange ambiguity of their practice: not staying in one place, rarely resolved, and critical of older neo-avant-garde approaches.

New Zealand artist Ronnie van Hout maintains a long-standing involvement with the independent music community, and has carried over a satirically loaded but poignant sensibility into his interdisciplinary visual artworks, working across sculptural installation, photography, and video. One encounters multiple versions of van Hout, never stable, oscillating between an interventionist voice and a dark comedian. His works often enact a doubling, splitting or merging of the artist's competing selves, or the roles he chooses to play. In his video *The Other Mother* (2011), van Hout plays multiple roles in a scenario drawn from John Carpenter's *The Thing* (1982).

The artist recounts some of the context underlying this work in a catalogue essay:

> In 1938, a 28 year old John W. Campbell published in *Astounding* magazine, what was to be his last major piece of writing; the sci-fi story: "Who Goes There?" It was one of a handful of sci-fi stories Campbell published under his pseudonym Don A. Stuart. John Carpenter adapted this story, of a malevolent shape-changing alien terrorizing a group of men in an Antarctic base, into the feature film *The Thing*, released in 1982. John Campbell's father was a cold, impersonal, and unaffectionate electrical engineer. His mother, Dorothy was a warm but changeable character who had an identical twin who visited them often and who disliked young John who was unable to tell them apart and was frequently coldly rebuffed by the person he took to be his mother.[50]

Other influences on the work were an image of a cyclops found in an encyclopaedia that fascinated and terrified the artist as a child, as well as subsequent encounters with *UFO* and *Famous Monsters of Filmland* magazines. Van Hout's art practice has reflected his affinity with and connoisseurship of an eclectic range of visual culture artefacts, from the esteemed to the reviled. In playing his multiple roles, van Hout decided to use "method" acting techniques, stating that "method goes beyond simulation of a character but the actor attempts to 'become' the character, 'a replica of the self', like the alien in *The Thing*, or the images from childhood that get into your system and change your atoms".[51]

The recent sculpture *Quasi* (2016) consists of a five metre-tall version of the artist's hand, from which van Hout's face emerges; a neo-surrealistic, nightmarish concatenation.

In a deceptively simple video work entitled *Back Door Man II* (2003), which sums up a main theme of his practice, we see van Hout knock repeatedly at a door and, after a period in which no one answers, walk away. A bit later, another "van Hout" answers the door, to find no one there.

1.15 Ronnie van Hout, *The Other Mother* (2011). Digital video. Courtesy of the artist.

1.16 Ronnie van Hout, *Quasi* (2016). Steel, polystyrene and resin. Commissioned by Christchurch Art Gallery Te Puna o Waiwhetu. Courtesy of the artist.

Ronnie van Hout inhabits a mixture of self-deprecating and self-lionizing personae, but he also examines the tremendous impact of popular culture in shaping our ideas of selfhood and subjectivity. His works have referenced many other artists and musicians, including making a Lilliputian diorama of iconic New Zealand painter Colin McCahon in the midst of making his (generally enormous) work, or nods to Andy Warhol and other pop figures, such as in his early 16mm *Elvis Presley Movie* (1981) which features indie musician Ritchie Venus (aka Michael Braithwaite) impersonating the King. In the context of his own band Into the Void, van Hout arguably impersonated a post-punk singer by becoming his own version of one. Critic Anthony Byrt has commented of van Hout:

> Watching his work is like watching a bunch of alcoholics get drunk at a party. It starts out being kind of funny, then it turns sad, then it gets scary. But at a time when so much boring identity art is being produced in New Zealand he is one of the few artists who knows that to lurk in the boggy marsh of fixed identity is to commit artworld suicide. Instead, why not copy other artists, why not imitate the already been?[52]

In his film *I'm Not There* (2007)[53], director Todd Haynes enlisted six actors differing markedly in terms of age, ethnicity, gender, and nationality to "play" a role based on one of the many distinct eras of Bob Dylan's lengthy career. As Dylan has long been notorious for his acts of subterfuge, control, and artifice concerning his art, this splitting of a well-known creative self into separate selves was a novel route, spawning a series of evocative vignettes based on the singer's biography, songs, and surrounding historical context. In the attempt to get at "thereness" if not truth, it is striking what this strategy still reveals in the midst of simultaneously camouflaging the actual details of Dylan's life.

Beyond the fascination many have had with Dylan's work, what Haynes focused on is the mystery that we confront in studying the legible, accessible plethora of material on Dylan and how he remains as remote as ever, yet perhaps freshly challenging. Dylan's pasts and present have been manifold, broken and bent, and shatter any cohesive articulation of a unified self, demonstrating that we are composed of a fluid amalgam of traits, energies and personae. Biographer and critic David Dalton has stated Dylan's "fabrications are the most profound, interesting, and authentic part of his personality".[54] While we could propose similar notions regarding the late David Bowie, Bowie was always a proponent of blatant artifice and theatricality rather than conjured authenticity, as when Dylan falsely proclaimed early in his career that he had travelled around like a hobo, joined the circus, or that his (still living) parents were both dead. When Dylan appeared for his October 31, 1964 Carnegie Hall performance, he wryly stated: "It's Halloween. I got my Bob Dylan mask on".[55]

Playwright and actor Sam Shepard travelled with Bob Dylan's 1975 Rolling Thunder Revue, and writes evocatively in his account of the period:

> A concert audience has a face. It looks worked upon. Wild eyed. Stimulated from a distant source like a laboratory experiment. As though the stage event, the action being watched and heard, is only a mirror image of some unseen phenomenon. The only protected space is up on stage. Dylan says it's the only time he feels alone. When he's up there. When he's free to work his magic. No one can touch him. [...] Who is he anyway? What's the source of his power? An apparition?[56]

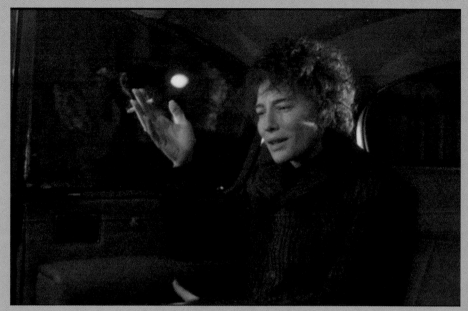

1.17 Cate Blanchett in *I'm Not There* (2007). Dir: Todd Haynes. The Weinstein Company.

1.18 Linda Montano, *Linda Montano as Bob Dylan/Woodstock* (2014). Video still. Photo courtesy of Tobe Carey.

What Haynes – an ambitious and eccentric filmmaker who had previously recounted the tragic biography of a pop star via stop-motion animation of Barbie dolls (*Superstar: The Karen Carpenter Story* [1987]), resuscitated the glam rock era (*Velvet Goldmine* [1998]) and dramatized the writings of Jean Genet (*Poison* [1991]) – accomplished in *I'm Not There* was to zero in on Dylan's mutability, reframing it for the twenty-first century context of blurred identities.[57] In a certain way, despite the artist's individual importance, Haynes's interpretation of Dylan's work lends credence to a notion that "we are all Dylan now". Given the examples of shifting selves discussed above, Dylan's strategic games of moving across planes of subjective experience are not as unique as one might think today. In a collaborative work by Tony Tasset and Melanie Schiff, Tasset's son is pictured publicity-style in a revised version of Dylan's *Hard Rain* (1976) LP sleeve, a young man in harlequin whiteface peering out, rainbow streaks surrounding his eyes.

For years, record industry executives searched for a "new Dylan", and it's a long list of musicians who were bestowed this status, usually as fleeting as the changes in Dylan's own styles: hats, bandannas, hairstyles, beards, glasses, facial make-up, vocal timbre, ideological beliefs. A curious notion, as if the manifest specificity of a Nobel laureate these days more compared with Shakespeare than the Beatles could be captured in a bottle. As the search for new Dylans has faded, the star continues to perform on his own never-ending tour, reiterating the significance of his legacy, while soundalikes mimic his work and younger musicians cover his material. In 2014, on the occasion of Dylan's 73rd birthday, Linda Montano performed for seven hours atop a 14-foot lift in Woodstock, New York, wearing sunglasses and Dylan-style paraphernalia, lip-synching to the sounds of guitar, harmonica, and familiar vocals.

By making art in which the ostensible subject is not only fragmented but exhibits a rather anarchic, distorted, and unpredictable trajectory, the artists I have discussed here demonstrate that just as art and life intersect quite intensely but cannot exactly cohere, one body cannot correspondingly adhere to any singular notion of self – selfhood being manifold and elusive – and art can only serve to reiterate this. With the artists and actions discussed above, along with many others, the challenges involved in integrating subjectively rendered information derived from the realms of both life and art are enduring. So many of the questions raised by these artists retain their urgency, even if the sharp edges of creative practices appear smoothed over by the high-end, heavily sponsored art world contexts in which the work is shown. While specific exhibition contexts and practices have changed markedly, the desire to reach across thresholds to create new meanings has not ceased to be compelling and of continuing relevance.

CHAPTER TWO

Unfinished Filliou:

On the Fluxus Ethos, Origins of Relational Aesthetics, and the
Potential for a Non-Movement in Art[1]

Pure foolishness restores.

—FRIEDRICH NIETZSCHE, 1895[2]

There is so little to do and so much time to do it in.

—GEORGE BRECHT[3]

The French Fluxus artist Robert Filliou (1926–87) is too rarely discussed considering the prescience and significance of his practice, as recorded in his book *Teaching and Learning as Performing Arts* (1970) and his related video works. In this chapter, I reflect upon the influence of Filliou's work on other contemporary artists, the critical formulation "relational aesthetics" (as posited by the French curator and writer Nicolas Bourriaud), and examine the legacy of Fluxus in more recent years. My central goals are to reconsider Filliou's visionary approach to art-making in the late 1960s and early 1970s, and what it portended for so much "relational" art yet to come, as well as what the heritage of Fluxus implies in the era of social networking, long after its emergence. Fluxus as a radical, interdisciplinary creative model helped to usher in a drastic shift in the notions underlying many younger artists' works in terms of both theory and practice. And critical discussions around relational modes of practice have been both energetic and highly contentious.[4]

In Filliou's *Teaching and Learning as Performing Arts*, the layout designed by the artist leaves a blank section of each page for the reader to add their own comments, thereby participating interactively in the unfolding of the book itself, which includes interviews with (among others) Joseph Beuys, John Cage, and Allan Kaprow.

Filliou's methods can be linked by association to examples by several later artists, including Rirkrit Tiravanija, Pierre Huyghe, and Christine Hill, whose works have been cited as exemplary of the relational aesthetics paradigm insofar as the importance of social relations, relations of exchange, and broader relations with the surrounding context outweigh the direct analysis of the aesthetic properties of the work in question. Bourriaud has cited Filliou's memorable comment: "Art is that which makes life more interesting than art".[5]

While the first major museum retrospective of Filliou's work in over a decade, entitled *Génie sans talent*, travelled across Europe in 2003–04, the artist remains a cult figure.[6] Although recognized by many experimental artists for the compelling and innovative qualities of his practice, Filliou has been comparatively under-researched within the scholarly community.[7] Meanwhile, relational aesthetics has become a topic for much global discussion. Closer examination of Filliou's life and work thus delineates a significant case study in the integrity of

Auf und ab, 3 Jahre der Arbeit, und jetzt erschienen im Verlag Gebr. König, Köln - New York, die erste Fassung LEHREN UND LERNEN ALS AUFFUEHRUNGSKUENSTE von ROBERT FILLIOU und dem LESER, wenn er will. Unter Mitwirkung von JOHN CAGE, BENJAMIN PATTERSON, GEORGE BRECHT, ALLEN KAPROW, MARCELLE, VERA und BJOESSI und KARL ROT, DOROTHY IANNONE, DITER ROT, JOSEPH BEUYS. Dies ist ein Multibuch. Der Schreibraum des Lesers ist beinahe so umfangreich, wie der des Autors.

Off and on 3 years of work and now VERLAG GEBR. KOENIG, KOELN - NEW YORK publishes the first draft of TEACHING AND LEARNING AS PERFORMING ARTS by ROBERT FILLIOU and the READER if he wishes, with the participation of JOHN CAGE, BENJAMIN PATTERSON, GEORGE BRECHT, ALLEN KAPROW, MARCELLE, VERA and BJOESSI and KARL ROT, DOROTHY IANNONE, DITER ROT, JOSEPH BEUYS. It is a Multi - book. The space provided for the reader's use is nearly the same as the author's own.

2.1 Robert Filliou, *Teaching and Learning as Performing Arts* (1970). Front cover. © Estate of Robert Filliou.

2.2 Robert Filliou, *Teaching and Learning as Performing Arts* (1970). Book interior. © Estate of Robert Filliou.

art practice as a holistic activity, situated in an entirely different context and rooted in vastly different expectations than those common within today's art world.[8]

When does a work of art begin its existence? How can one evaluate its importance? How does a work of art made with peripheral and tangential relation to the art market have determined worth? When is a "creative action" to be considered a performance, a happening or a simple life occurrence? When does simply "doing nothing" spawn creativity? When do the terms "art", "research", and "leisure" become equivalents? These are among the most challenging questions that emerge from Filliou's art practice.

As in his life, contradictions were integral to the artist's work; this is not to treat them as entirely exclusive realms, as Filliou was an important figure in terms of blurring such boundary distinctions. Today, this has become a commonplace of many performative and interdisciplinary approaches. Yet from the 1960s to the 1980s, Filliou's concepts, driven by a hyperactive, inquisitive intellect and the determining belief that art was the most genuine route to personal freedom, were extraordinarily provocative in their interrogation of contemporary art practice.

Filliou's Background

Raised in France and the recipient of a scholarship to secondary school – though often less than a model student due to his wandering interests – he was intellectually curious. According to one childhood friend, "with a pen, he was the king, but in manual tasks, he was a nothing",[9] an interesting foreshadowing of his dedication to the basic and skeletal rather than polished craftsmanship. Filliou was a young member of the French Resistance but later rejected any medals and accolades as he became increasingly dedicated to pacifism. A one-time communist, he discarded specific ideological and political involvements as time went on in favour of a broader interest in social commitment via the apparatus of art.

We can see his views on non-violence and pacifism evidenced on several occasions, such as in the multiple *Optimistic Box No. 1* (1968), which carries the phrase: "Thank god for modern weapons/we don't throw stones at each other anymore". On a larger scale, *Seven Childlike Uses of Warlike Material* (1970) is a sculptural installation of modest materials brought together with various textual inscriptions and a series of related prints: on planks of wood, "Could be guns"; on a rectangular frame, "Could be outer space"; on an overturned chair, "Could be Mountains"; on a bottle, "Could be a Bonfire"; on a coat, "Could be Uniforms"; on a bucket, "Could be stars"; and on several cards, "Could be Flags and Bureaucratic Documents".

It is a subtle yet terrifying piece, depicting "warlike materials" with great candour and simplicity as a bunch of grouped-together, ordinary object-toys coupled with word-text juxtapositions one might more readily associate with René Magritte or (Filliou's friend) Marcel Broodthaers.

Filliou gained training as an economist, earning a master's degree at UCLA in 1950, and spent several years in the "straight world" in a variety of seemingly normal guises. He learned English while bottling soft drinks as a factory labourer in the United States, and later he

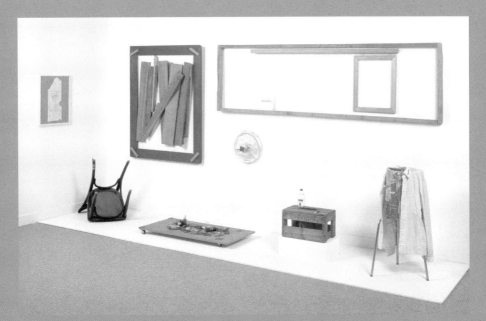

2.3 Robert Filliou, *Seven Childlike Uses of Warlike Material* (1970). Paris, Centre Pompidou – Musée national d'art moderne – Centre de création industrielle Photo © Centre Pompidou, MNAM-CCI, Dist. RMN-Grand Palais / Philippe Migeat © Marianne Filliou.

referred to his job title as "Coca-Cola Man". Filliou subsequently assisted in the production of a regular American television series on current political events, and acted as a key economic advisor and negotiator with the United Nations in Egypt, Japan, and Korea.

However, by 1954, a dissatisfied and restless Filliou "dropped out", commencing his artistic life at the ripe young age of 37. He then immersed himself fully into the most advanced and experimental art of the time, his work taking the form of performances, assemblages, dialogues, artists' books, and concrete poetry. During the late 1950s, Filliou spent time in Spain, Denmark, and France; befriended many artists, including Dieter Roth, Daniel Spoerri, and Emmett Williams; met and became inseparable from his life and art partner, Marianne (Staffeldt); and began writing plays, which soon developed into street theatre events.

Initially, and for much of his career, he led a hand-to-mouth existence that depended on strategic, personalized economies and decision-making, including the use of charm and conversation, barter and exchange, intelligence and foresight. Filliou held the bohemian lifestyle in high regard, perhaps romanticizing it to a fault, at the expense of his own comforts. Lack of money was a constant, but a wily attentiveness in how to maximize opportunities was also present. When Filliou exhibited at the Galerie Köpcke in Copenhagen, run by the fellow Fluxus artist Arthur "Addi" Köpcke, he requested indirect payment in the form of much-needed everyday articles, such as cases of beer, furniture, bedding, and more. German artist Köpcke opened the gallery in 1957, in part to gain Danish citizenship, and meanwhile also exhibited Piero Manzoni, Niki de Saint Phalle, Roth, Spoerri, and Williams. Köpcke was a kindred spirit to Filliou, also seeking to eradicate perceived barriers between media and art/life experiences, and proclaiming similar notions, including, "[u]se your own imagination in an infinite process".[10]

It is important to underline the international scope of Filliou's art activities: he exhibited and travelled widely, including to Hungary, where he collaborated with artist Joachim Pfeufer on a utopian creative project, the *Poïpoïdrome* installation (1976); and his work was also included in both *documenta 5* and *6* exhibitions in Kassel, Germany.[11] Filliou visited Canada numerous times, and became influential in the alternative scenes exemplified by groups and spaces such as Arton's and W.O.R.K.S. (We. Ourselves. Roughly. Know. Something.) (Calgary), Véhicule (Montréal), General Idea (Toronto) and the Western Front (Vancouver).[12] His work initially was not as well received in France, largely owing to a general antipathy toward conceptually oriented approaches. However, according to Anny De Decker, co-director of the gallery Wide White Space in Antwerp:

> When I showed Filliou, for example, I sold five or six pieces very quickly. People didn't know his work, but they liked it and they were used to objects of that kind. I was amazed to see that it worked pretty well, even though Filliou was almost unknown. People knew that he existed, but they didn't really know his work. I think it was Ben Vautier who talked to us about him; we saw him often.[13]

Filliou's artworks convey his nomadic, playful spirit and frequently involve the multiple, a format used in so many Fluxus projects. The multiples manifest the artist's wry humour, as in the *Frozen Exhibition* (1972) which offered documentation of various events and actions

2.4 Robert Filliou, *September 23 to October 6 Calendar* (1970). Red felt pen on cardboard with iron wire, mirrors and photographs; 32.7 x 25 cm. © Estate of Robert Filliou. Courtesy of the Estate of Robert Filliou and Peter Freeman, Inc.

2.5. Robert Filliou, *Permanent Playfulness* (1973). Wood, hooks, wire, pastel on tracing paper, photograph and pastel on cardboard box torn in two; 35 x 75 x 3 cm. © Estate of Robert Filliou. Courtesy of Marianne Filliou.

within a portfolio shaped like a bowler hat, referring to his Duchampian idea of a miniature exhibition transported on the artist's person. The godfather of conceptual art gets his share in Filliou's *Optimistic Box No. 3* (1969), which features the text "so much the better if you can't play chess/you won't imitate Marcel Duchamp". Other works have a provisional, intentionally rough appearance, as in *September 23 to October 6 Calendar* (1970) and *Permanent Playfulness* (1973).

Filliou in his early career could be compared to the seeker types described in Jack Kerouac's 1958 novel *Dharma Bums*:

> I see a vision of a great rucksack revolution thousands or even millions of young Americans wandering around with rucksacks, going up to mountains to pray, making children laugh and old men glad, making young girls happy and old girls happier, all of 'em Zen lunatics who go about writing poems that happen to appear in their heads for no reason and also by being kind and also by strange unexpected acts keep giving visions of eternal freedom to everybody and to all living creatures [...].[14]

Filliou's interest in the "genius of the café" or the everyday gesture as a work of art is directly informed by the Beat countercultural period of the late 1950s and 1960s. In a sense, he was dropping out of mainstream society and into art, as many artists have chosen to do at the expense of material security, years before the members of Kerouac's rucksack revolution were exhorted by Timothy Leary to "tune in, turn on, drop out".[15] "Tune in" is perhaps the pivotal phrase here, as Filliou, over the course of the ensuing period until his death in 1987, fine-tuned his creative capacities to a precariously balanced yet incorporative approach, often sceptical but spiritually inclined, wilfully naïve but deeply informed.

Works like Kerouac's *Dharma Bums* and the contemporaneous poetry of Allen Ginsberg and Gary Snyder demonstrate how Zen Buddhism radically influenced post-war American culture. In France, Zen notions also influenced the *nouveau réaliste* group, with which Filliou had many contacts and close associations, most specifically his sometime collaborator Spoerri.[16] Yves Klein, a judo adept, spent time in Japan and had read Daisetz T. Suzuki's works on Zen, major touchstones for figures including musician John Cage. For Cage and Klein, emptiness and nothingness were exemplified via their sonic and pictorial representations, respectively.[17]

Filliou held out hope for art as an intimate form of subdued activity, though often undertaken amidst the clutter and noise of urban spaces. To embody this belief, he performed in New York City on February 8, 1965, a work entitled *Le Filliou Ideal*. The score of this "action poem" is as follows: "[N]ot deciding/not choosing/not wanting/not owning/aware of self/wide awake/SITTING QUIETLY/DOING NOTHING".[18] Filliou is one of a number of experimental artists who emerged from a background in poetry, including Vito Acconci, Dick Higgins, Yoko Ono, and Roth.

In the final period before his death from cancer in 1987, Filliou spent time in retreat within a Buddhist monastery, enacting again an emphasis upon actions rather than representations, and an artist known as a garrulous talker became wrapped in quiet solitude. In writer Jeff Kelley's exhaustive study of Allan Kaprow, he notes that while Kaprow was also influenced

by Zen Buddhism, among the experimental visual artists of this period it was only Filliou who managed to take the plunge of fully integrating Buddhist teachings into his life as well as his art.[19] Filliou also fostered connections between significant Buddhist figures including the Dalai Lama with the artist Joseph Beuys. As Fluxus scholar Chris Thompson has pointed out:

> In his Artists-in-Space and Art-of-Peace projects – interrelated initiatives that he began in 1983 and that occupied him until his death in 1987 – Filliou and a number of his students and fellow artists (anyone who cared to take up his invitation) explored the question of what exactly "peace" is, if it is to be imagined as something other than merely the absence of or pause between wars. If the space between a history of art and an anthropology of art has to do with one's position with respect to a notion of "humanism," Filliou's question of how to articulate and produce a substantive and dynamic notion of peace, over and against simply the absence or opposite of war, has never been more urgent for either field or for the imagining of humanism that links them.[20]

Teaching and Learning, Writing and Performing

Much material concerning Filliou's artistic practice is found in his book *Teaching and Learning as Performing Arts*. In it, Filliou launches an attack on what he considers the limitations of contemporary art and its social context:

> Why do artists specialize? Problem of time, of course. Problem of limits of everyone, of interests and aptitudes. But also, on the part of the artist, desire to maintain the image he has created, to impose it fully, and finally to make a living out of it. That is to say, after creating a big enough racket so that there is a demand for his work, to supply it.[21]

Here we have, in summary form, the anti-careerist notions of Filliou, which were not the most helpful in terms of a stable and consistent livelihood. As biographer Pierre Tilman points out:

> Filliou found himself in an incessant and difficult contradiction: on one hand, he didn't want to consider art as a career, on the other, he didn't want to do something else to make a living. He refused, and even when he tried, it must be said, it didn't work.[22]

The cover of *Teaching and Learning* describes the book as a "first draft" culminating from "off and on 3 years of work".[23] Significantly, in both these qualifying notes Filliou makes clear the sporadic aspects of production; rather than being a rush job, Filliou took his time, allowing the work to emerge organically from his ongoing concerns. To call it a first draft is to acknowledge its status as a work-in-progress, further emphasized by the comment – again placed on the front cover so the reader cannot miss it – "It is a Multi-book. The space provided for the reader's use is nearly the same as the author's own."[24] The reader is encouraged to use the book less as an artwork than a workbook. In Filliou's words: "It is a long short book to keep writing at home". This is a book that performs, and by spawning video artworks made in response to it, it performs once again.

"Performing" as a term in the book's title is not equivalent to the now-academicized interpretation of "performance art" as a discrete category, but as the performative aspect of creation (the term Filliou preferred to art-making). Filliou commented elsewhere:

> Instead of using the word "art" most of the time in trying to invent new concepts I have thought of our activity as one that involves Permanent Creation. It is not surprising of course the problems that people were tackling – like the Dadaists started to say that life is more interesting than art. Of course art is only one activity.[25]

Filliou notes in *Teaching and Learning*, "Writing also is a performing art".[26] Filliou again: "WHATEVER I SAY IS IRRELEVANT IF IT DOES NOT INCITE YOU TO ADD YOUR VOICE TO MINE".[27] This democratizing impulse toward dialogue and interaction is both a characteristic product of the 1960s countercultural and Fluxus ethos, and prefigures interactive or dialogue-based projects occurring 30 years later, such as those of the artists Rirkrit Tiravanija and Philippe Parreno, or the curator Hans Ulrich Obrist's *DO IT* (2002), a virtual exhibition and publication of instructional artworks.[28]

In describing his method of leaving blank space on one-half of the page for the reader to fill in, thereby becoming an author-participant, Filliou adds an aside in a footnote: "There must be better ones. I have thought of loose cards in a box, even postcards. You might want to start our collaboration by suggesting some on this first page". In 1965 Filliou had published a book in the form of 93 boxed cards called *Ample Food for Stupid Thought*, each one with a different question: "How are you and why?" "Isn't art a remarkable thing?" "What's the big idea?" "No kidding?"

This project recalls other non-linear experiments in literature, exhibition catalogues, and other publishing ventures of the 1960s and 1970s: *The Unfortunates* (1969), a boxed book of 27 separate signatures to be read in any order the reader chooses by the British author B. S. Johnson; the exhibitions *557,087* (Seattle, 1969) and *955,000* (Vancouver, 1970) curated by Lucy R. Lippard, their catalogues printed as envelopes of index cards; *Water Yam* (1963), Fluxus artist George Brecht's set of instructional cards; or even Gilles Deleuze and Félix Guattari's *A Thousand Plateaus* (1980), in which the authors urge the reader to consider the book's sections as if dropping a needle at points on a long-playing record.

Over the course of his residencies in Canada and in collaboration with a variety of experimental artists, Filliou made a number of videos extending upon the themes of the *Teaching and Learning* book project. Filliou discusses his ideas while directly addressing the camera: over tea, newspaper classifieds, and a cigarette at the breakfast table, or onstage, his face covered with shaving cream, creating a satirical burlesque before the audience. In the videos, his conversational and informal style incorporates his dialogue with off-camera members of the audience, usually other artists.[29] As Filliou commented: "Making videos can be very amusing; watching them can be very tiresome".[30] The videos include improvisation, and are technically basic to the point of being skeletal, rough, working against any polished outcome.

Filliou's video experiments serve as a disarming time warp, a window into an intimate setting by which spectators can be brought closer to one of the most important Fluxus artists. That

what makes this the land of the free and the home of the brave?

how often do you see each other?

going back to school soon?

anyone in town you wish to know personally?

how are you, and why?

when will all that nonsense end?

2.6 Robert Filliou, *Ample Food for Stupid Thought* (1965). Designed by Dick Higgins for the Something Else Press. Offset lithograph on paper 5 x 7-1/16 x 1-3/16" overall. Collection Walker Art Center, Minneapolis. Special Purchase Fund, 1989.

Filliou's oeuvre was among the most emphatically performative of the performative artists' movement makes his videos especially significant representations of his practice. Upon initial viewing, his videos may appear disarming, unhurried, and welcoming, but this only partially disguises works that are challenging in terms of their philosophical dimensions, broader implications, and inventive strategies.

At a point when many artists were exploring video as a technological signal to be tinkered with, or as a framing device for quavering, pictorial abstraction, Filliou was more interested in the ways in which video could both enable and depict reciprocal and responsive dialogues between artists and audiences. The results often feature a mixture of pub humour and Zen *koans*: bad jokes and puns (*Video-Universe-City*, 1979), and spiritual profundities alongside a neo-vaudevillian sensibility – a portrait of the artist as a quasi-song-and-dance man.

Aspects of Filliou's approach resemble those of more prominent artists of the 1980s like Laurie Anderson and Spalding Gray, both renowned for their focus on the monologue, and whose works overlapped with popular entertainment. Yet this was not the case with Filliou's practice, which remained resolutely non-commercial and avant-gardist. Filliou also never valorized technology for its own sake, although he was an early participant in many dispersed artistic communities: "The Artist must realize also that he is part of a wider network, la Fete Permanente [Eternal Network] going on around him all the time in all parts of the world".[31]

Porta Filliou (1977) is a video anthology of the artist's most crucial statement-works. This compendium of black-and-white clips was created in collaboration with members of Arton's, a Calgary-based arts centre. Not unlike Marcel Duchamp's infamous *Box in a Valise* (1935–41), it acts as a portable retrospective, and in analogous fashion evokes Filliou's peripatetic travels. In the opening scene, Filliou stands with his arms outstretched. As the viewer regards the possibly Keaton-esque or Christ-like figure of the artist, a litany of descriptors of Robert is read aloud:

> Crazy, holy, fanatic, inventive, genius, significant, bum, tart, loving, cheap, magnificent, wise, criminal, absurd, pervert, peaceful, joker, liar, true, good, victim, fool, great, poor, killer, sober, rich, ugly, dead, bastard, good, optimist, creep, indifferent, thief, handsome, false, humane, gay, empty, soft, pig, loud, fabulous, sad: Robert Filliou.[4]

The artist then bows theatrically.

Filliou's expertise as an artist involved careful timing, in which his devotion to particular ideas led to simple yet incisive interrogations of received notions, upending them in favour of new approaches that could be interpreted as utopian and unrealistic. Filliou consistently cited the influence upon his work of the nineteenth-century social thinker Charles Fourier, who stated: "When men run out of imagination, it's time to turn the world over to the women and children".[32]

Telepathic Music No. 7: The Principle of Equivalence Carried to a Series of 5 (1977) exemplifies Filliou's "principle of equivalence", which, in brief, involves indicating the equivalence between "well made", "badly made", and "not made" artworks. In the video, the artist stands

near a rubber plant waving at the camera and repeating such phrases as "Welcome!" and "Farewell!" Abruptly, the colour shifts radically, the frame crops the artist's head, and the image goes out of focus. Filliou thus questions assumptions around professionalism, formulae, and techniques. How *does* one make a "proper" video? What *is* a "not made" video?

By exploring these questions in a format resembling a broadly satirical gesture, Filliou highlights the question of how one determines what a "serious" artwork is, and how to go about making one.

> In video what I would do is to make a tape involving an action in which I could be involved, and this initial action might last 10 minutes. This first tape would be to the best of my ability well made. Then I would do the same action but this time badly made. Perhaps by overcharging the information or not erasing errors as they come in – but at any rate there is no normative value judgment implied between well-made and badly made – it is just the contrast added to which is the not made. That is to say [...] I would make another tape explaining the concept [...] and actually this is what I am doing now. You have seen an action and so on and so on. Three times it was a well-made badly made – now it is a not made.[33]

The intensity and legacy of Filliou's work lies in its uncompromising awareness that the worlds of the production, dissemination, and reception of contemporary artwork were becoming increasingly bureaucratized and standardized in nearly the same ways as the worlds Filliou abandoned in order to rechristen himself an experimental artist. The often whimsical, utopian, and sometimes outlandish proposals put forth in Filliou's practice came from an artist who was a former economist and who had tangible experience drafting "real-world" policy. His art did not comprise mere castles in the sky. If often reflecting a utopian impulse, these were propositions created as radical experimental alternatives to call attention to the shortcomings of actual political endeavours.

As designer, writer, and long-time Fluxus artist Ken Friedman notes:

> The grand irony of Robert's work is that he was transformed from a public thinker into an artist, with all the limitations this implies. As a thinker, Robert Filliou opposed the notion of art as a new form of specialization, subject to the control of dealers, critics, collectors, and the highly specialized institutions that serve them. As a thinker, Filliou worked in the productive border zone between art and public life. Unfortunately, Robert Filliou became an artist, and the art world linked his ideas to mercantile interests. This was not Robert's fault.[34]

Statements such as the following about correspondence art recorded in *Porta Filliou* are strikingly prescient:

> So the way I see the [Eternal] Network, as a member of the Network, is the way it exists artistically through the collective efforts of all these artists in Europe, in North America, in Asia, in Australia, in New Zealand – everywhere. In Africa also (I have received communication from Yemen, for instance) each one of us artistically functions in the

Network, which has replaced the concept of the avant-garde and which functions in such a way that there is no more art center in the world.[35]

Filliou's videos often include little more than the artist in a room, at a table, or on the barest trace of a stage. In these pre-digital era vignettes, the works involve face-to-face interactions with other participants rather than today's Facebook-style interactivity. While the camera eye and screen necessarily mediate the proceedings, a testament to these rough, often *no-* rather than *low-*budget productions is that they seem cheerfully offhand and resistant to critique. Filliou's ebullient optimism might be considered either contagious or frustrating, as in the winding video monologue entitled *Teaching and Learning as Performing Arts Part II – Travelling Light, It's a Dance Really* (1979):

> I'm 53 [...] my beard is growing [...] say, could one of you come closer so that I could look into your eyes, so that I could mirror myself in your eyes? I'm shaving to look presentable [...]. Oh, I forgot to put a razor blade – oh never mind. Shaving makes hair grow they say. Strange. Are some of you here happy? I'm glad, but soon you will be unhappy. Are some of you sad? I'm sorry, but soon you will be happy. Being happy makes us unhappy, sleeping wakes us up. Don't you agree? It's a dance really – shall we dance? We don't need any music to dance. Let's dance to telepathic music. All we have to do is go round and round and round and round. [...] Soon what's called "the earth" will keep turning round and round without what's called "me" and "you." It's a love song really [...].[36]

The video unfolds leisurely. Filliou exclaims, "Sing me a song!" and the camera goes out of focus, waiting for the response. The artist later describes this as a "[m]inimum social program for humanity":

> I started it in the streets of Portugal. Ask your children, I proposed – or the child in you – what they really wanted to obtain in life, that is to say, are there some minimum goals upon which humanity could agree, and then go on to apply maximum energy to achieve them. So to know this you can't ask just a scientist or a politician or an artist, you've got to go and ask the people themselves, so I ask you now.[37]

Another lengthy interval ensues. The camera's lens loses its focus for about fifteen seconds as Filliou nods theatrically, then returns to focus on Filliou:

> My answer would be harmony, telepathic music, traveling light – constant appreciation of the daily miracles. Right now, for example, I feel like peeing, you must excuse me while I go to the toilet. Pee – empty my bladder – if that's not a miracle I don't know what is! Now look: TV also is a miracle.[38]

Filliou turns on a television, the camera zooming in to frame it tightly as an announcer's voice states "Is it the cheese that makes it taste better?" The artist clicks to another channel, cue melodramatic music. A car's headlights appear, and a woman's anxious voice exclaims, "I didn't do it!" Filliou returns: "TV is really a miracle. What I like best is built-in miracles, like yawning or sneezing. I'm sure you can think of a few others [...]"[39]. I am describing this

2.7 Robert Filliou, *Teaching and Learning as Performing Arts Part II* (1979). Video still. © Estate of Robert Filliou. Courtesy of the Estate of Robert Filliou & Peter Freeman, Inc.

The Danger of Lecturing . . .

Danger Music Number Seven
(for Isou)
Milfhk Kopwnu vyeer nusfyekosj hue.
(February 1962)

Danger Music Number Eight
Play it safe. (February 1962)

Danger Music Number Nine
(for NJP)
Volunteer to have your spine removed.
(February 1962)

Danger Music Number Ten (for PK)
Smallish cowbirds.
Do they get along with goldfinches?
(February 1962)

Danger Music Number Eleven
(for George)
Change your mind repeatedly in a
lyrical manner about Roman Catholicism.
(February 1962)

Danger Music Number Twelve
Write a thousand symphonies. (March
1962)

Danger Music Number Thirteen
Choose. (April 13th, 1962)

Danger Music Number Fourteen
From a magnetic tape with anything
on it, remove a predetermined length of
tape. Splice the ends of this length to-
gether to form a loop, then insert one
side of the loop into a tape recorder, and
hook the other side over an insulated

16

a satyr for donovan
or
an event in the life of peregrine dare

peregrine dare
had a smile that was square
which a mummy had learned from an
eagle
the shoes that he wore
displayed eskimo lore
and were made from the hide of a beagle
"shiver my whiskers!"
peregrine said
"a fabulous fancy's come
into my head!
instead of not talking i'll
make noodles instead!
and double my bubble in
gentian!"

the farther he went though
the more he felt spent though
his nostrils drooped slowly but surely
the noodles alone
made a desert of bone
and his elbows and flowers said demurely:
"we shivered your whiskers
six light years, moreover
we helped you with chalk
from the white cliffs at
dover
and now you're alone and
your chance is over
you can't double your bubble
in gentian!"

Barton, Vt.
July or August 1968

Intermedia

is no reason for us to go into history
in any detail. Part of the reason that
Duchamp's objects are fascinating
while Picasso's voice is fading is that
the Duchamp pieces are truly be-
tween media, between sculpture and
something else, while a Picasso is
readily classifiable as a painted orna-
ment. Similarly, by invading the land
between collage and photography,
the German John Heartfield pro-
duced what are probably the great-
est graphics of our century, surely
the most powerful political art that
has been done to date.

The ready made or found object,
in a sense an intermedium since it
was not intended to conform to the
pure medium, usually suggests this,
and therefore suggests a location in
the field between the general area of
art media and those of life media.
However, at this time, the locations
of this sort are relatively unexplored,
as compared with media between the
arts. I cannot, for example, name
work which has consciously been
placed in the intermedium between
painting and shoes. The closest thing
would seem to be the sculpture of
Claes Oldenburg, which falls between
sculpture and hamburgers or Eskimo
Pies, yet it is not the sources of these
images themselves. An Oldenburg
Eskimo Pie may look something like
an Eskimo Pie, yet it is neither edible

17

2.8 Pages from Dick Higgins, *foew&ombwhw* (New York: Something Else Press, 1969). Designed by Dick Higgins. Permission granted by the Estate of Dick Higgins and the Something Else Press.

sequence at length as it ably represents the twisting paths one follows when watching Filliou's videos.

In *Teaching and Learning as Performing Arts Part II – Video Breakfasting Together If You Wish* (1979), Filliou sits drinking tea and reading aloud bits from the classified ads:

> "An international company is now hiring twenty enthusiastic individuals for training in the marketing field." Well I think enthusiasm is important for artists, no? "Dependable, personable person." Are artists dependable? "A mature person selling lifestyle product." Art *does* have to do with sales, very unpleasant. A great deal of artists' work has to do with *un*learning, with *anti*brainwashing. Artists as they contribute to the unlearning process they should be paid reasonably for their work too like skilled workers. [Smokes a cigarette] It seems to me art has more to do with the criminal classes than the security forces. Art to my mind is an illustration of work as play and I suppose many members of the criminal class consider their work as play. Whether artists would make good security agents I don't know.[40]

In the companion piece *Footnote to Footnote A: Video_Breakfast with Roy Kiyooka* (1979), the Japanese Canadian artist Roy Kiyooka watches this sequence on a small television monitor and talks back to the screen, interjecting his comments while turning the television off, or lowering its volume. Kiyooka states:

> I thought I would turn your voice down, Robert, as I am fascinated by the brilliant rose halo around your head [...]. I would say the halo is unintentional, a minor aberration in the technology, but the painter in me likes that rose halo around your head.[41]

Viewing both artists poised with their teapots and newspapers "watching" each other in this 1979 video seems a ghostly precursor of Skype technology.

Regarding the notion of "teaching and learning as performing arts" advanced both in Filliou's 1970 artist book of the same title and the related videos, the art historian Hannah Higgins (and daughter of Dick Higgins and Alison Knowles) has noted that the artists associated with Fluxus:

> [...] argue for learning situations that are not tied to degrees, that are liberated from the constraints of time (daily as well as academic schedules), from fixed locations (especially in the sense of a "physical plant" consisting of bolted-down desks and uniform lighting), and from institutional affiliation (which too often means institutional ideas). Experiential learning goes some way toward eradicating these circumstances; after all, experience, in a sense, meanders through one's life, allowing a constant redefinition of both place and time.[42]

Filliou's *Teaching and Learning* book compares intriguingly with that of his close friend Dick Higgins' from roughly the same time, bearing the unwieldy title *foew&ombwhnw: a grammar of the mind and a phenomenology of love and a science of the arts as seen by a stalker of the wild mushroom* (1969), the initial letters signifying "Freaked Out Electronic Wizards & Other Marvelous Bartenders Who Have No Wings".

According to Higgins, the full title had been amusing, but he then abandoned it except for the codelike letters he refers to as a "shell", much like the cover of the book itself, which uncannily resembles a Bible – embossed gold lettering on a black binding, replete with fragile, crackling paper and a ribbon bookmark. This ironic nod to religion is a proto-postmodern gesture, as is the arrangement of its text: Higgins divides each page into two vertical columns, running four different narratives, essays, art pieces or poems simultaneously.

Appropriately, the book commences with Higgins's seminal essay on his notion of "intermedia", with its prescient opening gambit: "Much of the best work being produced today seems to fall between media".[43] Higgins continues to skewer what he perceives as the irrelevance of many media-specific modes of practice, condemning the mercantile aspects of pop art. (He satirizes the movement with his conflation of three integral figures, Ivan Karp [dealer], Henry Geldzahler [curator] and Lawrence Alloway [critic] into one mythical beast, a "Mr. Ivan Geldoway", who cannot prevent pop from being "colossally boring and irrelevant";[44] Higgins supports instead happenings and other performative actions.) Higgins also cites Filliou in his remark that "the constructed poems of Emmett Williams and Robert Filliou certainly constitute an intermedium between poetry and sculpture".[45]

Higgins' remarks on the relations between life and art offer resonance and sympathy with those of Filliou, as when in his 1966 essay "Statement on Intermedia", he sharply noted:

> Art is one of the ways that people communicate. It is difficult for me to imagine a serious person attacking any means of communication per se. Our real enemies are the ones who send us to die in pointless wars or to live lives which are reduced to drudgery, not the people who use other means of communication from those which we find most appropriate to the present situation. When these are attacked, a diversion has been established which only serves the interests of our real enemies.[46]

On Playing Games and Researching Nothing

Another essential book published by Higgins' Something Else Press, George Brecht's *Games at the Cedilla* (1969), collates an eclectic array of bits and pieces, the remnants of an experimental gallery/shop/collaboration – "a free city of the arts, a center of research, of ideas" – operated by George Brecht and Filliou in Villefranche-sur-Mer in the south of France in the late 1960s.[47] Brecht and Filliou's motto – *"La Cédille qui Sourit"*/"The Cedilla that Smiles" – permanently creates anything which has or has not already been created.

Filliou writes in the introductory passages of his *Teaching and Learning*: "Since the end of World War one [sic], invention has tended to replace composition as the standard of excellence in avant-garde circles".[48] Browsing through *Games* suggests that this brand of invention manifests itself as a proclivity toward verbal instructions and comic rejoinders. The poet-artists urge their correspondents, friends and readers to engage in collaborative activities.[49]

Art historian Steven Harris notes, "Brecht and Filliou shared a great many ideas and values with the surrealists, yet Filliou, despite his friendship with the surrealist painter Victor Brauner, never referred to surrealism, and Brecht only did so to make his differences with it clear".[50] We can also recall the introductory line of Bourriaud's "Relational Form", the first chapter

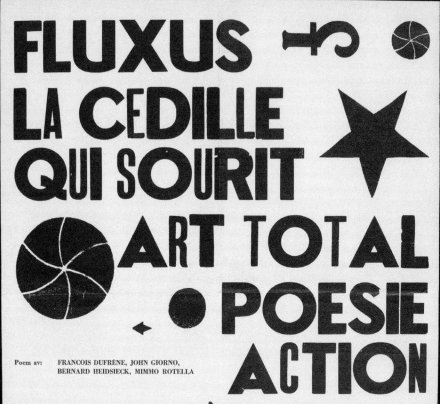

2.9 George Brecht, *Fluxus/La Cedille Qui Sourit/Art Total/Poesie/Action* (1967). Offset lithograph on paper, 15-7/16 x 12-1/16". Collection Walker Art Center, Minneapolis. Walker Special Purchase Fund, 1989.

of *Relational Aesthetics* (1998): "Artistic activity is a game, whose forms, patterns and functions develop and evolve according to periods and social contexts; it is not an immutable essence".[51] Filliou's voice wraps itself around material unrelated to art in order to perpetually reenact the realization that most experiences are tenuous and unstable. The best tools for navigating this uncertain landscape emanate from a bemused, conscious awareness of human connectivity and the problems that befall us.

Projects such as the Cedilla and *Research at the Stedelijk* (1973) assert the idea that art must involve the social, other disciplines, reciprocal discussions, and that the museum is an appropriate site to house some of this activity. In residence at Amsterdam's Stedelijk Museum from November 5–December 5, 1971, Filliou instituted the Genial Republic, in which he carried out a series of interdisciplinary discussions. He referred to the term "research" frequently, the term itself becoming malleable according to the artist's specific plans of the moment. He remarked: "Research is not the privilege of people who know – on the contrary, it is the domain of people who do not know. Every time we are turning our attention to something we don't know we are doing research".[52] The word "research" also creates an aura of significance via a nominal sleight-of-hand. In one of his conceptual proposals, "The Speed of Art", Filliou stated, "O.K. I leave it open, it's research in progress. I can only go so far – nobody so far has helped me carry out this type of research. That's the fate of most artistic propositions – we must do them ourselves".[53]

It is perhaps too easy to discount Filliou as a "major" artist, as in his practice he questioned the inflated claims and posturing of "major" art, working in ways that are often considered minor: using humour and parodic strategies, and thereby preserving an ironic distance from more mainstream thinking. At the 1970 Cologne *Happening und Fluxus* exhibition, Filliou was assigned a small area in which to perform:

> [I] created something I called the "Wishing and Joking Room," there was a bowl full of water and a mic. On the bowl was written, "Toss a coin and make an innocent wish" and on the mic was written, "Now come to the mic and tell a joke".[54]

One of Filliou and Brecht's proposals at the Cedilla was to compile an anthology of jokes, and in the early 1990s, Filliou's portrait adorned a catalogue of an exhibition at Venice entitled *Infamie* (1995) devoting itself to the failed and unrealized.[55]

A central consideration here is failure, the incomplete, the open-ended, the undone – in essence, to mount a defence for that which simultaneously remains unrealized, but has been planned and pondered. Filliou's career was defined by a series of such acts; completion was not a measure of their success, especially as any finality escaped them in their era. Today we can rethink our assessment of Filliou with convenient hindsight. Turning toward Filliou's legacy now, as it has affected more recent art, is an outcome of this revised vantage point.

Relational Aesthetics and the Legacy of Fluxus

One could argue that the artists associated with relational aesthetics take selective attributes of past works by Fluxus practitioners and emphasize their presentation, production, and dissemination, rather than the offhandedness, ephemerality, and small-scale virtues of their

first instances. Relational aesthetics artists are often the gleaners, scavenging for the bits and pieces of conceptual and performative gamesmanship that can now once again coalesce into the appearance of novelty. Some examples: Christine Hill may breathe an exhausted sigh when her German *Volksboutique* shop of the early 1990s is compared with Claes Oldenburg's *The Store* (1961), but the comparison is there and relevant; when Philippe Parreno projects films onto a multi-panel white canvas at 4' 33" intervals (the duration and title of Cage's watershed "silent" composition of 1952), a certain type of historicization becomes wearisome; the blankness of Rirkrit Tiravanija's emptied walls, spaces, and slide shows is all too reminiscent of Nam June Paik's *Zen for Film* (1965) or Yoko Ono's "non-existent" but nonetheless sublime instruction paintings of the early 1960s.[56]

We arrive then at the crux of the matter: such instances sample the past. The subjectivity and intentionality of these artists becomes irreconcilable with those of their 1960s predecessors, and a strange series of reverberations occurs, a temporal dislocation; many in the contemporary art audience are caught by our own postmodern self-consciousness. While the incisive sting of Filliou's work, particularly his videos with all their attendant awkwardness, emerges from its amateur approach – that of the researcher who knows nothing – today we know all too much how the game is played. Playing games at the Cedilla seems like a lost world of possibilities that we are incapable of accessing in all but a very limited though more detailed fashion, endnotes in place of the experiential. (I will expand more on this point later in this chapter.) Artists are historians revising past approaches; curators are reenacting crucial exhibitions; and critics are channelling voices we have already heard.

We can also assess the reception of relational aesthetics in terms of an American–Continental European divide. In discussions in the United States, relational aesthetics often elicits a climate of unease, likely owing to its lack of pragmatism, materiality, and medium-specificity. The more paradigmatic relational aesthetics work is more geared to Europe, a bringing-to-bear of the social body not set apart in atomized alienation, but existing in convivial formations, often exclusive, occasionally flirtatious, and reminiscent of the lively and haphazard groupings in cafés, bars, and restaurants, the private sphere spilling out on fine days into the public space.[57]

A revealing exchange is captured in a 2004 interview with Pierre Huyghe, published in the journal *October*. Art historian George Baker queries the dematerialized aspects of relational aesthetics, and Huyghe replies abruptly, "[w]e're not returning to that old trap".[58] The artist asserting that however provisional his work might appear, it remains a material entity.

If we return by comparison to Robert Filliou, the genius who inhabited the café across from the Cedilla at Villefranche left traces such as documents, photos, and posters, but the rent still became due, the landlord came calling, and the artist's actions in that context ceased. While Huyghe argues for the tangible primacy of his works, even as they are formally dispersed, Filliou spent his time assisting in the fabrication of works by others, living in modest accommodations, and seeking intellectual connection with others while maintaining a mobility that is revealed in the lightness of his practice. Such a practice interrupts received ideas and constructs, and does not touch down for very long at any one time. By contrast, despite the jet-setting mobility of a few renowned artists, a heaviness and predictability has attached

2.10 Pierre Huyghe, *Streamside Day* (October 11, 2003). Festival held at Streamside Knolls, NY. Courtesy of the artist and Hauser & Wirth, London.

2.11 Liam Gillick, *How are You Going to Behave? A Kitchen Cat Speaks* (2009). Installation at the German Pavilion at the 53rd Esposizione Internazionale d'Arte, La Biennale di Venezia. Photograph © Natasa Radovic.

itself to certain relational-style practices. If dematerialization is a trap, we can see Filliou's practice falling into it by virtue of its disregard for the object-world except as primarily feeding further discussions; "ample food for stupid thought", to repeat the artist's own phrase.[59]

In the most significant examples of relational aesthetics, the discursive is not simply a framework, but enacted; this can be seen in Huyghe's engagements with the cinematically staged versus actual reality, Liam Gillick's idiosyncratic narrative tableaus, and Carsten Höller's hybrid works located somewhere between fact and fiction. This discursiveness may take the form of the suburban celebratory festival recorded in Huyghe's video *Streamside Day* (2003); of Gillick's *A Kitchen Cat Speaks* (2009), housed in the German pavilion of the Venice Biennale and featuring a "talking cat" perched over Ikea-style minimalism; or of Höller's earlier staged events, such as *Children Demonstrate for the Future* (1991–92).

At another crucial point in the Huyghe interview, Baker asks:

> Baker: But your work's idea of the relational seems to focus upon ideas of the open work, the link between practices, the permanent construction site. [...] Why is it important to work in this way now? Is it a political gesture? A linkage, like Pasolini's, between poetics and politics?

> Huyghe: It is an expanded field. The more tools, the more one can expand the game. The more one can play. The tools themselves are not important in comparison to the ability to play. Think about Robert Filliou.[60]

After this point, in which Filliou's example could have become a compellingly relevant one to insert into the discussion, there is no further mention of the artist, or discussion of his ideas or practice. Huyghe, a French artist, is well acquainted with Filliou's work, but my suspicion is that Baker, an American writer, is less so, as Filliou is generally treated in the United States (if at all) as only a peripheral figure in the Fluxus movement, arguably a peripheral movement itself. In this context, Filliou plainly disappears, becoming a spectral referent not incorporated into the exchange. This absence and act of elision is not unusual, but offers yet another instance of Filliou's historical "invisibility".

Huyghe's response to a lengthy interrogation immediately after the Filliou "nonexchange" is noteworthy. Baker contrasts what he calls a displacement of "a model of politics and critique that was central to advanced art in the 1980s":[61]

> Is it a kind of pragmatism or realism that we face here – a realization that false political claims for artistic practices were made in the 1980s, and one must not falsely claim immediate political functions for cultural or aesthetic projects?

> Huyghe: Your last point is key. And it should apply as well to critics and historians. It is obviously difficult to define oneself after a postmodern period where we all became extremely self-conscious and aware about the consequences of our actions. *This is why conclusions should be suspended but the tension should remain. There is a complexity that should be recognized and that produces a fragile object.* [...] It is a huge problem

when the "political" becomes a subject for art. For me Buren is a political artist. It is a practice that is political, not the subject or content of art.[62]

Of particular note is the fact that Huyghe has called his work a "*chantier permanent*" or "permanent construction site"; the term is also the title of a 1993 Huyghe work, and an intriguing parallel to Filliou's earlier term "permanent creation".[63]

In Nicolas Bourriaud's first follow-up to *Relational Aesthetics*, he characterized recent art as involved in acts of post-production, stating that the representative examples of this were the DJ and the computer programmer, both of whom reorient, reconfigure, and revise existing materials, transforming them, their constituent ready-made parts shifted by the voice of the artist as instigator-editor-producer. To a large degree, Filliou was engaged in the act of creating new discursive patterns; arguably a proto-postmodernist, he was still involved in the notion of the originary, as in his ideas of perpetual creation. In a conversation with Cage, Filliou commented:

> What I had in mind was a kind of pioneer world that should be in the hands of artists, where we will create, and by creating, make claims upon this part of the world. I call this the idea of permanent creation. There would be no difference between students and teachers. It might be just as a kind of availability or responsibility that the artist is willing to take, but anybody might make suggestions about what kind of things might be investigated or looked at and I think it might be in a spirit of fun at times, but many problems may be solved by the way.[64]

If Filliou casts less of a judgmental eye on finished products, it is because for him the experiential process is paramount. To create is to make anew, and Bourriaud's post-production is in some part a reheated broth of postmodernism, the "it's-all-been-done-what-do-we-do-then-with-all-this-accumulated-baggage?" line of inquiry. Filliou's optimistic interest in interrogating the culture was invested in a certain emancipatory or liberatory potential. Such an outlook must be read within its specific historical setting. If we conjure such utopianism today it is in ironic fashion, using acts of quotation, citation, and repetition to reiterate our distance.

Fluxus 2.0: Reconsidering Fluxus Today

> I used the term [information superhighway] in a study I wrote for the Rockefeller Foundation in 1974. I thought: if you create a highway, then people are going to invent cars. That's dialectics. If you create electronic highways, something has to happen.
>
> Nam June Paik, 2001[65]

Fluxus has frequently operated as an art of hearsay, its often entangled modes of dissemination depending as much on oral histories, commentaries, and respondents for its continued presence as on the more traditional museological work of the archivist or conservator. This is not entirely specific to Fluxus, but relates to many fields of creative endeavour that incorporate the performance and the event, the spoken and the sung, the poetic and the fantastical. A certain mystique surrounds the residual artefacts and ephemeral traces of the art actions, and that mystique circulates via whispered gossip, critical letters, creative echoes.[66]

Even evidential and particular remnants such as scores, photos, and recordings can be interpreted in various, widely divergent ways when dissected in an art historical fashion.[67] For example, images become evocative, affecting fragments unto themselves rather than solely providing some platform for recounting cold hard data. I am interested also in the differences between reenactments and reinventions. Part of the job in analysing the significance of Fluxus and its manifold approaches is to speculate about Fluxus, its heritage, and its future. (For more on Fluxus scores, see Chapter 7.)

If Fluxus depended, like its inspirational figures John Cage and Marcel Duchamp, on the transition between early modern aesthetic forms and the postmodernism of the late twentieth century (and the according technological shifts throughout these periods), it is becoming an intriguing period now for considering virtual realms of communication and how they might create a conversation retrospectively with Fluxus, especially as all art and its analysis arguably involves time travel, whether back and forth, to and fro, or all at once. While being duly attendant to historical matters, it is encouraging that some recent initiatives have steered Fluxus away from pure art history back into the land of the living. Conversely, if Fluxus works have no presence in major institutions and historical sources, its influence diminishes.

It is unsurprising that the resurgence of dialogical and relational modes of art practice has occurred in a time when face-to-face conversations are becoming less of a basic feature of our daily lives, when rapidly fired-off texts, e-mails, and multiple forms of virtual messaging are supplanting more leisurely models of social interaction. The information society that was developing in the post-war era elicited many profound and traumatic shifts, and such issues were taken up in many of the writings, comments, and speculative "what ifs" put forth by Fluxus artists.

As a critic and writer, I often feel fascinated by the Fluxus movement, like one of those white folklorists knocking on the door of Mississippi Delta residences in the 1960s searching for the nearly long-gone sounds of the pre-war blues, reaching for some version of "authenticity" that appears to be (a) disappearing, (b) disappeared, or (c) never existed in the first instance. To follow along this tenuous analogy, looking at evidence of Fluxus artworks or the artworks themselves puts me in mind of listening to scratchy 78s or silent films, and the attempt to both see through and fetishize the accumulated patina of age. At the same time, I find myself laughing, prompted by the joy of Fluxus misadventures. How many artworks can deliver as much confusion as a Fluxus compendium? In the end, I am being laughed *at*, tricked by the works and their creators; the joke is on me, and as much as I want to be "in" on the merriment, I am perpetually outside some of its internal mechanisms and workings, built upon inside jokes and circular illogic. This experience of being both close to yet distanced drastically from Fluxus works still demonstrates their resounding power.

What relics are reproduced in massive doorstop volumes such as the *Fluxus Codex* (1988)?[68] A lot of silly things, akin to props for magic tricks, printed handbills, secret boxes of toys, and trinkets. Hannah Higgins writes evocatively in her key study *Fluxus Experience* (2002) of the manner by which Fluxus artworks enable "an experience for the handler that *is* the sensation

contained in it; the Fluxkit is not *about* the sensation".[69] She describes how the following questions might arise from considering Larry Miller's 1974 *Orifice Flux Plugs*: "Where would this fit? Could I really use this? How blunt is this tip? How sharp is this edge? Will the fuzz shed all over the inside of my nose or my ear?"[70]

Recalling silent comedian Buster Keaton, often cited by Fluxus artists George Maciunas and Dick Higgins, we can see slapstick influence being profoundly evident in many of the artists' routines: playing in the middle of the street or other locations (Ben Vautier), creating musical and robotic contraptions (Nam June Paik), and so on. It is difficult to say when Keaton's inventive visual routines began – likely over the course of a variety of initial iterations during his childhood raised in vaudeville. A good joke becomes a tale told again and again. This experience is central to much of the live, spontaneous origins of Fluxus in the European performances of the 1960s. In his analysis of Filliou's work, scholar Marc Léger discussed the artist's use of humour as a "coping mechanism", particularly in relation to the "social order" and the "violence of global capitalism".[71] Humour plays an integral role within Fluxus practices, as it reveals our humanity more directly than any other trait. The most significant Fluxus notions are threefold, involving the immediate, the everyday, and the playful.

Being a retrospective analyst of this art involves discarding and embracing multiple versions of Fluxus, which once offered iconoclasm; now its gestures shape the fabric of recent art, and its iterations have become familiar. Does Fluxus resemble the Dada movement it was once linked with insofar as it occupies a newfound status in histories of contemporary art but is consigned to its historical moment? *Sometimes.* Is Fluxus fading in relevance from these very developments? *Not really.* Has Fluxus produced creative heirs? *Of course!* Should it have? *Why not?*

Artist and Fluxus historian Owen F. Smith has written on ways to articulate, exemplify, and activate the current and future options for Fluxus, not simply relegated to solely academic research, but via an experiential approach to pedagogy:

> To approach Fluxus in an educational environment, whether an art history classroom or a studio space, what first needs to be done is to communicate the work as a lens through which to look at the world. I have come to realize that one cannot approach Fluxus through solely traditional historical methods or models to thoroughly communicate what is interesting or significant in Fluxus. Fluxus does not bring life or meaning to a classroom from the student's awareness of its historical activities, but from its existence as a kind of permission to experiment, to have fun and to take chances. Fluxus fully begins to resonate for students in the fullest way when we intertwine historical knowledge and living engagement, linking thought and action. The work should be seen as something to do, and doing them gives us our best sense of the future possibilities that Fluxus holds.[72]

Fluxus ideas also have a distinct status as aesthetic-philosophical literature, but they are products of different times, and cannot completely be separated from their historical contexts. Yet emerging artists still fall in love with the bracing gestures of Fluxus, and share

their interests in these gestures with newfound commitment and generosity. Perhaps Flux-us, with all its first-hand dialogue and interactions, camaraderie and contentiousness, is well-suited to the recent social networking interfaces. Beyond its reputation for experiential immediacy, many gain their introduction to Fluxus via streaming video, web publications, or e-mail bulletins.

Courses taught at many institutions have highlighted reenacting and reconsidering the Fluxus score, which becomes a continuing source for generating new performances that bear only a cursory resemblance to their starting points. Moreover, in consulting the assorted blogs and sites which act as cousins once-removed of Fluxus, they recall the Flux kits and boxes as containers of eclectic notions, texts, ephemera, images: virtual spaces to house an array of sets, collections, lists, the fragmentary nature of their construction offering a piece-meal collective consciousness unified by a graphical interface.

Amidst the disturbing precariousness of current global economic and political conditions, individual creative subjectivity remains under great pressure and stress, but I would hope that the use of digital technologies to expand the viability of hybridizing, incorporating, and revising Fluxus-related notions past, present, and future holds great – and as yet undetermined – potential. Nevertheless, Robert Filliou once said that all he needed as his primary art tools were pencil and paper. Such a Zen simplicity is not altogether character-istic of today's dominant art practices, but the widespread interest in Buddhist philosophy common to so many artists and thinkers owes much to the path-breaking amalgam of East–West thought that ran through so many works by Fluxus artists. As is the fact that art can function as a mechanism for engagement, enlightenment, and spreading love, hu-mour, and ecstatic commentaries, rather than being subsumed by either the spectacular or the pedantic.

Fluxus is an art of circulating ideas and traces of lived moments. Certainly, it is necessary to recognize museological acts of preservation, and it is highly significant to see Fluxus works on view within the Museum of Modern Art's galleries, rather than having them confined to the library. But that is not to forget or neglect the significance of fostering new and more elusive artistic conversations that may move in unpredictable directions, not easily directed, housed, or shaped by the white walls of the institution.

Returning to my opening title and the "unfinished Filliou", my intention is to emphasize the unfinished, ongoing, incomplete nature of Filliou's visionary praxis. If originary traces of relational aesthetics – a dominant model for certain contemporary artists – are clearly manifest in Filliou's work, we must quickly assert in addition that Filliou, along with Hig-gins (or even Beuys for that matter), was just as engaged in dialogue with the premodern and modern as the postmodern. Filliou was a highly self-aware and self-critical artist who realized that he was entering art in the middle; that the games had begun and the party had commenced long before his particular arrival, thereby beginning in the middle, in the midst, in-between. In addressing Filliou and the Fluxus non-movement, it is virtually impossible to effectively historicize such a shifting set of variable components except by presenting an array of correspondingly associative, allusive fragments. I hope some poetic qualities have still managed to emerge from this extended series of observations.

CHAPTER THREE

Autobiographical Voices and Entangled Identities:
On Monologues and Memoirs; Comedians, Celebrity, and Camouflage[1]

AL: When I interviewed Vito Acconci, I asked him, as a music enthusiast and someone who started off as a poet and moved into performance-art activities, if he was a fan of Leonard Cohen, and he said he loved him, because when Cohen used the word "I" it never seemed to be the same "I" from song to song. He said he felt like there were "a thousand 'I's" with Leonard Cohen.

WO: Yeah, and I never feel like he's singing about himself, even though he probably says "I" and "me" in almost every song. Just understanding that using the word "I" is a signifier and not a self-reflexive thing; to use the word "I" to represent a relationship to self and to identify a force that's moving through this song, and that's it.

—ALAN LICHT AND WILL OLDHAM, AKA BONNIE PRINCE BILLY, 2012[2]

It is always a mistake for the reader to believe that the first person character is the writer talking. As soon as you put someone in your book, he becomes a character. You become separate from him. I don't have a particular voice that is mine. I have any number of voices.

—WILLIAM S. BURROUGHS, 1979[3]

An artist-celebrity is like a fetish object. You love them and hate them. You want to abuse them but you also worship them.

—MARTHA ROSLER, 2014.[4]

The use of the first-person autobiographical monologue as a narrative structuring device has gained prominence throughout late twentieth- and early twenty-first-century cultural production, whether in the form of performance art or criticism, stand-up comedy or popular music, in addition to memoirs created for the page, the cinema, or the video screen. Such cultural artefacts and their lingering influence tell us much about the art/life divide, particularly in light of artists' intricate crafting and merging of life experiences to energize their complex creative practices. This is my focus in the current chapter, which comparatively considers works by Dave Chappelle, Megan Dunn, Geoff Dyer, Bryce Galloway, Spalding Gray, Dick Gregory, John Haskell, Andy Kaufman, Chris Kraus, Glenn Ligon, Steve Martin, Richard Pryor, John Jeremiah Sullivan, and David Foster Wallace.

All of these cultural producers stretch, interrogate, extend, twist, fold, and transform the language. Examining their approaches both to language and the entangled multiplicities of self assists the process of thinking through what happens when autobiographical experiences are treated by artists and writers, actors and musicians. For one thing, it makes it difficult to analyse their works as discrete, isolated constructions. The shifting of the author's voice to encompass varying tones and modes of communication interests me as well – performing as a reaction to personal grief and trauma; transforming one's experiences into visual and literary narratives; breaking the frame of the television screen; and throughout these processes, the repeated slippage of the "I", as noted in the preceding epigraphs. Any conventional understanding of what autobiography actually "consists of" is reshaped radically when it involves multiple stylistic voices. The examples cited here feature aspects found in the wake of postmodernism, including pastiche, satire, and intertextuality, that may also operate alongside (and in tandem with) tactics of distancing, masking, and mediation.

Alternative Comedy, Social Criticism, and the Self

Viewed in retrospect, one could argue that the proliferation of first-person accounts onstage, on-screen, and in galleries throughout the late twentieth century constructed a foundational context for the ubiquitous blogs, reality TV, and YouTube cacophony of more recent vintage. If those coming of age in the 1970s were once classified as the "me" generation, it is intriguing how many ways one could have overheard specific details about multitudinous "me's":

confessions, comedy routines, performance monologues, speeches, testimonies, journalism and criticism, underground comics, poetry, autobiographies, and singer-songwriters.

Television assisted in circulating such accounts widely from late-night comedy to daytime talk shows. Meanwhile, artists experimenting with the "hand-me-down" technology inherited from broadcast studios, or the comparatively inexpensive and relatively compact Portapak technology, interrogated how the medium of video might be severed from its identification with mainstream commercial broadcasting. As media scholar Chris Hill writes, in surveying early video art practice:

> For feminists, community producers, and artists, the video project's relationship to its audience was assumed to be a structural aspect of work that expressed a range of radical subjective assertions. The early feminist insight, that both cultural production and viewer reception were constructed according to gender, continued to be articulated across other cultural differences such as class, race, and ethnicity.[5]

Chris Burden bought short advertising spots during the evening news to showcase glimpses of his performance and text works, while the Ant Farm collective interrogated the hegemonic role of television in terms of power, politics, and spectacle by driving through a stack of sets in their *Media Burn* (1975). It is also intriguing to recall how self-consciously arts-related some television could become just at the time artists began to investigate video as an alternative tool for experimentation: Yoko Ono and John Lennon co-hosted Mike Douglas' syndicated talk show, speaking out for peace and radical causes; Dick Cavett often spoke with a wide range of writers and cultural figures; and free-form, often politicized, public access programming was available in many urban centres.

One also encounters innovative use of video as a medium by such popular comedians as Richard Pryor, Andy Kaufman, and Steve Martin. Pryor created a television series in which he attempted to preserve his own highly independent artistic viewpoint within the restrictive context of industrialized entertainment production. Pryor sought to discuss content that was radically challenging, commenting on issues relating to class, race and sexuality, and hypocrisies within American society. Significantly, with a strong amount of empathy, as Pryor once stated, "there's a thin line between to laugh *with* and to laugh *at*."[6] The experiment was short-lived. Sketch comedy was the framework of the show, but Pryor's sketches and set-ups became increasingly confrontational over the course of a few programmes – and more than a few battles with network censors. Pryor enacted satirical critiques of religion, militarism, censorship, and celebrity roasts, and adopted the role of the First Black President.

Pryor had spent years battling both his own personal demons and the demanding expectations placed upon aspiring comedians, particularly comedians of colour. In the early 1960s a major transition was occurring as certain figures performed so-called "colour blind" material (Bill Cosby), just as others were becoming radicalized (Dick Gregory), and the so-called "chitlin' circuit" of all-black touring musicians and comedians was ending. Growing up within a brothel run by his grandmother, with Pryor's mother a prostitute and his father a pimp, provided brutal circumstances for the comedian's development as a keen observer of the human condition. By the mid-1960s, Pryor was gaining prominence, but felt that he was not

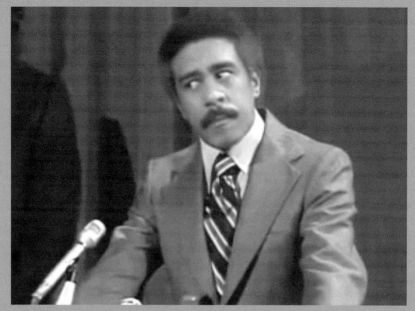

3.1 Richard Pryor as the First Black President in *The Richard Pryor Show* (1977). Created by Richard Pryor. Produced by Rocco Urbisci for Burt Sugarman Productions. NBC-TV. Video still.

tapping into more significant social issues in his material as he tried to fit into the conservative parameters of mainstream entertainment, and was still contending with how to incorporate his own biography.

Even when Pryor made mention of his actual childhood experiences to an interviewer from *Ebony* magazine, she assumed he was making a joke. After several crises, including a breakdown on stage in Las Vegas, and numerous turbulent relationships, Pryor began to perform and record more direct, forceful material. His biographer Scott Saul notes in his informative *Becoming Richard Pryor* (2014):

> The salty characters of his teenage years in Peoria glided and swaggered on the stage of the Troubadour, where they were joined by a wild assortment of Uncle Toms and black militants, faith healers and mainline ministers, prison guards and stage directors.[7]

The intensity of Pryor's perception enabled his uncanny ability to consider others as material, but also to be inconsiderate of others in his interpersonal relations, in which he would often lash out, acting both violently and self-destructively.

During the early 1970s in Berkeley, Pryor radically shifted his working approach, as Saul describes:

> For the next seven months, Richard delved into his own agonies, exploring them from the inside out, revisiting the traumas of his life with an unblinking stare. He had been hurtling forward for eight years, trying desperately to hurtle upward; now he pressed the Pause button. He crawled into himself and ruminated. He experimented – in routines onstage, in bids at spontaneous poetry, in screenplays and in an avant-garde sound collage – with being *un*funny.[8]

Pryor's friendships with experimental writers like Ishmael Reed influenced the construction of his performed material, both aesthetically and politically. Pryor committed himself to a determined self-exploration and an unsystematic but informed social research. Lamentably, many of Pryor's routines concerning perceptions of race, the specifics of police brutality, and institutional racism are still timely decades later.

Artist Glenn Ligon has drawn upon Pryor's stand-up in his early text works, and in his recent large-scale video installation entitled *Live* (2015), in which details from Pryor's 1982 *Live on the Sunset Strip* concert film are projected onto seven screens – in silence.[9]

One would think that this would mute Pryor's impact, but he was an extremely physical, embodied presence as a performer, and even with no soundtrack one can witness Pryor's vivid gestures. As art critic Holland Cotter notes:

> In one clip, he appears to be weeping; in others, he looks enraged. What's going on at this point, content-wise? Are these stage emotions – part of the act – or something else? Without words, we can't know. Their absence creates guesswork, which imposes certain pressures on a viewer, including the decision when to give up guessing and go.

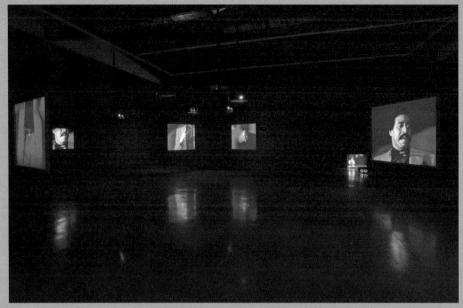

3.2 Glenn Ligon, *Live* (2015). © Glenn Ligon. Image courtesy of the artist, Luhring Augustine, New York, Regen Projects, Los Angeles, and Thomas Dane Gallery, London.

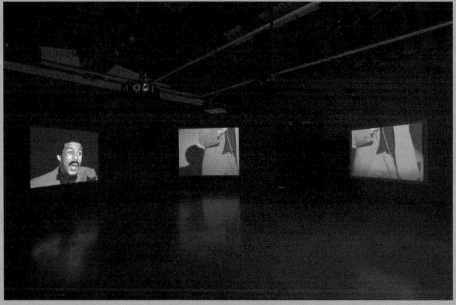

3.3 Glenn Ligon, *Live* (2015). © Glenn Ligon. Image courtesy of the artist, Luhring Augustine, New York, Regen Projects, Los Angeles, and Thomas Dane Gallery, London.

"Live" runs for almost an hour and a half. It takes patience to watch in full. But hanging in has rewards. Among other things, it gives you the time to infuse it with content – emotional, spiritual, political – of your own. Watching Mr. Pryor silently perform for you – at you – becomes disturbing: entertainment as endurance for artist and audience. There are no verbal gags to relieve tension. Simmering anger, not easy hilarity, stands out. And if Mr. Pryor's anger was strong years ago, you can imagine what it would be today, in the America of Freddie Gray and Sandra Bland, of jam-packed prisons, and permanent poverty the de facto law of the land.[10]

Critic Sharon Mizota also notes the jarring effects of the installation's fragmentation:

> This atomization can be fetishizing, objectifying, dehumanizing, but it is also a refraction, a multiplication and amplification of aspects of Pryor's performance that usually escape notice. In addition to his unexpected vulnerability, the focus on Pryor's shadow is interesting not only for its parallels to blackness and absence but also as a "body part" that is literally in the background and typically ignored. It's also telling that Pryor's entire body appears only occasionally on a screen outside the main circle. Wholeness is elusive.[11]

Pryor becomes a ghostly apparition, and it is important to note that Pryor's self-sabotage did not just encompass his disputes with Hollywood magnates, but his own self-examination of his own fears. In his most reckless period, the late 1970s, his drug use had escalated to the point that an alleged suicide attempt while freebasing cocaine led to his being burned over much of his body. *Live on Sunset Strip* was Pryor's comeback film, although it was unclear for a time whether he would ever return to the stage. When Ligon reworks this footage and revives Pryor once again, it highlights the multiple lives and extended legacy of his insightful work as a comedian and social critic, even if the Pryor on these screens becomes concentrated flashes of gesticulation: Pryor pointing at himself, clenching fists, waving fingers, holding microphone, cradling a phantom telephone, strutting across the stage, grimacing and raising his eyebrows.

Ligon's Pryor becomes a performative collage; and as with many comedians, his practice involved acts of collage: argumentative juxtaposition, with leaps from topic to topic making uneasy relations between disparate subjects of discussion. Worlds perceived as separable by class and race divides became reconfigured in Pryor's satiric micro-universe. His comedy involved direct address to the audience or audacious characterizations, and he often successfully mixed the two approaches.

The play *Turn Me Loose* (2016) takes as its focus Dick Gregory, along with Pryor a central figure in introducing social awareness into comedy.[12] Here the actor Joe Morton "inhabits" Gregory across a span of nearly 50 years, periodically shifting his voice, posture and the subtleties of body language to uncannily conjure the presence of the charismatic comedian. Gregory – who entitled his first autobiography *Nigger* (1964) in the hope of disempowering the word – is an integral figure across a number of other fields, including political activism, and health and wellness. Like Pryor, his gigs shifted from nightclubs to campuses in the late 1960s, and his routines incorporated a wide range of surrounding material that was

not viewed as light entertainment. In Gregory's own words, "when you accept injustice, you become unjust".[13]

In *Turn Me Loose*, Morton offers a virtuosic performance, a spirited evocation of Gregory (who died on August 19, 2017 at the age of 84). Disconcertingly, despite being set decades ago, many of the themes within the play are still of direct relevance: drastic inequality, police brutality, and persistent institutional and codified methods of preserving racist assumptions and policies. Gregory's humour shed light and perspective on a very demeaning array of contexts, without taking away their sting or treading lightly. He concluded an early perfor- mance to an unsympathetic white audience: "I take my sheet off to you. […] Pay your checks, burn your crosses and get on home!"[14] In Gregory's 1964 autobiography, he commented:

> This is a revolution. It started long before I came into it, and I may die before it's over, but we'll bust this thing and cut out this cancer. America will be as strong and beautiful as it should be, for black folks and white folks. We'll all be free then, free from a system that makes a man less than a man, that teaches hate and fear and ignorance. […] And now we're ready to change a system, a system where a white man can destroy a black man with a single word. Nigger. When we're through, Momma, there won't be any nig- gers any more.[15]

One of the foremost inheritors of Pryor and Gregory's comedic legacy, comedian Dave Chap- pelle gained critical and popular acknowledgement for his television programme *Chappelle's Show* (2003–06), which directly addressed America's enduring racial fissures.

A primary approach of Chappelle, a gifted writer, improviser, and satirist, was to foreground the absurdity of the discursive language framing race and identity in entertainment, sports, and everyday existence. In a series of disarmingly funny and incisive sketches, Chappelle portrayed racial stereotypes from a variety of angles, such as envisioning "Black [George W.] Bush" meeting with "Black [Tony] Blair"; a white 1950s sitcom-style family named "the Niggars"; an interview with a blind, black white supremacist; and a "racial draft", parodying the characteristic annual ritual of American football.

Chappelle's calling attention to historical and contemporary traumas and deep rifts still brings us together, as laughter – shared with rather than directed at – tends to unite us even if momentarily. Chappelle brought forward in many respects the irreverent and generous spirit of Pryor, whose work was a major influence on his own. Chappelle also conducted his own battles with big media. Almost overshadowing the impact of Chappelle's innovative television work was the fact that the comedian stepped away abruptly from the show while preparing for its third season, turning down a purported $50 million contract, feeling that the programme was getting beyond his artistic control.

Aside from appearing in director Michel Gondry's 2006 film *Dave Chappelle's Block Party*, and the continued circulation of his programme via record-breaking DVD sales, Chappelle con- tinued doing "pop-up" appearances in clubs, festivals, and theatres, which generated huge interest, but often involved hecklers and incomprehension on the part of the audience, as Chappelle would avoid overtly crowd-pleasing material in favour of rambling improvisations.

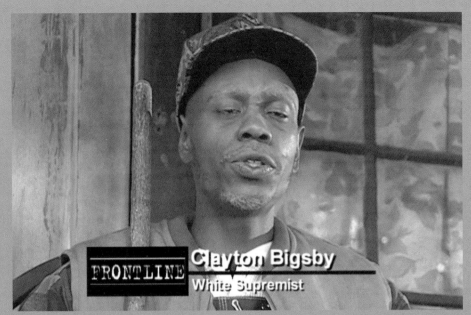

3.4 Dave Chappelle in *Chappelle's Show* (2003–06). Created by Dave Chappelle and Neal Brennan. Comedy Central/Viacom Global Entertainment group. Video still.

3.5 Steve Martin appearing on *The Tonight Show with Johnny Carson* (1974). NBC-TV. Produced by Fred de Cordova and Peter Lassally.

Chappelle has set records for endurance onstage, such as five-hour plus sets. This is more reminiscent of the tactics of a performance artist rather than those of a television icon. The best comedians are generally artists who have gained a large following due to their quick wit, charisma, and improvisational skill; but when a comedian moves in a direction that abandons some of the more formulaic models used to ensure accessibility to a mass audience, to search for other, more explorative tactics, they are regarded as a failure, a has-been and – an even more damning label – not funny.

It is an intriguing area for exploration: what happens when entertainers are *not* entertaining, comedians are *not* funny, and so on; does this open up a correspondingly challenging and different realm of activity? How are these borderlines maintained, reiterated, and policed? When Chappelle is labelled "not funny", it depends on the mutual expectations of artist and audience, and a thwarting of the former or the latter (or both). This recalls Woody Allen's 1980 film *Stardust Memories*, in which his autobiographical protagonist attends a festival to be told, "We love your films, at least the early funny ones".[16]

Scholar Sophie Quirk, in her book *Why Stand-Up Matters: How Comedians Manipulate and Influence* (2015), characterizes "stand-up" as a form of dialogue rather than monologue, in that the performer depends on manipulating the audience skilfully enough to elicit laughter. Although Quirk's focus is on recent alternative comedy scenes in Britain, her arguments are relevant here:

> In stand-up comedy, there is a dangerous merging of two contradictory interpretative forces. On the one hand, comedy is about laughs rather than accuracy, and it is acceptable (within limits) to abandon ethics and ideology when necessary. On the other, joking provides us with social criticism, and successful stand-up allows an individual a platform from which to have his messages heard and understood.[17]

Comedians often gain popular acknowledgement when things are flowing well; that is one reason why I am so intrigued by the intentional severing of this sympathetic bridge between performer and audience, when "things go wrong". This raises a question as to whether things actually *are* working or not. Is an experimental performer who becomes "less funny" testing the edge of their field to extend it, much like the free experimental noise and sounds that emerge from melodic jazz or pop contexts? Does their "seriousness" become a jarring static, as it becomes more difficult for the audience to easily decode their comedic remarks?

One of Chappelle's routines references the iconic *Seinfeld* actor and comedian Michael Richards' nearly career-ending performance, in which his angry retorts to a heckler in the audience escalated into offensive racist slurs. Some time afterward, at the same club, The Laugh Factory, Chappelle addressed the audience:

> Every time I see this backdrop I think about Kramer fucking up! I tell you the truth when I seen Kramer's tape, I learned about myself. You know what I learned? I think I'm only about 20% black and 80% comedian. You know what I mean […]? Black dudes can relate... you know what I mean brother? When you saw that shit you was furious, right? And I'm thinking, "Kramer you motherfucker!" I was hurt! And the comedian in me was

just like, "Whew! Nigger's having a bad set! Hang in there Kramer! Don't let them break you Kramer!" Ah, I wish I was there so bad! 'Cause you know in the back of his mind he was thinking: "I'll get 'em the next show!" "There won't be a next show Kramer!"[18]

What one encounters and registers with the best comedians is some preternatural force, rather than a singular conjuring of laughter; individuals who are harnessing their own idio-syncratic communicative talents to comment on the wider social group. This very tension brings us in empathically as viewers, conferring a false sense of intimacy. If the comedian proceeds to demolish this atmosphere of trust, the audience might react strongly to this rebuff, as if spurned by a close friend, lover, or family member. This is even more complicated given that the relation is "virtual" rather than actual. It seems no accident that comedians are stalked just as often as other types of celebrity.

Director Martin Scorsese's film *The King of Comedy* (1982) remains one of the most chilling responses to this facet of the comedian-celebrity's existence, in which characters played by actors Robert De Niro and Sandra Bernhard (a comedian herself, who had worked on Richard Pryor's show mentioned earlier) kidnap and hold hostage actor Jerry Lewis' character, Jerry Langford, a well-known talk show host, modelled after Johnny Carson.[19] In a series of conversations with the film critic Richard Schickel, it is evident that Scorsese considers this one of his most personal films, and one of the most taxing emotionally and psychologically:

> *King of Comedy* was really scary. Bob De Niro gave me that script when I was doing *Alice* [*Doesn't Live Here Any More* (1974)], I think, and I didn't get it. I just thought Paul Zimmerman, who did the script, was a wonderful writer. The script is hilarious. But I thought the movie was just a one-line gag: You won't let me go on the show, so I'll kidnap you and you'll put me on the show. Hmm. After I took *Alice*, *Taxi Driver* [1976], *New York, New York* [1977], and *Raging Bull* [1980] around the world to different festivals, I took a look at the script again and I had a different take on it. I began to understand what Bob's association with it was, what he went through after *Mean Streets* [1973], certainly after *Godfather II* [Francis Ford Coppola, 1974] – the adulation of the crowd, and the strangers who love you and have got to be with you and have got to say things.[20]

The director has called it the favourite of his many collaborations undertaken with actor De Niro, although the film was not a commercial success.

Comedian Steve Martin acknowledged the creepy and isolating qualities of comedy stardom in his autobiography:

> Cars would follow me recklessly on the freeway, and I worried for the passengers' lives as the driver hung out the window, shouting, "I'm a wild and craaaazzzzyy guy!" while steering with one hand and holding a beer in the other. In a public situation, I was expected to be the figure I was onstage, which I stubbornly resisted. People were waiting for a show, but my show was only that, a show. It was precise and particular and not reproducible in a living room; in fact, to me my act was serious. Fame suited me in that the icebreaking was already done and my natural shyness could be overcome. I was,

however, ill suited for fame's destruction of privacy, for the uninvited doorbell ringers and anonymous phone callers. I had never been outgoing, and when strangers approached me with the familiarity of old friends, I felt dishonest and returned it in kind.[21]

In John Haskell's 2009 novel *Out of My Skin*, a New York writer (a surrogate for Haskell himself) relocates to Los Angeles to "write about movies" but ends up in the meandering way of so many contemporary narratives doing almost anything but. The protagonist has repeated brushes with fame, including an awkward face-to-face encounter with actress Scarlett Johansson at a movie premiere, and more significantly meets an actor named Scott, whose day job consists of impersonating Steve Martin as a "celebrity lookalike". In discarding his initial scepticism, the narrator becomes impressed by Scott's interpretation of Martin:

"It's a state of mind," he told me.
This was probably true because, although he was thin, and had the white hair and the easy smile, he bore only a passing resemblance to the celebrity actor he was paid to imitate. "It really doesn't matter what I look like," he said. "It's the white hair. It's a trick."[22]

On witnessing Scott/Steve's appearance at a child's birthday party, he also notes:

People who have the gift of letting go of themselves enjoy the gift because, by letting go of who they are, they can afford to let go of what doesn't work. And the trick, it seemed to me, is to have something waiting, another self or another way of being, something, so that in the moment of letting go, in the sensation of that sense of nothingness, there's something to hold on to.[23]

Haskell takes us on a circuitous journey around Hollywood, encompassing musings upon displaced identities: Edgar G. Ulmer's classic film noir *Detour* (1945), in which a man (also named Haskell) takes on another man's identity after accidentally causing his death; the transformation of Archibald Leach into the movie star Cary Grant, who reportedly once said, "Everyone wants to be Cary Grant, even I want to be Cary Grant"; and the exploits of a Houdini-style escape artist.[24]

Over the course of this lean novel, the narrator involves himself in also becoming more "like Steve" in order to impress a woman he's dating, to calm his own state of mind. At one point, he watches Scott/Steve prepare:

When I asked him why he didn't change his clothes in his house, he said that he didn't want to confuse who he was with who he was trying to become. And when he said the word *become*, although I noticed the change in his voice and the change in his posture, he was talking about more than physical resemblance. "The job is to make people happy," he said, and again he used the term being Steve. "When I'm being Steve," he said, "I have to forget about myself." I thought I knew what he meant because every so often I forget about who I am. Usually, when I do, I like it, and as I watched Scott, or Steve, whoever it was, as I saw the transformation in him, I wanted to learn a little bit about how that transformation happens.[25]

One of the most interesting aspects of Haskell's book, beyond its intricate tale involving multiple cases of mistaken identity, is noting the fact that the once iconic comedian Steve Martin achieved his fame due to his hard work on another intricately constructed performative self, superimposed over his own identity.

Martin's comedy routines were more influenced by analytic philosophy, conceptual art, and the surrounding alternative and psychedelic culture than traditional comedy. As Martin recounts in his autobiography:

> With conventional joke telling, there's a moment when the comedian delivers the punch line, and the audience knows it's the punch line, and their response ranges from polite to uproarious. What bothered me about this formula was the nature of the laugh it inspired, a vocal acknowledgment that a joke had been told, like automatic applause at the end of a song […]. What if there were no punch lines? What if there were no indicators? What if I created tension and never released it? What if I headed for a climax, but all I delivered was an anticlimax? What would the audience do with all that tension? Theoretically it would have to come out sometime. But if I kept denying them the formality of a punch line, the audience would eventually pick their own place to laugh, essentially out of desperation. This type of laugh seemed stronger to me, as they would be laughing at something they chose rather than being told exactly when to laugh.[26]

While often appearing spontaneous, Martin worked for years as a journeyman comic before becoming a huge celebrity in the late 1970s. In Martin's performances of that time we see a rather unfunny but absurd and captivating man wearing a white suit, a uniform of effacement, a ready-made screen for projecting upon.

As performance theorist Philip Auslander notes:

> Martin adopts the gestures, tone, and manner of the traditional stand-up comedian, of a simultaneously smug and desperate comedian who will resort to wearing rabbit ears or a fake arrow through his head to get a laugh, insisting all the while that his fake arrow is a professional model, not to be confused with the toy version any member of his audience could buy at a novelty shop. Martin's pastiche of stand up comedy is void of content: his persona is blank and cynical, apparently only going through the motions of seeming to want the audience's attention and affection, treating the conventions of stand up comedy as a dead language, as if to suggest there is nothing left to laugh at except the idea that someone might try to make us laugh.[27]

In Haskell's reinvocation of Martin, we have a writer writing of a writer who performatively enacts the surface attributes of a constructed comedic self.

The brash performative exploits of the comedian Andy Kaufman in the early 1980s included prankish set-ups, such as challenging women from the audience to wrestle him, that were roundly considered unfunny, distasteful, and bizarre.

3.6 Andy Kaufman performing in 1979. Still from *The Real Andy Kaufman* (2001). Dir: Seth Schultz.

3.7 Spalding Gray (*c*.1992). © Ali Hossaini. Courtesy of the photographer and the Estate of Spalding Gray.

Kaufman was notorious for his inscrutably ambiguous routines: a man slight in build, with an indeterminate false accent states that he will now "do the Elvis Presley". And with his back turned to the camera/audience, the portentous music for introducing the "real" Elvis plays, segueing into a transformative act... as the imposter becomes uncannily believable, his body language terrifically convincing.

Kaufman's arsenal contained many baffling permutations and personae: his wrestling challenges; miming along with a children's Mighty Mouse record played on a toy phono-graph; taking the entire audience out for milk and cookies after a live performance in New York; eliciting the audience to sing along as though he was channelling folk singer Pete Seeger. These stunts occurred while Kaufman was a supporting actor on the mainstream and popular situation comedy *Taxi* (1978–83). Yet the stunts of Kaufman, such as taking on the role of a belligerent, anachronistic stand-up comedian named Tony Clifton, were of-ten read as cheap, insulting, free of humour; an egotistic grandstanding becoming darker and tiresome.

Scholar Florian Keller, in his analysis of Kaufman's cultural significance, states:

> As a result of his persistent identification with the innermost fantasies of American cul-
> ture, he confronted the public with the fact that the realization of their shared fantasy
> would imply the dissipation of the self and consequently, may lead to the death of any
> sense of coherent subjectivity.[28]

Kaufman's later, more confrontational actions were often treated as indecipherable or inex-plicable, even when placed in the context of his earlier, more well-received routines. Kau-fman continually complicated the issue of which Andy Kaufman was onstage, on-screen, or supposedly "being himself". To wear many masks becomes simultaneously a tactic of camouflage and erasure. The artist cannot be located and situated; Andy/Elvis has left the building.

The Artist in the First Person: Autobiographical Monologues and Texts

While comedian Kaufman became more of an idiosyncratic performance artist and television star, the actor Spalding Gray emerged into performance art from experimental theatre, and subsequently several of his performance works became popular art-house films.

Gray's monologues were neurotic and searching. His insightful yet rambling spoken narra-tives hearkened back to the American oral tradition and figures like Mark Twain. Gray's earli-est works included being interviewed by the audience. In such instances, the responses from "Spalding Gray" could either be read as coming from a character or the actor himself. In his *A Personal History of the American Theatre* (1985) the set-up developed into the shuffling of titles of plays in which Gray had acted, and he would proceed to riff upon them, relating personal anecdotes. But Gray's work also had a foundational moment in the attempt to make sense of his early life in suburban Rhode Island and the devastating suicide of his mother dur-ing his teenage years. Mortality, interruption, failure, guilt, seeking love and understanding – these are among the paramount themes in Gray's work.

Likewise, Gray could be criticized for his white male subjectivity being at once exposed yet guarded, still privileged and in control.[29] Gray was frequently likened to a comedian, but chose to distance himself from such a characterization:

> I've never been a fan of jokes or stand-up, I think of myself as a humorist. I never laugh, or I rarely laugh. The children make me laugh occasionally, but when my audience is laughing, they're laughing for me. It completes a relationship there. And the laughter is not based around set-up and delivered jokes, but based around more a sliding humour, which is juxtaposing the sad, the poignant, and the funny, all like life.[30]

Gray's practice became the translation of life events into performance monologues:

> Here then is another reason why I like the monolog form. When I was writing [...] the order of the memory seemed random as I'm sure it is. The memories would appear to me as if on a wheel and to set them in print would be to stop the wheel but to speak them in different order each night would be free to spin the wheel until the right combination came up and what is the right combination? Finding the right combination is finally some intuitive combination of psychological insight and aesthetic form. The monolog form is more open. It is not set in print. It is a wheel that spins in a new way each night. It is much more true to how reality is.[31]

Gray, a former member of the seminal New York experimental theatre company The Wooster Group, moved into his monologues from the group's avowed interest in bridging the art/life divide, and more specifically the difference between a "theatrical production" and a more experimental postmodern event interrogating the terms under which it operated. The ways in which this occurred included examining the overlap between staging and audience, actor and role, as well as combining recorded and live performance. The first major works by Gray formed an autobiographical trilogy, although he reached wider fame through director Jonathan Demme's film of the monologue *Swimming to Cambodia* (1987), which recounted Gray's experiences when playing a small role in the major Hollywood film *The Killing Fields* (Roland Joffé, 1984).

A paradox became how to discern when Gray was "on" or "off" in terms of performance, as the drafting of his work was largely an oral process, in part due to the nature of the work and owing to the actor's own severe dyslexia. The monologues would be told again and again, reiterated until they reached a particular point, at which time the author considered them completely finished. Gray's staging consisted of wearing a simple plaid shirt and jeans, and placing a school notebook and a glass of water on a wooden table, a microphone either attached to his lapel or poised in front of him. With these ingredients, Gray highlighted a lack of artifice that became a trademark. After the critical success of Demme's film, several of Gray's monologues were filmed for the cinema. Although the works were generated via an oral process, and intended for live, spoken performance, the resulting texts from this process read vividly on the page as well.

Gray's monologues anticipate such works as novelist Dave Eggers' memoir *A Heartbreaking Work of Staggering Genius* (2000); the bemused but incisive tone of David Foster Wallace's essays; Sam Lipsyte's work on the well-educated but low-achieving abject white male of the

early 2000s, as recorded in his novel *The Ask* (2010); or that of Jess Walters in his post-2008 satire *The Financial Lives of the Poets*. The fact that novelistic memoirs by authors Karl Ove Knausgaard and Elena Ferrante have been global bestsellers in the past decade is also an indication of contemporary audiences' fervour for reading the details of others' lives.[32]

Also characteristic recently is the post-punk monologue or memoir, which involves examining retrospectively the unwise but formative periods of one's youth, coming-of-age tales perhaps, but incorporating a specific view of what that eventually portends: increasing obligations and the need to increase one's mature interpersonal connections while still feeling stunted, immature, questioning. Several punk singers, including Henry Rollins of Black Flag and Jello Biafra of the Dead Kennedys, have had productive "afterlives" in spoken-word performances, travelling widely to deliver monologues featuring their critical responses to current events.

New Zealand artist Bryce Galloway, whose practice emerged from punk and independent music contexts, has insightfully engaged both with our relation to celebrity culture and the mostly mundane aspects of everyday life. In regular instalments of his zine *Incredibly Hot Sex with Hideous People* (the longest-running zine in New Zealand), Galloway relates aspects of his family life and workaday existence.

As artist and writer Tessa Laird notes:

> You might say he has a kind of recording mania: he is constantly capturing, then revisiting, important moments on his personal timeline. [...] The cross(es) Bryce has to bear are not extraordinary – he is husband, father of two, artist, teacher, and musician, leading what seems like a fulfilling life. But the challenges of aging and parenting, the constant judging that is concomitant with an art practice and a job in a contemporary educational institution, mean that Bryce's incisive self-portraits are often haggard, gloomy, and painfully self-deprecating.[33]

The typical content in Galloway's zine includes comic diaries of recent life events, vintage excerpts from his teenage diary, single-spaced typewritten accounts of subjects ranging from the banal to the profound, and pages of aphoristic notes alongside drawings:

> *SOULMATE WANTED, MUST HAVE OWN CAR; It's too late in the day/night to do a proper drawing. I've got kids, I've got responsibilities [...] now; My life is open to ridicule/ office hours; I thought I was depressed but then I wondered if I was just being romantic; I thought I was just deadpanning but then I realised I was depressed; What kind of day is having you?*

Galloway's writing has recorded his shifting roles over time, as alternative musician, MFA candidate, university lecturer, family man; and the reflections in these passages become some of the most resonant and affecting:

> Any residual bitterness I may have is as likely to be aimed at the failings of youth's counter cultural project as my own inability to take part. The differences between playing

3.8 Bryce Galloway, cover of *Incredibly Hot Sex with Hideous People* 26 (Summer 2006–07).
Courtesy of the artist.

mum 'n' dad and playing rock 'n' roll now seem arbitrary. This is both a source of solace and of frustration. I sometimes miss the nightlife, but not for its phoney secrets, only for its promise of momentary oblivion. I'm feeling betrayed, because I was so committed to youth's project that I've flagellated myself for every step taken toward respectability. Now that I've crossed over I see the conspiratorial pose of all that nocturnal bingeing and camaraderie as just that, a pose. Those for whom it is a lifestyle choice specifically about voiding responsibility will find my indictment ridiculously earnest.[34]

Galloway also compiles the celebrity encounters his colleagues, family and friends have had under the subtitle "meeting famous-ness". Whether glimpsing Nick Cave in the park or Dave Grohl in a local café, such run-ins with those one rarely runs into are awkwardly funny. They also reflect to a degree the cultural sensibility of New Zealand, in which celebrities are brought down into the orbit of "ordinary" people, and one finds less fawning over celebrity than one might encounter elsewhere.

Galloway also pays homage to pop bands with a series of tribute CDs taking on such iconic pop stars as John Lennon, Madonna, and the Eagles. The ironic appreciation rather than complete embrace of some of these figures is likely evident. Galloway has noted that even though the Eagles seemed a stretch at first with their middle-of-the-road, laid-back aesthetic, the act of learning their songs summoned a more genuine appreciation of the band's skill as songwriters.

In the comments accompanying the CD *My Life with John Lennon*, Galloway writes with characteristic humour:

> I like taking ownership of the material of such an omnipresent rock icon and making it my own. I like the Lennon with Kiwi accents and low-fi production. Lennon in bedrooms and hallways. Lennon the bum. Hardcore industrial Lennon. I mean why not? The guy's so famous he might even enter your dream world; you might find yourself polishing his bejeweled toenails with a dirty toothbrush (er...dream example only). So if we can't escape the guy's presence, then how about the right of reply.[35]

One of the key factors in our attachment to popular culture is the appearance of immediate access. Very often celebrities seem like our long-lost, good-looking cousins we check in on from time to time at the cinema, club, or computer. The fact that they might be singing in our ears, living on the walls of our homes, inhabiting our phones gives them an especially eerie presence within our daily lives. Writer David Foster Wallace acutely described this sensation in his 1993 essay on television and its effect on the contemporary novel:

> For we gaze at these rare, highly trained, seemingly unwatched people for six hours daily. And we love these people. In terms of attributing to them true supernatural assets and desiring to emulate them, we sort of worship them. In a real Joe Briefcase-type world that shifts ever more starkly from some community of relationships to networks of strangers connected by self-interest and contest and image, the people we espy on TV offer us familiarity, community. Intimate friendship. But we split what we see. The *characters* are our "close friends"; but the *performers* are beyond strangers, they're

images, demigods, and they move in a different sphere, hang out with and marry only each other, seem even as actors accessible to audience only via the mediation of tabloids, talk show, EM signal. And yet both actors and characters, so terribly removed and filtered, seem so *natural*, when we watch.[36]

Wallace's argument revolves around the notion that television, in its one-way voyeuristic attraction, influenced the context and content of the postmodern novel. However, today we might consider the complications of the social networking era and the interchanges that unfold.

Wallace, renowned for his massive novel *Infinite Jest* (1996), plotted a parallel course in a series of stylistically eclectic yet carefully crafted and influential essays and short stories. In the essays, Wallace becomes a teller of convoluted, comedic tales of surreal situations and everyday chaos, whether discussing a political campaign, a cruise ship voyage, or a rural state fair. The notion that the personal essay can be a vehicle for fanciful invention while exhibiting an empathic as well as satirical relation to the subjects under scrutiny continues, as can be seen in other essay collections by Geoff Dyer and John Jeremiah Sullivan, for example. Their usage of personal voice, or at least adopting subjective personae, works as a successful, if slippery, narrative device.

Dyer's *Out of Sheer Rage* (1997) portrays the author as he unsuccessfully attempts to write a biography of writer D. H. Lawrence. Instead, Dyer takes detours, both intellectually and geographically, and creates something marvellous. I then wonder how seriously Dyer ever intended to approach his initial project in the first place. Was it in fact a shell game from the beginning, camouflaging another kind of book altogether (the kind of book Dyer has a tendency to write anyhow)? Along the way, we learn some intriguing facts about Lawrence, but find ourselves even more curious about the writer/character that Dyer conjures, offering witty asides, threatening to shelve his project entirely, and travelling through disparate locales.

We are vicarious witnesses of a failure that is not one. Thus, it both tugs at our sense of unease regarding our own steps to accomplishing something and makes us feel a sense of superiority on reading the extravagant missteps the author so cleverly describes; an internal monologue of self-doubt externalized for our amusement and at the author's expense. Literary critic James Wood has compared Dyer's work to the much darker – but frequently comedic – Austrian writer Thomas Bernhard, acknowledging "a familiar vaudeville of despair, whereby every possibility is shadowed by its negation, and nothing can ever be completed, because it is always being ceaselessly re-started".[37] It's perhaps unsurprising that Steve Martin's jacket blurb states, "The funniest book I've ever read".

The writer and filmmaker Chris Kraus developed an innovative style of intense, autobiographical fiction in her novel *I Love Dick* (1997), loosely based on imagined triangular relations between Kraus, her then husband, French cultural theorist Sylvère Lotringer, and a recent émigré to the United States, the British theorist known only as "Dick". Most of the book consists of letters written to Dick by Kraus (and sometimes Lotringer) about Kraus' obsessive interest in "Dick" after a brief dinner meeting that was taken (by Kraus) for a flirtation. The book becomes an uncategorizable amalgam of art criticism, a stalker's diary, and a feminist reworking of the epistolary novel.

In reference to Kraus' work, Mira Mattar writes that "[e]schewing borders between modes of writing that tend to dictate and bind content, Kraus instead uses her own biography to stitch together a wide range of material, resulting in unconstrained, disobedient texts".[38] Meanwhile, Travis Jeppeson writes: "How, after all, does one go about summing up a sensibility animated by such a ruthless, anarchic deployment of subjectivity? A style marked by an effortless movement across vast strata of subject matter and ideas, whose sole vehicle is the 'I'?"[39] Although in contrast, one could insert a comment from Kraus in an interview where the notion of "subjectivity" arises: "You know I always get so confused when they use that word in art school and there are a few words they love – 'narrative: I will create a narrative' – I will tell a story, right? Something like subjectivity, I mean *what isn't subjective*?"[40]

The following exchange from a 2012 interview with John Jeremiah Sullivan takes up the difficult issue of strategically writing in the first person:

> I sort of had to tame the first person I guess. It's a process of training your ear. You know when you listen to your own voice on a tape it sounds strange? You can't really hear it the way other people hear it. You're trying to do the exact same thing with the first person. You want to hear it the way a disembodied third person observer would hear it. What does it sound like in the larger *scrum* of human communication? You're trying to tune in to that and it takes time. [...] I try to stay on guard toward the first person wanting to be there for it's own sake. It's one of those things. It's good for your writing to have a healthy skepticism of the first person and to want to make it work for its pay. It's like, okay, if you're going to come in here and start talking in the middle of my piece, saying "I" and pretending to be me, then you better be working, you better be taking me somewhere the piece couldn't go.[41]

Sullivan has also commented: "I never *really* feel like I've given myself away, in a piece; the 'first person' isn't you; you're zero. The first person already involves the assertion of a mask".[42]

One of Sullivan's most pointed essays addresses Michael Jackson, the mega-celebrity and innovative musician who has inspired responses from a host of writers:

> On the Internet, you can see a picture of him near the end of his life, juxtaposed with a digital projection of what he would have looked like at the same age without the surgeries and makeup and wigs. A smiling middle-aged black guy, handsome in an everyday way. We are meant, of course, to feel a connection with this lost never-being, and pity for the strange, self-mutilated creature beside him. I can't be alone, however, in feeling just the opposite, that there's something metaphysically revolting about the mock-up. It's an abomination. Michael chose his true face. What is, is natural. His physical body is arguably, even inarguably, the single greatest piece of postmodern American sculpture. It must be carefully preserved.[43]

Sullivan's essay becomes a wide-ranging rumination, far from the average puff piece embalming of the celebrity. Yet one of the most intriguing moments occurs when Sullivan

quotes from an *Ebony* magazine interview in which Jackson himself comments, "Deep inside I feel that this world we live in is really a big, huge, monumental symphonic orchestra. I believe that in its primordial form, all of creation is sound, and that it's not just random sound, that it's music".[44] This insightful statement acts in stark counterpoint to the more sensationalist readings of Jackson.

However, it does become difficult not to consider the madness of celebrity culture when reflecting upon Jackson as myth, as writer Megan Dunn has in her short story envisioning a mime group called "The Michael Jackson Quintet":

> The Michael Jackson Quintet first performed in Rome to an audience of stray cats. The Quintet had painted their faces white, as the mime incorporated several events from MJ's later years, including his death, which the group expressed as a communal convulsion. [...] [T]he Quintet had only two rules. No audience interaction. No mime that does not celebrate the life of Michael Jackson. [...] After staging the dangling of five babies in five hotels in five minutes in five different cities of the globe – the press a frenzy of snapping photographers – and the subsequent imprisonment of the Quintet for five months and their collective fine of well over five thousand dollars – there was public outcry, not to mention the outcry of the babies [...]. Prince Michael Junior II released the following statement to the world media: My family is shocked by the irresponsible behaviour of The Michael Jackson Quintet. My father would have in no way condoned their actions. The Dangling of the Five Babies heralded a difficult period in the Quintet's career. They began to doubt their practice: Are we taking Michael's life too literally? Would he disapprove? Is mime a racially offensive act? Is our work relevant?[45]

Here, in a concise tale, Dunn encapsulates some of the most disturbing aspects of Michael Jackson's fame using an only slightly fantastical extrapolation on actual events. If cultural celebrity now levels the differences between pop stars, television personalities, artists, comedians, and fashion models, it is telling to return to another relevant quote from Will Oldham (cited in the epigraph), who has worked both as an actor and musician:

> I think something that singles me out from a lot of people involved with music is that I would prefer to be a Marx Brother than Mick Jagger if I had my choice. I know that on some level, when you're experiencing say the Marx Brothers or Abbott and Costello or the Little Rascals, or the stand up comedy of Steve Martin or Richard Pryor, the impression is that they're living on the correct plane of existence. Living moment to moment, and very quick with their brains, quick with their voices, or in the case of Harpo Marx, quick with their actions. And also using that speed of thought to turn dark situations into light situations. So they're the ultra wizards of society, because they can conquer the most complex and devastating of issues and turn them into something that's nothing but laughter, really just release the power of those things.[46]

The current chapter, along with its interest in performative experimentation drawn from life experiences, has sought to explore whether we are less in an era of the "dialogic" – as

championed by writers such as Grant Kester in his significant book *Conversation Pieces* (2004) – than the "monologic". How does one make a strong artistic statement without a singular, idiosyncratic commitment to a persona, a distinctive approach? It is fascinating that memorable performers, writers, musicians, and artists have negotiated what it is to be themselves, yet have become something beyond themselves. This necessitates a stance of considerable empathy, vulnerability, and compassion, or else those cultural works will not and cannot connect in any meaningful or resonant ways.

CHAPTER FOUR

Intervals, Moments, and Events:
Performative Tactics and the Reinvention of Public Space[1]

I know that if you work as an artist in public space, there's never total success, just as there's never total failure.

—THOMAS HIRSCHHORN, 2004[2]

Redefining Public Space

Recently, a multitude of artists' endeavours to creatively engage with various configurations of the "public space" have become more aligned with the temporal than the spatial. The virtualization and reconceptualization of a traditional vision of public space – as exemplified by an architectonically designed and structured common, park, square – has allowed for elusive, radically dispersed types of intervals, moments, and events.

Creative projects related to "site-specificity" – as in specifically situated, spatially oriented constructions – have a greater preoccupation with so-called non-spaces and non-sites. The paradoxical inability to pinpoint exact sites of newer public artworks shifts the balance towards floating data, periodic broadcasts, developing occurrences, and a proliferation of documentation. The space between and beyond sites becomes the nowhere, non-existent and the never-to-be-attained.

Thus, a public space becomes reoriented towards a not-quite-here, not easily comprehended nor unified entity. Also notable in certain recent artworks investigating public presentation is the pronounced movement from the grandiose to the more intimate in scale. Art practices rooted in institutional critique now tend to trade in playfulness rather than pontificate, although often seeking to maintain a shrewd approach incorporating multiple angles and vantage points.

Beyond what has been referred to as the performative turn or the experiential turn in contemporary art, many recent art practices have involved an explicitly choreographic turn as artists configure and stage participatory activities. This recalls the era of early Fluxus and happenings, in which dancers, artists, writers, and musicians collaborated on interdisciplinary, event-based artworks.[3] However, such developments might be regarded as muting the force of politically informed and invested creative approaches, as they propose more deliberately ambiguous stances. At times, the amount of direct agency and the impact of certain artists' critique has shifted substantially in the direction of retreat and reflection.

In art historian Miwon Kwon's influential 1997 essay, "One Place After Another: Notes on Site Specificity", she writes:

[T]he deterritorialization of the site has produced liberatory effects, displacing the strictures of fixed place-bound identities with the fluidity of a migratory model, introducing the possibilities for the production of multiple identities, allegiances, and meanings, based not on normative conformities but on the nonrational convergences forged by chance encounters and circumstances.[4]

Almost two decades of creative production since that point has proven Kwon's comments to be both relevant and prescient, as this model for the flow of artistic momentum continues without ceasing.

One can conclude that aspects of our "personhood" and our "place-hood" have been eroding to the point of disappearance for a very long time (particularly if consulting the historic critical writings of such public intellectuals as Herbert Marcuse, Ivan Illich, and Richard Sennett, among others).

The perceptible reinvigoration of performative practice in public settings also coincides with an increase in public spaces that have become more strictly controlled, aesthetically sterile, and eerily depopulated. In reference to the burgeoning amount of private, gated communities under construction in the place of older style public neighbourhoods, the late historian Tony Judt argued:

People who live in private spaces contribute actively to the dilution and corrosion of the public space. In other words, they exacerbate the circumstances which drove them to retreat in the first place. And by doing so, they pay a price.[5]

The anthropologist Marc Augé writes evocatively in his influential 1995 book *Non-Places: Introduction to an Anthropology of Supermodernity*:

If a place can be defined as relational, historical, and concerned with identity, then a space which cannot be defined as relational, or historical, or concerned with identity will be a non-place. The hypothesis advanced here is that supermodernity produces non-places, meaning spaces which are not themselves anthropological places [...] where a dense network of means of transport which are also inhabited spaces are developing; where the habitué of supermarkets, slot machines and credit cards communicates wordlessly, through gestures, with an abstract, unmediated commerce; a world thus surrendered to solitary individuality, to the fleeting, the temporary and ephemeral, offers the anthropologist (and others) a new object, whose unprecedented dimensions might usefully be measured before we start wondering to what sort of gaze it may be amenable.[6]

Along with the above writings, the artistic activities under review here have not occurred in any sort of art critical-theoretical vacuum, but in a period characterized by proliferating commentary and analysis of the state of public practice. Examples would include curator Claire Doherty's interest in art as situations: "Fixed sites, itineraries which offer up works as points on a map and targeted constituencies are becoming redundant for the commissioning of situation-specific artworks because these formats no longer acknowledge the nature

of place as an event-in-progress".[7] Theorist Malcolm Miles also notes, "I find another refusal of the dominant model of cultural production now in collaborative but not only non-gallery projects in which the boundary between art and social process is a site of creative tension, not a dividing line".[8] Artist Mark Hutchinson has proposed a more generative vision:

> [A] public art that potentially transforms itself; transforms its publics, allows itself to be transformed by its publics; and allows these relationships and definitions to be transformed, too. [...] Such art might, then, be hard to see and to judge because it will be transforming what counts as seeing and judging.[9]

Whether temporal and event-based public projects in the cultural field can muster a renewed critical energy remains a difficult factor to determine, particularly without a substantive amount of rethinking and revision.

My goal for this chapter is to consider a variety of examples of artists' projects, actions, and interventions that are illuminating as to how challenges relating to both public/private space and the art/life divide are being addressed and interrogated. Among the diverse range of creative works relevant to this discussion are those of Francis Alÿs, Mark Boulos, Harrell Fletcher, Sharon Hayes, Toby Huddlestone, Maddie Leach, Tino Sehgal, Jane Tsong, and the Yes Men. Significantly, much of this work has occurred relatively recently, actively traverses national borders as a global phenomenon, and corresponds to increasingly interdisciplinary and dispersed approaches to making art.

Choreographed Bodies

A body in a room: that is what Berlin-based artist Tino Sehgal's *Instead of allowing something to rise up to your face dancing bruce and dan and other things* (2000) physically amounts to (the Bruce and Dan referenced here are the influential American artists Nauman and Graham, respectively). A lone androgynous figure in everyday street dress (jeans, sneakers, a cardigan) is slowly inching – one might call it writhing, slinking, or stretching – her way from the centre of the room towards the adjacent wall, and back again. There is a mimetic yet non-specific connection with performance art antecedents, yet the cryptic and lengthy title gives meagre assistance in nailing the particularities of the piece. A creeping, slowly turning dancer occupies the space, which is otherwise empty, but has a large window facing onto the street. Thus, spectators are expected to watch a meticulously choreographed work of live art, which can also be observed by those passing by the exterior of the gallery space.

A review of an exhibition in Germany featuring a different staging of this specific artwork – or "constructed situation" to use the artist's preferred term – comments that "[w]ithout any outspoken political references the work manages to convey a tone that acutely matches current political sentiments. The political content of the work is not so much stressed as transmitted through images of absurdity and despair".[10] The reviewer also mentions that the actor trained to carry out this choreographed piece "seems to be crawling in pain, disturbing one's visit by silently agitating over an unknown cause".[11] In contrast to these comments, it was the spare, slow-paced ambiguity of the artwork that I noticed. Perhaps this interpretation stems from some likely differences between the actions, gestures, and sounds of the

German participant and the one I witnessed in Auckland, New Zealand, but this is difficult to verify, especially as Tino Sehgal explicitly prohibits any official images or videos to be taken to represent his prestigious artworks.

This prohibition has helped to foster the auratic status conferred upon his work. Art historian Caroline A. Jones has noted, "Sehgal's exquisitely careful management of the discourse about his work, marking his as the most intellectual approach within this experiential turn".[12] Arguments can be made for the historicism of the work, its value as critique, and its timeliness. Sehgal plays the roles of ringmaster, prankster, interventionist, and interloper, while simultaneously seeming almost the opposite of these terms. Perhaps it is exactly this ideological slippage in the work that keeps it functioning, along with its novelty and precision. Jones further remarks:

> He does an elegant postmodern end run around the problems of any critique being easily co-opted by the museum and the market: He has the work aggressively acknowledge them both. Neither unprecedented (Andrea Fraser is the extraordinary magus of this maneuver) nor even surprising anymore, Sehgal's foregrounding of the market is nonetheless satisfyingly hilarious, performed in simple scripts (*This Is So Contemporary*, 2004, requires museum guards to sing the work's title and owner) or worked out with participants (*This Is Exchange*, 2003, requires museum staff to discuss market exchange with visitors, who then get a discount on their entry fees).[13]

Sehgal's practice addresses many provocative notions relevant to the current moment: borders between public and private space; documentary and fictional approaches; references to historical precedents; material and immaterial components of a work of art; lived and scripted experiences. Moreover, the work, whether turbulent *or* critical *or* political, offers those potentialities in a calm, mannered, and controlled, indeed choreographed manner. That is not to say that productive tensions are not involved, but it remains unclear what some of those specific productive tensions are and how they might inform us.

Regarding such productive tensions in relation to the surge in art reenactments, art critic Sven Lütticken has noted:

> Re-enactments are to a greater or lesser extent representations of the "original" performances, but many artistic re-enactments try to transcend slavish reproduction and create a difference. Like other performances, re-enactments generate representations in the form of photos and videos. Is the fate of the re-enactment to become an image? And are such representations just part of a spectacle that breeds passivity, or can they in some sense be performative, active?[14]

The Dan Graham piece that Sehgal references involves the artist physically rolling while holding a camera, and the subsequent documentation of that action photographically. Graham's work, which consistently interrogated intersubjectivity via the use of mediations (glass, mirrors, monitors, screens, and architectonic structures), is performatively glossed by Sehgal in this instance, although with the camera eye amputated, blinded, disappeared.

The placing of a body in motion within a room while being watched by others acts as a paradigmatic structuring device of performance art. Although this particular example was presented in about as calm and serene a viewing condition as one might hope for, this was a quieter piece by the artist, as many involve a verbal exchange or series of exclamations. Sehgal takes issue with the characterization of his work as performance, but here we encounter some of the most crucial contradictions underlying his practice: that an artist schooled in dance and economics creates live, staged temporal works he has called "human sculpture", but which closely resemble canonical moments of performance art history.

Thus, a body in a space, under controlled circumstances, which addresses largely art-related questions can be posited in contrast to multiple bodies congregating in the street, under changeable circumstances, rapidly responding with political urgency to current turbulent events. The quietude of the gallery space in Auckland markedly differed from the images one could witness during the same period on the Internet, in newspapers, and on television depicting catastrophic occurrences in such locations as Haiti and Thailand, among others. Critic Marius Babias writes:

> The problematic aspects of art intervention are obvious. Such projects can be charged with communitarianism, being a function of socio-political compensation and moral grandstanding. The often advanced advantage of irregularity, mobility and the value of a political programme, which follows Mao's notion of guerrilla warfare, do stabilise the groups on the inside but can only develop their "revolutionary" forces to a certain degree – and then mostly as single gestures, marginal political improvements, communicative exchange services, object-fixated symbolics, etc. The more fundamental problem is that capitalism, which produces social antagonisms as well as critical art practices, eludes radical transformations by way of co-optation and assimilation.[15]

On a similar note, written half a decade earlier, art historian Francis Frascina concluded his richly detailed study on "aspects of the art left in sixties America" with the following insights:

> [C]ultural and political amnesia enables the United States to police or manage dissent and at the same time to make a few more bucks by encouraging the production of commodities and media spectacles in the market of ideas. This market not only poses little actual threat to capitalism but also provides the system's guardians and cultural commissars with interesting information on what the actual and fantasized oppositions are thinking. For them there is nothing better than to encourage dissent, with its novel forms ripe for commodification, when its more troublesome manifestations are contained and fragmented.[16]

These two quotes address related notions involving the management and containment of artistic endeavours that had previously envisioned and idealized radically different outcomes. This highlights another important set of questions: given the many activist-style tactics imported into art world contexts, and the correspondingly artful tactics of many practitioners often read as activists, where do the differences between these contexts merge? How do they overlap? Do they succeed? Or achieve any of their goals?

Many contemporary artists are enacting and using the derivations of social organizing and historical protests, albeit reframed as artworks. The lengthy list would include Sam Durant, Carsten Höller, Jeremy Deller, Liam Gillick, and Gerard Byrne. (The following chapter will delve more specifically into reenactments in visual culture.) So, in some odd way, it is as if we are offered some bits of documentation of protest as artistic homoeopathic remedies, keeping away large-scale worries with incremental soft cures for our irritating, recurring ailments. "Radicalism" is transformed into aestheticized, sophisticated repetitions and reiterations. Activism, protests, strikes are transformed into the artistic idiom, represented by placards, play-acting, and performative videos. We thus obtain a curated and distanced view of issues, critiques, and worries without the full throttle difficulties and pain of being immersed and involved in the risks of actual activism.

The American writer David Shields proclaims a need for more reality-driven work rather than fantastical narratives. In his collaged text *Reality Hunger* (2010), Shields argues that "every artistic movement from the beginning of time is an attempt to figure out a way to smuggle more of what the artist thinks is reality into the work of art".[17] Shields makes a list of potential characteristics of this movement, and comes up with little groundbreaking material, but cites "a blurring (to the point of invisibility) of any distinction between fiction and nonfiction, the lure and blur of the real".[18]

Often today those involved in the creation of fictions are incorporating more factual material, and those involved in portraying so-called realities – politicians, activists, journalists, essayists – are incorporating more outright fictional material into their depictions. In such cases, live bodies and luminous spectres have become as interchangeable and malleable as the differences and hierarchies between public and private space, and more political or formalist modes of practice. It has been startling and disorientating most recently to encounter the Trump Administration's demonstrably false propositions spun under the rubric "alternative facts".[19]

Increasingly, artists' projects question boundaries and modalities, mixing and mashing them up. Portland, Oregon-based artist and educator Harrell Fletcher often analyses existing cultural texts and social settings via collaborative dialogue with others to forge an entirely new contextual framework. In his work *Blot out the Sun* (2002), Fletcher, in collaboration with Steve MacDougall and the owner of Jay's Quick Gas, Jay Dykman, created a film of Joyce's novel *Ulysses* by having clients and staff of the garage active participants.[20]

Fletcher related the following in an interview with artist Allan McCollum:

> That's what was so fascinating to me about it, that there was this person I hadn't met yet [Jay], but I knew he wanted a film made at his gas station. I got the grant and then I went and talked to him. He said he had been waiting for me to show up for the last 10 years. He wanted it to be filmed there, and screened on this big white wall that's attached to the gas station. I said, "Okay, what should the film be like?" And he said, "It's about all of the things that go on here," because to him the gas station is the center of the universe. And it was just so interesting to me, he's not an artist, he's not a filmmaker, but how many people are there that don't fit into a category? You know, they're not

4.1 Harrell Fletcher, *Blot out the Sun* (2002), 22:13. Video still. Courtesy of the artist.

4.2 Friends Dan and Carmel test the swivel action of Jane Tsong and Robert Powers' *Swivel Chair, Coronado Street, Los Angeles*, from *Comfy City* (2003–06). Alteration of abandoned palm stump with hardware; 40" high. Courtesy of the artists.

98

like the person who wants to make a film. They're the person who wants a film made at their place. What is that? Can you go to school for it? Can you have a career of it? You can't. Most of these things slip through the cracks. And there's all of these people out there who have an idea, but they don't know how to go about it at all. He said the film should be like *Ulysses* by James Joyce. I hadn't read *Ulysses*, so he explained it to me. Later as I was reading the book I decided that I would use the text directly and have the people at the gas station speak the lines. I made postcards announcing the screening before it was actually shot, giving myself three weeks to do it. Then I had to figure out how I was going to make this thing. I wrote cue cards with lines from the book and had the people there read them, which allowed the mechanics to keep working on the cars, and let people who were pulling up for gas, who would only be there for a few minutes, still be in the project. They read their lines and then got a postcard to come to the screening.[21]

Blot out the Sun is disarming with its montaged multiplicity of voices and mini-soliloquies. Though situated in a particular place and time, it is the rapid passage of people through this series of quasi-improvised moments – checking oil, carrying on repairs in and under cars – that lends a vivid energy to this project. Although shot as a fractured documentary and referring to one of the most complex texts of modern literature, the video's everyday atmosphere vacillates between the comic and poignant. Fletcher's work, which could have pursued a number of potential directions from its starting point, highlighted aspects of Joyce's modern text as inspiration, and exemplified social practice in the wake of postmodernism. In his reappraisal of Joyce's novel, literary scholar Declan Kiberd writes:

It is time to reconnect *Ulysses* to the everyday lives of real people. The more snobbish modernists resorted to difficult techniques in order to protect their ideas against appropriation by the newly literate masses; but Joyce foresaw that the real need would be to defend his book and those masses against the newly illiterate specialists and technocratic elites. Whereas other modernists feared the hydra-headed mob, Joyce used interior monologue to show how loveable, complex and affirmative was the mind of the ordinary citizen.[22]

Fletcher's collaborative video project reroutes *Ulysses* into the midst of one of the most ordinary situations imaginable: the automotive garage, with its ever-mysterious, but utterly prosaic, compressed air, gas pumps, and hydraulic lifts.

Another West Coast artist, Jane Tsong investigates social space, both in terms of particular sites but also how those sites might initiate a playful yet incisive form of performative practice. In Tsong's project entitled *Comfy City* (2003–06), a collaboration with Robert Powers, abandoned tree stumps lining the edges of Los Angeles' residential streets were converted by the artists to seats, stools, chairs.

The outcomes are mostly rough-hewn and minimalist, although in a commissioned work carried out in collaboration with local woodcarving artist Miguel Holek in Tijuana, one of Tsong's chairs becomes baroquely configured with customized ornamentation. A 2003 statement by the artists reads:

> Please have a seat. Or make one. Our urban spaces could definitely benefit from more public seating and relaxation. How luxurious it will seem when we are able to rest our feet where we please once in a while. Let us know the location of other stumps in need of improvement. Or for the handy and brave, a chain saw can do the job with two careful cuts. Ask your local tool rental shop for safety tips. Let us make the comfy city ours.[23]

The project involves everyday but overlooked sites which become transformed via artistic intervention. This sets up a context for further performative actions, whether relatively calm (reading, relaxing) or playful (dancing, spinning). It is not about the work having a specific look, but setting into motion a sequence of events. And Tsong, in a not entirely intentional nod to Fluxus instructional works, circulates the notional idea of creating these works in future iterations, which could proliferate without the artist being directly involved at all.

Her interest in creating a circuit of activity relates equally to other analyses via mapping, drawing, documents of water systems, wind patterns, native flora. For example, the *World Savings Bank Proposal* (2001–02) was a study of the patterns of wind within the context of a bland, open corporate plaza in Los Angeles. Instead of analysing the relations between people and the architecture of the space, Tsong used the wind, which was causing a "fountain" effect, and the assorted bits of detritus caught in its paths as "performers", a corporation's façade reduced to its exterior, non-monumental activities involving the randomized trajectories of cups, fast food wrappers, cellophane, and leaves.

Jane Tsong's working methodology exhibits an active, attentive engagement with the reciprocity between art and life, and her investigations of public settings – although whimsical to a point – become deceptively strong political statements. Her project located at the Brightwater Wastewater Treatment Plant in Seattle, Washington (2011) incorporates blessings written by the poet Judith Roche; in doing so, a "grounded" site treating water flow for the region initiates a release of a more immaterial, spiritual sort. Appropriately, Tsong titles her website "myriad small things", representing her focus upon taking things in small, deliberate steps to better investigate the scope of much larger, often overlooked, phenomena.

Narrative Trajectories

New Zealand artist Maddie Leach's works offer an amalgam of seemingly antithetical properties: open to possibilities, yet highly controlled; sparse conceptual frameworks and aesthetically alluring installations; informed and timely, although engaged with historical concepts and materials. In Leach's practice, each new project maintains a disarming quality of appearing from out of nowhere. Yet, given the artist's methodical research, this is far from the case.

In Leach's artworks, the sea or other bodies of water are frequently referenced, either in actuality or as signified through closely related materials, whether boat sheds or ice rinks. This fact also summons another notion: Leach's continuing focus upon the artwork in flux; moreover, in the midst of evoking such fluidity, the artworks exhibit little abandonment of control and internal coherence. As is the case with most New Zealanders, Leach has never lived far from the ocean, beaches, harbours, the shipping industry, ferries, piers. There are

particular features of the topography of any given locale that invariably become implicated in an artist's practice, whether directly manifested or not. Leach's practice has carefully responded to both her local context (often considered peripheral) and how this relates to the broader global community. And Aotearoa New Zealand seems a lot closer to cultural production occurring elsewhere than it once was, with high speed communications and the Internet transforming so many dispersed points of contact into a virtually unified terrain of endlessly streaming data.

Leach has often gravitated toward curious conceits: building a boat from start to finish and having it hoisted atop the Museum of New Zealand Te Papa Tongarewa high above Wellington Harbour (*My Blue Peninsula,* 2006); creating a dance floor in a gallery (*Take Me Down to Your Dance Floor,* 2004); and installing an actual ice rink with a nearby video portraying the passage of a cruise ship (*The Ice Rink and the Lilac Ship,* 2002). What binds these activities is the artist's effort to contain, organize, and merge aspects of the everyday with her own artful versatility. The works demonstrate as much affinity with the language of fables and tall tales as with documentarian modes of social practice. This keeps the viewer guessing, speculating, and the works gain an intensity from a sense of being precariously situated.

More recently, Leach's practice has shifted toward the discursive, immaterial, and occasionally inaccessible. After a long period of engaging with expanded forms of sculpture, the elasticity of the projects has moved into a more conceptual, literary register. Leach's 2014 project entitled *If you find the good oil let us know* culminated in an artist's book after a tangled narrative trajectory.

The project began subsequent to Leach's travel to New Plymouth, New Zealand for the Taranaki Artist-in-Residence programme hosted by the Govett-Brewster Art Gallery, an important contemporary art space. Leach initially sent a letter to a number of people she dubbed "companions":[24]

> I am writing you a letter to invite you to write a letter, a letter that I hope will find its own way to respond to a proposition and a narrative, a project I am about to tell you about. It's kind of a long story. It starts in April of last year when I became the owner of 70 litres of "whale oil" from a quenching tank when the Engineering School closed down at Massey University in Wellington. […] Used for cooling hot metal, it was suspected that the oil had been in the tank since at least the early 1960s when it was apparently still possible to get hold of genuine whale oil and it was commonly sought for quenching processes. Its authenticity was uncertain, and where it came from unknown, but it was plausible.[25]

Notions of authenticity and plausibility receive an exhaustive going over as Leach proceeds to invest much time and creative investment into discussions with not only art world writer-companions (curators, historians, critics, and artists) but a supporting cast comprising ex-whalers, environmental scientists, cement plant managers, industrial transport services, harbour masters, and shipping companies. In the midst of practical world analyses of the content of the oil and various means of disposal, conceptual and discursive analyses ensue from the enlisted correspondents.

4.3 Maddie Leach, *If you find the good oil let us know* (June 25, 2012–February 14, 2014). Installation at Taranaki Artist-in-Residence, Govett-Brewster Art Gallery, New Plymouth, New Zealand. Curated by Mercedes Vicente.

4.4 Maddie Leach, *If you find the good oil let us know* (June 25, 2012–February 14, 2014). Installation at Taranaki Artist-in-Residence, Govett-Brewster Art Gallery, New Plymouth New Zealand. Curated by Mercedes Vicente. Image courtesy of Shaun Waugh.

To realize a project within an intertextual, epistolary framing, Leach extends her habit of dispersing her projects spatially and temporally into other forms of communication with strong anachronistic flavour: the local newspaper, the personal letter, and the letter-press book. Leach opens the parameters of the work into public spaces, as well as the more intimate, writerly spaces of either the meditative or more heated responses. While the Govett-Brewster is a high-end art space once touted by *Artforum* magazine as the best in New Zealand, members of the local populace often maintain a residual hostility toward contemporary art practices perceived as unconventional and potentially alienating.

The incorporation of both the sympathetic and sceptical correspondents allows for an intriguing collection of texts, as Leach decided to include her letters and a few periodic updates to her companions, along with their own letters and those from the community, all published in the local *Taranaki Daily News*. Predictable comparisons to the emperor's new clothes, the taxpayers' burden, and complaints over art snobbery and impenetrable jargon erupted over several weeks on the Letters to the Editor page, as well as the sarcastic phrase, "If you find the good art let us know".[26]

Over the course of the project, Leach investigates how to properly dispose of what turns out to be "70 litres of used mineral oil, a common liquid by-product of the distillation of petroleum from crude oil".[27] The title of her work came from a statement made to the artist by the ex-whaler Peter Perano: "If you find the good oil let us know". Leach became aware of a "'Used Oil Product Stewardship Scheme' in existence in New Zealand run by the Holcim cement plant in Westport where 'the immensely high temperatures reached in firing a cement kiln make the kiln ideal for the environmentally secure disposal of used oil'". [28]

> It's not that the oil becomes cement, rather it is burned with coal to create the conditions to make it. It undergoes a disappearance within the process while supporting the emergence of another material. I have also been unable to depart from the thought that this project needs to go to sea. That something should happen out on the horizon, where there are few witnesses and perhaps only hearsay that something has occurred.[29]

Art historian Peter Brunt notes in his perceptive response:

> I could not help but be struck as well by the way your work brought the culture of scientific expertise into relation with [...] what shall we call it? Religion? The residues of religion? Throughout, your story throws up incidents of believing, hoping, wishing and witnessing. It throws up the idea of the "good oil" and its healing, beneficial, almost miraculous properties. It contains sentiments of stewardship and fidelity; ideas of symbolism, expiatory ritual, secrecy and trust; of the artist as alchemist or storyteller. In another time, in another context, the social potentialities of what is simply believed about a substance could make it the agent of more powerful passions and social effects – more ambiguous and dangerous ones too – than the gentle ironies and self-deprecating humor elicited in you and your collaborators.[30]

Brunt expresses uncertainty concerning the broader significance of Leach's efforts:

> On the one hand, there seemed to be nothing much at stake, no world-transforming idea, no attempt to marshall those propensities it tapped into, and which are so tamed in so many of us. On the other hand, what could be more important to the human family and the planet, or more basic to the reality we have constructed around us as a civilization than mineral oil?[31]

Brunt is not the only interlocutor to articulate the ambiguities, contradictions, and paradoxes around Leach's evocative project. As art historian Gregory Minissale later noted:

> Leach's work suggests a system of belief in something that is not visible or tangible, removed from site/sight and known only through tales and relics. This could be the mythic power of the whale, the sea and the recycled energies of lost monuments, or it could be the enduring power of the imagination that causes all these things to move.[32]

Ultimately, the audience was offered photographic "proof" of a concrete block dropped from a ship into the water. But this act seemed inconclusive somehow, evidence of a materially weighted but highly performative action, which was incapable of foreclosing the many questions, whether aesthetic, conceptual, or political, surrounding Leach's self-described "speculative narrative".

When we witness larger-scale politicized agendas responded to via the artistic process, it is often as if such agendas recede farther from us in terms of significance, although we are reassured by our participation by proxy. Many so-called political artworks simply proclaim rather anodyne liberal bourgeois sloganeering, becoming an echo chamber for existing surreal political events, bringing to mind also the committed artists and writers who separated their art and political endeavours (the painter Ad Reinhardt being a historic case in point).

But of particular interest is the way some artworks call attention to their potential to fail both as artworks and in terms of political agency. A 2007 work by artist Sharon Hayes appropriates its title from a sixties-era protest sign: *Everything Else Has Failed! Don't You Think It's Time for Love?* (2007).

Here, Hayes performs a spoken monologue into a handheld microphone while standing in midtown Manhattan (6th Avenue and 51st Street) at midday.

Hayes begins:

> *My dear love, my sweet lover* [an address to an intimate audience of one.]

> *I am shaking a bit. I'm not sure exactly how to begin.* [A tentative beginning.]

> *I'm worried that my letters are not getting to you or that yours are not getting to me.* [Again alluding to some interpersonal conflict, yet then Hayes continues.]

4.5 Sharon Hayes, *Everything Else Has Failed! Don't You Think It's Time for Love?* (2007). Audio installation (PA system, five speakers) and five spray paint works on paper. Courtesy of the artist and Tanya Leighton, Berlin.

4.6 Sharon Hayes, *Everything Else Has Failed! Don't You Think It's Time for Love?* (2007). Audio installation (PA system, five speakers) and five spray paint works on paper. Courtesy of the artist and Tanya Leighton, Berlin.

I don't know what's happening and it's making me particularly anxious. [Here this statement opens up a wider variety of readings: we, who are listening to or watching her performance, are likely anxious as well. Is Hayes' anxiety about a fraught personal relationship or a corrosive political situation?]

I was trying to see the war as a measure of time but I got lost. I remember the last phone call was before the U.S. started arming Sunni insurgents. And it was before Bush said U.S. troops would stay in Iraq like they stayed in Korea. [Thus a radical shift occurs as Hayes warps, weaves, meshes and intermingles personal/political contexts of her narrative.]

I am standing and people are passing behind and in front of me I look at them and find traces of you. [Suddenly emphasis changes toward Hayes' immediate surroundings, and she refers to them directly.]

Or that guy with one lip that's slightly redder than the other, although his is his bottom lip and yours your top. [...] You're in all these strangers. But I don't have any new words to say to you. I'm suspended between silence and repetition. I can say nothing or I can repeat. [Again another turn, Hayes adopts a more defiant, emphatic tone, such as that of a political address.]

My truth is I am a gay American. This is an intensely personal decision, not one typically meant for the public domain. [Proceeding towards her conclusion]

I march in the parade of freedom but as long as I love you, I am not free. [...] I love you. I love you. There's no more to say. Be safe my love. [End]

When interviewed, Hayes spoke about her approach and its tangled interrelations between past and present, event and documentation:

One of the lines that repeats in almost all of the texts is the line, "I know that the ears are the only orifice that can't be closed." Impacted largely, I believe, by my generational formation, I am unwilling to let go of hope. But I'm also not able to embrace it. Neither hopeful nor hopeless, I throw, literally project, words out into the space of the public. Like thousands of people have done before me, and like thousands of people will do after me. In the narrative of the text, it is in the hope that somehow my words will find their way to my lover. But in the works' reverberations, the hope is that somehow the words will find their way to a body public, to a body of people, that they might somehow find their way to political meaning or significance. It is not a commentary on the promise and limitation of political demonstrations today, it is, hopefully, a demonstration that makes the desires and disappointments that are provoked by such promises and/or limitations more transparent. It is a piece that, somewhat simply and sincerely, attempts to work in the space of emotion by trying to find precise intersections between desire, politics, and war.[33]

Artist Toby Huddlestone has questioned the efficacy of old style protests.

If, for example, you could have the largest one-day demonstration in history on the eve of the Iraq War, which made virtually no impact on the governmental decision-making process,

4.7 Toby Huddlestone, *Protest Apathy* (June 27, 2009). Apathetic demonstration held in Trafalgar Square, London. Courtesy of the artist.

what's next? In a series of "lecture apathy" talks and "apathy protests" he acutely satirized an era of disaffection. In such events, notably one taking place in July 2009 at Trafalgar Square, Huddlestone distributed a number of broadsheet newspaper-sized signs emblazoned with the following slogans: "CARRY ON", "NO REASON TO MOAN", "EVERYTHING IS OK", "NOTHING TO COMPLAIN ABOUT", "IT'S NOT WORTH IT", "NOTHING WRONG", "IT'S ALL FINE", "SAY YES TO EVERYTHING".

Huddlestone has commented:

> A lot is being discussed of temporal space as public space at the moment and has been for quite some time now – while this interests me I'm actually more interested in psychological space as public space, as it's inherently more political. [...] [T]his very much informed *Protest Apathy* – the idea of offering the apathetic banners [...] to offer a new psyche to those present in the square on the day. Very simply, I wanted to invent and create a protest that could not be nullified by the authorities by seemingly suggesting that "everything is OK" and that there is "nothing to complain about" – puncturing the bubble from the inside rather than being overtly in opposition to authority, which simply does not work anymore (and hasn't worked since the mid-90s). The sarcasm was obvious through the people proclaiming their apathy on the day – everyone knows everything is NOT OK and that there are one million things to complain about.[34]

In his performance *Lecture Apathy* (2009), Huddlestone offers a comically accelerated and condensed "history of disobedience and dissent", an itinerary incorporating the Cuban revolution, Vietnam War protests, civil rights demonstrations, counterculture, Beats, hippies, punks ("the Sex Pistols and a whole bunch of copycat wankers after them"), the miners' strikes and the collapse of the Berlin Wall:

> This is New Labour, this is new labour Bono [...] Geldof shit! [...] subsumed! [...] Reality TV! The whole fucking country subsumed! The largest organized protest the world has ever seen *ever*. Did they work? We need a new line of attack! [...] Sarcasm. Massive. Everything is *not* OK. Be non-specific, be non-compliant, be non-political. There are too many things to protest about so protest about nothing but still protest. Protest something that cannot be subsumed by the machine. [...] *VIVA APATHY!*[35]

Mixing send-up and pointed critique, Huddlestone's comic timing makes this satire move along briskly, perched on the edge of the media-drenched abyss. Ironically, at the same moment that Huddlestone was generating these projects, the Occupy Movement and events of the Arab Spring were just emerging with undeniable impact.

Détourned Documentary

Projects by artists Francis Alÿs and Mark Boulos both involve video recordings and a personalized approach that takes the documentary form as its point of departure, but culminates in outcomes that defy rigid categorization. New discursive "sites", in the form of video installations, emerge from the artists' engagement with their specific contextual endeavours. We could say that these artists, along with the tactical pranksters the

4.8 Mark Boulos, *All That Is Solid Melts into Air* (2008). 2-channel installation, HDV, colour, sound, 14' 20". © Mark Boulos. Courtesy of Stigter Van Doesburg, Amsterdam.

4.9 Francis Alÿs, *The Green Line*, Jerusalem (2004). In collaboration with Julien Devaux. Video documentation of an action. Image: Rachel Leah Jones. Courtesy of the artist.

Yes Men collective, have enacted a *détournement* of classic documentary approach, to reroute or hijack aspects of documentary for their own, more idiosyncratic purposes. (*Détournement* being a term once used by the International Situationist movement during the 1960s and onwards.)

Mark Boulos' *All That Is Solid Melts into Air* (2008) consists of dual screens onto which are projected conflicting but intertwined vignettes of global capitalism played out over the course of a compressed and harrowing quarter of an hour (although looping in a continuous cycle).

Futures traders yell and gesticulate madly on one screen, as masked citizens of the Niger delta chant on the other, livid at the fact that their "wealth" is syphoned off by big petroleum companies who leave the region demoralized and impoverished. Of the former, Boulos commented:

> The shouting traders are buying and selling these complex financial products called futures and derivatives. And I like the term "futures": the money doesn't exist yet, the commodity doesn't exist yet, nothing exists yet. To me, it symbolizes the metaphysics of capitalism. The average liberal critique of capitalism is that it's too materialistic, and the Marxist critique is that it's not materialistic enough. Rather, it's metaphysics with a very tenuous relation to reality, which is precisely why it will collapse.[36]

The Nigerians shown in the video are participants in MEND (The Movement for the Emancipation of the Niger Delta), a militant organization that dedicates itself toward fighting the highly exploitative multinational oil companies located in the region. Boulos continues, "I'm interviewing two fighters, who are explaining their relation to the War God Egbisu, who protects them and makes them bullet proof in battles. Here, the religious beliefs make the revolution possible".[37]

Boulos' background experience as a documentarian has included work with the long-standing collective of grassroots video-makers Paper Tiger Television. Writer/artist Jesse Drew writes of PTTV:

> The Paper Tiger collective evolved along with these multitudes of video organizations, moving beyond media criticism, away from reacting to the culture industry, toward determining its own agenda, its own aesthetics, its own relationship to technology. By the 1990s, The Paper Tiger collective had made some several hundred video programs, on a wide range of both social and artistic subjects, that sought to illuminate what was ignored by the culture industry. They did so with the now standard PTTV approach – a sense of humor and a decidedly low-tech DIY sensibility.[38]

An intriguing facet of Boulos' work is the notion of an individual artist making use of "collectivist" tactics out in the field and bringing work back to the gallery. If this might appear a problematic ethnographic procedure, it *is* problematic, but responds in interesting ways to these issues by configuring novel aesthetic presentations and initiating discussions concerning its often jarringly different component parts.

Shortly after the above work was completed, Boulos spent time living in the Philippine jungle to record *No Permanent Address* (2010), a project on the New People's Army, an armed Maoist group considered terrorists by the US and the EU.[39] As Boulos writes, "They live nomadically, camping in the spaces between coconut fields in the semi-feudal countryside, moving every night to evade the military, always protected by their peasant hosts".[40] Although Boulos uses a documentarian's tactics, he also revises his approach very intentionally:

> I'm trying to develop an anti-journalistic documentary, basically anti-empirical, I'm starting from a philosophical point that's not empiricist but phenomenological [...] taking a bunch of different phenomena compositing them into something that looks real and then pulling them apart to show that it's a construction.[41]

Francis Alÿs' *Sometimes Doing Something Poetic Can Become Political and Sometimes Doing Something Political Can Become Poetic* (2004) (also known as *The Green Line*) attempts to circumvent some of the liabilities of politicized practice by varying its strategies, perspectives, and modes of address.

The focal point of the project was a video that recorded Alÿs reenacting a work from 1995 called *The Leak*, in which the artist walked while a line of blue paint dripped from a can he carried. The original work operated as a meta-commentary on painting and individual identity, generally read as "poetic".

By dripping this now green leak almost ten years later in a manner referencing wider historical narratives, Alÿs' artwork became reinvigorated by different connotations and transformed once again. The historical material in question is the carving up of Palestine in 1948 via a green line sketched with General Moshe Dayan's pencil. Beyond Alÿs' orchestrated spilling of 58 litres of paint over the course of a 24 kilometre-long walk, he later spoke with various activists, intellectuals, and officials as they watched excerpts from his documentary footage. Alÿs conducted his interviews in a format loosely resembling that of a working journalist.

Rima Hammami, an anthropologist from Birzeit University in Jerusalem, responds to a query from Alÿs concerning whether cultural actions – be they artistic or poetic – can counter pragmatic situations:

> Definitely, and it probably has more roles than you are conceiving. For Palestinians, anybody who comes and wants to look is already doing a great service. Anybody who wants to come and see beyond what they are supposed to see and what they are supposed to know is extremely important for us. And, also, the way other people see, that what you're doing is not such a violent, dominant, regular way of representing what's happening. It's also really wonderful because sometimes we get locked into how we see. [...] So it's also really wonderful to have somebody coming who is not coming to aggressively say who we are, or what things are, but is making an empathic act, and at the same time is pushing us to maybe see things or to think about doing things in different types of ways. [...] Sometimes it just seems like it's such a powerful closed box,

and no one can speak to it, and nobody can shake it, and nobody can even make a hole in it, and so a poetic act is a very powerful thing to do in that context, because it says, "I refuse to serve the dominant ways of doing things".[42]

Such considered and measured comments are integral to the effect of Alÿs' work, and enact a view of the potentialities within public projects more generally when addressed from varied perspectives.

For the 2005 Whitney Biennial exhibition entitled *Day for Night*, artist Rirkrit Tiravanija sought the collaboration of veteran sculptor Mark Di Suvero to remake a version of the Peace Tower, created decades ago by artists in Los Angeles as an act of protest against the Vietnam War. The work seemed apt in its timing just two winters into the Iraq War, which was escalating in its horror and increasingly compared to Vietnam. Many artists contributed to the re-visioning of the earlier piece, but it failed to generate much energy in its siting in the outer terrace of the museum, and its effort to revise the caustic and timely critique of the earlier piece seemed ineffectual. The pointed interventionism of the 1966 version was now displaced and thwarted by the intervening time in between, as the *now* had a very difficult time catching up with the *then*.

A more striking intervention occurred on November 12, 2008, when over a million copies of a mock *New York Times* were freely distributed in a handful of cities spread across the United States. The fourteen-page newspaper had been created and planned over the course of eight months leading up to that date by the Yes Men, a collaborative group featured in several widely circulated documentary films. The newspaper featured a bold headline proclaiming, "IRAQ WAR ENDS".[43] Several years later, the announcement of the end of US "combat operations" and acknowledgement that the war in Afghanistan lasted longer than the Vietnam War further sharpened in retrospect the Yes Men's decision to distribute their paper in November of that general election year. The collective urged President-elect Barack Obama to make good on his promises. As they said at the time, "[t]his was about showing people how much change we really want".

The Yes Men's action recalls the following quote from Guy Debord's *Society of the Spectacle* (1983): "Ideas improve. The meaning of words participates in the improvement. Plagiarism is necessary. Progress implies it. It embraces an author's phrase, makes use of his expressions, erases a false idea, and replaces it with the right idea".[44] Yes Man "Mike Bonanno" offers a similar perspective on the group's notion of "identity correction": "We target people we see as criminals and try to steal their identity to try and make them more honest. We are trying to create public spectacles that in some kind of poetic way reveal something that's profoundly a problem".[45]

It is telling that Bonanno and fellow Yes Man "Andy Bichlbaum" previously worked on interactive video games, and became known in small circles for their Situationist-style *détournements* of existing media products, whether video games or children's dolls.[46] The impulse behind these efforts appears as indebted to surrealism as social activism, and this theme has carried through many of their projects, initially as the collective RTMark and later as the Yes Men.

4.10 The Yes Men, *The Yes Men Fix the World* (2009). Dir: Andy Bichlbaum and Mike Bonanno. 87 mins. Courtesy the Yes Men.

The Yes Men's projects have often been "unveiled" with their careful use of tactical media, such as press conferences, the mock newspaper, and the televised interview of "official" spokespeople (most often "Andy" using an assortment of different outlandish surnames and outfits).

These intermittent broadcasts are like a seam that becomes apparent to the discerning eye when examining the fabric of the mainstream media. In addition, the Yes Men have contributed "real" editorial commentary to "real" newspapers, as in their 2009 statement in the *Washington Post*: "We are the Yes Men, two guys who dress up as powerful businessmen, propose horrible things to audiences of actual powerful businesspeople and film them cheerfully applauding our most outrageous – and often illegal – ideas".[47] News channels seeking continuous material to feed through their cycles of bulletins, profiles, and updates have – in ironic fashion – assisted the Yes Men, both in terms of placing them within the context of the "talking heads" style discussion and later stories that reveal the earlier hoaxes. To this end, the Yes Men have become skilled in choreographing media outlets to their advantage.

A major factor plaguing much art with an ostensibly politicized or activist slant is its relative impotence in the face of the overwhelming onslaught of government-sponsored and corporate media. If culture jamming was an approach emergent in the 1980s and 1990s, it remains unclear how versions of such activities can occur today with efficacy. Especially with the massive amounts of previously classified documents leaked into the public sphere over the past decade, access to politically charged material has increased, and it is up to the informed artist whether to bring that material into the scope of their practice. It becomes less a case of directing people's attention to the context we are in than what might be done to creatively respond to all this data, all this material, in the face of networked, fluid yet hegemonic power structures. Theorist Chantal Mouffe has noted that:

> I do not see the relation between art and politics in terms of two separately constituted fields, art on one side and politics on the other, between which a relation need be established. There is an aesthetic dimension in the political and there is a political dimension in art. From the point of view of the theory of hegemony, artistic practices play a role in the constitution and maintenance of a given symbolic order, or in its challenging, and this is why they necessarily have a political dimension. The political, for its part, concerns the symbolic ordering of social relations, and this is where its aesthetic dimension resides. This is why I believe that it is not useful to make a distinction between political and non-political art. Instead, the crucial question concerns the possible forms of critical art. According to the approach that I am advocating, this means examining the different ways in which artistic practices can contribute to unsettling the dominant hegemony.[48]

Despite a climate of heightened self-consciousness and ongoing information flows, it is constantly challenging to figure out revised frameworks for the success or failure of artworks with a commitment toward public intervention, whether coming from the activist/protest angle or the art/performance direction. This requires a nimble and constantly reevaluated scale of queries concerning the changing shape of ongoing performative practices, methods, targets, and, perhaps most importantly, desires. (Chapter 6 will take up some further responses to the broad notion of "social practice" and will discuss more of these issues.)

Current temporary, ephemeral, and non-categorizable artworks ultimately gain much of their form and meaning via their encounter and intersection with the public. This act of encounter is a manifold act of becoming, the viewer becoming aware and cognizant of the work's presence as the work becomes itself, takes shape, materializes; to return to Duchamp's phrase: "The spectator makes the picture".[49] However, it becomes exceedingly difficult in the early twenty-first century to determine what a first-hand encounter with a work of art actually is.

We are now more likely to witness fragmentary evidence – often in digital form – of all that we scrutinize closely, whether as spectators, researchers, or enthusiasts. Such evidence is likely to have been further mediated by a variety of filters, networks, interfaces, and screens in advance of our initial encounter. It can seem disturbing to realize that we are encountering echoes – and distorted ones – just as we try to reassure ourselves that we are on the threshold of new forms of experience.

To *re*encounter both recent and historical works today presents a challenge, as we reread and re-view their residual forms to resuscitate them from their documentary status into some direct relation to our own lived experience. But so it goes: novelty hand in hand with the past, as younger artists enact an ongoing dialogue with the history of temporal practices, which call into question received notions of the object-/image-based work's status in favour of the artwork seen as a process, an event, an encounter. What is most pressing today is the self-conscious yet generative nature of this dialogue, raising the hope that artists will thread provocative aspects of their encounters with the world into the complex fabric of their works so as to not continually describe that which already exists, but that which we yearn to experience, as our encounters continue to unfold before us.

Artists are reinventing and reconfiguring their approaches to the public arena, space, sphere, even as they are thwarted in defining what such "publicness" exactly consists of; currently, it might be located in the mirage-like confines of avatars, blogs, streaming video, virtual chats, or social networking sites, all of which are increasingly featured in hybridized ways in many artworks. As a related evacuation of more tangible public spaces occurs, a primary challenge to be addressed by artists is how to orient new senses of structure within a context of "placelessness". Examining the present moment seems not unlike describing a waking dream-state, in which many eclectic aspects of fact and fiction, life and art, novelty and reiteration maintain a precarious but productive coexistence.

CHAPTER FIVE

Reenactments, Remixing, and Restaging the Contemporary

It is only the unimaginative who ever invents. The true artist is known by the use he makes of what he annexes, and he annexes everything.

—OSCAR WILDE, 1885[1]

Art's filthy lesson is inauthenticity all the way down, a series of repetitions and reenactments: fakes that strip away the illusion of reality in which we live and confront us with the reality of illusion.

—SIMON CRITCHLEY, 2016[2]

They are floating around us, ubiquitous: cultural materials that are shared, archived, and commented upon. The social networking environment brings notions of sampling and covering, appropriation and citation, collage and assemblage into a more familiar arena; the initial discomfort and radical disjuncture of avant-garde procedures and strategies has now morphed into our everyday forays into the digital environment. Contemporary conditions have propelled us far from historical patterns, revealing a new, unpredictably shifting set of situations.

The reconfiguration, revision, and reenactment of existing artistic materials has become widespread, and upon reflection, profoundly significant. Living in an era of simultaneous ahistorical amnesia and continual re-excavation of the past becomes a brutally confounding experience. If the remixed and hybridized seems more familiar to today's viewer than the ostensibly whole, unified, and cohesive, this actively disrupts long-standing assumptions of originality and authorship. Although this could be regarded as an after-effect of "the post-modern condition", I would submit that many key aspects of postmodernism are still with us.

In order to better contextualize our present moment of memes, mash-ups, and other manipulated data, I will discuss in this chapter a variety of artists' projects involving the reenactment, re-presentation, and reworking of existing artworks, along with other cultural production. Among these examples are the performative events and works of artists Ant Farm and T. R. Uthco, Tania Bruguera, Iain Forsyth and Jane Pollard, Our Literal Speed, Sturtevant, Shannon Te Ao, Dick Whyte, filmmaker Charlie Kaufman, and novelist Tom McCarthy.

One recurring factor of reenactments is that more elements are transformed than remain closely allied to the original source material. There is also – bearing in mind my comments in Chapter 3 – something comedic about the repetitive iterations involved in the artist re-make. This occurs in multiple ways: from a more aged protagonist taking on the same action that might seem unintentionally nonsensical or ludicrous; or the atmosphere of an in-joke for those unaware of its context and complicated backstory. With the reassembling of pop bands some decades later, as in the case of groups from the sixties or seventies – now in their sixties or seventies themselves – the marketing of such reunion gigs tends to show archival images or a memorable logo rather than a portrait of greying musicians.

Critic Simon Reynolds asserts that the recent history of music consumption revolves around our obsessiveness with the past, or what he terms "retromania", to a certain extent at the expense of the active reception of the emergent, different, and unexpected.[3] Whether or not this phenomenon is beneficial or not, one can be assured that from live performances and recordings to museum and gallery exhibitions, television, and cinematic fare, what is older will almost inevitably be resuscitated to become "new-ish" again.

The performance scholar Rebecca Schneider insightfully states:

> Reenactment troubles linear temporality by offering at least the suggestion of recur-
> rence, or return, even if the practice is peppered with its own ongoing incompletion.
> There is a pointedly temporal aspect to the term unlike other terms for doubling that
> do not overtly accentuate time, such as mimesis, imitation, appropriation, citation, re-
> iteration, performativity. Perhaps only the term "theatricality," through its nominal link-
> age to the widely varied practices of theatre – a famously time-based art of the live –
> carries within it a suggestion of the temporal. […] To trouble linear temporality – to sug-
> gest that time may be touched, crossed, visited or revisited, that time is transitive and
> flexible, that time may recur in time, that time is not one – never only one – is to court
> the ancient (and tired) Western anxiety over ideality and originality. The threat of the-
> atricality is still the threat of the imposter status of the copy, the double, the mimetic,
> the second, the surrogate, the feminine, or the queer.[4]

In relation to the preceding chapter's discussion of public interventions and the temporal overwhelming the spatial, this chapter addresses further implications of foregrounding temporality as a zone of investigation where many cultural practices intersect and engage with liveness and the virtual, memory and the mimetic.

Narratives of Reenactment

In British writer Tom McCarthy's alternately gripping and frustrating novel *Remainder* (2005), an unnamed narrator recounts a tale that unfolds after his being involved in an "accident" which "involved something falling from the sky. Technology. Parts, bits".[5] Aside from the fact that the protagonist seems unclear about any details due to trauma-induced amnesia, he signs a non-disclosure agreement in return for £8.5 million. Despite this situation, he remains directionless:

> I'd been out of hospital for four months, out of physiotherapy for one. I was living on my
> own on the edge of Brixton, in a one-bedroom flat. I wasn't working. […] I didn't feel like
> going back to work. I didn't feel like doing anything. I wasn't doing anything. I passed
> my days in the most routine of activities: getting up and washing, walking to the shops
> and back again, reading the papers, sitting in my flat. Sometimes I watched TV, but not
> much; even that seemed too proactive. […] Mostly I just sat in my flat, doing nothing. I
> was thirty years old.[6]

Beyond this were new, disorienting considerations, involving intensive physical therapy to choosing an investment portfolio:

Everybody bored me. Everything too. I'd spent the days since my meeting with Matthew Younger pondering what to do with the money. I'd run through all the options: world travel, setting up a business of my own, founding a charitable trust, splurging it all. None of them appealed to me in the least. What kind of charitable trust would I have founded? I didn't feel strongly about any issues. If I went out on a mad spending spree, what would I buy? I wasn't interested in art, clothes, or drugs.[7]

An unexpected epiphany occurs, however, when McCarthy's protagonist attends a party, then sees a crack in the plaster of the bathroom wall, and becomes subject to "a sudden sense of déjà vu"[8]. He undergoes, in a Proustian manner, a rapid wave of associations:

Most of all I remembered this: that inside this remembered building, in the rooms and on the staircase, in the lobby and the large courtyard between it and the building facing with the red roofs with black cats on them – that in these spaces, all my movements had been fluent and unforced. Not awkward, acquired, secondhand, but natural. [...] Right then I knew exactly what I wanted to do with my money. I wanted to reconstruct that space and enter it so that I could feel real again.[9]

The protagonist then hires a personal assistant and a large cast of supporting characters to realize his very difficult-to-communicate "vision"; a reenvisioning of a space accurately remembered but without clear directions for how to reenact this vision. The process of searching for an as yet unseen target, however, is not unlike the early, hunch-driven but urgent stages of so many art projects, albeit with nearly unlimited funding. From buying a block of flats to hiring actors and making models of "sites", the scenario becomes increasingly creepy and macabre, particularly as the reenactments include restaged shootings and robberies, and the post-traumatic stress the protagonist has endured resurfaces with a vengeance.

McCarthy's *Remainder* is an extended, allegorical parable of the art-making and remaking process, and it becomes particularly astute in terms of how the iterative process of things recalled, recreated, and generated anew attracts and confounds artists. McCarthy's background research was wide-ranging and eclectic:

With *Remainder* I was reading Pierre Janet and Bergson on duration, and some positivist psychologists on trauma, and thinking of J. G. Ballard and Sterne (Uncle Toby's endless reconstructions of his trauma scene in *Tristram Shandy*). It all seemed to merge into this plane of consistency whose iteration was the novel I was writing.[10]

It probably isn't surprising that McCarthy has been involved in art collectives and written essays on related topics, and has stated, "I'm a writer through and through, but the art world – to a large extent – provides the arena in which literature can be vigorously addressed, transformed, and expanded".[11] In his short text *Transmission and the Individual Remix: How Literature Works* (2012), McCarthy argues that:

If literature, on the other hand, is to do anything worthwhile (and I don't mean socially or even philosophically worthwhile; I mean truly and profoundly useless in a way so

powerful it devalues use itself) – if it's to be worth the paper or the screen it's written on, it needs to appreciate its own interruptedness, its disarticulation; to understand its own embedding within media, and mediation; to understand that media's own history is always and automatically at play in it, the shift from one-to-one to one-to-many to many-to-many networks in which sender and addressee are simultaneously masked and multiplied; to understand that it not only broadcasts, but is subject to the logic of broadcasting (of dissemination) – and to embed this understanding too, and broadcast it again, regressively.[12]

McCarthy characterizes writers not as originating speakers, but obsessive listeners, and describes the role of the author as "[a] receiver, modulator, transmitter: a remixer".[13]

Screenwriter and director Charlie Kaufman's film *Synecdoche, New York* (2008), presents some intriguing affinities with McCarthy's *Remainder*.

The film follows the daily life and creative struggles of Caden Cotard (played by the late Philip Seymour Hoffman), a director of regional theatre in Schenectady, New York. His life is unfulfilling, and time appears to be passing extraordinarily quickly (from one day to the next, the newspaper changes from September 22–October 17), and he begins to exhibit symptoms of an undefined illness. The actual Cotard's Syndrome "comprises any one of a series of delusions that range from a belief that one has lost organs, blood, or body parts to insisting that one has lost one's soul or is dead".[14]

After increasing calamities and depressing circumstances – although the film is sharply written by Kaufman, filmed with nuanced expertise by cinematographer Fred Elmes, and expressively acted by an outstanding cast – Cotard unexpectedly receives a MacArthur Foundation award, enabling him to take on a more ambitious, large-scale project. His therapist, Madeleine (Hope Davis), a media-savvy writer of self-help books, asks him:

Madeleine: "Do you know what you're going to do with it?"

Caden: "A theatre piece. Something big and true and tough. Y'know finally put my real self into something".

Madeleine: "Oh, Caden, what is your real self, do you think?"

Caden "I don't know yet. The MacArthur is called 'the genius grant'. And I want to earn it".

Madeleine: "That's wonderful. God bless! I guess you'll have to discover your real self, right?"

But very little leads the viewer to believe there are any real selves anywhere, as a host of *doppelgängers* pile up, chiefly those performing Caden and his unrequited love Hazel, his otherwise loyal assistant. Cotard creates a large hangar-like warehouse space, and subsequently two others within its confines, and he works and reworks for decades scenes from

5.1 Still from *Synecdoche, New York* (2008), 124 mins. Dir and written: Charlie Kaufman. Sony Pictures Classics. Actors Philip Seymour Hoffman and Michelle Williams.

5.2 Still from *Synecdoche, New York* (2008), 124 mins. Dir and written: Charlie Kaufman. Sony Pictures Classics. Actors Emily Watson, Samantha Morton, Philip Seymour Hoffman, and Tom Noonan.

his own life, within a surreal landscape reminiscent of a triage encampment during a natural disaster or human rights crisis. Cotard persists in making directives and motivational speeches to his assembled set of actors, even as one demands, "Caden, when are we going to get an audience? It's been seventeen years!"

Near the end of the film, an elderly Caden receives instructions through an earpiece from Ellen (Dianne Wiest) who has recently taken on Caden's directorial role in his life/play continuum, and she states: "This is everyone's experience. Every single one. The specifics hardly matter. Everyone is everyone". This is the ultimate conflation of selves as the reverberations accumulate in a densely-packed film; the atmosphere on-screen is claustrophobic visually, yet expansive in terms of philosophical notions to explore. As Kaufman has remarked:

> I think that people create the world that they live in. Your existence is very subjective, and you tell stories and organize the world outside of you into these stories to help you understand it. I don't think the world objectively exists the way we think it exists, you know? There's a constant sort of storytelling process.[15]

Synecdoche, New York is a dark and rather uninviting film, off-putting to many. Critical responses were unenthusiastic, with the late Roger Ebert one of its few major proponents. Even in a rare favourable assessment, *The Observer*'s Philip French deemed it "at various times intriguing, funny, disturbing, eerie and occasionally irritating".[16] Stuart Klavans of *The Nation* reported that one of three audience members left during his screening,[17] and Gavin Smith in *Film Comment* reported that reviewers at the Cannes Film Festival had little patience for such a seemingly indulgent tale.[18] However, *Synecdoche, New York*, much like McCarthy's *Remainder*, is an essential work for the early twenty-first century, as it considers life, mortality, and the fragility of the artist with great subtlety, conveying, as Kaufman aptly sought, a dreamlike logic to be applied to the real world.

The Sturtevant Case

Perhaps it is not so much my own goal to continue emphasizing the point that has been made (almost ad infinitum since the emergence of postmodernism) regarding the "unoriginal" traits of so many works of art, but how such works function not only conceptually and intertextually, but as a social and philosophically invested process across a range of existing cultural phenomena. What might we continue to learn from countless acts of hybridity and destabilization of singularity in terms of both artwork and artist?

Street photographer Garry Winogrand once commented, "[t]here is nothing as mysterious as a fact clearly described".[19] And while addressing his own particular subjective approach to documentary-style work, I recall his words in examining the practice of artist [Elaine] Sturtevant (1930–2014).

Her works involved copious renderings of a range of existing artworks by other (mostly canonical or prestigious) artists. In so doing, there is a flat clarity of description summoning the mysterious quality of which Winogrand spoke. Does it make it easier or more difficult to approach a Duchamp, Warhol, or Beuys that is not one? Which in turn is a Sturtevant? And

5.3 Sturtevant, *Warhol Licorice Marilyn* (2004). Synthetic polymer and acrylic on canvas 40.5 x 34 cm. Private collection, Belgium.

who was Sturtevant? This is a question that can transport viewers of her artworks, despite themselves, into a philosophical vortex surrounding the politics of authorship. No less so (and arguably much more) than the appropriation artist Sherrie Levine, the artist upends many assumptions regarding art practice.

Rather than visually seducing, Sturtevant's works intellectually confront... No, that is not it. They do both. By summoning ghost images of existing contemporary artworks, they trap viewers into a bewildering network of questions. There is no linear trajectory to be either critically or conceptually elicited directly from these works. They spawn a fine mess of messy meanings. Sturtevant's contradictory works are disruptive of tidy expectations, and would not be as compelling otherwise. Each work generates a range of worries over what it is doing, belying an utterly flawed but resilient notion that an appropriationist tactic (although she did not ally herself with appropriation art) is somehow simple or simplistic.

Sturtevant has made charged, vivid statements in the process of contextualizing her work: "My work terrifies people, and part of that is the power, and that power comes from intention, it is not something you can swallow and say, 'now I understand'".[20] The distinctions the artist makes between origin and originality are provocative: "The appropriationists were really about the loss of originality and I was about the power of thought. A very big difference".[21] Or: "My intentions are to extend and develop our present notion of aesthetics, to investigate originality, and to examine the relation between original and origins; opening up space for new thinking".[22]

Sturtevant's intentions are less than straightforward or clear, and have frequently been difficult for many viewers, however sophisticated, to "get". As art historian Patricia Lee notes:

> Sturtevant's keenness to distance her work from the term "copy" stemmed from her awareness of the negative connotations adhered to it, namely, forgery, fraudulence and deception. In defending her practice against such accusations, Sturtevant had to grapple with serious misunderstandings both from the artists upon whose work she based her own and from disconcerted audiences unconvinced of her stated objectives.[23]

Scholar Elisa Schaar points out that "[i]f Sturtevant's subjectivity had for many years largely been disguised by a mimetic practice, then with the publication of the statements and their performative presentation in public forums surfaced her strong and highly individualistic artistic personality".[24] Sturtevant's belated rediscovery is now another component to assess when considering her work, in that from the mid-1970s to late-1980s the artist took a hiatus (which may or may not have been an art gesture in itself) subsequent to a hostile reception of her restaging of the 1963 *The Store by Claes Oldenburg* installation (Oldenburg was one of the least amused). She later mounted some versions of Keith Haring's subway drawings, his impish improvisations reified into Sturtevant's forensic procedural of high-art imagery.

While it is inevitable for critics and historians to consider the feminist implications of the work, the artist steadfastly rerouted the discussion when these questions were raised, by turns imperious, dismissive, and authoritarian in her tone. What lingers in the case of Sturtevant and why she is so enduringly relevant is her assertion that her work made a "leap from image to concept" and that it "throws out representation".[25] The very fact that it depends

on manifestly visual, well-known imagery to dispense with representation in favour of an esoteric and cryptic ideation is fascinating, and more in line with a tactic of philosophical exploration than visual appropriation.

Performance and Reenactment

The fields of performance and performance studies have seen some of the most vital involvement with and consideration of notions surrounding reperformance and reenactments. How to reconfigure historical live events presents a number of quandaries, both practical and logistical, but also conceptual and ideological. A range of writers have investigated these issues, from the seminal arguments by Peggy Phelan describing "liveness" as antithetical to its residual recording, to discussions of the performativity and significance of performance documentation by other scholars such as Philip Auslander and Amelia Jones.[26]

Historians have offered various critical approaches concerning the significance of reperformative strategies; some of the more nuanced appraisals have come via performance scholars like Rebecca Schneider and Shannon Jackson, while art historian Hal Foster has been vigorously dismissive, stating, "[n]ot quite live, not quite dead, these reenactments have introduced a zombie time into these institutions",[27] and condescendingly that "[f]or purposes of activation and attention give me a Piet Mondrian over a George Maciunas any day".[28]

The curatorial field has been actively supporting the twenty-first century surge of reenactments, re-presentations and remixed historical works, with such key exhibitions as *A Short History of Performance* (Whitechapel Gallery, London, 2002–03) or *Life, Once More: Forms of Reenactment in Contemporary Art* (Witte de With, Rotterdam, 2005), and the highlighting of reenacted projects within many group and thematic exhibitions. Artist-writer Melanie Gilligan in her oft-cited 2007 essay "The Beggar's Pantomime" stated:

> Performance has lately acquired a central status in institutional programming, and occupies a similarly important place at art fairs, where it fills a critical inter-shopping-relaxation niche as the free aperitif that whets the appetite for the billed dish of painting and sculpture – the sexy supplement that makes everything else seem less run-of-the-mill. In each case, performance is valued for its potential to reimport a desired immediacy, albeit one often accompanied by caveats acknowledging the ubiquity of mediation. Yet in these contexts, the immediacy and immateriality of performance – once counterstrategies against commodification – aid rather than inhibit its functioning within the market. The medium has clearly moved past its historically antispectacular mission. By this logic, the spectator who is conscripted as performer is also conscripted as commercial-corporate functionary. We can all fairly say, "Le Spectacle, c'est moi!"[29]

Amelia Jones has equally noted both the connections between reenactments and the demands of the global art market, as well as the complex and contradictory aspects of writing about live art via its material traces:

> Even the most sophisticated performance theorist/historian argues her points "as if" her interpretations hold water somewhere in relatively fixed form, "as if" they are not

5.4 Tania Bruguera, *Tribute to Ana Mendieta* (Conception year: 1985; Implementation years: 1986–96). Recreation of works, long-term projects, Ana Mendieta's artworks and unrealized projects, lectures, exhibitions, interviews, texts at St. Pancras Church, London. Photo © Iniva.

5.5 Tania Bruguera, *Tribute to Ana Mendieta* (Conception year: 1985; Implementation years: 1986–96). Recreation of works, long-term projects, Ana Mendieta's artworks and unrealized projects, lectures, exhibitions, interviews, texts at Centro de Desarrollo de las Artes Visuales, Havana, Cuba. Photo © Gonzalo Vidal Alvarado.

dependent on material traces after the immutable always already "gone" character of the act establishes its "non presence" in the world. In the rush to privilege the supposedly unfixable ephemerality of the act, most scholars or critics writing about live art will tend to downplay (if not completely disavow in many cases) our reliance on photographic and filmic documentation, textual descriptions, and our own memories of live acts witnessed. This tendency is understandable (if regrettable), for, after all, while live performance is clearly of interest partly because of its liveness, its apparent confirmation of presence, there seems to be little point intellectually or politically in engaging with works in a way that truly accommodates the fact that their ephemerality makes them forever inaccessible to full knowledge – this would be to throw our hands up and admit defeat at the hands of time.[30]

One of the more interesting twists here is how artists have grafted themselves onto varying strategies of re-presentation of their own works and those of others. This has had radically different significations depending on the specific contexts surrounding and determining such choices. For example, the early works of Cuban performance artist Tania Bruguera entitled *Homenaje a Ana Mendieta/Tribute to Ana Mendieta* (1985–96) involved her concerted efforts to re-present the performances of the late performance artist Ana Mendieta to, in a dual sense, "bring her back to life" and bring them back to Cuba. Mendieta herself had worked abroad as an émigré artist, and Bruguera was working from reproductions and texts from an American exhibition of the artist's work.

Bruguera cited the dates when she reenacted the works, to further demonstrate that Mendieta's works "lived again":

> At the beginning it was a kind of homage to her, a very emotional homage of trying to actually connect with her, through her work. But then it became something else, more like I was trying to avoid the fact that that she was dead, a form of denial probably. And then it became a political gesture about the people who left Cuba, and about trying to put Ana into Cuban art history. Of course Ana did that herself, and she was part of Cuban art history by reputation, but I wanted to make it a fact. I decided to finish the project the day two art history students from the University of Havana came to me because they were writing about Ana's influence in Cuba. Then my work was done. This is what I wanted, for people to acknowledge her significance.[31]

It is especially intriguing and poignant that Bruguera speaks of her gesture as a generative act of "bringing to life" the artist and her work, which contrasts sharply with the notions that reenactments are somehow entirely false, economically driven, or a kind of living dead-style "zombification" of an artwork.

Reenacting the Media Spectacle

The British artist and filmmaking duo Iain Forsyth and Jane Pollard have restaged the late David Bowie's Ziggy Stardust concert, as well as other historic pop performances. Working since the 1990s, they also gained attention more recently for their ficto-documentary portrait of the musician Nick Cave, *20,000 Days on Earth* (2014). Their painstaking recreation

5.6 Iain Forsyth and Jane Pollard, *File Under Sacred Music* (2003). Video still, Single channel video projection, 22:00, black and white, sound, Courtesy of the artists.

of a 1978 videotape of American proto-punk rock and roll band The Cramps performing at a California mental health facility, *File under Sacred Music* (2003), is among the most extreme examples of their approach.

Here, the artists exactingly recreated footage from the Napa Mental Institute that was originally recorded on low-resolution black-and-white videotape and bootlegged so often that the technical quality was marginal to say the least.

A fetishized cult item of underground music thus receives a renovation treatment by Iain and Jane without smoothing every rough edge in their perverse attempt to mimic the exact document. The artists cast uncannily similar musicians and extras, and shot the project at London's Institute of Contemporary Art:

> After various rejected attempts at digital post-production, together with their editor Robin Mahoney, Forsyth and Pollard decided to explore more "tactile" strategies for degrading the footage. Several days were spent re-filming from dusty television screens, borrowing ancient VCR machines and outputting to second-hand VHS video tapes that were then scratched and physically damaged by hand before being redigitised and compiled into a final edit.[32]

The comparison of these similar yet entirely different documents is a provocative one, as if inhabiting a comfortable space whilst becoming aware of a creeping discomfort and disjunction. Suturing together this discontinuity cannot be easily resolved or tidied, and raises further issues. Aptly enough, the aforementioned author Tom McCarthy was in attendance at the restaged Cramps gig, and wrote a lively account of the experience:

> Two different events, two different event-zones, might have been taking place simultaneously, superimposed over one another in the kind of quantum-logic way the real Cramps, fans of trashy sci-fi, would have loved – but the raw power of Zone One, the Orphic gig-zone, made it impossible to remain safely enclosed within Zone Two, the conceptual art zone. At the same time, the very process within which Zone One was framed made Orphic abandonment impossible, for me at least. I felt exhilarated and uneasy at the same time – which is more or less how I felt the first few times I went to gigs aged sixteen or seventeen.[33]

The Cramps were an appropriate choice for restaging given their cult status. As originators within the early New York punk scene of the 1970s, they were often considered too comic, satirical, and beholden to old school rock and roll tropes. While The Ramones were similarly invested in past styles, they have been belatedly canonized as original figures, while The Cramps have not. For example, the only time they made the cover of *Rolling Stone* was when young New Zealand musician and breakthrough pop star Lorde wore a Cramps T-shirt for her own cover story (not unlike the way Nirvana's Kurt Cobain promoted such cult figures as Daniel Johnston when he became well known and much photographed).

Iain and Jane's works also recall the recycling of popular culture via tribute bands to offer the "real experience" of historic musical groups. Among the choices most prone to this

treatment are sixties favourites (Beatles, Pink Floyd), metal crowd-pleasers (Led Zeppelin, Black Sabbath), and punk-alternative bands (Clash, Pixies). Iconic pop musicians have also been touring and re-presenting their classic albums: Patti Smith's *Horses* (1975), Brian Wilson's *Smile* (2004), Van Morrison's *Astral Weeks* (1968), and so on. This always raises questions as to whether these musicians are covering their own material, acting as an oldies show, simply doing it for the money, indulging the nostalgic audiences, etc. But the phenomenon of reissues is ubiquitous, from the director's cut to the box set to such restagings as the one in *File under Sacred Music*.

The Cramps reenactment also recalls another art historical antecedent, *The Eternal Frame* (1975) by the Ant Farm and T. R. Uthco collectives, in which they staged a reenactment of President Kennedy's assassination at the same Dallas, Texas location where it actually occurred.

I screened this video for an art history class in the early years of the twenty-first century. One mature student remembered hearing the news of the assassination as a young adult and was visibly shaken in a different way watching the video than the group of twenty-somethings in the class, where a deeply affecting event became both distanced temporally and by the tactics used by the artists. As Ant Farm member Doug Hall commented in 1984:

> The intent of this work was to examine and demystify the notion of the presidency, particularly Kennedy, as image archetype [...]. This work seems particularly appropriate today when one considers that image politics has been refined to the point that we can elect an actor to be our president.[34]

In Ant Farm's works of this period, including *Media Burn* (1975), in which they crashed their cartoonishly customized rocket-car into a pyramidal stack of televisions, they offered a scathing critique of the media environment in the capitalist sphere, not dissimilar to Jean Baudrillard, Guy Debord, or Paul Virilio's inquisitions of the media spectacle. The assorted wigs and suits, make-up and mirrored sunglasses, pillbox hat and pink dress (the latter worn by artist Doug Michals) become the recognizable and noticeably outlandish accoutrements of power structures. Nonetheless, the shocking assassination replayed as farce can still shock the viewer. Novelist Don DeLillo, whose book *Libra* (1988) is one of the most chilling works inspired by the circumstances around Kennedy's death, has called *The Eternal Frame* "an act of eerie deadpan surrealism, with meanings collecting by the minute in an enormous plastic baggie of assassination aura".[35]

A key moment is a close-up of a woman wearing a bouffant hairdo, clearly affected by witnessing the restaged event:

> Oh look, he's reenacting it. [Lowered voice] *Oh no*. [Wiping tears away] Just like the real thing. [...] So realistic. It's terrible. [...] I don't know how this could happen to somebody so wonderful. I'm glad we were here. I really am. We just made it in time to see this. I feel bad and yet I feel good. Beautiful enactment. I wish I had a still camera so we could have caught it to show it. It was too beautiful.[36]

5.7 Ant Farm and T. R. Uthco, *The Eternal Frame* (1976). Video still. © Ant Farm and T. R. Uthco. Courtesy of the Video Data Bank, www.vdb.org, School of the Art Institute of Chicago.

5.8 Ant Farm and T. R. Uthco, *The Eternal Frame* (1976). Video still. © Ant Farm and T. R. Uthco. Courtesy of the Video Data Bank, www.vdb.org, School of the Art Institute of Chicago.

The video intercuts between the reenactment (which the group repeated approximately fifteen to twenty times according to participant Chip Lord), rehearsals, interviews, speeches, and reactions from bystanders throughout its tight 23-minute length footage. At one point, Hall, dressed in his Kennedy guise, answers the question, "Would you call this art?" by responding, "This is not *not* art"[37]. Hall commented retrospectively in a 2012 panel discussion:

> There is this notion it seems to me that images, that we have these experiences in the world, they come to us in these mediated forms, we're processing them constantly, and I think that we tend to appropriate these and then regurgitate them. I mean artists do it all the time of course. I think we do it in our everyday lives as well. And I think this kind of work has a relationship to appropriation art, the so-called Pictures artists in New York, I think are related to this kind of interest in sort of grabbing into the stream of data and loaded imagery, sifting it out, then re-appropriating it, re-formulating it, and I think in that act of reformulation creates the notion, not so much that we have control over images of that sort, but that we can nurture them and use them in our own imagination.[38]

What is it when a television pilot is *not* actually a television pilot, although in almost every respect it follows procedures for generating a pilot; that is to say, a "spec" programme for a potential series? This is the case with artist Christine Hill's *Pilot* (2000).

In writer John Hodgman's words:

> What begins as an emulation of a thing soon escapes and becomes the thing itself. [...] In some ways, the talk show is the perfect form for an artist besotted with form. It is Kabuki-like in its structural rigor: the monologue, the desk bits, the commercial breaks, the remote segments. Each is observed and replicated, and while "Real Late with Christine Hill" certainly breaks new ground in its field (particularly in the addition of a small dog that is obviously insane), it primarily plays between rewarding and confounding long-programmed expectations.[39]

Hill's exhibition at Ronald Feldman Gallery consisted of transforming the gallery into a pre-production office and rehearsal area in the run-up to the taping of *Pilot*, which subsequently went on view along with sets from the shoot. The existing residual material from the project involves a fragmented array of stills, press commentary, and texts in response (such as Hodgman's), and the characteristic ephemera surrounding any exhibition. *The New York Press* deemed it to be the "[b]est confusion of art and life".[40] Heather Felty in *Flash Art* astutely commented, "Believing talk shows are 'brilliant sculpture' and taking on yet a different persona in this performative work, Hill blurs the line between life and art: Is Pilot a talk show or is Late Night with Conan O'Brien performance art?"[41]

Hill's works of the 1990s involved inhabiting differing roles (tour guide, masseuse, shopkeeper) with a straight face and dedication; however, they were intentionally misaligned to a degree since they were taken on "as an artist" and had potential viability "as art", although the situations in which they occurred overlapped with the everyday life of the artist, and often functioned as a means of support.[42] As Hill told writer Cynthia Carr:

5.9 Christine Hill, "The Invention, Presentation and Filming of a Late Night Television Talk Show", *Pilot* (2000). Video still. Courtesy of Ronald Feldman Fine Arts, New York.

5.10 Christine Hill, "The Invention, Presentation and Filming of a Late Night Television Talk Show", *Pilot* (2000). Video still. Courtesy of Ronald Feldman Fine Arts, New York.

I always think that if you want to do something avant-garde or subversive, it doesn't mean a departure from the norm, from the mainstream. It means taking what you recognize from the norm and fixing it, personalizing it. There's no sense in bastardizing it so much that it's unrecognizable, because then you're not doing it. You're doing something else.[43]

While Hill assiduously researched talk shows such as Conan O'Brien's, attending them backstage and studying videotapes, she had no desire to make subsequent programmes, thereby transforming an artwork into actual television. As Hill recounted:

For me, the meat of the piece was the installation and the organizational/entrepreneurial undertaking [...] not the video. So, there is footage of the *Pilot* taping (2 actually, it was made in NYC and Cleveland), but it has not been edited, and I don't actually show it nor send screeners.[44]

In a contradictory manner, an art exhibition adopting broadcast television's methodology became its antithesis, while more recently, home videos and DIY productions are broadcast online from millions of residences daily.

Reenacting, Revising, and Restaging Histories

The prominence of YouTube has seen a profligate amount of reposting, remixing and reworking of archival video and audio materials: from cute pet clips to ambitious, responsive takes on existing cultural production. New Zealand artist, musician, and writer Dick Whyte is fascinated with the potential of this context to enable such works as *Pulp Fan Fiction* (2017), which compiles and assembles a sequence of Quentin Tarantino fans' remakes of scenes from the 1994 film *Pulp Fiction*. Whyte's compilation runs for a similar length to the original, which is itself riddled with quotations, citations, and knowing cinematic references.

Whyte has assembled a range of works contending with historical imagery, such as compiled YouTube footage of re-performances inspired by the short film *Andy Warhol Eats a Hamburger* (2010).[45] His *Corrupting Rauschenberg Erasing de Kooning* (2010) is a critical gesture operating in all of a few seconds, an animated GIF loop of Rauschenberg's *Erased de Kooning Drawing* (1953) incorporating digital distortion; a glitch-effect interrupting a work that raised issues of authorship, effacement, and representation. Far from being a copy, Whyte's work updates associations with those themes, albeit in a cultural environment in which *Erased de Kooning Drawing* is treated just as canonically as any of de Kooning's "own" paintings.

In *4' 33" [May '68 Comeback Special]* (2010) Whyte edited together 68 responses to John Cage's seminal silent composition of the early 1950s, posted by YouTube users. The compilation showcases many different settings: pianists, guitarists, concert halls, a silent video game, Grand Central Station, a rock and roll band, subway passengers, music students, campers, a sports arena, a silent ukulele, a baby, a busker, a back garden. In Whyte's view, this footage demonstrates how Cage's work can become viable in a more democratized fashion, as it reenters and operates within the context of everyday life rather than as some isolated intellectual exercise.[46]

5.11 Dick Whyte, *John Cage 4'33" [May 68 Comeback Special]* (2010). Compilation of screenshots courtesy of the artist.

5.12 Our Literal Speed, *7 March 1965* presented by Our Literal Speed, interview with Louretta Wimberly, 10 August 2013, Selma, Alabama. Courtesy of OLS.

As Cage stated, "[i]n Zen they say: if something is boring after two minutes, try it for four. If still boring, try it for eight, sixteen, thirty-two, and so on. Eventually one discovers that it's not boring at all but very interesting".[47] Which elicits some relevant questions regarding attention span in the social networking era. The silence highlighted within Cage's piece is enduringly evocative, and has even more significance today, in an era when the environment is rarely silent, filled with the hum of electronic signals and other white noise. As artist and writer Salomé Voegelin notes:

> Silence shapes the subject in his sonic form. In a sonic life-world, the "I" is produced as ephemerally as the sounds that sound the world perceived. The reciprocal intertwining of the "I" with the sonic life-world produces a transient and fleeting subject, en par with the sounds of its composition. This intertwined "I" is not a solid identity but an ever passing and evolving subjectivity that drifts in and out of certainty from the doubt and experience that form it continually and contingently as a formless sonic self.[48]

Reenactments of recent years have often dwelt in the sphere of discursive language, whether the restaging of talks, protests, manifestos, lectures, or panels. Recalling critic Benjamin H. D. Buchloh's analysis of the manner by which the conceptual art of the 1960s emulated the formats of the era's bureaucratic institutions, reenactments of the later twentieth and early twenty-first centuries function within the dynamic vortex of so much talking about art, as witnessed via public programming, podcasts, as well as university and art school contexts.[49]

The collective Our Literal Speed is a notable example of this strand of remixed and hybridized reenactments, drawing upon academic conventions as well as those of popular culture and the art world.

Their projects generally thwart direct understanding, call attention to mediation, and ensure a sense of unease and disorientation via ambiguity and tactical détournement. A discordant atmosphere emerges from many of Our Literal Speed's activities. These include: a performance artist delivering an art historian's talk; staged debates around art and politics with orchestrated Q & A; writings published under a collective byline; and video artworks. What these projects explore are the shifting mechanisms by which one might question the accepted formats of institutional discourse. Whether such strategies can effectively surmount the considerable pressures of institutions, like popular media, to subsume anything particularly idiosyncratic or intentionally radical is an open question. Our Literal Speed's approach becomes an event-based, choreographed, quasi-curatorial mode of working as much as it resembles re-performed acts.[50]

Artist-writer Zachary Cahill has discussed Our Literal Speed and a number of other contemporary artists as exemplifying the notion of artists as "double-agents": artists working across and occupying multiple roles, as in the case of day jobs like teaching, arts administration, and curatorial and editorial work:

> Double agency may amount to a type of romantic project whereby artists assert their subjectivity through various masks and by morphing identities within larger institutional structures. While deeply locked in the logic of capitalism, double agency strives

to wrest time away from its clutches, to divert the flow of human capital by haunting institutions with artistic spirit. No doubt this is a tightrope walk. For in the end, who is to say where the individual stops.[51]

As for Our Literal Speed, Cahill notes:

> OLS operates in a liminal zone of authorship, not exactly nameless nor faceless. [...] The agents play double roles both within and beyond the project. This is key to understanding the methodology of OLS. [...] [I]f you look hard enough, you can figure out who all the players are; it is not an instance of secrecy in the conventional sense, but rather, as [Slavoj] Žižek so often describes the functioning of ideology, it is about hiding best while wearing a mask of oneself. [...] OLS could be thought, through their various activities, to be manifesting a new form of art-historical writing, in which the artists are writing their own history, or histories.[52]

Some artworks are not exactly reenactments but evocations of what one might term "dis-remembered" histories, and are charged with a correspondingly affective power and significance. In New Zealand artist Shannon Te Ao's *Follow the party of the whale* (2013), the artist performs before a video camera, pacing around a small outdoor area repetitively drinking from a case of bottled water and spewing sprays of water.

Collaborator and cinematographer Iain Frengley's handheld camera hovers not far away, putting us in the place of both uneasy bystander and intimate spectator. A barefoot Te Ao is wrapped in a woollen blanket, placed shawl-like around his shoulders but later abandoned. In the artist's words:

> Ambling across the cold, wet tarmac I am occupied with intaking fifty litres of soda water. I intermittently expel each mouthful and, in turn, take in more. I am invested in the singular, bodily experience; one's "personal" relationship to a multitude of conflated influences.[53]

Te Ao's project references a significant and highly traumatic event in Aotearoa New Zealand's history: the invasion by over 1500 colonial soldiers and militia on November 5, 1881 of Parihaka, in the Taranaki region of the North Island, a pan-tribal indigenous community. The settlement was a thriving and self-sufficient collaborative entity. The government's intention was both to confiscate the Māori land and subvert the influence of the Māori prophets Te Whiti and Tohu Kākahi, who were among the arrested and had been promoting notions of non-violent, passive resistance. The settlement had come together in part due to the increasing force, disruption, and oppressive tactics used against smaller regional communities. The 2000 residents of Parihaka did not resist arrest, greeting Native Minister John Bryce in a peaceful manner. Nevertheless, the invading soldiers completely destroyed the Parihaka settlement and brutally victimized its residents.

This material, physical, and spiritual devastation extended to suspending any due rule of law, with the Māori Prisoners' Trials Act introduced to enable the prisoners to be incarcerated without legal recourse. The men of the community were imprisoned in different locations on

5.13 Shannon Te Ao, *Follow the party of the whale* (2013). Two channel video, colour and sound, 12:51; 2:49min. Cinematography Iain Frengley. Courtesy of the artist and Robert Heald Gallery.

5.14 Shannon Te Ao, *Two shoots that stretch far out* (2013-14) Single channel video, colour and sound, 13:22min. Cinematography Iain Frengley. Courtesy of the artist and Robert Heald Gallery.

the South Island; those transported to Dunedin were conscripted as labourers to construct the harbour wall and other parts of its civic infrastructure, and the extreme conditions under which they were held captive led to half of them perishing from tuberculosis. Such a devastating illness involves a kind of internal drowning, connecting with Te Ao's evocative, spare scene in the video, shot in a vacant area once used as a bowling green near Dunedin centre, but more disturbingly a site which witnessed some of the historical events described above.[54]

Te Ao's work not only attempts to coordinate a complex response to a number of different highly charged incidents, but to invest himself in the reimagining of the feel of a physical location, and to pay the utmost respect to the ancestral spirits who underwent hardship at the site. As an artist of bicultural heritage, Sydney-born, his mother Australian and his father of Ngāti Tūwharetoa descent, Te Ao's work also occupies a particular subjective positioning. Art historian and curator Anna Marie White has noted that Te Ao's access to the Parihaka content explored in his work comes more from previous art historical responses to those histories rather than a direct connection in terms of place or lineage (*whakapapa*), but that this still operates "in terms that are authentic to his experience".[55] This notion of authenticity is a particularly loaded one in Aotearoa New Zealand, as are questions of cultural identity and related inclusion/exclusion. White states:

> [Te Ao] recognises the value of claiming a space for Māori at the highest levels of Pakeha cultural production. In this respect Te Ao is different to the general attitude in the contemporary Māori art movement, which maintains a sense of exclusivity associated with the esoteric nature of their work and indifference to the task of educating Pakeha audiences.[56]

White's comments indicate how difficult it is to consider a bicultural nation with indigenous population in relation to the arguments I have been asserting throughout this book in terms of mutability of self. In traditional Māori worldviews, there are particular demarcations of identity in correspondence with the tribal affiliation (*iwi*), geographical lands of origin (*whenua*), family (*whanau*), and familial lineage (*whakapapa*). That certain cultural knowledge is also protected, sacrosanct, and circumscribed by factors relating to all of the above is a resilient and significant belief across Māori communities. This is true to the extent that when a writer such as myself – a migrant to Aotearoa, middle-aged, middle-class, and white – speaks towards indigenous culture, I must qualify that while my beliefs are drawn more closely from a European American perspective, they are constantly being reshaped and informed by living and working within a dynamic bicultural (and increasingly multicultural) context.

If our selves are potentially mutable, transitory, and hybridized, this does not necessarily sit well in relation to traditional protocols and understandings that long precede my argument, and which I continue to learn much from. Much contemporary art by Māori artists (including that of Te Ao) simultaneously contends with richly inscribed cultural traditions, and attempts to create intricate responses to those traditions and more, including the effects of how one's particular hybridized life experiences intersect with existing systems of belief. Te Ao's work connects into a larger continuum of past and present, particularly if one acknowledges indigenous notions of time, and the Māori proverb which states that one "walks backwards into the future [*ka mua, ka muri*]".

Te Ao's 2016 Walters Prize-winning work, *Two shoots that stretch far out*, is a video which depicts the artist reading an English translation of a Māori song poem (*waiata*) iteratively to a number of animals: a donkey, a wallaby, a swan, chickens, and a few ducks.

The conceit is a novel one, and so ingeniously threaded into the work that one can be quickly engaged with a work addressing themes of translation, transformation, and empathy across time, space, and species. The *waiata* is written from the point of view of a woman who has been wronged by her husband, who has taken on another partner. Yet Te Ao recites the text, confounding our ability to precisely distinguish the speaker's role. Critic Anthony Byrt has characterized Te Ao's role in the work as a disruptive "shapeshifter":

> *Two shoots* is about a waiata. But it is also about crossing oceans, crossing genders, crossing between times, between the dead and the living, between the animal and the human, and between the earth and the stars. Te Ao, fixed in human form, nonetheless embodies mercurial energy throughout.[57]

In his own ruminative statement discussing *Follow the party of the whale*, Te Ao writes:

> As you attempt to engage with a place or an event – deepen your understanding through some activity – over time the things that you might want to account for, or be responsible to, start to add up. A simple enough proposition is short-lived. We try to set tasks or propose actions that re-activate our presence within that process – a different kind of remembering. As it happens, the handling of dark material, complexity, history, and the insertion of our own agency within that, can be a murky business. There is no "one way" and so you can never get it "right". If and when the dust settles it doesn't stay that way for long.[58]

Perhaps the most significant aspect of art involving strategic reworking, recombining, and reenactments is that, at least in the most generative examples, the process of restaging is not simply an act of restating. In multiple, notable ways, the act of reenvisioning an event, image, or work is to realign, redirect, and reconceive its contact with the world in relation to its audience and circulation.

CHAPTER SIX

Social Practices and the Shifting Discourse:
On Collaborative Strategies and "Curating the Social"

If art and politics meet at all, it's in the obligation to work concretely in the present toward an ideal that may never be fully attainable.

—BARRY SCHWABSKY, 2012[1]

The distinction between art practice and other creative human endeavors is irrelevant to us.

—TEMPORARY SERVICES[2]

Today we are living inside evolving spaces between screens and commercial walls, and are hollow to our core when it comes to being fully present. The single serving experience economy is taking its toll, and artistic space is becoming its battleground.

—PETRI SAARIKKO, 2015[3]

This chapter focuses on contemporary art's increasing incorporation of so-called "social practices" over the past two decades. How are we to regard this moment as social practice has been commented upon more widely, disseminated within critical and curatorial venues, and becomes problematic and challenging in so many respects. What happens when a micro-scaled, process-based work is subsumed into the global art economy? How can collectives take advantage of "group mind"? What are the distinguishing factors between creative and symbolic representations, and "actual" activism? How do social practices function within contemporary curatorial culture? How does an emphasis upon collectivism and participation affect, strain, and potentially expand traditional notions of creative authorship?

Contemporary art depends on its social capacity, potentiality, and reach just as it is manifestly at odds with it. The aspiration for art to achieve social goals is amplified as entertainment streams swiftly into our daily lives, while art is often much less prominent. Art is often created in contexts of relative isolation, but a central concern is how, when, and why it relates to its external contexts: *Which* audiences? Made for *what* reasons, and in dialogue with *whom* exactly? Many terms that need not be brought together in tandem are frequently treated in convergence, such as the collaborative and the socially engaged; that is to say, many collaborative practices might not have a social imperative specifically in mind, and could have as many differing approaches as art made in a solitary manner.

Although one can trace a long and varied list of socially involved art projects as historical precedents for the recent proliferation of such projects in institutional contexts, many writers have dated the social turn to the 1990s, with the increasing amount of high-profile curatorial projects; collaborative, dialogical, relational, and situational works; and the steady integration of performance art and performative projects into academic discourse. In the following sections, I will thread together some provisional responses to the above issues and questions. In "Discursive Shifts and Contradictory Critiques", I briefly discuss a number of writers' thoughts both in relation to social practice, and to art and society more generally, including those of Franco Berardi, Boris Groys, Ivan Illich, Jeremy Rifkin, and Anthony Schrag. Their statements are discussed for two reasons: both to demonstrate the timeliness and comparative urgency of social engagement, and to present a wide range of equally valid interpretations of such terms as conviviality or the social in relation to contemporary art.

In section two, "Affects/Effects of Socially Engaged and Collaborative Projects", I refer to commentaries by artists, curators, and writers, including Theater Gates, Dan Peterman, John Preus, Gregory Sholette, Nato Thompson, and Temporary Services. In the final section, "Social Models of Curating: Art Spaces and Living Spaces", I discuss three initiatives which involve small-scale, independently run artists' galleries located adjacent to the living spaces of the artists (and their families). The examples share marked similarities, yet occurred in globally dispersed locations: The Suburban (Oak Park, IL), SHOW (Wellington, New Zealand), and Kallio Kunsthalle (Helsinki, Finland).

Discursive Shifts and Contradictory Critiques

Writings around social practice have been extremely contentious, and are increasing both in volume and relative prominence.[4] I would like to trace a path around some of this material without rehearsing all of the most well-trodden debates, particularly those around curator Nicolas Bourriaud's "relational aesthetics", especially given that I have discussed that notion in tandem with its Fluxus-indebted lineage in Chapter 2. Numerous critics have taken pains to emphasize the role of the antagonistic and the conflicted within the most significant socially engaged works, with Claire Bishop once leading the charge.[5] One of the best analyses of the contradictory aspects of the relational paradigm is to be found in Grant Kester's book *The One and the Many* (2011) in which the author calls out "the deep suspicion which both Bishop and Bourriaud hold for art practices which surrender some autonomy to collaborators and which involve the artist directly in the (implicitly compromised) machinations of political resistance".[6]

There are many other artists and writers who make insightful points along these lines, but whose comments have been referenced less often. For example, British artist and writer Anthony Schrag makes the point that "being a bit of an asshole" might actually be beneficial for achieving the goals of a socially engaged project, particularly zeroing in on the fact that being an "asshole" means to be "contemptible"; and it is this latter term that makes the difference in bringing contempt, disobedience, and disrespect to the status quo and its codes in order to present a valid, subversive challenge.[7]

Schrag also notes that "the asshole is not intentionally rude, but rather is merely operating from different rule-sets than the dominant and accepted cultural framework".[8] Along with this enticing (or polarizing) set-up for his discussion, Schrag has done his homework on UK arts policy, including the increasing instrumentalization of "public art" since Blair's New Labour tenure, and afterwards, when quite cynically the Conservative coalition government simultaneously advanced a policy of austerity while sustaining some community projects on the cheaper end of the arts policy spectrum, lending the outward appearance of social awareness.

In Schrag's counter-intuitive estimation, since the 2008 global economic crisis, times have been relatively good for community-based project involvement. This is arguably the case in Aotearoa New Zealand as well, during a period in which the national government's regime has continually reduced its arts support and involvement. Schrag predictably raises Bishop's antipathy towards the emphasis upon conviviality rather than antagonism in socially engaged and relational practices, and continues:

The framing of participatory art projects as "nice" can also be seen to emerge from state-funded, Social Exclusion policies, in which the erasure of "exclusion" (in favour of a universal and convivial "inclusion") is the primary goal. This elides with the notion that publicly funded, policy-enacting agencies – i.e., Local Authorities – cannot be seen to support projects that are overtly exclusionary, selfish or contentious, as they are public bodies and must, therefore, represent the entirety of the public. They cannot, in their public position, but defer to the entirety of the social and thus the majority of public projects in the United Kingdom maintain a "state aesthetic" that are – to be simplistic – safe, nice and good for everyone.[9]

Owing to the reoccurring mandate that "everyone must get along", the potential for an ano-dyne array of projects in the social realm emerges. Meanwhile, Schrag contends:

[T]he asshole is he or she who is willing to be disobedient to those who set the rules; he or she is willing to call those rules in question; to ensure they are not amoral or unethical or uncritical. The asshole with participatory practices is the artist that is willing to take the risk to bite the hand that feeds in order to produce both critically aware and ethical art projects, as well as expose problematic policy.[10]

Writer Michael Birchall insightfully remarks: "The difficulty faced with socially engaged art is the act of unifying the social conditions; communities, whether they are unstable or not, do not always require an opening up or a dialogue instigated by an artist, a curator, or an institution".[11]

Schrag lends another interesting edge to his analysis, viewed through the prism of his own works (two of which he uses as case studies). In *The Legacy of City Council Arts Projects* (2008), Schrag brought by taxi (he uses the term "kidnapped") a number of arts manage-ment professionals from the museum sector to the housing estate in which he was enlisted to make a socially collaborative project as a form of intervention. While this would seem almost a logical operational procedure, it is indeed rare to have the tables turned, in this instance re-sulting in a consultation in the community, surrounded by community members – an unusual circumstance in the cold-blooded, relatively removed zone of institutional curating.

Also intriguing given the current emphasis on art fairs, biennials, and large-scale events in the global art context is Schrag's more recent artwork, *Lure of the Lost: A Contemporary Pilgrimage* (2015), undertaken from the north of Scotland to the Venice Biennale, a journey of more than 2500km, conducted over the course of three months.

Schrag commenced his trek on June 13, 2015, the Feast Day of St. Anthony, patron saint of the lost. His performance calls attention to multiple aspects of the current moment: the politics of selection/rejection; relative mobility; and the creation of durational performance works in the public sphere.

Lure of the Lost was commissioned and in part publicly funded, but the project has a con-siderable amount of institutional critique embedded in its premise. However, in reading the artist's lengthy blog recording the encounters he had on the way to Venice, the work shifts

6.1 Anthony Schrag, *Lure of the Lost: A Contemporary Pilgrimage* (2015). Photo courtesy of the artist and Stuart Armitt.

down to a different scale – not relating to ambition, but in terms of its emphasis upon inter-personal dialogue with other individuals and groups.[12] Schrag was more frequently asked about the logistical elements of his journey (the "whats") rather than the conceptual impera-tives (the "whys"); but in considering either, both entered into the discussion.

Schrag transported to Venice an oak seedling purportedly originating from one of artist Joseph Beuys' social sculpture ventures. However, from the photographic evidence, it ap-peared less a heroic and valedictory gesture to carry this to Venice than melancholic and quixotic. Shifting from "thinking *from* making" to "thinking *as* making", so to speak, recalls Beuys' definition of social sculpture:

> [H]ow the concept of sculpting can be extended to the invisible materials used by everyone. THINKING FORMS – how we mold our thoughts or SPOKEN FORMS – how we shape our thoughts into words or SOCIAL SCULPTURE – how we mold and shape the world in which we live: SCULPTURE AS AN EVOLUTIONARY PROCESS; EVERY-ONE AN ARTIST.[13]

In a densely articulated but provocative set of comments by veteran critic Boris Groys, he writes of the significance of "art activism" being in the crux of contradictory impulses and traditions:

> On the one hand, art activism politicizes art, uses art as political design – that is, as a tool in the political struggles of our time. [...] Design is an integral part of our culture, and it would make no sense to forbid its use by politically oppositional movements under the pretext that this use leads to the spectacularization, the the-atricalization of political protest. [...] But art activism cannot escape a much more radical, revolutionary tradition of the aestheticization of politics – the acceptance of one's own failure, understood as a premonition and prefiguration of the coming failure of the status quo in its totality, leaving no room for its possible improvement or correction.[14]

But there is a brighter side, as Groys argues, finding this contradiction "a good thing":[15]

> First of all, only self-contradictory practices are true in a deeper sense of the word. And secondly, in our contemporary world, only art indicates the possibility of revolution as a radical change beyond the horizon of our present desires and expectations.[16]

Eliciting the figure of the U-turn, Groys is not thwarted by the prospect of the "total aesthet-icization" that we are living within and surrounded by:

> One can aestheticize the world – and at the same time act within it. In fact, total aes-theticization does not block political action; it enhances it. Total aestheticization means that we see the current status quo as already dead, already abolished. And it means further that every action that is directed towards the stabilization of the status quo will ultimately show itself as ineffective – and every action that is directed towards the destruction of the status quo will succeed.[17]

When reconsidering contentious disagreements around "the convivial", it is significant to shift the frame of reference here toward a text that is often overlooked today, despite its prescient arguments. *Tools for Conviviality* (1973) by the visionary theorist of education and society Ivan Illich critiqued the increasingly technocratic and managerial social context of the era. And if read in the context of the twenty-first century, his arguments are all too hauntingly familiar. Illich's salient remarks are rarely cited today, so it becomes important to quote two passages at length:

> Present institutional purposes, which hallow industrial productivity at the expense of convivial effectiveness, are a major factor in the amorphousness and meaninglessness that plague contemporary society. The increasing demand for products has come to define society's process. I will suggest how this present trend can be reversed and how modern science and technology can be used to endow human activity with unprecedented effectiveness. This reversal would permit the evolution of a life style and of a political system which give priority to the protection, the maximum use, and the enjoyment of the one resource that is almost equally distributed among all people: personal energy under personal control. I will argue that we can no longer live and work effectively without public controls over tools and institutions that curtail or negate any person's right to the creative use of his or her energy. For this purpose we need procedures to ensure that controls over the tools of society are established and governed by political process rather than by decisions by experts.[18]

Contemporary readers might easily discern a socialist idealism prevailing here, but Illich's core ideas resonate strongly with more recent progressive notions, such as those of attorney Lawrence Lessig, environmentalist Bill McKibben, economist Jeremy Rifkin, politician Bernie Sanders, and the countless ecologically driven discussions occurring over the past decade. Illich also echoes other figures who actively critiqued mid-twentieth-century alienation, including Buckminster Fuller and Herbert Marcuse:

> This world-wide crisis of world-wide institutions can lead to a new consciousness about the nature of tools and to majority action for their control. If tools are not controlled politically, they will be managed in a belated technocratic response to disaster. Freedom and dignity will continue to dissolve into an unprecedented enslavement of man to his tools. As an alternative to technocratic disaster, I propose the vision of a convivial society. A convivial society would be the result of social arrangements that guarantee for each member the most ample and free access to the tools of the community and limit this freedom only in favour of another member's equal freedom. At present people tend to relinquish the task of envisaging the future to a professional elite. They transfer power to politicians who promise to build up the machinery to deliver this future. They accept a growing range of power levels in society when inequality is needed to maintain high outputs. Political institutions themselves become draft mechanisms to press people into complicity with output goals. What is right comes to be subordinated to what is good for institutions. Justice is debased to mean the equal distribution of institutional wares.[19]

Illich's enduring relevance resides in several respects: his critique of the supposed infallibility of institutions; advocacy of shifting social relations in a more democratic direction; and emphasis

upon preserving the freedom of individuals and use of their energies for "non-productive" (i.e. creative) pursuits rather than industrial outputs. This valuing of creative potentiality separated from being a mere mode of production into an experience unto itself, as well as the valuing of an interpersonal "conviviality", provides significant background context for more recent discussions around relational and socially engaged art, and is again reminiscent of Beuys' notions of social sculpture as a catalyst towards the release of revolutionary creative energy.

Comments by Illich also summon those of Italian theorist Franco "Bifo" Berardi. In his book *The Uprising: On Poetry and Finance* (2012), Berardi writes that "[t]he financialization of the capitalist economy implies a growing abstraction of work from its useful function, and of communication from its bodily dimension".[20] According to Berardi, "finance has turned into a social virus that turns things into symbols. The symbolic spiral of financialization is sucking down and swallowing up the world of physical things, of concrete skills and knowledge".[21] And the "financial class", as Berardi terms it – essentially the so-called 1 per cent – reaps the benefits of these increasingly virtualized transactions.

The systematic manipulation of language, Berardi argues, is impoverishing society: "Debt is an act of language, a promise. The transformation of debt into an absolute necessity is an effect of the religion of neo-liberalism, which is leading the contemporary world towards barbarism and social devastation".[22] For Berardi, hope lies in poetry: "Poetry is language's excess: poetry is what in language cannot be reduced to information, and is not exchangeable, but gives way to a new common ground of understanding, of shared meaning: the creation of a new world".[23]

For economic and social theorist Jeremy Rifkin, a potential for a more ecological understanding of the world stems from the *Third Industrial Revolution* (2013), the period into which we are just emerging. Amidst transformations in labour, technology, and productivity that displace and revise existing notions of employment and the marketplace, Rifkin argues that a new era of empathic collaboration is upon us in the wake of a downturn in industrial productivity. Rifkin asserts that the non-profit third sector becomes more appealing for younger people raised in the era of social networking and virtual spaces:

> Like the open-source commons that make up the very sinew of virtual space, the third sector is a commons as well, where people share their talents and lives with another for the sheer joy of social connectivity. And like the Internet, the core assumption in civil society is that giving oneself to the larger networked community optimizes the value of the group as well as its individual members.[24]

Resembling Illich's critique of a bureaucratic society, Rifkin writes: "in the third sector, the relationships are an end in themselves, and are therefore imbued with intrinsic value rather than mere utility value".[25] And in an interesting parallel with Berardi's discussion of the significance of "poetry", Rifkin supports the value of "play", arguing that the collaborative era ushers in more opportunity for social engagement in "deep play":

> I use the term deep play because what I'm talking about is not frivolous entertainment but, rather, empathic engagement with one's fellow human beings. Deep play is the

way we experience the other, transcend ourselves, and connect to broader, ever more inclusive communities of life in our common search for universality. The third sector is where we participate, even on the simplest of levels, in the most important journey of life – the exploration of the meaning of our existence.[26]

Rifkin's observations, although not speaking directly towards the cultural sphere, are highly resonant in regard to the amount of "deep play" occurring in the arts and non-profit art projects, within galleries and via temporal initiatives and events, activist efforts, collaborations, workshops, loose coalitions, and residencies. The next two sections will move further into exploring examples of such efforts.

Affects/Effects of Socially Engaged and Collaborative Projects

One of the most striking factors that emerges when analysing socially engaged practices is the very real sense of how much engaging with communities informs and educates artists, curators, writers, and other arts professionals, rather than the other way around. This is also reflected in the reaction, reception, and residual effects of a project. Is it a bit too much to ask for a lasting effect from a project? And can truly significant projects take the form of short-lived events?[27] And how incorporative, encompassing, and wide-ranging might a socially motivated project become? What important affects/effects might the works anticipate and provoke?

How directly must artists reference politics and respond to political concerns to be considered politically engaged artists? In *Seeing Power* (2014), a book sketching curator Nato Thompson's ongoing involvement with commissioning social practice artworks, he comments:

> For many involved in the arts, an artwork must remain opaque enough to invite a proper amount of speculation and guesswork. Confusion is applauded over the crass simplicity of the obvious. An artwork easily open to interpretation provides a certain freedom from instrumentalization – from an agenda – and allows a viewer to experience speculation and consideration. In activism though, clarity is celebrated, and a cogent message can reach a wide audience and can serve as a weapon. The two ends of this dynamic, which I refer to as the ambiguous and didactic, have long proven irreconcilable.[28]

It would be impossible to address all of the above wide-ranging and open-ended questions in depth, but I enlist them here to provide background context as I continue the various discussions in this chapter. As artist and writer Gregory Sholette maintains in his analysis of distinctions between recent social practice and its precedents within community-based art:

> One difference is the move away from producing an artistic "work," such as a mural, exhibition, book, video, or some tangible outcome or object, and towards the choreographing of social experiences itself as a form of socially engaged art practice. In other words, activities such as collaborative programming, performance, documentation, protest, publishing, shopping, mutual learning, discussion, as well as walking, eating, or some other typically ephemeral pursuit is all that social practice sometimes results in.

> It's not that traditional community-based art generated no social relations, but rather that social practice *treats the social itself as a medium and material of expression.*[29]

Sholette is one of the most acute voices within contemporary social practice, having been involved for decades in the field, predating the comparatively recent surge of interest, and he describes this complex phenomenon in concise fashion:

> By working with human affect and experience as an artistic medium social practice draws directly upon the state of society that we actually find ourselves in today: fragmented and alienated by decades of privatization, monetization, and ultra-deregulation. In the absence of any truly democratic governance, works of socially engaged art seem to be filling in a lost social by enacting community participation and horizontal collaboration, and by seeking to create micro-collectives and intentional communities. On the surface, it's as if they were making a performative proposition about a truant social sphere they hope will return once the grownups notice it's gone missing.[30]

Sholette notes the micro- rather than mega-projects that characterize the recent wave of socially engaged works, often diffusing sincere motives into banal outcomes, writing caustically that "hell is undoubtedly paved with many good interventions".[31] Reading Sholette's discussion of the carnivalesque quality in the 2004 exhibition *The Interventionists* curated by Thompson at MassMOCA, I am sympathetic to the notion that much social practice is indeed absurd, humorous, volatile, and evades the solemnity or literalism that one might (falsely) attribute to a stereotype of "social" art. Works responding to huge social issues can certainly coexist with satire, as has often occurred in many tactical media efforts.

In addition, it is important to acknowledge the deficiencies and limits of "community" and "collaboration", as those terms have been increasingly adopted into the discourses of economic imperatives, neo-liberal ideologies and power structures. Artist Martha Rosler expresses scepticism, stating:

> Young artists perennially reinvent the idea of collaborative projects, which are the norm in the rest of the world of work and community and only artificially discouraged, for the sake of artistic entrepreneurism and "signature control," in the art market world.[32]

Rosler also notes "some disquiet" when thinking of past collective efforts such as communist workers' councils or car design "quality circles".[33]

Writer Jasper Bernes signals a note of caution in his appraisal of artist Melanie Gilligan's films on the current neo-liberal climate:

> [W]e shouldn't lose sight of the long list of bad collectivisms nourished by anti-individualist discourse. As preceding generations knew all too well, the discourse of the people can be used for the most repugnant of populist, corporatist, fascist, or statist projects. In the face of a new capitalism happy to deploy ideas of "sharing" and "friendship", we would do well to sharpen our sense of the distinctions worth preserving. Perhaps the pertinent line of opposition does not run between

individuality and collectivity but between different forms of community, forms which imply, as a matter of course, different definitions of the individual: on the one hand, what Jacques Camatte, following Marx, calls the "community of capital", and on the other, "the human community."[34]

Examining the human, artistic community is definitely the direction in which I would like to proceed in the remainder of this chapter, with particular focus on artists' projects, the overlap with inventive curatorial strategies and methods, and the ways domestic, lived spaces inform efforts to maintain smaller-scaled art spaces.

Chicago has historically been one of the most active centres in the United States for developing and supporting socially engaged practices, and thus becomes an interesting place to explore some of the varieties of social and collaborative practice, as well as some of the questions I raised above. Artists relevant to this inquiry include Dan Peterman, Theaster Gates, John Preus, and Temporary Services.[35] Chicago's dynamic art community is defined by a few key factors: many high-profile art schools graduating emerging artists every year and employing artists as staff; fewer commercial galleries; a large number of public institutions; as well as fringe efforts that can remain short term "pop-up" initiatives, although some of them seed much longer endeavours. I would like to focus on a number of representative efforts by significant artists that have occurred within this context.[36]

Some features of Chicago's art scene are locally specific, but word does spread. Although it is frequently demoted to less than "the second city" in some accountings of the US art world (after Los Angeles), it has offered a tough and gritty critical environment within a city of extreme contradictions, once hosting one of the best national art magazines (the *New Art Examiner*), and now hosting such critical fora as the podcast *Bad at Sports*. Chicago's history of non-profit ventures has also been lengthy and formidable. I want to consider how such ongoing alternative and social ventures have continued, but are also increasingly interwoven into efforts connected to the broader fine art economy.

Dan Peterman is one of the most representative artists in Chicago's art scene: his projects have ranged from speculative utopian to logistic utilitarian, both community and art world-based, and have provided a map towards a particular model of creative and social imagining.

Peterman has said that art in Chicago is "not just to represent culture but [also] to afford the possibility for culture in which art could be more of a social force".[37] This reading of art as more energetic force than static object relates to the uses of many of Peterman's own projects, which have included a public dance floor, urban park seats, and various anachronistic and quotidian ready-mades reconfigured into finely crafted, idiosyncratic tools.

A fringe ecology is made manifest in Peterman's practice, which has used cast-off materials recycled into both public artworks and practical, usable, well-designed objects and support systems, especially via his working base set within a South Side neighbourhood, a not-for-profit centre called the Experimental Station. Rather than solely focus on art, this centre comprises numerous activities that address the community's needs, including a bicycle workshop, food distribution network, and more. The Experimental Station's roots were in an earlier

6.2 Dan Peterman, *Running Table* (1997). Recycled, post-consumer plastic, 28 x 36 x 1200 inches. © Dan Peterman. Courtesy of Andrea Rosen Gallery, NY.

resource centre in the same area, dating from 1969 and run by Ken Dunn. In the 1980s, Peterman began working there and subsequently took over the site. Although it suffered the effects of a devastating fire in 2001, the Station was rebuilt and continued in the same vicinity.

Reflecting upon the Experimental Station and its heritage, Peterman commented:

> I felt an attraction to a counterculture which brought all kinds of things together, from rigorous academic directions to "feel-good," "do-it-in-your-garden" sentiments. There was a whole range of approaches that somehow coexisted. There also were dynamics that were a bit camouflaged but very problematic in the sense of being hard to change or resist. It was hard to assert order within that kind of formlessness, to do anything except let it be, let everybody get along – just like in all the clichés. There was a kind of friction between individualistic tendencies and collective ones.[38]

While Peterman keeps his focus local and works as an art educator, he maintains gallery representation in New York, and his practice, particularly due to its responsiveness to conceptual and environmental concerns, has been well-received abroad, especially in Europe. But what is equally interesting about Peterman's approach is his blurring of art with activist categorizations and nominative designations. Rather than avoiding those questions, he insightfully articulates his specific point of view:

> This project has certainly been influenced by what you might call elements of an ecological consciousness, the appreciation of complexity being one of them. But there are other equally important elements. For example, you might be attracted to something aesthetically, through artistic training and an awareness of pattern, texture, form, etcetera, and those qualities of that thing may move into politics or social relations or some similarly broadened arena of social concern. It's hard to define how this hybrid activity is or should be seen – aesthetic, biological, political – and I'm not particularly interested in making those distinctions.[39]

This blurring of distinctions has been shared by other initiatives within Chicago, such as with the collective Temporary Services, whose statement I chose as an epigraph for this chapter: "The distinction between art practice and other creative human endeavors is irrelevant to us".[40] The group has functioned as a printing house (there are over 116 Temporary Service publications, including the above interview with Peterman), an archive, and communications hub for a range of other activities as much as an art collective per se. This demonstrates their commitment towards conceptual flexibility and the incorporation of multiple modes of practice. Drawing as much of their inspiration from the DIY punk ethos of independent bands as design and social initiatives, this leaves room for changes and shifts in the scope of activity. Temporary Services' current members are the artists Brett Bloom and Marc Fischer (who have worked together since 1998; artist Salem Collo-Julin was also a member between 2000 and 2014).

Temporary Services have emphasized factors of access, multiplicity, and portability within their works such that the ways in which information is transmitted is woven into the methodologies used in their projects.

6.3 "Prisoners' Inventions", drawings and writings by Angelo in collaboration with Temporary Services, 2006. Courtesy of Temporary Services.

6.4 Temporary Services, *Booklet Cloud* (2013). Texas State University, San Marcos, TX, 2013. Courtesy of the artists.

Access is not taken lightly: publications and imagery are available freely or inexpensively via their website, and licenced under the Creative Commons to further enable circulation. In their earlier projects, the group worked on an ongoing basis with the portion of American society most lacking in access, namely its citizens living within the prison system. A range of works, documents, and publications were spawned from this initiative, including collaborations with artists in prison and projects examining aspects of prison life. Among these were a selection of drawings by Angelo, an artist incarcerated in California, an archive collecting examples of *Prisoners' Inventions*, and a campaign to obtain magazine subscriptions for inmates.

In 2007, Temporary Services assembled a series of interviews with and articles about art and "non-art" collectives for a book entitled *Group Work*. For the members, the project was generated by a number of considerations:

> Being a group, for us, means reiterating our place in a larger general culture of people working with other people. It's this kind of self-analysis that led us to seek out other groups and their histories, and bring this book to the table.[41]

Interviewees included: General Idea's A. A. Bronson; Chicago artists Haha; "Jane" aka The Abortion Counseling Service of the Chicago Women's Liberation Union (CWLU); Austrian artists WochenKlausur; Dutch punk band The Ex; Croatian curators "What, How & for Whom"; San Francisco proto-hippies The Diggers; the band Funkadelic; and NYC art/activists Political Art Documentation/Distribution (PAD/D). The very range of this roster speaks toward Temporary Services' inclusive approach and egalitarian ethos.

More recently, Theaster Gates has become the Chicago-based artist gaining the most media attention, for a wide range of artistic endeavours, which cut across and actively hybridize sectors of knowledge production.

To a degree, his practice operates in a related mode to that of Peterman, but Gates has amped up the art world, economic, and social capital assigned to his works, being a very high-visibility managerial presence. As with many contemporary artists, he is engagingly charismatic within such avenues of dissemination as the TED talk, the artist lecture, or the performative presentation. This fact, paralleling a range of ambitious, often spectacular artworks, enables Gates to cross into areas of the public sphere that are often closed to artists, or seem antithetical to certain grass-roots approaches – you are as likely to see Gates profiled in glossy business magazines as art journals.

Gates' practice, both in its specifics and commonalities with the broader field of social practice, offers an intriguing entry point to a discussion around authorship and subjectivity. In many respects, Gates is merging the byline of individually conceived and rendered art projects with a collective involvement in the negotiation and realization of such projects so as to gain financing, community awareness, and buy-in from contributors, whether patrons or assistants. Gates is a project manager in a way that has often been associated with the curatorial as much as the artistic role. Gates' combination of lateral movement and relative fluidity in terms of the subjective positioning and socially scripted roles he consciously inhabits has assisted a range of events to occur within his dynamic practice.

6.5 Theaster Gates, *The Dorchester Projects, Archive House and Listening House*, exteriors. Chicago. Courtesy of Theaster Gates Studio.

6.6 Theaster Gates, *The Dorchester Projects, Archive House*, interior. Chicago. Courtesy of Theaster Gates Studio.

Dorchester Projects, Gates' refurbishing and fitting-out of properties he purchased on the South Side of Chicago, transforming them into a studio, reading room, archive and social centre, has been the central foci of discussions around his work, as it enacts and becomes a literal "housing" for so many intersecting real-world issues (in tandem with its revised consideration of both material culture and conceptual strands of art practice). Gates turned a discarded, underused space in a neighbourhood with vibrant cultural history – yet hugely affected by debilitating aspects of economic disenfranchisement – into a place in which many discordant energies could not only coincide, but enact a generative rethinking and reevaluation: of books and records rescued from bankrupt stores; an art history department's glass slides treated as cultural treasures rather than anachronistic detritus; soul food served within Japanese pottery made carefully on-site for that purpose.

Gates has progressed from projects that were initially modest to larger, public ventures. His training as a ceramicist and craftsman has been partially overshadowed by his interest in public policy and renovation of the urban fabric (Gates also holds a degree in urban planning, and once worked for the Chicago Transit Authority, organizing its art projects). But Gates still reiterates his ties with the art community, and the significance of materials and materiality. What becomes particularly notable in Gates' work, beyond its impact in terms of a site-responsive awareness and aestheticism, is how it operates across segments of the public sphere, reengaging with the art world by shrewdly bridging socially motivated practices with the hard economic realities of art biennales, fairs, and galleries.

Curator Claire Doherty has commented on the ways *Dorchester Projects* differs from earlier durational projects:

> Just as this South Side territory acts a gathering point and resource for ongoing activities, so Dorchester Projects and Gates' studio acts as the production nerve centre for a set of worldwide projects that are consciously framed within the institutional context of an art exhibition (such as his contribution to dOCUMENTA (13) in 2012), thereby creating a circular economy.[42]

In speaking, Gates maintains a confident, engaging tone that echoes his many roles: artist, activist, businessman, manager, motivational speaker and/or minister. This raises the question: who is the author of the works and when? The Gates who negotiates with the mayor of Chicago, or becomes the emphatic public spokesperson for his projects? Or the Gates who involves himself in aspects of the design and enacting of his large-scale plans? Art historian Matthew Jesse Jackson offers a vivid account of Gates' performance persona:

> 2011. Late summer in Aspen. The Anderson Ranch Arts Center. High-end art collectors and curious locals milling around. Veuve Clicquot, a vat of chilled shrimp. The vegetarians gnaw tofu skewers. Capacity crowd. They're here to hear Gates and the Black Monks of Mississippi, his band. In no time Gates is belting out these angular dirges about a nineteenth century potter named Dave the Slave. (Four years back, Gates did this same performance in Chicago. Five people were at that gig, and three of them worked for the gallery.) Anyway, the crowd's frozen in place like it's Madame Tussauds. They hope this black man in front of them is not really and truly angry, but they're fearing this black

man in front of them really and truly is. He looks mean. Singing mean. After ten minutes of Plastic Ono Band primal screaming interlaced with some high-pitched gospel interludes, Gates is staring at the ground, immobile, silent. Doing a damned good imitation of Catatonic Gates. Then, up pops that tight-shaven head, a big happy-to-be-alive smile strobe-lights the audience – and, like lightning cracking long and hard in July, the White People Go Apeshit: "He's not angry, honey! He's just acting!" They're exulting like Bobby Thomson's rounding third behind the shrimp.[43]

Gates' practice involves an intricately crafted mix of personae. While his aesthetic often involves the reworking of modern vernacular minimalism, broadly speaking Gates is a maximalist, possessing a twenty-first century identification with the artist becoming and inhabiting as many roles as possible.

Gates has worked closely and actively with others in the construction of *Dorchester Projects*. One of these artists is John Preus, who often incorporates his abilities as a skilled carpenter and sculptor, and applies them to deftly reusing and crafting existing materials. Preus, the lead designer and fabricator for the two earliest Dorchester houses – the Archive House and the Listening House – has worked closely with Dan Peterman and the Experimental Station, and has participated in several art collectives.

In 2014, Preus designed and built an enormous construction called *The Beast* within the interior of Chicago's Hyde Park Art Center.

The Beast in question resembled a giant steer, its component materials incorporating recycled wood and furniture from closed Chicago public schools. Preus' project involved multiple collaborators, was the culmination of a year-long residency, and benefited from a successful crowd-funding campaign to assist its final stages of completion. Upon erecting the structure, Preus hosted a range of discursive events within *The Beast*, including music, panels, storytelling, and dinners. As a result, a different pedagogical environment was resuscitated in the gallery, literally within the belly of the work. According to Preus:

> I consider it a great success that it has become the high school hangout, and a venue for all manner of public meetings and conversations, that it has created a somewhat novel form of reflective behavior, unlike others that I have experienced, a combination of wariness, delight, adventurousness, speculative ripeness, a willingness to venture big ideas. But maybe it is, by and large, a form of what Simon Critchley calls "mannered situationism," which describes the limits of theater, and the lot of all art world versions of politics, which brings us back to Debord and the spectacle. I think of it as a spectacle in the sense that the Trojan horse was a spectacle, a decoy appearing as a gift. But there are many ways to think about a decoy. An icon is also a decoy, intended to project a reality beyond the surface of the image. It works to the degree that it seduces your attention, but then becomes a lens beyond the surface of the image.[44]

The Beast confounded some viewers with the striking differences between its interior and exterior appearance, as Thea Liberty Nichols writes:

6.7 John Preus, *The Beast* (exterior) (2014). Solo exhibition at the Hyde Park Art Center. Materials collected from closed Chicago public schools, wood, felt carpet padding. Photo: Tom van Eynde. Courtesy of the artist.

6.8 John Preus, interior of *The Beast* during moth-inspired story hour, a four part series on themes associated with The Beast. Courtesy of the artist.

> Stepping into *The Beast* is like going down the rabbit-hole to Wonderland. From the outside, it seems much smaller, and muted by sleep or death. Inside it's brightly lit by flood lights strung from the arched masonry overhead. A winding path of inlets, bump-outs, and cubbyholes terminate at the windowed garage doors that serve as part of the art center's exterior wall. When the doors are open, it's not unusual to see kids whizzing in and out shouting, find an out-of-sight viewer upstairs reading, or spot teenagers noodling on the chair swing. There's a moment of confusion when you step back out onto the sidewalk and into the surrounding neighborhood though, because you realize that rather then bring everyday life into the art space, Preus has pushed art out into the everyday world.[45]

Preus has also moved within *The Beast* project, from concentrating on the small-scale, domestic and utilitarian to the larger-scaled and utopian. At the same time, he preserves an intimacy due to his careful uses of materials and aesthetic choices. From youth events to philosophical discussions, *The Beast* became an example of "social sculpture" that enacted a multiplicity of ideas rather than simply representing them. Preus knowingly referenced Beuys by fashioning *The Beast*'s skin from felt carpet underpadding rescued from a nearby dumpster, discarded by a local office.

Social Models of Curating: Art Spaces and Living Spaces

If there have been vast changes in the definition of curatorial practice, one of the most significant shifts has been in the direction of the contextual, dialogical, interventionist, participatory, relational, and situational. Curator Paul O'Neill has noted these changes and more in *The Culture of Curating and the Curating of Culture(s)* (2012), his lucid account of contemporary curating. O'Neill follows the trajectories of the past several decades, particularly the ways curators became increasingly recognized via their authorial roles in the late 1980s, moving towards a "supervisibility" of curators during the 1990s.

> The amplification of the notion of the curator as an agent responsible for overall exhibition structure and narrative established the now-ubiquitous usage of the phrase "curated by" (in the context of exhibition invitations, press releases, and catalogues). As a normative attribute to all exhibitions, "curated by" articulates a semi-autonomous authorial role for the curator. Curating in the context of group exhibitions – the exhibition form that most clearly brought the curator to the fore and helped to establish the "curated by" credential – made evident the idea that there is an agency other than the artist at work within all exhibitions, and that the exhibition is a form of curatorial vocabulary with its own grammar.[46]

If one traces the implications of the context O'Neill is describing, the authorial role of curators is still strong, used to both secure and launch projects, and to attach a "vision" to exhibition projects. The author/curator can become a brand as much as the artists involved, and sometimes even more so. Historically, there are many precedents for a strong reading of curatorial authorship, such as in Cold War-era Poland, with its "author's galleries", which were often run by artist/curators in apartments, non-art contexts, and other peripheral spaces. Here, authorship was meant to signify the close relation between works shown and curatorial ideologies, often involving an interest in unconventional, conceptualist-driven alternatives.[47]

In a potentially intriguing development wherein artists have become more dispersed in their practices, often taking on collaborative or curatorial roles, the role of the curator is frequently considered a singular authorial voice. As notions of what art might consist of have loosened conceptually and aesthetically, the curator is often a guide or interpreter of cryptic or inde-cipherable artworks. This role parallels the "educational turn" noted within the contexts of both curatorial practices and event-based artworks. As artist-writer Mick Wilson has noted, the discursive elements once perceived as peripheral to the art exhibition have now gained in centrality, "becoming the main event".[48]

This pedagogical turn in contemporary art runs alongside ongoing crises in art educational contexts, from astronomical tuition fees and massive student debt to the increase in "free" alternatives, although many such ventures exist in close proximal and symbiotic relation to mainstream universities and art schools. As critic Andrew Berardini, who teaches at the free-of-charge, artist-run Mountain School of Arts in Los Angeles, noted in a 2015 essay: "In Southern California, the cost of an MFA ranges from $31,000 at UCLA a public university, to just under $79,000 at Art Center, a private school. This does not include accommodation, food, materials, books, etc. It only includes tuition".[49]

Over the past decade, the emphasis upon authorial, discursive, and educational modes of curatorial practice has been evidenced across a spectrum of art world sectors, from mi-cro-gallery ventures to the initiatives of museums and biennials. However, even if a prevalent concern, it has been voiced very differently depending on the initiators, participants, and public involved. I am increasingly interested in how domestic spaces and art spaces inform one another. Artists have often maintained small-scale exhibition contexts closely linked to their own living areas and domestic environments. I will now consider aspects of the pro-duction and the reception of a number of such projects, conceptually linked by some shared concerns: The Suburban (USA), SHOW (Aotearoa, New Zealand), and Kallio Kunsthalle (Finland).

A primary link between these different ventures is the way artists create non-institutions that may have a capacity for transforming into "actual" formalized institutions, but which actively resist growing larger. Various factors influence these contexts, including capital, the shared goals of participants, and the ability to increase awareness and legibility, along with a creative intensity and integrity. They involve artists having multiple positions within diverse settings in the arts. For example, Michelle Grabner, who has run (along with her partner, the artist Brad Killam) The Suburban, and its later offshoot The Poor Farm, is a painter, educator, curator, and writer. All of these identities have been crucial components influencing Grab-ner's ability to structure a long-running, renowned art space.

Grabner and Killam have operated The Suburban since 1997; the gallery consists of an unim-posing, cinderblock building adjacent to their home in Oak Park, a suburb located nine miles west of Chicago.

Inspired by other alternative gallery efforts, such as Robin Klassnik's east London space Matt's Gallery (in turn inspired by Polish authors' galleries of the 1980s, such as Akumulatory in Poznań), the artists planned a space that would be informal, self-funded, and occupy a

6.9 Exterior view of The Suburban, Oak Park, IL. Photo courtesy of The Suburban.

6.10 An opening event at The Suburban, Oak Park, IL. Photo courtesy of The Suburban.

presence somewhere between a studio and a gallery space. As Grabner noted on the occasion of The Suburban's ten-year anniversary:

> Exhibitions here tend to follow one of three routes. Some artists break off a little piece of their usual production and show it here to see what it looks like in this context. Others take the opportunity to develop a minor yet key part of their work. Still others will jump out of their skin, so to speak, and try something completely different than their usual practice. Who shows at the Suburban is related to our movement through the world and who we encounter through the normal networking process; our relationships are with artists rather than with the commercial galleries that represent them. Extending an invitation to exhibit is a curatorial decision. There's no getting around that, but there is a way of sharing it. Since 2003, we've had two spaces – one small, one *very* small – that run concurrent exhibitions. We deemphasize the curatorial model by letting one artist invite another. This introduces us to more new artists, it reduces potential interpersonal friction, and it recognizes networking as another shaping force in the contemporary art world.[50]

In the above description, the phrase "who shows at the Suburban is related to our movement through the world" merges the gallery's procedural methodology with the couple's life activities and "the normal networking process".

Openings at The Suburban can seem cheerfully domestic; with weekend evening barbeques tended outside the space, and artists sharing beers in the open air, the claustrophobic atmosphere of so many official art events is all but banished from the proceedings. If this resembles any typical barbecue in Chicago's outlying suburbs, The Suburban has hosted an impressive range of national and international artists. In 2007, Grabner's retrospective at the University Galleries at Illinois State featured a recreation of The Suburban within the space, hosting mini-exhibitions throughout the course of a survey of Grabner's own projects.

As critic Lane Relyea noted in his catalogue essay, questioning the exact motives and outcomes of this uncanny reinstallation's "meaning."[51]

> The meaning gained from recreating the actual cinderblock structure owes not to some act of reification, an exploiting of the gallery's ability to serve as a free-floating sign of itself, but rather the opposite; the purpose is to ground The Suburban and its function in a specific context. [...] And what exactly is this context? Just look around: its specificities continue to unfold throughout the rest of the show – in Grabner's photographs, for example, which often feature hers and Killam's garden and the houses of some of their Oak Park neighbors; and in the cooking-lesson videotapes, for which their kitchen serves as soundstage. Also on display are some of Grabner's paintings from the mid to late 90s, which appropriate as source material various washcloths, blankets, and other textiles and found patterns from around the home.[52]

A number of issues are raised here, not least having a mix of emerging artists and established figures hosted in the same tiny (8 x 8ft/2.4 x 2.4m) once-utilitarian shed. Moreover, there is active flow between spaces: both the domestic space adjacent to the art space; and the

6.11 vjRex and Dr. Kron, *Insidious Pop* (March/April 2005), SHOW Wellington, New Zealand. Courtesy of Jenny Gillam and Eugene Hansen.

6.12 Maddie Leach, *A Cord of Wood (or How to Light a Dark Corner)* (April/May 2005), SHOW Wellington, New Zealand. Courtesy of the artist.

spaces of Grabner's own distinctive practice as a painter, video-maker, writer, and curator. A more recent exhibition of Grabner's work was aptly entitled *I Work from Home*.[53]

Another more short-lived venture, although manifesting a related curatorial ethos, was Jenny Gillam and Eugene Hansen's gallery SHOW, running from 2004–06 in Wellington, New Zealand.

Several project spaces had closed in Auckland where the artists lived, and during the process of planning a new effort, the couple relocated to Wellington to take up teaching positions. Wellington, a much smaller cultural setting than Auckland, had far fewer non-profit exhibition contexts, apart from larger-scale institutions. As Gillam writes in the preface to a publication that retrospectively documents SHOW:

> We established SHOW because we felt we were not seeing enough of the work of a number of artists we respected and as artists we need to see art that both challenges and engages us. At some point we realised we didn't need to wait for others to provide us with the exhibitions we wanted to see, nor could we rely on existing galleries to have interests that were aligned with our own. Simply, we wanted our local art world to expand in such a way that might encourage more speculative art practices.[54]

Gillam and Hansen took particular care in ways that departed from most larger, established spaces, such as their decisions not to hold public programme events, apply for public funding, or place wall texts or notes with the work. This assertion of independence and a desire to speak towards an existing, informed art community, but potentially grow that base without undue compromise is the kind of approach that can rapidly become co-opted or disrupted if transported into a larger institutional framework. The tensions of organizing a space adjacent to your flat increase when the art involved interferes with your daily rituals. In writing of Australian performance artist David Cross' inflatable sculptural installation, Hansen noted, "Saturday 10 AM, get up and make the gallery minder a coffee. Can't sleep in anyway, bloody David and his industrial blower".[55] But the couple's beloved Jack Russell terrier Frank might get an opportunity to perch on the gallery minder's lap. Sometimes small *is* better.

SHOW's exhibitions tended toward installations, with wide-ranging examples incorporating performance, sound, video, and durational events. It is a cautionary tale about the art world's conservatism that to create a space that considers a range of media perfectly viable to be shown in the same context, especially by mid-career artists whose works are not viewed as "saleable" in the conventional sense, becomes a bold endeavour. Much of the commercial art world functions around low-risk, high-return propositions such that experimentally-focused project spaces are difficult to foster and maintain; paradoxically so, as given this situation, their role is very much needed. SHOW also highlighted collaborative practice, which is unsurprising given Gillam and Hansen have worked together as a collaborative team in multiple projects and with other artists as well. Hansen, whose own interdisciplinary practice – and under the alias vjRex – features sculpture, sound, and video, works collaboratively most of the time.

Hansen and Gillam have continued "post-SHOW" with the pursuit of their own art projects and curatorial efforts. One of the most recent enlists webcasts as a method of curating

performance and event-based projects in a real-time online environment. This draws upon Hansen's research into online gaming environments and streamed music performances. Creating the platform testpattern.tv is their attempt to initiate a "virtual project space" for fortnightly events, which have the potential to include a wider audience than the several dozen viewers that would attend SHOW's openings – a micro-effort that created a ripple effect throughout Aotearoa New Zealand's art community.

Efforts like those of Gillam and Hansen speak toward the demands of creating high-quality exhibitions in a small-scale context. The benefits of such exhibitions are a relative autonomy and freedom without being directly co-opted by external pressures. This approach allows for curatorial latitude, combined with a commitment to preserving eclecticism, playfulness, and variety. SHOW's exhibitions featured many process-based and ephemeral projects that have not always been shown in New Zealand's dealer galleries, despite the fact that a substantial portion of its art community have participated in performative, post-object, and relational projects.

According to a statement posted for the 2014 Stockholm Independent Art Fair:

> Kallio Kunsthalle is a pocket of art in the heart of Kallio (Kallio in translation means "bedrock") Its principles are based on the European Year of Volunteering 2011. It is a product of artists, scholars, and local associations. Kallio Kunsthalle's main partner is Helsingin Optimistit, and its site is at the former meeting room of the Association for Healthy Lifestyles, at Toinen Linja 31 Helsinki. Kallio Contemporary Art Museum is a 160 x 120 cm table with a glass top. During the exhibition year a best- (or worst-) of exhibition will be collected in the table, which will, in the end, go touring.[56]

Kallio Kunsthalle reflects the acerbic sense of humour and irreverence of its founder, Petri Saarikko, who incorporates diverse creative approaches within Kallio Kunsthalle.

Examples include works by one of the most notorious criminals of Northern Europe, the paintings of an antiquarian bookseller, and the tools of a blacksmith. Saarikko refers to himself as having had a Jekyll and Hyde career, the former being his day job as an interactive software designer and IT expert, and the latter his evenings spent as a gallerist and institutional critique artist. If the term "Kunsthalle" evokes a large exhibition space, Saarikko's gallery occupies a modestly sized storefront space.

Saarikko and his partner, the Swiss-Haitian artist Sasha Huber, live adjacent to their gallery in Helsinki, and their studio is not far away, nor is the childcare centre for their young son Basil. This information is relevant insofar as Saarikko and Huber have interwoven aspects of their lived existence into their art projects. As Huber becomes more renowned as an artist, the family has travelled widely to international residencies. Saarikko calls the Kunsthalle a living social space, and has used the phrase "curating the social" over the course of his activities. As an experienced IT systems designer, he has a well-informed but critical perspective on the neo-liberal environment:

> I am concerned about the role of authoritarian social engineering appearing visibly in the domain of free art practice. We are not far from acknowledging how utilitarian

6.13 Kallio Kunsthalle, *Aboriginal Kunsthalle* (2016). Exhibition of graphic etching and aquatint works of Aboriginal contemporary artists at Kallio, Helsinki, Finland. Photo courtesy of Petri Saarikko.

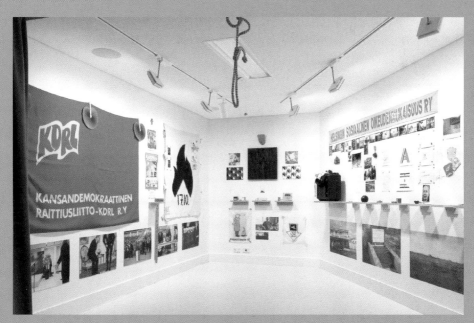

6.14 Kallio Kunsthalle, *Ernst Collection* (2015). Collection of fragments and narratives from exhibiting artists and non-artists in an expanding suitcase at Te Whare Hēra Gallery, Wellington, New Zealand. Photo courtesy of Petri Saarikko.

forces attempt once again to instrumentalise some of the freest forms of knowledge production.[57]

Kallio Kunsthalle has made an active curatorial space for emerging and established artists, outsider artists and non-artists. (As of this writing, the gallery continues, but under the direction of a group of young Finnish curators.) Saarikko's commitment to the gallery has involved preserving its unpredictable programming, actively open to encounters with the world surrounding the gallery, intentionally letting it flow into the space. Saarikko appears energized by surrounding pressures, which paradoxically fuel the dynamic projects exhibited in the gallery. This recalls Robert Filliou's aphorism cited earlier: "Art is what makes life more interesting than art".

In Saarikko's words:

> Encountering new people and their narratives passing through the Kunsthalle keeps me going. It's definitely not their nubile or theoretically deconstructed bodies, but discovering and meeting pure strangers, and the unknown. Wherever I settle would surely allow me to establish an agency or a community of some kind. It's about commitment and discovery of meaning from our surroundings. The question of existence regarding a space like Kallio Kunsthalle is no longer really economical. It's an ideological setting that pervasively renders visible those brutal collective forces that limit the freedom of expression and freedom of art in our society. Tough questions that relate to structural and even cultural violence.[58]

The forces to which Saarikko alludes in his phrase "structural and even cultural violence" are ubiquitous at this point: from the short sightedness of many political institutions globally to the disputes within cultural discourse.

Along these lines of inquiry, within the context of a recent manifesto-style pamphlet, the American art historian David Joselit states in his essay "In Praise of Small" (2016):

> What should the responsibility of art institutions be at a time when the verb to curate has migrated from the context of museums to describe, for instance, the choice of amenities in a luxury real estate development, or the selection of artisanal cheeses? In this context to curate belongs to a long line of ideological practices for producing distinction. Do those of us involved in "curating" (artists, critics, art historians, institutional curators, engaged patrons) need to assume responsibility for this massive appropriation of "art" as a tool for prettifying the dominance of the 1%?[59]

Joselit writes in the wake of the diminishing support for and future prospects of alternative art spaces in New York, and concludes:

> While large institutions canonize – i.e., turn information into history – small arts organizations may pluralize its shapes (as in all species of conceptual art), as well as the stories it can tell. To make information malleable and mobile again in unexpected ways, and to resist its enclosure by elites and its reification into dominant narratives is to make art political.[60]

By keeping spaces that assert an idealized autonomy necessarily small in scale and also, correspondingly, precarious, cultural work can operate with awareness of exterior pressures yet without entirely succumbing to them. Whether "heterotopic" or not, spaces such as The Suburban, SHOW, and the Kallio Kunsthalle have hosted an abundance of events and exhibition projects. The very act of maintaining such opportunities supports different, significant trajectories for communication and dissemination, fostering experimental contexts for the future.

CHAPTER SEVEN

Emergent Notions of Subjectivity and Authorship:
How Might We Occupy the Present?

I hate to think that the art world is doomed to remain a playground where anything goes until we exit into the "real" world and have to pay our bills. But I suspect that real revolution (hardly in the forecast), not just "paradigm shift," is the only thing that would shake everything up enough to create true alternatives. In the meantime, Occupy Everything and see what happens.

—LUCY LIPPARD, 2013[1]

In this chapter I consider three examples: (1) changing formats for and means of dissemination within critical writing in the arts; (2) the Fluxus score as a form of both writing and enacting performance as a charged social event; and (3) an appraisal of artist Thomas Hirshhorn's views on "un-shared" authorship in his works, most specifically in the *Gramsci Monument* (2013).[2] I am especially concerned with how we might consider the shifting aspects of authorship and initiation of artistic projects; however, the trio of sections here reconsiders art writing and subjectivity, lessons learned from historical modes of performance, and the revisiting of a recent high-profile public artwork. My argument involves less an emphasis upon particular models for individual or collective practice than a spectrum of approaches that could both reassert an authorial autonomy and exemplify awareness of the lateral movement between roles that we, as subjects, occupy today.

Are today's artists more comfortable with shape-shifting and mutability, or is this an inevitable effect of the climate of precarity that is so ubiquitous and often determinative of ways of making decisions and moving forward? This chapter amounts to a circular series of discussions, speculating once again and trying to link questions such as: how might criticism matter? How might scores that are temporally distanced from us ignite the imagination again, performing as texts and as live experiences? What are we doing as authors? What might different notions of authorship do for us?

I have proposed in much of this book that the roles of artists are shifting radically and have been for decades. This presents a challenge for critical writing in the arts, especially as it has become increasingly difficult since the end of the twentieth century to maintain a notion of an author as occupying a privileged orientation towards the work, enabling them to describe, detail, and decode its specific meanings. Whether this can be a tenable and workable way of outlining this process remains to be seen. But a question emerges: as artworks become ever more contingent and dispersed, how does that impact the corresponding strategies for addressing such works?

Writing towards Dispersed Practices through Dispersed Voices

Almost two decades into the twenty-first century, criticism finds itself pressured by new technologies that hover on the cusp of being emergent and anachronistic. Although

criticism is far from dead, questions can be raised as to its current health and future prospects.[3] Many of those sceptical about the contemporary relevance of criticism are asserting the fact that the premises guiding much earlier criticism are less viable when discussing the newer approaches, attitudes, and configurations of recent art practice. This is particularly the case when addressing works that involve collaboration and dialogue, mediated modes of communication, and the myriad forms that defy easy classification.

There are those who seek to cordon off criticism, either as a kind of academic writing, or as promotional texts geared towards serving the interests of various institutions besides their audiences. The contexts in which critical essays are commissioned, written, and disseminated have shifted dramatically in recent years. As art criticism has been rather polemically termed by scholar James Elkins (among others) as "writing without readers",[4] I am interested in whether this is an accurate assessment: who is actually reading criticism, how do they choose what to read, and how does this impact contemporary practice?

In *Right About Now* (2007), an anthology of texts by artists, critics, and theorists, the editors proposed that "the art that has been produced in the last fifteen years has generated virtually no theoretical reflection or historical contextualization".[5] This operates as a broad generalization to contrast the recent era with the period of labelling – pop, op, minimal, conceptual – that diminished after the 1960s. But whether one salvages any truth from this hyperbolic statement or not, it is relevant to consider whether the diversification and dispersion of contemporary art practice has contributed to the dilution of significant critical commentary.

Art criticism has always been a precarious, marginal activity, such that proclaiming a crisis in the field could appear strange. Indeed, criticism functions and often thrives in part due to its very marginality and its ability to question received assumptions. Yet art writing is often perceived to be jargon-ridden and superfluous, demonstrating little effort to challenge or test its own largely self-imposed limits. What might offer a way out of this predicament? The shifting, mutable critical voices careening and chattering through the electronic ether in the form of blogs and other digital interfaces and phenomena are reshaping the contexts in which we read critical writing; social networks and digital environments enable user-driven processes of collecting, scavenging, sampling, collaging, commenting, and suturing together.

Writing about art is a game whose rules are elastic, changing according to eras, audiences, and models of production/dissemination. Notwithstanding the amount of graduate programmes now dispensing degrees in criticism, such writing has often come from those working in other fields: poets, novelists, artists, journalists, and essayists. (Although full- or part-time positions as a working critic are almost non-existent.) In my own case, I am often not pondering the philosophical context of criticism; I am instead more influenced by the following: tight deadlines, short word counts, targeting audiences, and the attempt to be informative and engaging within the constraints of a limited space, about topics too often considered obscure or irrelevant to readers' lives.

We live in a climate characterized by distraction. Given this, it might be helpful to return to remarks theorist Walter Benjamin originally made in reference to cinema and its impact on the audience:

> The technological reproducibility of the artwork changes the relation of the masses to art. The extremely backward attitude toward a Picasso painting changes into a highly progressive reaction to a Chaplin film. The progressive reaction is characterized by an immediate, intimate fusion of pleasure – pleasure in seeing and experiencing – with an attitude of expert appraisal. Such a fusion is an important social index. As is clearly seen in the case of painting, the more reduced the social impact of an art form, the more widely criticism and enjoyment of it diverge in the public.[6]

This is not so distant from us when one considers YouTube and other phenomena merging the social, aesthetic, and the experiential within spectacular entertainment. We are well on from 1939 and Benjamin's own specific context, but his prescience in terms of recognizing foundational moments in modern culture has few equals. When Benjamin speaks further of a "reception in distraction […] [film] encourages an evaluating attitude in the audience but also because, at the movies the evaluating attitude requires no attention. The audience is an examiner, but a distracted one",[7] he seems to speak uncannily toward our own era of intermingled distraction and reception manifest in the model most used for circulating criticism.

Blogs are simultaneously inconsequential, archived, commented upon, up-to-the-minute, mercurial, transitory. But this does not undermine their numerous effects. To dismiss blogs as lacking in importance is to miss the point. We must welcome distraction and commence our analysis from that point. As Jill Walker Rettberg notes:

> A literary critic will rarely see the binding of a book as being important to its literary quality. A blog, however, cannot be read simply for its writing, but will always be seen as the sum of writing, layout, connections and links, and tempo.[8]

Criticism was historically an amateur pursuit; a vocation reflecting the term writer Dave Hickey has often used to refer to participants in the art world: "volunteers"[9]. The blog – apart from the vast amount underwritten directly by corporate sponsorship – is most often an amateur's virtual space, with a greater likelihood of being generated quickly, randomly, or haphazardly than in traditionally formatted journals, magazines, and newspapers.

I am currently fascinated by the manner in which many of the best contemporary writers in the arts work across a spectrum of voices and styles, among them Fred Moten (poetry, long-form critical writing), Maggie Nelson (poetry, non-fiction essays and books), Wayne Koestenbaum (poetry, critical essays), Chris Kraus (novelist, critic), and Hilton Als (short-form criticism, experimental prose). While all of the above writers are distinctly professional, they take risks by opening up opportunities to reinvigorate their texts; to consider the poetry embedded in prose, as well as the converse – works that operate self-reflexively, but with reference to the surrounding lived world; art no longer walled away in some formalist vacuum, yet also pressured by the inescapable traumas and worries of the everyday. Multiple voices are at play in works such as Nelson's memoir *The Argonauts* (2015) or her musings on performance in *The Art of Cruelty* (2011), Als' collection entitled *White Girls* (2013), or Moten's essays, criticism, and poetry, all of which respond to existing contexts and generate altogether new ones.

By managing to take on so much, Maggie Nelson's *The Argonauts* has become a defining work in a relatively short time. Its visceral descriptions of bodies, coupling, and procedures sometimes distract from what the work is really about (and it is "about" so many things): fluidity and the complicated relations between the fluidity of self we both take on and are granted anyhow, despite any of our choices; and the love we encounter and shape with others. *The Argonauts* is a memoir of the author's life with her partner Harry Dodge, a performance, video, and installation artist who is undergoing transgender surgeries during the course of the book, while the couple also parent a new baby along with Dodge's son from a previous relationship.

Nelson has written many previous works, in particular around grief, violence, and intense experiences, as in a study of her aunt whose murder case became a long-unsolved "cold case"; and in *The Art of Cruelty*, which dealt with the violence within avant-garde art and popular culture. But *The Argonauts* is a brave book written with a meditative, even gentle spirit of inquiry. Love stories are intricate and complicated no matter what their surrounding circumstances. In Nelson and Dodge's case, they dialogically interrogate the relative incapacities of language throughout the course of the book, whether in speaking of pronouns demarcating social assumptions, personal identities never entirely synchronous with one another, or the inability of language to ever be clear, encompassing, meaningful.

Returning to the title of this book – *Across the Art/Life Divide* – to keep a division between these binary terms is to maintain the pretence that art can simply carry on, unaffected by goings-on in the broader world. Art being ever more incorporative must involve strategic responses to its context or diminish in efficacy; not necessarily as a tool of social action, but as a statement of conviction, nevertheless inclusive of doubt and ambivalence. Instead of asking "what is an author?", we might ask "who are authors?" in that a state of multiplicity is central to considering practices of writing; to be many at once without splitting chaotically, and to have empathy for others while in the midst of negotiating our own roles and voices.

Fluxus and its Scores: Re*listening*, Re*reading*, Re*living*

Fluxus event scores exist within a number of formats, including the archival art publication, snippets of audio and visual documentation, reenacted performances, and the circulation of written scores through art publications and digital networks. I wonder what happens when one wipes away the dust to reconsider the implications of these orchestrated actions, movements, recitals, pranks, and acts that tread a line between the destructive and violent, the whimsical and meditative. Rereading Fluxus scores, we encounter social microworlds, their coordinates mapped by a loose collective of multigenerational, multicultural, multiethnic, multilingual beings: a crowd/hive which hummed – or spoke, screamed, sang, shouted – loudly at points throughout contemporary art history.

As discussed earlier, the impact of Fluxus is clearly evident yet frequently overlooked. Examining the generative importance of performative texts to this non-movement is essential. Fluxus continued by convening sporadic festivals and socially engaged events; parties if you will. And the lingering effect – especially if the likelihood of the party now is to resemble a bit

more of a dispersed community or a séance-like deterritorialization – is to engage with the thoughts that link and connect past and present. The enduring immediacy of Fluxus scores as modes of performative address assists in bridging this temporal chasm.

To notice, make note of and respond creatively to the surrounding world in its everyday varieties – this is a key concern of so many contemporary artists of the twenty-first century, and this synchronizes closely with the goals of the Fluxus artists. Fluxus scores are now/then, political/apolitical – multiple frameworks colliding. My interest is in returning to the deceptive simplicity of the Fluxus score, and to scratch into some of the accumulated patina on the historical record of Fluxus so as to reencounter these texts as living entities. As a student of mine recently remarked on reading Fluxus scores, "[i]t's as if I'm allowed to do these as well". This raises questions concerning authorship and art as an act of gifting, and the fact that once you have read, or seen, or reenacted a Fluxus score, you can never undo that experience.

The Great Bear pamphlet entitled *by Alison Knowles*, published in 1965 by Something Else Press, collected a number of early scores by the artist. Knowles' descriptions of actions and gestures are concise, tersely stated triggers for one's imagination. Number one is *Shuffle* (1961) in which "[t]he performer or performers shuffle into the performance area and away from it, above, behind, around, or through the audience. They perform as a group or solo, but quietly".[10] What is striking here is Knowles' use of the qualifier "quietly". How often is an artwork presented as a quiet shuffle around the audience rather than a spectacular, forced attempt to gain its allegiance? Number two is *Proposition* (1962), likely Knowles' most famous work, exhorting the reader to "[m]ake a salad".[11] Knowles has directed the making of salads at art venues for more than 50 years since. (Number three is an alternative version of number two: "Make a soup".)[12] The *Nivea Cream Pieces* (#s 4 and 5) (1962) involve directing performers to rub cream onto their hands in front of a microphone, and to apply to their arms and face as well.

Although you might get the gist of the actions contained in the small book from the above citations, there are many more, such as *#15 Wounded Furniture* (Summer 1965) (damaging old furniture further, then bandaging it), *#4 Child Art Piece* (December 1962) (one or both parents assisting a 2–3-year-old with a pail or a banana), *#6 Shoes of your Choice* (March 1963) (describing your current shoes or another favoured pair), *#10 Braid* (March 1964) (finding something to braid), and *Variation #1 on #10* ("*String Piece*", April 1964) (tying up the audience).[13]

While Fluxus scores used everyday objects as a starting point for investigations – whether paper, shoes, shaving cream, water, kitchen utensils, or food items – they generated an intersubjective experience rather than being treated simply as material entities. Art historian Julia Robinson perceptively articulates the difference between the treatment of objects by Knowles and pop artist Claes Oldenburg:

> Between the rendering of one perception and that of many stands the intervention of the score. Oldenburg's art works through the object, Knowles's through the subject experiencing it. Where Oldenburg created a loaded-up sandwich, a lumpy, drippy

#2 —

Proposition (October, 1962)

Make a salad.

Premiered October 21st, 1962 at Institute for Contemporary Arts in London.

Misrult 1962

7.1 Alison Knowles, *Proposition #2 Make a Salad* (1962). Event Score. Courtesy of the artist and James Fuentes Gallery.

7.2 Alison Knowles, *Make A Salad* (1962). Courtesy of the artist and James Fuentes Gallery.

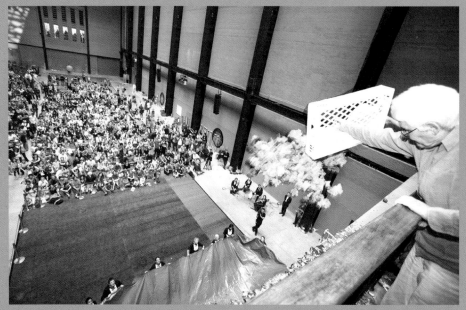

7.3 Alison Knowles, *Make A Salad* (2008). Tate Long Weekend, London. Courtesy of the artist and James Fuentes Gallery.

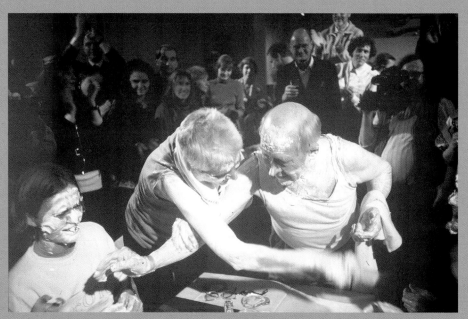

7.4 Alison Knowles, *Nivea Cream piece for Oscar (Emmett) Williams* (1962), 1992 performance with Emmett Williams in London. Courtesy of the artist and James Fuentes Gallery.

hamburger, or food items in a glass display case, Knowles dealt with the topic of the sandwich by creating a shareable performance like *The Identical Lunch*.[14]

The work in question involved sharing an identical tuna sandwich, and was drawn from Knowles' own daily lunch ritual of the late 1960s.

The Fluxus event scores took musical scores as their point of reference, but quickly departed from standard musical forms, although many of the Fluxus ideas derived from John Cage's experimental notions of compositions. Many, if not most, of the central Fluxus artists were highly skilled musicians, including Charlotte Moorman, Nam June Paik, and Ben Patterson. Composer Earle Brown was also very influential in this regard, as scholar Anna Dezeuze has noted:

> While George Brecht followed Cage in singling out Earle Brown's scores for the range of choices they offered the performers, the event scores written by Brecht and other Fluxus artists took this form of experimentation one step further by removing abstract musical notation altogether, and reducing the score to verbal instructions. The freedom given by Earle Brown to his musicians was extended to any possible performer: neither musical training nor a concert situation are required to perform Fluxus scores. The conception of music as an "activity", pioneered by Brown, was taken to new lengths by Fluxus artists as they decided that music could be redefined as incidental to any activity. An activity could be performed that produced noise, imperceptible sounds, or even no sound at all. It could take place anywhere, and for durations exceeding the span of a public performance.[15]

The comparative latitude offered by a score that launched improvisational activity became a wellspring for new experiences in performance. As Fluxus artist and historian Ken Friedman notes: "With Fluxus, it is important to consider the musical nature of the work. In performing events, the work is not reenacted, but performed or realized from the score. That said, the work can always be reinvented through reinterpretation".[16] Musician and theorist Paul Hegarty further comments that "[t]he score becomes a recommendation, a way of encouraging chance sounds or actions. Retaining the instructions prevents chance or aleatoriness from turning into personal interpretation of 'mood' or 'moment'".[17]

Thus, music and silence, fixity and indeterminacy coexist in a precarious mix. As Knowles states:

> John Cage's experimental music composition class is very important because Cage's definition of experimental was that "when you begin the piece, you don't know what it will be like at the end," which in terms of musical compositions knocks down the whole developmental approach to composition. The freshness of his experimental approach kicked off this group to be able to face an audience and do a piece in which the outcome of the piece was not known in advance.[18]

Cage, in the sort of gesture that would be highly unlikely today, opened his course to students from a variety of disciplines, some having no formal musical training. A major factor

in the course was its emphasis on increased attentiveness to that which was not tradition-ally accepted as musical: everyday sounds and noises; philosophical musings; scientific and technological developments; and the intensive incorporation of chance and spontaneity into creative practice.

As Cage biographer Kenneth Silverman writes:

> Working with a Cagean democracy of material, the students produced intermedia works involving radios, toy whistles, cellophane, paper clips, colored flashlights, light-bulbs, objects they made themselves. Cage also had them create pieces on the spot in class, having at their disposal the room's piano and percussion instruments, as well as Oriental instruments Henry Cowell had used for his New School course in world music. "We all felt something terrifically exciting was going on in that class," Kaprow recalled; "I just couldn't wait to get back there every week." Many of the students shared [artist George] Brecht's view of Cage as "the great liberator".[19]

Accounts of Cage's course evidence his passionate encouragement of inventiveness within a supportive climate during a period (the Cold War era) when such things were entirely need-ed. Artist Dick Higgins notes:

> [T]he best thing that happened to us in Cage's class was the sense that "anything goes," at least potentially. [...] [T]he main thing was the realization of the possibilities, which made it easier to use smaller scales and a greater gamut of possibilities than our previous experience would have led us to expect. Ultimately, of course, this contributed to the development of the happening.[20]

Cage's notions exemplify the shift toward a practice directly and reciprocally engaged with life:

> Our intention is to affirm this life, not to bring order out of a chaos or to suggest im-provements in creation, but simply to wake up to the very life we're living, which is so excellent once one gets one's mind and one's desires out of its way and lets it act of its own accord.[21]

Therefore, and paradoxically, artists are creating too much interference in life with their ac-tions, according to Cage. If artists open themselves more fully to life, it will become a much more enriching experience.

In his study *Avant-Garde Performance and the Limits of Criticism* (2000), Mike Sell com-ments that "the scripts and memoirs surrounding event art are oddly melancholy souvenirs, objects that evoke memory and inspire aesthetic production":[22]

> [...] The thing about these art events that makes them so fascinating – and so useful for all kinds of dissident performance in a postmodern era – is that they are a textual form of "bad memory" that is always available for new performances, morsels for the

beloved's tongue. As scripts they continually allow the reader-performer to reconfigure the past for present purposes. [...] Art events – whether Happenings, Fluxus – are the myth of an art form that compels us away from the past and into our own localities, our own unknowables.[23]

Sell's remarks are resonant concerning the simultaneous displacement in time but residual immediacy of the Fluxus score/text:

> A productive, enticing gap exists in our ability to know event art; that much I think is clear. The politics and economics of these kinds of events highlight the politics of memory in late-capitalist culture; the materiality of the event, the desires of the moment are left behind like a well-thumbed promptbook, the sweat of a line-worker, a dirty spoon, burned-out match, placenta. The result of this alienation, oddly enough, is a strange kind of liberty for the events and their participant-members, a peculiarly unalienated existence in the wilds of historical memory and theory that is distinct from other vanguard movements of the 1960s.[24]

There are instances when one can nearly leap across that gap or, conversely, the Fluxus performances can leap forward into a striking contemporaneity. Reading in 2016 of a bookshop café in Cairo in which, owing to everyday stresses and restrictions upon free speech, patrons are invited to scream in an adjacent, ostensibly soundproof room – a kind of catharsis for hire – again recalls Fluxus artist Dick Higgins.[25] His 1962 *Danger Music No. 17,* score reads, "Scream!! Scream!! Scream!! Scream!! Scream!! Scream!!"[26] The implicit danger involves what might happen to any individual who locks their screams inside rather than letting them go.

In the Fluxus scores, one still encounters a clear notion of authorship; voices are confident, unswaying, exhorting, commanding. (This also took form along a wide spectrum between the intentionally blurred, myriad dynamics of collaboration, to the artist George Maciunas' idea of removing bylines of individuals in favour of the collective nominal designation "Fluxus".) Alison Knowles has specified:

> I'm not at all flexible or loose about what goes on. Such as *Make a Salad,* one is only making a salad. I've sometimes had people try to interject ideas or performances of their own but this is not allowed because what I want people to do with the piece is to see how really simply things can be done if you concentrate on that that's what you're doing. You're only making a salad and these are the best salads.[27]

With so many of the Fluxus scores, one confronts a complex intermingling of emotional and psychological registers. There are elements of flirtation, sexuality, seduction, and abandon. The over-the-top physicality of the hand cream, especially if moved elsewhere on the body, remains messy, sticky, and slapstick-comical. Scored directions by a woman artist become a proto-feminist or directly feminist statement. And in *Child Art Piece* there is a parental authority, but with a freeing slippage of authoritarianism. What is childlike art without children, without extended and often unconventional familial units, without the meeting up and convening of different generations?

7.5 Dick Higgins, *Danger Music No. 17* (1962). New York, Museum of Modern Art (MoMA). Gelatin silver print, image: 9 5/16 x 7 5/16" (23.6 x 18.5 cm); sheet: 9 15/16 x 7 15/16" (25.2 x 20.2 cm). The Gilbert and Lila Silverman Fluxus Collection Gift. © 2017. Digital image, The Museum of Modern Art, New York/Scala, Florence.

7.6 Yoko Ono, *Cut Piece* (1964). Performed by the artist at Sogetsu Art Center, Tokyo, Japan. Photo by Minoru Hirata © Yoko Ono. Used by Permission/All Rights Reserved.

In a retrospective discussion of the legacy of Fluxus, Bracken Hendricks, son of artist Geoff Hendricks, noted:

> We [children of Fluxus] were part of the creative process, and part of our child identity and our child's way of comprehending the world was appreciated, embraced, and bolstered. So it's a question of what was the art, what wasn't the art, what was the history, what wasn't the history, what was really going on in those experiences, and was it where the light was shining or was it what was happening outside the light? These questions are very rich. A piece of what Fluxus can contribute is the elevation and the real connoisseur's appreciation of things that are trivial or small or not embraced or empowered. It's finding that beauty is much more accessible and that meaning is much more present, so there's this kind of opening and liberating experience to it.[28]

Historian Kristine Stiles has pointed out the relative absence of discussion of "anomaly and sex" in the accounts of Fluxus objects and actions, the former being a term with which Stiles replaces Dick Higgins' use of "iconoclasm". Stiles goes on to list a host of terms synonymous with "anomaly":

> [They] present a scale of meaning ranging from the odd and abnormal (and therefore commonly thought to be unnecessary and unwanted) to the incomparable, unrivaled, and unsurpassed. In between these extremes, the normative and conventional hold sway over the suffocating institutions that govern and control most of life. [...] Fluxus artists habitually located their subjects at the extreme ends of convention, without ever directly rejecting it, precisely to avoid and simultaneously, to alter, the center.[29]

With works such as Ben Patterson's *Lick Piece* (1964), the carnal extent of performance art and its modes of acceptance of sheer sensual physicality are challenged, as are the codes of the time, in terms of both racial and gender politics: "Cover shapely female with whipped cream/lick/ [...] topping of chopped nuts and cherries is optional".[30]

In reconsidering this performance, writer Fred Moten compares the work in context with artist Carolee Schneemann's *Eye/Body* (1963), for which she was not well-received by George Maciunas, who disparaged her work as "messy" (along with using other unfavourable and disparaging epithets). The explicit use of representations of Schneemann's own body serves an interesting counterpoint to Patterson's staging of another unclothed body.[31]

Retrospectively, Schneemann has stated, "I am 'provisional fluxus'; I really come out of Happenings, where real materials seem to be more complex, more physical, and messier".[32] In Moten's estimation:

> [Patterson] must remain unheard and invisible. The unrecognizability of the black male artist is part of the general constitution of the atmosphere – we'll call it the art world – within and out of which Patterson's work emerges. [...] Anticipated by Schneemann, whom he anticipates, Patterson is subject to a double exposure. Overexposed, in the glare of the nothing that is not there and the nothing that is, he disappears.[33]

To which it's also important to note the comparative invisibility of so many of the Fluxus art-ists, both in relation to the types of works they were making – largely performed, interdisci-plinary, multiple and uncategorizable – and their identified positioning as coming from many diverse backgrounds and origins. Hannah Higgins further notes of *Lick Piece*:

> [T]he display of a black man licking whipped cream off a white woman (only later would the piece be performed with women of colour) produces the oblique view that acknowl-edges the open secret of our subjugated bodies, the one female in the performance and the one black man exposing the deeper mechanics of the normative relationship between the clothed and the nude, the black and the white, the male and the female.[34]

Lick Piece is rightly controversial for the manifold problems within which it functions, although it disrupts expectations as well. Perhaps it provides a curious mirror image to Yoko Ono's con-temporaneous *Cut Piece* (1964), in which viewers were invited to remove the artist's clothing using a pair of shears, which elicits a more visceral conjuring of violence and vulnerability.

While *Lick Piece* might be construed as a sexist objectification of the "shapely female", the responses to the piece and variants in its later performances are complex. Patterson re-enacted *Lick Piece* using inflatable objects, including a cartoonish alligator and a kitschy rendering of Edward Munch's *The Scream* (1893), choices emphasizing the slapstick absurd-ity of the work over its conflicted sexual politics.

In *Lick Piece*'s early 1960s iteration, artist Lette Eisenhauer played the role of the "shapely female" in question, and she has commented on the particular significance of the work during a "sexually conservative period": "I thrive when shocking people while presenting myself as a 'socially proper' woman".[35] Patterson later included music from *Tristan and Isolde*, and stated:

> Everybody is now invited to come with chopsticks rather than licking. This little bit of distance between the actor and the subject everybody fills in with their thoughts and their minds but not physically so it's more interesting that way than licking. I don't think I thought of it as being an exploitative situation.[36]

The African American performance artist Clifford Owens states:

> In the canon of performance-art-history, we just don't exist. We're invisible. The only artists who are part of the canon are the two usual suspects: David Hammons and Adri-an Piper. It's as if US black artists didn't do any performance art at all since the '50s.[37]

In Owens' case, he has been amassing a large array of performance works in recent years, many of them responses to and restagings of historical works. These include a series of Ben Patterson's Fluxus scores (including *Lick Piece* in 2006) and *One for Ben Patterson* (2011) which comprised a nude body print of the artist using coffee grounds and Vaseline, made onto a large sheet of paper, while enlisting the assistance of audience members.

Owens actively excavates, interrogates, and reanimates performance works of the past, but in so doing they are refocused and recharged in their relation to the present.

7.7 Clifford Owens, *Four Fluxus Scores by Benjamin Patterson* (Lick Piece 1964) (2006). Three archival pigment prints; 30 x 40 inches each. Courtesy of the artist and INVISIBLE-EXPORTS.

7.8 George Maciunas, *Fluxus Manifesto* (1963). New York, Museum of Modern Art (MoMA). Offset, 8 3/16 x 5 11/16" (20.8 x 14.5 cm). The Gilbert and Lila Silverman Fluxus Collection Gift. © 2017. Digital image, The Museum of Modern Art, New York/Scala, Florence.

In a 2009 roundtable discussion, Alison Knowles pointed out:

> I think what is very important to speak about is how fluid were the interstitial spaces of the arts. That Barbara [Moore] would be publishing a book of somebody's and Carolee [Schneemann] would be in a Happening, I would be working on some event on Canal Street with La Monte [Young] and, certainly, George Brecht. It's only in the last few decades that the traditional boundaries have raised again. So one is again studying painting as opposed to sculpture, as opposed to performance and I hope to really stand against these borders.[38]

It is relevant also to cite comments from Japanese Fluxus artist Mieko Shiomi:

> [T]he best thing about Fluxus, I think, is that there was no discrimination on the basis of nationality and gender. Fluxus was open to anyone who shared similar thoughts about art and life. That's why women artists could be so active without feeling any frustration.[39]

Yet, given a remark such as Shiomi's, it is significant also to consider the frequent acts of "excommunication" of Fluxus artists by George Maciunas (much like previous avant-garde ringleaders such as the surrealist André Breton). While not always considered that serious or binding by certain artists such as Dick Higgins and Knowles – an exclusion that affected male as well as female artists – this seemed entirely contrary to the generally very open "spirit" of Fluxus.

Performance historian Kathy O'Dell writes:

> It is my contention that the root cause of these [exclusionary] practices, at least in part, has to do with the relationship in the work between *body* and *text*. And I mean these terms to be taken in the most down-to-earth way: body, as the actual physical entity of the artist; text, as the words the artist uses or produces. More to the point, it is, perhaps, the threat this relationship poses to dominant forms of power, when exploited – especially by women – that prompted dismissal of certain artists and/or certain of their works from the canon of Fluxus production.[40]

All of the above highlights the issue that Fluxus itself is often read as involving "messy" contingencies; that it somehow does not add up to a cohesive force, which simultaneously aids Fluxus as a kind of guerrilla element of art history, and leaves it by the wayside as ultimately too difficult to incorporate into a more streamlined canonical timeline. To be noisy, messy, excessive, provocative, but not curtail this into a univocal statement or modify it into a legible whole, provides a perpetual challenge, but lives up to the very use of the term Fluxus as "flowing or fluid discharge from the bowels or other part: esp. an excessive and morbid discharge; as the bloody *flux*." (re: the very dictionary definition collaged into Maciunas' own 1963 *Fluxus Manifesto*).[41]

The challenging, the open-ended, the worrisome, the tendentious: Fluxus scores unfold onto territories of thought that are, as evidenced above, still ripe for investigation, research,

evocation anew. Particularly to run contrary to a tendency to "disappear" such practices or control them hierarchically in terms of scholarly representations. These texts that exemplify and enact embodied experience have left a lengthy, intergenerational legacy. For those the artists of the 1960s and 1970s inspired, there is much that has occurred since; and as I outlined in Chapter 2, sometimes as gleaners of the residue of that sensibility or as an incitement to enact events that I am allowed to do as well. Perhaps works that were in no small part once initiated as aesthetic provocations are now textual incantations, spells we may recast to elicit renewed energies concerning performative engagement across an increasing temporal divide.

Hirschhorn: "Unshared Authorship", Temporal Projects, and Agency

In the summer of 2013, the Swiss artist Thomas Hirschhorn created an ambitious public artwork commissioned by the Dia Foundation entitled *Gramsci Monument* in the South Bronx's Forest Houses housing project, one of the 300 apartment complexes operated under the New York City Housing Authority (NYCHA).

The artist initially searched for a location and discussed his proposal with several NYCHA properties and their management. Forest Houses representative Erik Farmer lent the most sympathetic ear to Hirschhorn's pitch. It appears the two were very lucky to find one another. *Gramsci Monument* was the fourth in a series of public artworks created by Hirschhorn, occurring subsequent to his *Spinoza* (1999), *Deleuze* (2000), and *Bataille* (2002) *Monuments*.

The work encompassed a wide range of activities and events, situations and contexts within the grounds of the housing project. As curator Yasmil Raymond states:

> Quite precisely, *Gramsci Monument* would involve building a complex of rooms and elements – a stage, internet room, workshop, lounge, library, exhibition space, sculpture-pool, bar, banners, newspaper office, and radio station – and these spaces would be complemented by a series of daily and weekly programs, some scheduled in advance, others determined on-site by the residents or the artist.[42]

The spatial infrastructure was built from recycled plywood and other materials that preserve a provisional, ad hoc quality consistent with the artist's characteristic aesthetic of using materials accessible to anyone – although in Hirschhorn's case, massive quantities of them.

Handmade signage and banners adorned many of the surfaces of the structures and the surrounding buildings, mostly displaying quotes from Italian Marxist Antonio Gramsci (1891–1937) such as: "Every human being is an intellectual"; "Quality should be attributed to human beings, not to things"; "Destruction is difficult; it is as difficult as creation". And if these aphorisms did not make the case that Gramsci was an enduringly relevant reference, there was the library containing many volumes on the theorist and his work, as well as regular philosophical lectures and seminars. Gramsci's development of the notion of hegemonic power and the replication of same throughout public life via institutions certainly could have an amplified resonance in one of the most economically underserved areas of the United States,

7.9 Thomas Hirschhorn, *Gramsci Monument*, Forest Houses, Bronx, NY (2013). © Thomas Hirschhorn. Photo courtesy of Romain Lopez and the Dia Art Foundation, New York.

7.10 Thomas Hirschhorn, *Gramsci Monument*, Forest Houses, Bronx, NY (2013). © Thomas Hirschhorn. Photo courtesy of Romain Lopez and the Dia Art Foundation, New York.

7.11 Thomas Hirschhorn, *Gramsci Monument*, Forest Houses, Bronx, NY (2013). © Thomas Hirschhorn. Photo courtesy of Romain Lopez and the Dia Art Foundation, New York.

7.12 Thomas Hirschhorn, *Gramsci Monument*, Forest Houses, Bronx, NY (2013). © Thomas Hirschhorn. Photo courtesy of Romain Lopez and the Dia Art Foundation, New York.

but among the most relevant factors were those making available free and inexpensive services over the summer at Forest Houses.

Artist and educator Lex Brown, organizer of the site's Children's Workshop, notes in retrospect that rather than any shortcomings in terms of education opportunities for the children involved, one failure was "the lack of free food for the kids"[43]. However, she cites both Hirschhorn's interest in "unshared authorship" and the importance of love in relation to the project's relative successes: the former, while theoretical and conceptual, is evidenced through experience; the latter demonstrates a practical commitment beyond theory and concept via active engagement. In Brown's words:

> "Unshared authorship" is the term Thomas uses to describe a project in which multiple authors are making contributions under the terms of coexistence rather than collaboration. Group collaboration is a model for work celebrated in both art and corporate culture, but it can replicate the dynamics of a high school assignment. One person ends up taking over, three people are slacking off, and everyone else wants to pitch in but it's too hard to agree. Even if the project is deemed a success, people might be left feeling slighted, resentful, or used.[44]

Prompted by receiving a note from Semoni, a 9-year-old former student, one month after the project, which read "[y]our love is in my bare hands", Brown realized that "the love I got to give and receive was more real, lasting, transformative, and important to talk about than anything else".[45] Brown also recounted:

> Love in a social context is often dismissed as sentimental, superficial, or naïve, but in reality it is tough, powerful, and complex. Real love is not pity, charity, or an opportunity. During the monument I learned that love is showing up, again and again, and doing your work because you believe in it. It is listening to other people with the knowledge that you don't know everything – even about yourself. In the time since *Gramsci Monument*, I have learned that to be loved is to have your love received.[46]

This is a powerful statement reflecting the affective power for participants and those coexisting with the work. In addition, the affective dimension of the work is often scrutinized in terms of ostensibly tangible outcomes rather than reciprocal, interpersonal exchanges.

Although Hirschhorn's work has been associated with an "archival" impulse in art, *Gramsci Monument* resembled more of a fantastical, living organism or laboratory, involving distinctly temporal boundaries between July 1 and September 15, 2013. This raises a key question as to what the residual outcomes of the work actually are, and the ultimate effect of many durational activities occurring on-site, exemplifying Hirschhorn's credo "more is more".[47] Hirschhorn's practice intrigues me, particularly as the *Gramsci Monument* is in many ways a relevant descendant of some of the artworks and approaches to art practice I have discussed previously, and embodies contradictions that are not easily resolved, remedied or put aside, while also acting as a vibrant example of twenty-first century site-responsive art.

A project like *Gramsci Monument* operates amidst many pressing challenges of our time, and has been critiqued sharply by scholar Grant Kester for its perceived inability to account for its residual effects while benefiting from both huge art market backing, and the charged atmosphere and credibility on offer from a community project. Kester levels the accusation that Hirschhorn makes a work in the vein of community practice without taking on the responsibilities towards the community that such a gesture entails:

> [Hirschhorn] was able to retain his "purity" precisely by refusing to take any responsibility for the disappointment, frustration or disillusionment of those residents when, after eleven weeks, these resources, and the accompanying outpouring of public concern that the neighborhood had enjoyed, were abruptly withdrawn. The lesson, for the residents of Forest Houses, was that in the absence of the artist's charismatic personality (and funding sources), "art" as such is no longer sustainable. For Hirschhorn, the practices and methods of creative transformation necessary to produce more sustainable or meaningful change in Forest Hills are dismissed as intrinsically uncreative "social work".[48]

One reaches an impasse when critiquing an artwork for not accomplishing what it arguably did not intend to accomplish in the first place. Hirschhorn has repeatedly maintained that his projects are explicitly temporal, and often makes extreme statements that function more as contradictory propositions or pointed provocations than as clarifying mechanisms. For Kester, an advocate of dialogical, collaborative projects, Hirschhorn's *Monuments* are art world business as usual – although in this case, instead of an art fair, a circus-style event with ambiguous intent.

With regard to the strength of socially engaged projects historically, Kester continues:

> [F]ar from violating the purity of the aesthetic, socially engaged art practices often represent a compelling re-articulation of it, involving as they do many of the key features we have come to associate with aesthetic experience, including the suspension or disruption of habitual forms of thought, the cultivation of an openness to our own intersubjective vulnerability, and a recognition of our own agency in generating normative values. In order to develop a more substantive theoretical analysis of socially engaged art, however, I do believe it's necessary to challenge the singular privilege we've been taught to assign to art and the personality of the artist, and to acknowledge that art exists along a continuum with a range of other cultural practices that hold the potential to produce disruptive or counter-normative insight.[49]

Hirschhorn himself, a prolific writer and rapid-fire speaker, stated during the preparations for *Gramsci Monument*:

> [T]he real question, my hope, my ambition and also my problem – as the artist – is and will be: Are the residents coming to the Gramsci Monument? Are the residents having fun? Are the residents establishing a dialog or a confrontation with what the Gramsci Monument will produce? Are the residents hanging out there? Are the residents feeling

implicated? Are the residents making encounters? Are the residents exchanging with other residents they did not know before? Are the residents seeing something of interest to them in the Gramsci Monument output? Are the residents thinking of Gramsci's contribution to the thinking of today? Are the residents enjoying the artwork? Are the residents contributing to the achievement of an event?[50]

While Hirschhorn's remarks can be so unwavering as to be off-putting, his approach is strongly derived from his art influences – Andy Warhol and Joseph Beuys most clearly: the former because Hirschhorn himself (like Warhol) moved from training in design and also uses vivid, directly presented imagery drawn from existing cultural sources; the latter in the way Hirschhorn seeks to make claims for a more "social sculpture", amalgamating both in adopting Warhol's insistence that almost anything (he touched) could be art, and Beuys' provocation that "everyone is an artist".[51]

But beyond these influences, within this particular context, I would in addition recall affinities with Fluxus artist Robert Filliou's approach, both aesthetically (unafraid to make things "badly") and discursively (speaking to and with others). But while Filliou benefited from some modest grants and patronage (as I noted in Chapter 2), he was never afforded the economic benefits extended to the likes of Hirschhorn. Art historian Anna Dezeuze has discussed the influence of artists such as Beuys, Filliou, and Brazilian artist Hélio Oiticica on Hirschhorn's practice in her book on the *Deleuze Monument*. Hirschhorn was impressed by the relative poverty of Filliou's materials in relation to their artistic ambition and impact. Dezeuze notes further:

> The power of Oiticica's and Filliou's works lies, for Hirschhorn, in a celebration of live energy – be it "lived experience" (*vivência*), celebrated by Oiticica in the face of the repressive dictatorship of 1960s Brazil, or an "art of living," which Filliou frequently equated with art. [...] What distinguishes Hirschhorn's stance from theirs, however, concerns the relation of his practice to the field of work. Filliou and Oiticica both celebrated play and leisure against forms of work and productivity; they emphasised the lightness and grace of intuitions, sensations and creativity. In contrast, Hirschhorn's work appears driven by exertion.[52]

But the ongoing lectures, publications, workshops, and events of *Gramsci Monument* became integral to the project, and lent more conviction to the unwieldy entity. The responses of invited figures are both intentionally and circumstantially provocative in their implications. The poet and theorist Fred Moten recounted his experiences prior to his trip to the *Monument*, including his detention by the police:

> I rode up to the Forest Houses from Soho in a limousine called Precarity. The night before I'd been stopped and frisked in the lap of luxury. The way they say sir is worse than the way they say nigger. As property I was properly protected and therefore more than tired. I didn't think I needed this reminder, but their questioning, that interplay of menace and po theory, was a slave ship. So by the time I got to *Gramsci Monument* I'd already been there, in the grave of all, that's nothing, for a while. I mean, I'd been reminded, even before I got to the reminder, so I could rub and be rubbed in the remainder, that surplus thieves and zombies can't remember.[53]

Moten notes:

> [In] the novelty of my being down there what comes into relief is that where I was was not where they usually arrest us. This kinda shit happens every day, yeah, but not downtown so much as way uptown where I had come, now, so I could feel more free.[54]

In Moten's poem *The Gramsci Monument* (2015), an ode of sorts to the location/project and Hirschhorn's site responsive work/project, the two "projects" call back and forth:

> *if the projects become a project from outside*
> *then the projects been a project forever, held in*
> *the projects we the project they stole. We steal*
> *the project back and try to give it back to them.*
>
> […]
>
> *at the fugitive bar the food be tasting good. kitchenette's*
> *my cabin and flesh be burning in the hold. I love the way*
> *you smell. your cry enjoys me. let me taste the way you think.*
> *let me do this one more time while the project repeats me. I am*
> *replete with the project. you incompletes me. your difference folds*
> *me in your arms. my oracle with sweets, be my confection engine. hear*
> *my plea. tell me how to choose. tell me how to choose the project I have*
> *chosen. are you the projects I have chosen? you are the project I choose.*[55]

To challenge but to propel forward, to be steadfast as an author but to accept and encourage others to work alongside him, Hirschhorn has spoken frequently of two key aspects of his work: presence and production. As art critic Peter Schjeldahl writes:

> The monument is art in the mind rather than of the eye. Hirschhorn has a slogan: "*Energy=Yes! Quality=No!*" His penchant for wrapping things in miles of irredeemably ugly packing tape neatly exemplifies both principles. Beauty has no evangelist in Hirschhorn. Nor does humor, as distinct from intellectual agility and a showman's flair.[56]

Although Schjeldahl is less immediately seduced by Hirschhorn's aesthetic, he does concede:

> At the monument, I felt safely remote from the current art world's baleful pressures of ravening money and pandering institutions. The democracy of the place, levelling the artist with the kids asplash in the wading pool, brought tones of Walt Whitman to mind.[57]

Schjeldahl potentially over-romanticizes the proceedings, given the amount of art world patronage actually invested in Hirschhorn's work, and underestimates the contentiousness around the site. However, artist Glenn Ligon, when asked by *Artforum* to contribute a critical response to the work, also notes: "When Hirschhorn stepped into the projects, he tapped directly into the estimable cultural, emotional, and intellectual resources – vastly underutilized

ones, I might add – that the community already possessed".[58] Responding to Hirschhorn's comments that making art for a "non-exclusive audience" courts failure, Ligon writes:

> Indeed, it was this openness and unpredictability, and even the risk of failure, that gave the *Gramsci Monument* its vitality. Anything could be made out of it. While that has become a cliché that many artists use to mask a lack of rigor in their thinking, in Hirschhorn's case, this mutability was directly linked to his conception of art's function in the world.[59]

Hirschhorn references philosophical texts he admires in specific relation to many of his art projects, yet emphatically states:

> I hope. I dream. I want to act, and I want things to change. That is why I read philosophy. I am not interested in reading writers, philosophers, thinkers, as an artist. I am interested in them as a human being. I don't use their work for my work. I read it to try to stay alert, to keep my thoughts active.[60]

This activation clearly takes multiple forms, but speaks towards reading as at once a participatory and a performative act. Hirschhorn seeks to evoke and enact what he gains from the richness and complexity of philosophy, and at the very least indirectly import it into his own ways of inscribing meaning.

<p style="text-align:center">***</p>

In the above examples, I have sought to give some further context that might return us to some of the central themes of this book in relation to performance and performativity: new approaches to writing; the legacy of Fluxus; and the significance of socially engaged practice. The case studies I have discussed perhaps align precariously and untidily, but so it is with any discussion of contemporary art practice in a period of dispersion and excess, overestimation and disregard, instability and hybridity. How might we consider our complex present and present-*ness* during a time in which looking backwards and grasping forward seem to be our driving concerns? Mindful of the interwoven complexities of history and the flowing contemporaneous moment, I stop and wonder if I could somehow just still all this noise for a time, reflect, and truly occupy the present.

ACKNOWLEDGEMENTS

I have become acutely aware that writing a book is a very long journey (at least it was in this case), incorporating dialogue and participation, effectively blurring notions of authorship. I definitely could not have made this happen without massive amounts of input from others. That said, any errors and faults are entirely my own, and huge thanks to the many artists featured in the book, and all those who assisted with my discussion of their practices and the inclusion of representative images.

The team at Intellect Press has been incredibly helpful and supportive, and particular thanks to Katie Evans for all her work as production editor for *Across the Art/Life Divide*, and to the detailed and perceptive readings by the anonymous peer-reviewers commissioned by the press. I would like to also thank the other readers of portions of this manuscript in draft form and other selected material that eventually arrived here, especially those who offered important editorial suggestions, including: Joe Amato, Barry Blinderman, Chris Braddock, Dave Beech, Roger Conover, David Cross, Megan Dunn, Ken Friedman, Jenny Gillam, Michelle Grabner, Natilee Harren, Matthew Jesse Jackson, Maddie Leach, Aaron Lister, Schuyler Maehl, Simon Mark, Caroline McDonald, Scott Morrison, Greg Minissale, Paul O'Neill, Bruce E. Phillips, John Preus, Petri Saarikko, Anthony Schrag, Gregory Sholette, Tony Tasset, Shannon Te Ao, and Mike Ting.

Thanks to Katy Siegel for accepting an earlier version of Chapter 2 for publication in *Art Journal* during her stint as editor-in-chief, and Mel Jordan for accepting and ably steering a version of Chapter 4 to publication in *Art and the Public Sphere*. And thanks to the following publications and editors for their support of my writing over the years: *Afterimage* (Karen van Meenen), *Art Asia Pacific*, *Art Collector*, *Art Monthly* (Patricia Bickers), *Art New Zealand* (William Dart), *Art News New Zealand* (Virginia Were), *Centropa*, all at *Drain* art journal, *EyeContact* (John Hurrell), *The Listener* (Guy Somerset, Mark Broatch), *Reading Room*, *The Sixties* (Jeremy Varon), and *Third Text*. Thanks also for the opportunities extended to present earlier versions of this research at the Art Association of Australia and New Zealand (Sydney, 2012), College Art Association (Los Angeles, 2012), and Performance Studies International (Zagreb, 2009; Toronto, 2010) conferences.

Many thanks to Massey University, from whom I received a Massey University Research Fund grant in the earliest stages of this project, and later, additional support from the College of

Creative Arts towards the costs of this publication, and special thanks to head of Whiti o Re-hua School of Art Huhana Smith, School of Art research directors Kingsley Baird and Wayne Barrar, College Research Director Tony Parker, and Pro Vice-Chancellor Claire Robinson. In addition, I would like to thank Creative New Zealand for their support. I would like to extend special thanks to my research assistant Lara Lindsay-Parker who, during the course of her full-time art studies at Massey University, took on an internship and smoothly facilitated the process of obtaining image permissions, and assisted with many other editorial matters.

There are so many artists, colleagues, and scholars whose work has impacted this book, not least of whom those whose works are cited in this book. (A more inclusive list would merit another chapter.) I would also like to extend thanks to Stephen Bann, from whom I learned so much as my doctoral supervisor and as a crucial mentor. Also to the artist Bogdan Perzyński, whose friendship has been invaluable over the years, and has been a consistent source of inspiration, encouragement, and dialogue. David Cross welcomed me into the southern hemisphere with the utmost enthusiasm and collegiality, and has served as a key interlocutor regarding art criticism, performance art, and craft beer. Thanks to Carole Bonhomme, who has played a significant role in my life and discussed many ideas that influenced this book. Many thanks also to Chantal Bonhomme and the late Ernest Bonhomme.

Many thanks to the arts institutions across Aotearoa New Zealand who have invited me to participate in panel discussions, present lectures, and contribute essays that have assisted my thoughts on material in and around this book, including the Adam Art Gallery, Circuit Artist Film and Video, City Gallery Wellington, Dunedin Public Art Gallery, Ilam Campus Gallery at the University of Canterbury, St. Paul Street Gallery, and Te Tuhi Centre for the Arts. Thanks also to Aro Video in Wellington for their phenomenal DVD archive, long may they keep their doors open, and thanks for the latitude on late fees.

There are many people to thank at Massey University, particularly my colleagues in the School of Art: Emma Febvre-Richards, Bryce Galloway, Heather Galbraith, Jenny Gillam, Eugene Hansen, Simon Morris, Raúl Ortega Ayala, Sarah Jane Parton, Rachael Rakena, Richard Reddaway, Shannon Te Ao, and Karen van Roosmalen. Thanks are also due to other valued colleagues, including Catherine Bagnall, Tim Brennan, Mike Heynes, Marcus Moore, Sally Morgan, Anne Noble, Julieanna Preston, Ann Shelton, Shaun Waugh and Dick Whyte.

In writing these words, I am thinking of family members living thousands of miles away, most importantly my mother, Edith Patrick, who has offered essential support in so many countless ways over the years. I want to also acknowledge some of my closest family members no longer here to share this event: my father, Pat Patrick, my uncles Benny and Ronnie Patrick, and my grandparents, Thelma and Roy Patrick, and Ellen and Edgar Wilcock.

I would like to extend special and profound thanks to my wife, Rebecca Pilcher. Every day, in every way, I am so grateful for your friendship, love, and companionship.

To Zora, Oki, and Dune Patrick, and the exciting futures ahead of you. x Papa.

NOTES

Introduction

1 Robert Rauschenberg, "Statement (1959)", in *Theories and Documents of Contempo-rary Art: A Sourcebook of Artists' Writings,* eds. Kristine Stiles and Peter Selz (Berkeley: University of California, 2012), 373.
2 Allan Kaprow, "Manifesto (1966)", in *Essays on the Blurring of Art and Life*, ed. Jeff Kelley (Berkeley: University of California, 2003), 82.
3 Kellie Jones, *EyeMinded: Living and Writing Contemporary Art* (Durham, NC: Duke University Press, 2011), 251.
4 Allan Kaprow, *Untitled Essay and Other Works*, A *Great Bear Pamphlet* (New York, NY: Something Else Press, 1967), 5, accessed June 22, 2017, http://www.ubu.com/historical/kaprow/index.html.
5 Amelia Jones, *Seeing Differently: A History and Theory of Identification and the Visual Arts* (New York, NY: Routledge, 2012), 138, original emphasis.
6 Jean-Luc Nancy, *Being Singular Plural*, trans. Robert D. Richardson and Anne E. O'Byrne (Stanford, CA: Stanford University Press, 2000), 38, original emphasis.
7 Simon O'Sullivan, "Academy: The Production of Subjectivity", in *A.C.A.D.E.M.Y*, eds. Angelika Nollert et al. (Frankfurt: Revolver, 2006), 238–44.
8 Robert Filliou, undated postcard, noted in Chris Thompson*, Felt: Fluxus, Joseph Beuys, and the Dalai Lama* (Minneapolis, MN: University of Minnesota Press. 2011), 5.

Chapter One

1 Diane Arbus, *Diane Arbus* (Millerton, NY: Aperture, 1972), 2.
2 Adam Szymczyk, "The Song of a Skin Bag: Interview with Artur Zmijewski, 1997", in *Pawel Althamer*, eds. Roman Kurzmeyer, Adam Szymczyk and Suzanne Cotter (London: Phaidon, 2011), 122.
3 Guy Trebay, "Shadow Play", *New York Times*, September 19, 2004, accessed March 5, 2017, http://www.nytimes.com/2004/09/19/magazine/shadow-play.html.
4 The Clash, *Sandinista* (1980), 2 x CD reissue (1999), Columbia Records, 495348 2.
5 Mikhail Bakhtin, *Rabelais and His World*, trans. Helene Iswolsky (Bloomington, IN: Indiana University Press, 1984), 47.

6 Ibid.

7 Gregory Volk, "William Pope.L: Animal Nationalism", *Grand Arts*, accessed January 29, 2013, http://www.grandarts.com/past_projects/2008/2008_09.html.

8 Randy Kennedy, "Over and Over: Art that Never Stops", *New York Times*, June 3, 2009, accessed June 26, 2017, http://www.nytimes.com/2009/06/04/arts/design/04icel.html?pagewanted=all&_r=0.

9 Trabant's music can be consulted at http://www.myspace.com/trabantofficial (accessed January 29, 2013).

10 Edwin Stolk, "Ragnar Kjartansson", *Strange Messenger*, November 4, 2011, accessed January 24, 2013, http://strangemessenger.blogspot.co.nz/2011/11/ragnar-kjartansson.html.

11 For more on Marioni's life and work, see Tom Marioni, *Beer, Art, and Philosophy* (San Francisco, CA: Crown Point Press, 2004).

12 Tom Marioni, e-mail to the author, January 2011.

13 Linda M. Montano, *Letters from Linda Montano*, ed. Jennie Klein (London: Routledge, 2005), 269.

14 Martha Mockus, *Sounding Out: Pauline Oliveros and Lesbian Musicality* (New York, NY: Routledge, 2008), 105.

15 Ibid., 143.

16 Linda Montano, *Art in Everyday Life* (Los Angeles: Astro Artz, 1981), n.p.

17 Eva Díaz, *The Experimenters: Chance and Design at Black Mountain College* (Chicago, IL: University of Chicago Press, 2015), 4, original emphasis.

18 Jerry Hopkins, *Yoko Ono* (New York, NY: Macmillan, 1986), 24.

19 By 2011, *ReadyMade* magazine had folded, like many consumer publications that shut down in the wake of the 2008 financial crisis. That said, many regional, national, and international publications are currently focusing their attention towards DIY projects, crafts, and sustainability.

20 Dave Beech, "The Ideology of Duration in the Dematerialised Monument", in *Locating the Producers: Durational Approaches to Public Art*, eds. Paul O'Neill and Claire Doherty (Amsterdam: Valiz, 2011), 320, original emphasis.

21 Adrian Heathfield, ed., *Live: Art and Performance* (London: Tate Publishing, 2004), 8.

22 Peggy Phelan, *Unmarked: The Politics of Performance* (New York, NY: Routledge Books, 1996), 60.

23 Philip Auslander, "The Performativity of Performance Documentation", *PAJ* 84 (2006): 2.

24 Nikki S. Lee, "Interview with Gilbert Vacario", in *Projects by Nikki S. Lee*, ed. Russell Ferguson (Germany: Hatje Cantz, 2001) 103.

25 John Cage, *Silence: Lectures and Writings* (Middletown, CT: Wesleyan, 1973), 93; Kristine Stiles and Peter Selz, eds. *Theories and Documents of Contemporary Art: A Sourcebook of Artists' Writings* (Berkeley: University of California, 2012), 340.

26 Mark Godfrey, "Nikki S. Lee: Stephen Friedman Gallery, London", *Frieze* 52 (May 2000), accessed January 29, 2013, http://www.frieze.com/issue/review/nikki_s_lee/.

27 Gregory Minissale, *The Psychology of Contemporary Art* (Cambridge: Cambridge University Press, 2013), 230.

28 Hamza Walker, "Double Consciousness, Squared" (Chicago: Renaissance Society, 2013), accessed June 21, 2017, http://renaissancesociety.org/publishing/481/forlesen-poster/.

29 Maggie Nelson, *The Art of Cruelty: A Reckoning* (New York, NY: Norton, 2011), 202.

30 Shannon Jackson, *Social Works: Performing Art, Supporting Publics* (New York, NY: Routledge, 2011), 135.

31 Ibid.

32 Darby English, *How to See a Work of Art in Total Darkness* (Cambridge, MA: MIT Press, 2007), 259–60.

33 William Pope.L, *some things you can do with blackness...* (London: Kenny Schachter Rove, 2005), 4.

34 Sally Banes, *Greenwich Village 1963: Avant-Garde Performance and the Effervescent Body* (Durham, NC: Duke University Press, 1993), 202.

35 Artist's statement posted along with excerpt of *Reenactor*, a work-in-progress at Craig Saddlemire, "Reenactor: Excerpt", Vimeo video, March 6, 2012, accessed June 18, 2017, http://vimeo.com/38058016.

36 For a nuanced consideration of Civil War reenactments see Rebecca Schneider, *Performing Remains: Art and War in Times of Theatrical Reenactment* (New York, NY: Routledge, 2011).

37 William Pope.L, *Distributing Martin*, accessed June 17, 2017, http://www.distributingmartin.com/.

38 Jascha Hoffman, "The Africana QA: Performance Artist William Pope.L", *The Artists Network of Refuse and Resist!*, December 18, 2002, accessed June 17, 2017, https://web.archive.org/web/20150225220820/http://artists.refuseandresist.org/news3/news142.html#interview

39 William Pope.L, *William Pope.L: The Friendliest Black Artist in America*, ed. Mark Bessire (Cambridge, MA: MIT Press, 2002), 64–65.

40 Gerry Fialka, "Insanity and Social Sculpture: A Conversation with William Pope.L", *Venice Wake*, accessed June 17, 2017, http://www.venicewake.org/Articles/GF/04Insanity.html.

41 *Prospect 2 Event: Collectively Blink 10/22*, accessed June 17, 2017, http://goinvade.com/prospect-2-event-collectively-blink-1022/.

42 Ibid.

43 Antonin Artaud, *Collected Works: Volume Three*, ed. Paule Thévenin, trans. Alastair Hamilton (London: Calder and Boyars, 1972), 166–67.

44 Dominic Molon and Barry Schwabsky, *Gillian Wearing: Mass Observation* (London: Merrell, 2002), 31.

45 Kurzmeyer et al., *Pawel Althamer*, 2011.

46 Pawel Polit, "Experiences of Discourse. Polish Conceptual Art 1965–1975", *Art Margins Online*, October 26, 2000, accessed January 29, 2013, http://www.artmargins.com/index.php/2-articles/416-experiences-of-discourse-polish-conceptual-art-1965-1975.

47 Sven Spieker, "Interview with Pawel Althamer", *Art Margins Online*, November 13, 2003, accessed January 29, 2013, http://www.artmargins.com/index.php/5-interviews/304-interview-with-pawel-althamer.

48 Bakhtin, *Rabelais and his World*, 335.

49 Roberta Smith, "Swagger and Sideburns: Bad Boys in Galleries", *New York Times*, February 12, 2010.

50 Ronnie van Hout, "The Other Mother", in *The Artist's Cinema* [DVD booklet] (Wellington: CIRCUIT Artist Film and Video Aotearoa New Zealand, 2011).

51 Ibid.
52 Anthony Byrt, "Who's There: Ronnie van Hout and the Anti-hero Aesthetic", *Art New Zealand* 108 (Spring 2003), accessed June 22, 2017, http://www.art-newzealand.com/Issue108/vanhout.htm
53 *I'm Not There*, directed by Todd Haynes (New York, NY: The Weinstein Company, 2008), DVD.
54 David Dalton, *Who is that Man? In Search of the Real Bob Dylan* (New York, NY: Hyperion Books, 2012), e-book.
55 Bob Dylan, *The Bootleg Series, Volume 6: Live 1964* (Columbia: Legacy, 2004) 2 x CD. C2K 86882.
56 Sam Shepard, *The Rolling Thunder Logbook* (New York, NY: Omnibus Press, 2010), 79.
57 *Superstar: The Karen Carpenter Story* (1988) directed by Todd Haynes, written by Cynthia Schneider and Todd Haynes; *Poison* (1991) directed by Todd Haynes, written by Jean Genet and Todd Haynes; and *Velvet Goldmine* (1998) directed by Todd Haynes, written by Todd Haynes, story by Haynes and James Lyons, Miramax Films.

Chapter Two

1 This chapter incorporates material from three previous texts: Martin Patrick, "Unfinished Filliou: On the Fluxus Ethos and the Origins of Relational Aesthetics", *Art Journal* 69, nos. 1–2 (2010): 44–61; Martin Patrick, "On the Difficulties of Work as Play: The Video Art of Robert Filliou", *Afterimage* 38, no. 4 (2011): 20-23; and Martin Patrick, "Fluxus 2.0: On the Future Prospects of a Now-Historic Non-Movement" (paper presented at the College Art Association conference, Februrary 2012, Los Angeles, USA).
2 Friedrich Nietzsche, *Twilight of the Idols* (1895), trans. Walter Kaufmann, reprinted in *The Portable Nietzsche* (New York, NY: Penguin Books, 1977), 532.
3 George Brecht, *The Ashgate Research Companion to Experimental Music*, ed. James Saunders (Burlington, VT: Ashgate, 2009), 71.
4 See Nicolas Bourriaud, *Relational Aesthetics* (Dijon: Les Presses du réel, 1998), trans. Simon Pleasance and Fronza Woods with Mathieu Copeland (Dijon: Les Presses du réel, 2004); Claire Bishop, "Antagonism and Relational Aesthetics", *October* 110 (Fall 2004): 51–79; Claire Bishop, "The Social Turn: Collaboration and its Discontents", *Artforum* 44, no. 6 (February 2006): 179–85; Liam Gillick, "Contingent Factors: A Response to Claire Bishop's 'Antagonism and Relational Aesthetics'", *October* 115 (Winter 2006): 95–106.
5 Robert Filliou, quoted in epigraph to Nicolas Bourriaud, *Formes de vie: L'art moderne et l'invention de soi* (Paris: Éditions Denoël, 1999).
6 See Sylvie Jouval et al., *Robert Filliou: Génie Sans Talent*, exh. cat. (Villeneuve d'Ascq: Musée d'art moderne Lille Métropole, 2003). The exhibition, organized by Sylvie Jouval, first travelled to Barcelona and Düsseldorf.
7 Major exceptions are the contributions of Fluxus scholars, including Ken Friedman, Hannah Higgins and Chris Thompson. See the final chapter of Higgins' book *Fluxus Experience* (Berkeley, CA: University of California Press, 2002), which addresses Filliou's work as a pedagogical model. See also Thompson's "Responsible Idiocy and Fluxus Ethics: Robert Filliou and Emmanuel Levinas", *a-r-c* 5 (July 2001); and Friedman's "The Case for Bengt af Klintberg", *Performance Research* ("Re-received Ideas. A Generative Dictionary for Research on Research") 11, no. 2 (2006): 137–44.

8 *Premiers mouvements–fragile correspondances*, the 2002 inaugural exhibition of the FRAC Ile-de-France gallery Le Plateau, enlisted contemporary works to pay homage to Filliou. According to the curators, Sylvie Jouval and Eric Corne, "The goal of the project was [...] to offer up connections (either possible or impossible) between his work, its underlying thought process, and the work of other contemporary artists". See exhibition description, online at www.fracidf-leplateau.com/en/index.html (accessed October 30, 2009).

9 The richest source of biographical information on Filliou is the French language biography by Pierre Tilman, *Robert Filliou; Nationalité poete* (Dijon: Les Presses du reel, 2006), 16, author's translation.

10 Georg Kargl Gallery, "Arthur Köpcke", accessed April 6, 2017, http://www.georgkargl.com/en/box/exhibition/arthur-koepcke.

11 The 2007 exhibition *Fluxus East: Fluxus Networks in Central Eastern Europe* included valuable information on this activity. See www.fluxus-east.eu/ (accessed October 31, 2009).

12 For details of Filliou's Canadian sojourns, see Robert Filliou, *Robert Filliou: From Political to Poetical Economy* (Vancouver: Morris and Helen Belkin Art Gallery, 1995).

13 Sophie Richard, "Conversation with Anny De Decker, Antwerp, November 16, 2004", in *Unconcealed: The International Network of Conceptual Artists 1967–77; Dealers, Exhibitions and Public Collections*, ed. Lynda Morris (London: Ridinghouse, 2009), 407.

14 Jack Kerouac, *Dharma Bums* (New York, NY: Signet Press, 1959), 78.

15 For a comprehensive and riveting account of Leary's life see Robert Greenfield, *Timothy Leary: A Biography* (New York, NY: Harcourt Books, 2006).

16 See Daniel Spoerri et al., *An Anecdoted Topography of Chance* (London: Atlas Press, 1995).

17 See Helen Westgeest, *Zen in the Fifties: Interaction in Art between East and West* (Zwolle: Waanders Publishers, 1996); Alexandra Munroe, ed., *The Third Mind: American Artists Contemplate Asia, 1860–1989*, exh. cat. (New York, NY: Guggenheim Museum, 2009); Kay Larson, *Where the Heart Beats: John Cage, Zen Buddhism, and the Inner Life of Artists* (New York, NY: Penguin, 2012).

18 Robert Filliou, *Teaching and Learning as Performing Arts* (Cologne and New York, NY: Verlag Gebrüder König, 1970), 95.

19 Jeff Kelley, *Childsplay: The Art of Allan Kaprow* (Berkeley, CA: University of California Press, 2004), 200.

20 Chris Thompson, *Felt: Fluxus, Joseph Beuys, and the Dalai Lama* (Minneapolis, MN: University of Minnesota Press, 2011), xxvi.

21 Filliou, *Teaching and Learning*, 75–76.

22 Tilman, *Robert Filliou*, 59, author's translation.

23 Filliou, *Teaching and Learning*, cover.

24 Ibid.

25 Filliou quoted in Michael Erlhoff, ed. *Das immerwährende Ereignis zeigt Robert Fillliou [sic] = the Eternal Network presents Robert Fillliou [sic] = la Fête permanente présente Robert Fillliou [sic]* (Hannover: Sprengel-Museum, 1984).

26 Filliou, *Teaching and Learning*, 14.

27 Ibid., 12.

28 For more information on the *do it* project, see: http://curatorsintl.org/special-projects/do-it, accessed June 14, 2017; Hans Ulrich Obrist, ed. *do it: the compendium* (New York: Independent Curators International/Distributed Art Publishers, 2013).

29 On viewing an excerpt of this material, the New Zealand artist David Cauchi compared Filliou's didactic manner to that of *Sesame Street*, an interesting parallel in that the TV programme began in the same era as the *Teaching and Learning* book, and Filliou prided himself on making "childlike" works, creating several artist's books of this type. They include *Toi par lui et moi* (Brussels: Lebeer Hossmann and Yellow Now, 1998) and *Mister Blue from Day-to-Day* (Hamburg: Lebeer Hossmann, 1983).

30 Pierre Tilman, *Robert Filliou: Nationalité Poete* (Dijon: les presses du réel, 2006), 241, author's translation.

31 Filliou, *Teaching and Learning*, 204.

32 Quoted in Filliou, "Principles of Poetic Economy," in Filliou, Erlhoff, and Hannover, *The Eternal Network presents Robert Fillliou* 131.

33 Robert Filliou, *Telepathic Music No. 7, the Principle of Equivalence Carried to a Series of 5* (1977).

34 Ken Friedman, *99 Events 1956–2009* (New York, NY: Stendhal Gallery, 2009), 27.

35 Robert Filliou, *Porta Filliou* (1977), accessed June 26, 2017, https://www.youtube.com/watch?v=9BgOfsG7J0Q.

36 Citations from Filliou's videos transcribed by author from *Robert Filliou: From Political to Poetical Economy (1977–79)* (Vancouver: Western Front Society and the Morris and Helen Belkin Art Gallery, 2006), DVD.

37 Robert Filliou, *Teaching and Learning as Performing Arts, Pt. 2* (1979).

38 Ibid.

39 Ibid.

40 *Teaching and Learning as Performing Arts Part II – Video Breakfasting Together If You Wish* (1979).

41 *Footnote to Footnote: A Video Breakfasting with Roy Kiyooka* (1979).

42 Hannah Higgins, *Fluxus Experience* (Berkeley, CA: University of California Press, 2002), 206.

43 Dick Higgins, *foew&ombwhnw: a grammar of the mind and a phenomenology of love and a science of the arts as seen by a stalker of the wild mushroom* (New York, NY: Something Else Press, 1969), 11. According to Hannah Higgins: "When I asked Dick a year or so before his death if he ever declined a book for the press and then regretted it, the one book he mentioned was *Teaching and Learning*, which he loved and admired". E-mail to the author, October 30, 2009.

44 Ibid., 15.

45 Ibid., 27.

46 Dick Higgins, "Statement on Intermedia", 1966, accessed June 21, 2017, http://www.artpool.hu/Fluxus/Higgins/intermedia2.html.

47 George Brecht and Robert Filliou, *Games at the Cedilla; or, The Cedilla Takes Off* (New York, NY: Something Else Press, 1967). See Anthony Huberman's comparison of La Cédille's activities with those of post-2008 initiatives, "Talent is Overrated", *Artforum* 48, no. 3 (November 2009): 109–10.

48 Filliou, *Teaching and Learning*, 14.

49 For a more recent, insightful analysis of the Cedilla project, see Natilee Harren, "*La cédille qui ne finit pas*: Robert Filliou, George Brecht, and Fluxus in Villefranche

(deregulation version)", *The Getty Research Journal* 4 (2012). Also posted online at *Art and Education*, accessed June 22, 2017, http://www.artandeducation.net/paper/la-ce-dille-qui-ne-finit-pas-robert-filliou-george-brecht-and-fluxus-in-villefranche/.

50 Steven Harris, "The Art of Losing Oneself without Getting Lost: Brecht and Filliou at the Palais Idéal", *Papers of Surrealism* 2 (Summer 2004): 1.

51 Bourriaud, *Relational Aesthetics*, 11.

52 "Appendices, I", in *Robert Filliou: From Political to Poetical Economy*, 82.

53 Filliou, *Robert Filliou: From Political to Poetical Economy*, 83.

54 Filliou, *Robert Filliou*, exh. cat., 182.

55 Jean-Yves Jouannais, *Infamie* (Paris: Éditions Hazan, 1995).

56 For a relevant example of intergenerational artistic dialogue, see Rirkrit Tiravanija, "In Another Country: Yoko Ono in Conversation with Rirkrit Tiravanija", *Artforum* 47, no. 10 (Summer 2009): 280–83.

57 I would also note that over the course of almost a decade living in Aotearoa New Zealand, I have noticed that the influence of "relational aesthetics"-style practices is strong whereas Fluxus has never had any direct visibility, except via rather loose connections with some of the post-object artists of the 1970s.

58 George Baker, "An Interview with Pierre Huyghe", *October* 110 (Fall 2004): 89.

59 Robert Filliou, *Ample Food For Stupid Thought* (New York: Something Else Press, 1965).

60 Baker, "Interview with Pierre Huyghe", 99.

61 Ibid.

62 Ibid., emphasis added.

63 For the most engaging and extended scholarly discussion of Huyghe's practice yet to appear, see Amelia Barikin, *Parallel Presents: The Art of Pierre Huyghe* (Cambridge, MA: MIT, 2012).

64 Filliou, "John Cage", in *Teaching and Learning*, 116.

65 Tilman Baumgärtel, "I am a communication artist: Interview with Nam June Paik", *Noem Lab*, February 17, 2001, accessed April 5, 2017, http://noemalab.eu/ideas/interview/interview-with-nam-june-paik/.

66 My point is also that we garner much of our information about Fluxus from interviews with the artists, their statements, various remembrances and memoirs such as Emmett Williams, *My Life in Flux – And Vice Versa* (London: Thames and Hudson, 1992).

67 The most comprehensive art historical account of Fluxus remains Owen F. Smith, *Fluxus: The History of an Attitude* (San Diego, CA: San Diego State University Press, 1998).

68 *Fluxus Codex* is a 616-page compilation of works from the Lila and Gilbert Silverman Collection in Detroit, MI (now a part of the Museum of Modern Art's collection). Jon Hendricks, ed., *Fluxus Codex* (New York, NY: Harry N. Abrams, 1988).

69 Higgins, *Fluxus Experience*, 36

70 Ibid., 34.

71 Marc James Léger, "A Filliou for the Game: From Political Economy to Poetical Economy and Fluxus", *RACAR: revue d'art canadienne / Canadian Art Review* 37, no. 1 (2012): 64–74.

72 Owen F. Smith, "Teaching and Learning about Fluxus: Thoughts, Observations and Suggestions from the Front Lines", *Visible Language* 39, no. 3 (2005): 220.

Chapter Three

1 Some draft material for this chapter was first delivered in the invited lecture "When the Sh*t Hits the Fans: The Uneasy Relationship Between Celebrity Culture and Contemporary Art" (paper presented at the Wellington City Gallery, New Zealand, May 7, 2015).

2 Alan Licht, ed., *Will Oldham on Bonnie "Prince" Billy* (New York, NY: Norton, 2012), e-book.

3 William S. Burroughs interviewed by Richard Goldstein, *College Papers* 1 (Fall 1979), cited in Barry Miles, *Call Me Burroughs: A Life* (New York, NY: Twelve, 2014), e-book.

4 Quoted in Sarah Thornton, *33 Artists in 3 Acts* (London: Granta, 2014), e-book.

5 Chris Hill, "Attention! Production! Audience! Performing Video in its First Decade, 1968–1980", *Video Data Bank*, accessed June 26, 2017, http://www.vdb.org/content/surveying-first-decade-video-art-and-alternative-media-us-1968-1980-attention-production-aud.

6 James McPherson, "The New Comic Style of Richard Pryor", *The New York Times Magazine,* April 27, 1975, accessed June 25, 2017, http://www.nytimes.com/1975/04/27/archives/the-new-comic-style-of-richard-pryor-i-know-what-i-wont-do-says-the.html?_r=0.

7 Scott Saul, *Becoming Richard Pryor* (New York, NY: Harper, 2014), e-book.

8 Ibid.

9 For cogent and detailed analysis of Ligon's early paintings referencing Pryor's comedy, see Darby English, *How to See a Work of Art in Total Darkness* (Cambridge, MA: MIT Press, 2007).

10 Holland Cotter, "Refracting Race through the Comic Lens of Richard Pryor", *New York Times*, January 21, 2016, accessed June 21, 2017, http://www.nytimes.com/2016/01/22/arts/design/refracting-race-through-the-comic-lens-of-richard-pryor.html.

11 Sharon Mizota, "Glenn Ligon Takes Apart a Richard Pryor Performance", *Los Angeles Times*, September 20, 2015, accessed June 22, 2017, http://www.latimes.com/entertainment/arts/la-et-cm-glenn-ligon-at-regen-projects-20150914-story.html.

12 Gretchen Law, *Turn Me Loose*, directed by John Gould Rubin, Westside Theatre, New York, May 19–July 17, 2016.

13 Ibid.

14 Ibid.

15 Dick Gregory, with Robert Lipsyte, *Nigger* (New York, NY: Washington Square Press, 1986), 209.

16 *Stardust Memories*, directed and written by Woody Allen produced by Robert Greenhut, United Artists, 1980.

17 Sophie Quirk, *Why Stand-up Matters: How Comedians Manipulate and Influence* (London: Bloomsbury, 2015), 61.

18 Quote transcribed from Laugh Factory, "Dave Chapelle – Kramer", YouTube video, December 20, 2010, accessed August 25, 2016, https://youtu.be/Kth0UOU5a_M.

19 *The King of Comedy*, directed by Martin Scorsese, written by Paul D. Zimmerman, produced by Arnon Milchan, Twentieth-Century Fox, 1982.

20 Richard Schickel, *Conversations with Scorsese* (New York, NY: Knopf Doubleday, 2011), 150.

21 Steve Martin, *Born Standing Up* (New York, NY: Scribner, 2007), 186–87.

22 John Haskell, *Out of My Skin* (New York, NY: FSG, 2009), 17.

23 Ibid., 37.

24 Leslie Halliwell, *Halliwell's Who's Who in the Movies* (New York: HarperPerennial, 1999), 172.

25 Haskell, *Out of My Skin*, 49.

26 Martin, *Born Standing Up*, 111.

27 Philip Auslander, *Presence and Resistance: Postmodernism and Cultural Politics in Contemporary American Performance* (Ann Arbor, MI: University of Michigan Press, 1994), 137.

28 Florian Keller, *Andy Kaufman: Wrestling with the American Dream* (Minneapolis, MN: University of Minnesota, 2005), 20.

29 For further context on performance monologues by male artists including Gray, see Michael Peterson, *Straight White Male: Performance Art Monologues* (Jackson, TN: University of Mississippi, 1997).

30 Spalding Gray, "Morning, Noon, and Night", *National Public Radio: Weekend Edition Saturday*, September 18, 1999.

31 Spalding Gray, *The Journals of Spalding Gray*, ed. Nell Casey (New York, NY: Knopf, 2011), 179.

32 See Gaby Wood, "How Karl Ove Knausgaard and Elena Ferrante won us over", *The Daily Telegraph*, February 28, 2016, accessed June 23, 2017, http://www.telegraph.co.uk/books/what-to-read/how-karl-ove-knausgaard-and-elena-ferrante-won-us-over/.

33 From Laird's introduction to Bryce Galloway, *Incredibly Hot Sex with Hideous People: The Comics Diary* (Melbourne: Pikitia Press, 2017) 5–6.

34 Bryce Galloway, *The Book of the Zine Incredibly Hot Sex with Hideous People* (Auckland: Clouds, 2011), 218.

35 Bryce Galloway, *Incredibly Hot Sex with Hideous People*, no. 24 (Spring 2006), "The Winter Issue" (includes DVD).

36 David Foster Wallace, "E Unibus Pluram: Television and U.S. Fiction", *Review of Contemporary Fiction* 13, no. 2 (Summer 1993): 154–55.

37 James Wood, "From Venice to Varanasi: Geoff Dyer's Wandering Eye", *The New Yorker*, April 20, 2009, accessed June 23, 2017, http://www.newyorker.com/magazine/2009/04/20/from-venice-to-varanasi.

38 Mira Mattar, ed., *You Must Make Your Death Public: A Collection of Texts and Media on the Work of Chris Kraus* (London: Mute Publishing, 2015), 13.

39 Ibid., 8.

40 Martin Rumsby, "Chris Kraus #4: I Love Dick", YouTube video, July 21, 2008, accessed June 23, 2017, https://www.youtube.com/watch?v=c2DDibS9jnI.

41 Michael Goetzman, "Pulp Nonfiction: An Interview with John Jeremiah Sullivan", *Los Angeles Review of Books*, March 28, 2012, original emphasis, accessed June 17, 2017, https://lareviewofbooks.org/article/pulp-nonfiction-an-interview-with-john-jeremiah-sullivan/.

42 Greg Gerke, "The Rumpus Interview with John Jeremiah Sullivan", *The Rumpus*, April 24, 2012, original emphasis, accessed June 23, 2017, http://therumpus.net/2012/04/the-rumpus-interview-with-john-jeremiah-sullivan/.

43 John Jeremiah Sullivan, *Pulphead* (New York, NY: FSG, 2011), 114.

44 Ibid., 126.

45 Excerpt from unpublished story courtesy of the author.

46 Licht, *Will Oldham on Bonnie "Prince" Billy*, 48.

Chapter Four

1 An earlier version of this chapter was published as "Performative Tactics and the Chore-ographic Reinvention of Public Space", *Art and The Public Sphere* 1, no. 1 (2011): 65–84. It also incorporates some material from the essays "Into the Mystic: Maddie Leach's (Im-) Material World", *Reading Room 4* (2010): 168–75; and "Encounter", in *One Day Sculp-ture*, eds. David Cross and Claire Doherty (Bielefeld: Kerber Verlag, 2009): 39–42.

2 Lisa Lee and Hal Foster, eds., *Critical Laboratory: The Writings of Thomas Hirschhorn* (Cambridge, MA: MIT Press, 2013), 262.

3 For a lively historical account of these developments, see Sally Banes, *Greenwich Vil-lage 1963: Avant-Garde Performance and the Effervescent Body* (Durham, NC: Duke University Press, 1993); and for primary documents, including interviews, see Mariellen R. Sandford, ed., *Happenings and Other Acts* (London: Routledge, 1995).

4 Miwon Kwon, "One Place After Another: Notes on Site Specificity", *October* 80 (Spring 1997): 109.

5 Tony Judt, *Ill Fares the Land* (Victoria, Australia: Allen Lane/Penguin Books, 2010), 129.

6 Marc Augé, *Non-Places: Introduction to an Anthropology of Supermodernity*, trans. John Howe (London: Verso, 2000), 77–78.

7 Claire Doherty, "In Search of a Situation", *Breaking Ground: Art in the Life World Re-search Papers,* (Dublin: Ballymun Regeneration Art Commission Programme, 2008).

8 Malcolm Miles, "Interrupting the Public Realm: Performative Excursions", *Research in Drama Education* 12, no. 1 (February 2007): 17.

9 Mark Hutchinson, "Four Stages of Public Art", *Third Text* 16, no. 4 (2002): 438.

10 Anna Gritz, "Political/Minimal", *Frieze* (January 2009).

11 Ibid.

12 Caroline A. Jones, "Staged Presence", *Artforum* 48, no. 9 (May 2010): 217.

13 Ibid.

14 Sven Lütticken, ed. *Life, Once More: Forms of Reenactment in Contemporary Art* (Rotterdam: Witte de With, 2005), 5.

15 Marius Babias, "Subject Production and Political Art Practice", *Afterall* 9 (Spring/ Summer 2004), accessed June 23, 2017, https://www.afterall.org/journal/issue.9/sub-ject.production.and.political.art.practice.

16 Francis Frascina, *Art, Politics and Dissent: Aspects of the Art Left in Sixties America* (Manchester: Manchester University Press, 1999), 229.

17 David Shields, *Reality Hunger: A Manifesto* (London: Hamish Hamilton, 2010), 3.

18 Ibid., 5.

19 Aaron Blake, "Kellyanne Conway says Donald Trump's Team Has 'Alternative Facts.' Which Pretty Much Says It All", *Washington Post*, January 22, 2017.

20 *Blot out the Sun* can be viewed in its entirety at the UbuWeb site, accessed June 26, 2017, http://www.ubu.com/film/fletcher.html.

21 Allan McCollum, "Harrell Fletcher", *BOMB* 95 (Spring 2006), accessed June 21, 2017, http://bombsite.com/issues/95/articles/2800.

22 Declan Kiberd, *Ulysses and Us: The Art of Everyday Living* (London: Faber and Faber, 2009), 11.

23 Jane Tsong, Myriad Small Things website, accessed June 21, 2017, http://myriadsmallthings.org/.

24 Leach's invited "companions" were Peter Brunt, Jon Bywater, Melanie Oliver, Christina Barton, Jem Noble, Bill Cashman, Michael Edwards, Sandy Gibbs, David Cross, Mercedes Vicente, and Abby Cunnane.

25 Maddie Leach, *If you find the good oil let us know* (New Plymouth, New Zealand: Govett-Brewster Art Gallery, 2014), 12.

26 See "Letters to the Editor" in Leach, *If you find the good oil*, 75–83.

27 Leach, *If you find the good oil*, 24–25.

28 Ibid., 17.

29 Ibid.

30 Ibid., 34.

31 Ibid.

32 Gregory Minissale, "Problem Spaces in the Walters Prize", *Reading Room* 7 (2015): 145.

33 Matthew Buckingham, "Matthew Buckingham and Sharon Hayes", *DRINK THE NEW WINE,* accessed June 21, 2017, http://creativetime.org/programs/archive/newwine/buckingham.php

34 Toby Huddlestone, e-mail message to the author, August 31, 2010.

35 Toby Huddlestone, *Video Apathy* (2012), accessed June 23, 2017, http://www.outcasting.org/video-apathy-toby-huddlestone/.

36 Karl Lydén, "Ecstasy, Militancy, and Marxist Filmmaking", *Mousse Magazine* 24, accessed June 21, 2017, http://moussemagazine.it/mark-boulos-kar-lyden-2010/.

37 Ibid.

38 Jesse Drew, "The Collective Camcorder in Art and Activism", in *Collectivism After Modernism: The Art of Social Imagination After 1945*, eds. Blake Stimson and Gregory Sholette (Minneapolis, MN: University of Minnesota Press, 2007), 107.

39 Boulos' project was exhibited at the Morris and Helen Belkin Art Gallery, UBC, Vancouver from October 8–December 5, 2010.

40 Mark Boulos, e-mail message to the author, September 1, 2010.

41 Stedelijk Museum Amsterdam, "Mark Boulos – All That Is Solid Melts Into Air", YouTube video, August 13, 2008, accessed June 21, 2017, http://www.youtube.com/watch?v=BX-6rYfNzTJ8.

42 Francis Alÿs, *Sometimes Doing Something Poetic Can Become Political and Sometimes Doing Something Political Can Become Poetic* (New York, NY: David Zwirner, 2007).

43 The Yes Men, *New York Times,* July 4*,* 2009, accessed June 20, 2017, http://www.nytimes-se.com/

44 Guy Debord, *The Society of the Spectacle* (Detroit, MI: Black & Red, 1983), 207.

45 *The Yes Men*, directed by Dan Ollman, Sarah Price and Chris Smith (Los Angeles, CA: MGM/DVD, 2003), DVD.

46 The key members are the duo Igor Vamos (aka "Mike Bonnano"), an associate professor at Rensselaer Polytechnic Institute, Troy, NY, and Jacques Servin (aka "Andy Bichlbaum"), a former video game designer and programmer, and author of two books of short stories published by the experimental press FC2.

47 Jacques Servin and Igor Vamos, "Congress Went After ACORN. Big Business Must Be
 Next!", *The Washington Post*, September 27, 2009, accessed June 21, 2017, http://www.
 washingtonpost.com/wp-dyn/content/article/2009/09/25/AR2009092502016.html.

48 Chantal Mouffe, *Agonistics: Thinking The World Politically* (London: Verso Books, 2013),
 e-book.

49 Octavio Paz, *Marcel Duchamp: Appearance Stripped Bare*, trans. Rachel Phillips and
 Donald Gardner (New York: Arcade Publishing, 1990), 85.

Chapter Five

1 Oscar Wilde, "Olivia at the Lyceum, *Dramatic Review*, 30 May 1885", in *Complete Works
 of Oscar Wilde* (East Sussex: Delphi Classics, 2013), e-book.

2 Simon Critchley, *On Bowie* (London: Serpents Tail, 2016), 24.

3 Simon Reynolds, *Retromania: Pop Culture's Addiction to its Own Past* (New York, NY:
 FSG, 2011).

4 Rebecca Schneider, *Performing Remains: Art and War in Times of Theatrical Reenact-
 ment* (New York, NY: Routledge, 2011), 30.

5 Tom McCarthy, *Remainder* (Richmond, VT: Alma Books, 2006), 3.

6 Ibid., 5.

7 Ibid., 57–58.

8 Ibid., 64.

9 Ibid., 62.

10 "Tom McCarthy by Frederic Tuten", *BOMB – Artists in Conversation* 131 (Spring 2015),
 accessed June 19, 2017, http://bombmagazine.org/article/276933/tom-mccarthy.

11 Ibid.

12 Tom McCarthy, *Transmission and the Individual Remix: How Literature Works* (London:
 Vintage Digital, 2012).

13 Ibid.

14 A. Ruminjo and B. Mekinulov, "A Case Report of Cotard's Syndrome", *Psychiatry
 (Edgmont)* 5, no. 6 (2008): 28–29.

15 Tim Ryan, "RT Interview: Charlie Kaufman on *Synecdoche, New York*", *Rotten Tomatoes*,
 October 22, 2008, accessed June 19, 2017, https://editorial.rottentomatoes.com/article/
 rt-interview-charlie-kaufman-on-synecdoche-new-york/.

16 Philip French, "Synecdoche, New York", *The Observer*, May 17, 2009, accessed June
 21, 2017, https://www.theguardian.com/film/2009/may/17/synecdoche-new-york-film-
 review.

17 Stuart Klavans, "The Dread of Failure: On Desplechin and Kaufman", *The Nation*, Novem-
 ber 24, 2008, accessed June 21, 2017, https://www.thenation.com/article/dread-failure-
 desplechin-and-kaufman/.

18 Gavin Smith, "Prisoners: Three Takes on Living in Lockdown", *Film Comment* (July–
 August 2008): 59.

19 George Slade, "Garry Winogrand", *Encyclopedia of Twentieth-Century Photography V. 3
 O-Z*, ed. Lynne Warren (New York: Routledge, 2006), 1691.

20 Ingrid Langston, "Sturtevant's Double Trouble", *Inside/Out*, January 6, 2015, accessed
 June 21, 2017, http://www.moma.org/explore/inside_out/2015/01/06/sturtevants-
 double-trouble.

21 Eleanor Heartney, "Re-Creating Sturtevant", *Art in America* 102, no. 10 (November 2014): 141.

22 Alexander Tolnay, "Image is Origin: On the Art of Sturtevant,", in ed. Alexander Tolnay, *Sturtevant: Shifting Mental Structures*, (Berlin: Hatje Cantz Publishers, 2002), 6.

23 Patricia Lee, *Sturtevant: Warhol Marilyn* (London: Afterall Books, 2016).

24 Elisa Schaar, "Spinoza in Vegas, Sturtevant Everywhere: A Case of Critical (Re-)Discoveries and Artistic Self-Reinventions", *Art History* 33, no. 5 (December 2010): 887.

25 Lee, *Sturtevant: Warhol Marilyn*, 21.

26 See Peggy Phelan, *Unmarked: The Politics of Performance* (London: Routledge, 1996); Philip Auslander, "The Performativity of Performance Documentation", *PAJ* 84 (2006): 1–10; and Amelia Jones, "'Presence' in Absentia: Experiencing Performance as Documentation", *Art Journal* 56, no. 4 (Winter 1997): 11–18.

27 Hal Foster, *Bad New Days: Art, Criticism, Emergency* (London: Verso, 2015), e-book.

28 Ibid.

29 Melanie Gilligan, "The Beggar's Pantomime: On Performance and Its Appropriations", *Artforum* 45, no. 10 (Summer 2007).

30 Amelia Jones, "'The Artist is Present': Artistic Re-Enactments and the Impossibility of Presence", *TDR: The Drama Review* 55, no. 1 (Spring 2011): 25.

31 Tania Bruguera, *Tania Bruguera. La Biennale di Venezia/Prince Claus Fund for Culture and Development* (Chicago, IL: Lowitz & Sons, 2005), 17.

32 *File under Sacred Music*, accessed June 26, 2017, http://www.fileundersacredmusic.com/making/index.html.

33 Tom McCarthy, "Nests, Puke, Frames and Baby Faces", *File under Sacred Music*, accessed June 23, 2017, http://www.fileundersacredmusic.com/reading/index.html.

34 Chris Hill, ed. *R E W I N D: A Guide to Surveying the First Decade: Video Art and Alternative Media in the U.S., 1968–1980* (Chicago, IL: Video Data Bank, 2008), 74.

35 Don DeLillo, "Introduction: Assassination Aura", in *Libra* (New York, NY: Penguin Books, 2006), x.

36 Ant Farm, T.R. Uthco, *The Eternal Frame* (1976) 22:19. Video. Distributed by Video Data Bank, Chicago.

37 Ibid.

38 Constance Lewallen, "The Eternal Frame, Hosted by Constance Lewallen", KADIST Vimeo video, November 17, 2012, accessed June 21, 2017, https://vimeo.com/53734504.

39 John Hodgman, *Pilot* (unpublished text courtesy of artist Christine Hill).

40 "Best Confusion of Art and Life", *New York Press* (September 27–October 3, 2000): 174.

41 Heather Felty, "Christine Hill", *Flash Art* 33, no. 215 (November–December 2000): 107–08.

42 See Christine Hill, *Minutes: Work by Christine Hill* (Berlin: Hatje Cantz, 2007).

43 C. Carr, "Christine Hill Tapes her own TV Pilot, For Art's Sake: The Avant Late Show", *The Village Voice* (October 17, 2000): 59.

44 Christine Hill, e-mail message to the author, September 2012.

45 The original footage of artist Andy Warhol eating a hamburger is part of Jørgen Leth's documentary film *66 Scenes from America* (1982), accessed June 26, 2017, https://www.youtube.com/watch?v=vsh2NisRD8A

46 See "John Cage – 4' 33" [May '68 Comeback Special Edition]", *Circuit*, accessed June 26, 2017, https://www.circuit.org.nz/film/john-cage-433-may-68-comeback-special-edition.

47 John Cage, *Silence: Lectures and Writings* (Middletown, CT: Wesleyan, 1973), 93.

48 Salomé Voegelin, *Listening to Noise and Silence: Towards a Philosophy of Sound Art* (New York, NY: Continuum, 2010), 93.

49 Benjamin H. D. Buchloh, "Conceptual Art 1962–1969: From the Aesthetic of Administration to the Critique of Institutions", *October* 102, no. 55 (Winter 1990): 105–43.

50 See http://ourliteralspeed.com/.

51 Zachary Cahill and Philip von Zweck, "The Artist as Double Agent", *Afterall* 36 (Summer 2014): 73.

52 Cahill and von Zweck, "The Artist as Double Agent", 71–72.

53 Shannon Te Ao, *Part Tree, Part Canoe*. Master of Fine Arts exegesis (Wellington NZ: Massey University, 2015) 15.

54 For more detailed accounts of Parihaka, see Danny Keenan's comprehensive recent study *Te Whiti O Rongomai and the Resistance of Parihaka* (Wellington: Huia Publishers, 2015), and Te Miringa Hohaia, Gregory O'Brien and Lara Strongman, eds., *Parihaka: The Art of Passive Resistance* (Wellington: City Gallery, 2001).

55 Anna-Marie White, "Biography and Identity in the Work of Shannon Te Ao", in *Shannon Te Ao: I Can Press my Face up Against the Glass* (Christchurch: The Physics Room, 2014), 47.

56 Ibid., 47–48.

57 Anthony Byrt, *This Model World: Travels to the Edge of Contemporary Art* (Auckland: Auckland University Press, 2016).

58 Shannon Te Ao, "Reading While Driving: Speaking Poems in the Dark", in *Freedom Farmers: New Zealand Artists Growing Ideas* (Auckland: Auckland Art Gallery, 2013), 18.

Chapter Six

1 Barry Schwabsky, *The Nation*, January 12, 2012.

2 From statement on Temporary Services' website, accessed September 17, 2016, www.temporaryservices.org.

3 Erik Månsson and Susanne Ewerlöf, eds. *Verkstad: Rum för konst* (Norrköping: Verkstad Konsthall, 2015), 43.

4 Relevant sources on contemporary art and activism include Yates McKee, *Strike Art: Contemporary Art and the Post-Occupy Condition* (New York, NY: Verso, 2016); Gregory Sholette, *Delirium and Resistance: Activist Art and the Crisis of Capitalism* (London: Pluto Press, 2017); Andrew Boyd, *Beautiful Trouble: A Toolbox for Revolution* (New York, NY: OR Books, 2012); Nato Thompson, ed., *Living as Form: Socially Engaged Art from 1991–2011* (Cambridge, MA: MIT Press, 2012); and Marc James Léger, ed., *Culture and Contestation in the New Century* (Bristol: Intellect, 2011).

5 See Claire Bishop, *Artificial Hells: Participatory Art and the Politics of Spectatorship* (New York, NY: Verso, 2012).

6 Grant Kester, *The One and the Many: Contemporary Collaborative Art in a Global Context* (Durham, NC: Duke University Press, 2011), 33.

7 Anthony Schrag, "The Benefits of Being a Bit of an Asshole", *Journal of Arts & Communities* 6, nos. 2/3 (2014): 85.

8 Ibid., 86.

9 Ibid., 89.

10 Ibid., 92.

11 Michael G. Birchall, "Socially Engaged Art in the 1990s and Beyond", *oncurating.org* 25 (2015): 17.

12 Anthony Schrag, *Lure of the Lost: Huntly to the Venice Biennale* blog, accessed September 17, 2016, https://theartpilgrimage.wordpress.com/.

13 Joseph Beuys, compiled by Carin Kuoni, *Energy Plan for the Western Man: Joseph Beuys in America* (New York, NY: Four Walls Eight Windows, 1990), 19.

14 Boris Groys, "On Art Activism", *e-flux journal* 56 (June 2014), accessed September 17, 2016, http://www.e-flux.com/journal/on-art-activism/.

15 Ibid., 10.

16 Ibid.

17 Ibid., 13.

18 Ivan Illich, *Tools for Conviviality* (1973), accessed September 17, 2016, http://www.preservenet.com/theory/Illich/IllichTools.html.

19 Ibid.

20 Franco "Bifo" Berardi, *The Uprising: On Poetry and Finance* (Los Angeles, CA: semiotext(e), 2012), 19.

21 Ibid., 24.

22 Ibid., 31.

23 Ibid., 147.

24 Jeremy Rifkin, *The Third Industrial Revolution: How Lateral Power is Transforming Energy, the Economy, and the World* (New York, NY: St. Martin's, 2013), 268.

25 Ibid., 268.

26 Ibid.

27 See my extended discussion of artist Thomas Hirschhorn's *Gramsci Monument* in Chapter 7.

28 Nato Thompson, *Seeing Power: Art and Activism in the 21st Century* (New York, NY: Melville House, 2014), e-book.

29 Gregory Sholette, "Delirium and Resistance After the Social Turn", *FIELD: A Journal of Socially-Engaged Art Criticism* 1 (Spring 2015): 104, original emphasis, accessed June 21, 2017, http://field-journal.com/.

30 Ibid., 109–10.

31 Ibid., 125.

32 Martha Rosler, "Take the Money and Run? Can Political and Socio-critical art 'survive'?", *e-flux journal* 12 (January 2010), accessed June 17, 2017, http://www.e-flux.com/journal/12/61338/take-the-money-and-run-can-political-and-socio-critical-art-survive/.

33 Ibid.

34 Jasper Bernes, "Capital and Community: On Melanie Gilligan's Trilogy", *Mute*, June 23, 2015, accessed June 24, 2017, http://www.metamute.org/editorial/articles/capital-and-community-melanie-gilligan%E2%80%99s-trilogy.

35 Somewhat similarly, Pittsburgh's scene has hosted socially conscious and aesthetically progressive ventures. Milwaukee has also been active on a scale in-between these two larger cities, but with some resemblance. The list goes on though. Artist Roger White in his recent book *The Contemporaries: Travels in the 21st Century Art World* (New York, NY: Bloomsbury USA, 2016) uses Milwaukee as a case study for an

argument towards regional rather than national/international centres as holding much untapped potential for contemporary artists.

36 See the four titles in the Chicago Social Practice History Series: Mary Jane Jacob and Kate Zeller, eds., *Immersive Life Practices*, *Support Networks*, *Art Against the Law*, and *Institutions and Imaginaries* (Chicago, IL: The School of the Art Institute of Chicago and University of Chicago Press, 2014–15).

37 Rachel Gagnon, "Planning Social Practice: An Interview with Mary Jane Jacob", *art21 blog*, September/October 2014, accessed June 21, 2017, http://blog.art21.org/2014/09/17/planning-social-practice-an-interview-with-mary-jane-jacob/.

38 Dan S. Wang, *Downtime at the Experimental Station: A Conversation with Dan Peterman* (Chicago, IL: Temporary Services, 2004), accessed June 21, 2017, http://www.temporary-services.org/downtime.pdf.

39 Ibid.

40 From statement on Temporary Services' website, accessed September 17, 2016, www.temporaryservices.org.

41 Temporary Services, eds., *Group Work* (New York, NY: Printed Matter, 2007).

42 Claire Doherty, *Public Art (Now): Out of Time, Out of Place* (London: Art Books Publishing, 2015), 167.

43 Matthew Jesse Jackson, "The Emperor of the Post-Medium Condition", in *12 Ballads for Huguenot House*, ed. Theaster Gates (Köln: Walther König, 2012), 18–19.

44 "Artslant Interview with Thea Liberty Nichols", *John Preus*, June 30, 2014, accessed June 21, 2017, http://johnpreus.com/about/press/artslant-interview-with-thea-liberty-nichols/.

45 Nichols, "Interview with John Preus".

46 Paul O'Neill, *The Culture of Curating and the Curating of Culture(s)* (Cambridge, MA: MIT Press, 2011), 32.

47 Paweł Polit and Piotr Woźniakiewicz, eds., *Conceptual Reflection in Polish Art: Experiences of Discourse: 1965–1975* (Warsaw: Centre for Contemporary Art Ujazdowski Castle, 2000).

48 Mick Wilson, "Curatorial Moments and Discursive Turns", in *Curating Subjects*, ed. Paul O'Neill (Amsterdam: de Appel/Open Editions, 2007), 201–16.

49 Andrew Berardini, "How to Start an Art School", *Momus: A Return to Art Criticism*, February 10, 2015, accessed June 21, 2017, http://momus.ca/how-to-start-an-art-school/. For more background context, see Steven Henry Madoff, ed., *Art School (Propositions for the 21st Century)* (Cambridge, MA: MIT Press, 2009); and Howard Singerman, *Art Subjects: Making Artists in the American University* (Berkeley, CA: University of California Press, 1999).

50 Lauren O'Neill-Butler, "Michelle Grabner and Brad Killam Talk about the Suburban's Tenth Anniversary", *Artforum* (Summer 2010), accessed June 21, 2017, http://artforum.com/words/id=26066, original emphasis.

51 Barry Blinderman, ed., *Michelle Grabner* (Normal, IL: University Galleries, 2007), 9.

52 Ibid.

53 *Michelle Grabner: I Work from Home*, Museum of Contemporary Art, Cleveland, OH (November 1, 2013–February 16, 2014). This exhibition also featured a replica of The Suburban in the museum.

54 Jenny Gillam, "Preface", in *SHOW* (Auckland: Enzyme Publishing, 2009), ii.

55 Eugene Hansen, "Re-Tard: David Cross", in *SHOW*, 98.

56 "Kallio Kunsthalle at Supermarket Art Fair, Stockholm", accessed June 21, 2017, http://www.supermarketartfair.com/exhibitor/kallio-kunsthalle/2014.

57 Månsson and Ewerlöf, eds. *Verkstad: Rum för konst*, 36.

58 Ibid., 47.

59 David Joselit, "In Praise of Small", in *Near Contact* (New York, NY: Common Practice, 2016), 5.

60 Ibid., 19.

Chapter Seven

1 Lucy Lippard, "A Different One Percent", *The Brooklyn Rail*, February 5, 2013, accessed June 17, 2017, http://www.brooklynrail.org/2013/02/artseen/a-different-one-percent.

2 Some material in the first section of this chapter draws upon the article "Restlessness and Reception: Transforming Art Criticism in the Age of the Blogosphere", *Drain* (2010), accessed June 17, 2017, http://drainmag.com/restlessness-and-reception/.

3 *New York Times* cultural critic A. O. Scott wrote an eloquent book-length essay on the importance of criticism in his *Better Living Through Criticism: How to Think About Art, Pleasure, Beauty, and Truth* (New York, NY: Penguin Books, 2016).

4 See James Elkins, *What Happened to Art Criticism?* (Chicago, IL: Prickly Paradigm Press, 2003).

5 Margriet Schavemaker and Mischa Rakier, eds., *Right About Now: Art and Theory Since the 1990s* (Amsterdam: Valiz Publishers, 2007), 9.

6 Walter Benjamin, *Selected Writings, Volume 4 1938–1940* (Cambridge, MA: Harvard University Press, 2003), 264.

7 Ibid., 269.

8 Jill Walker Rettberg, *Blogging* (New York, NY: Polity, 2008), 4.

9 See "Dave Hickey interviewed by Sheila Heti", *The Believer* 5, no. 9 (November/December 2007): 62.

10 Alison Knowles, *By Alison Knowles* (New York, NY: A Great Pamphlet, 1965), accessed June 21, 2017, http://www.ubu.com/historical/knowles/index.html

11 Ibid.

12 Ibid.

13 Ibid.

14 Julia Robinson, "The Sculpture of Indeterminacy: Alison Knowles's Beans and Variations", *Art Journal* 63, no. 4 (Winter 2004): 101.

15 Anna Dezeuze, "'Open work,' 'Do-It-Yourself' Artwork and *Bricolage*", in *The "Do-It-Yourself" Artwork: Participation from Fluxus to New Media*, ed. Anna Dezeuze (Manchester: Manchester University Press, 2010), 54.

16 Ken Friedman, e-mail message to the author, December 31, 2012.

17 Paul Hegarty, *Noise/Music: A History* (New York, NY: Continuum Books, 2007), 28.

18 Janet A. Kaplan with Bracken Hendricks, Geoffrey Hendricks, Hannah Higgins and Alison Knowles, "Flux Generations", *Art Journal* 59, no. 2 (June 2000): 9–10.

19 Kenneth Silverman, *Begin Again: A Biography of John Cage* (New York, NY: Knopf, 2010), 136.

20 Richard Kostalanetz, ed., *John Cage: An Anthology* (Cambridge, MA: Da Capo Press, 1991), 124.

21 John Cage, *Silence: Lectures and Writings* (Middletown, CT: Wesleyan, 1973), 95.

22 Mike Sell, *Avant-Garde Performance and the Limits of Criticism: Approaching the Living Theatre, Happenings/Fluxus, and the Black Arts Movement* (Ann Arbor, MI: University of Michigan, 2005), 162–63.

23 Ibid.

24 Ibid., 163.

25 Ruth Michaelson, "Read, Browse, Yell! The Cairo Bookshop with a Screaming Room", *The Guardian*, October 30, 2016, accessed June 17, 2017, https://www.theguardian.com/world/shortcuts/2016/oct/30/read-browse-yell-cairo-bookshop-screaming-room.

26 Ken Friedman, Owen Smith and Lauren Sawchyn, eds. *The Fluxus Performance Workbook* (Performance Research e-publications, 2002) 27.

27 Smart Museum of Art, "Alison Knowles: Fluxus Event Scores", Vimeo video, February 14, 2012, accessed June 17, 2017, https://vimeo.com/36770983.

28 Kaplan, "Flux Generations", 11.

29 Kristine Stiles, "Anomaly, Sky, Sex, and Psi in Fluxus", in *Critical Mass: Happenings, Fluxus, Performance, Intermedia and Rutgers University 1958–1972*, ed. Geoffrey Hendricks (New Brunswick, NJ: Rutgers University Press, 2003), 61.

30 Benjamin Patterson, *Methods and Processes*, 2nd ed. (Tokyo: Gallery 360°, 2004).

31 See Anette Kubitza, "Fluxus, Flirt, Feminist? Carolee Schneemann, Sexual Liberation and the Avant-garde of the 1960s", *n.paradoxa* 15/16 (July/September 2001–July 2002).

32 Midori Yoshimoto and Alex Pittman, eds., "An Evening with Fluxus Women: A Roundtable Discussion", *Women & Performance: A Journal of Feminist Theory* 19, no. 3 (November 2009): 371.

33 Fred Moten, "Liner Notes for Lick Piece", in *Born in the State of FLUX/us*, ed. Valerie Cassel Oliver (Houston, TX: Contemporary Arts Museum, 2012), 213.

34 Hannah B. Higgins, "On Not Forgetting Fluxus Artist Ben Patterson", *Hyperallergic*, July 6, 2016, accessed June 17, 2017, http://hyperallergic.com/309399/on-not-forgetting-fluxus-artist-benjamin-patterson/.

35 Quoted in Astrid Peterle, "Fluxus Scores and Instructions: The Transformative Years, 'Make a salad'", *Women & Performance: A Journal of Feminist Theory* 19, no. 3 (2009): 439–41.

36 Ben Patterson video interview (2012) archived at *Fondazione Bonotto*, http://www.fondazionebonotto.org/fluxus/pattersonben/video/fxph1601.html.

37 Nick Stillman, "Clifford Owens", *BOMB Magazine* 117 (Fall 2011): 55.

38 Yoshimoto and Pittman, "An Evening with Fluxus Women", 371.

39 Ibid., 370.

40 Kathy O'Dell, "Fluxus Feminus", *TDR: The Drama Review* 41, no. 1 (Spring 1997): 45, original emphasis.

41 See caption info for this artwork.

42 Yasmil Raymond, "Desegregating the Experience of Art: A User's Guide to *Gramsci Monument*", in *Gramsci Monument*, ed. Thomas Hirschhorn (London: Koenig Books, 2015), 12.

43 Lex Brown, "Monument Time", in Hirschhorn, *Gramsci Monument*, 231.

44 Ibid., 230.

45 Ibid., 232.

46 Ibid.

47 Lisa Lee and Hal Foster, eds., *Critical Laboratory: The Writings of Thomas Hirschhorn* (Cambridge, MA: MIT Press, 2013), 2.

48 Grant Kester, "On the Relationship between Theory and Practice in Socially Engaged Art", *A Blade of Grass*, July 29, 2015, accessed June 17, 2017. http://www.abladeofgrass. org/fertile-ground/on-the-relationship-between-theory-and-practice-in-socially- engaged-art/

49 Kester, *A Blade of Grass*.

50 Sarah Lookofsky, "Thomas Hirschhorn: Project in the Projects", *DIS Magazine*, accessed June 26, 2017, http://dismagazine.com/disillusioned/47438/thomas-hirschhorn-on-his- project-in-the-projects/.

51 Claudia Mesch, Viola Michely, eds. *Joseph Beuys: The Reader* (London: I.B. Taurls, 2007), e-book.

52 Anna Dezeuze, *Thomas Hirschhorn: Deleuze Monument* (London: Afterall Books, 2014), 29.

53 Fred Moten, "Remind", in Hirschhorn, *Gramsci Monument*, 326.

54 Ibid., 328.

55 Fred Moten, "The Gramsci Monument", in Hirschhorn, *Gramsci Monument*, 329.

56 Peter Schjeldahl, "House Philosopher", *The New Yorker*, July 29, 2013, 77.

57 Ibid.

58 Glenn Ligon, "Thomas is a Trip", *Artforum* 52, no. 13 (November 2013): 228–32.

59 Ibid.

60 Lee and Foster, eds., *Critical Laboratory*, 96.

BIBLIOGRAPHY

Alÿs, Francis. *Sometimes Doing Something Poetic Can Become Political and Sometimes Doing Something Political Can Become Poetic.* New York, NY: David Zwirner, 2007.

Arbus, Diane. *Diane Arbus.* Millerton, NY: Aperture, 1972.

Artaud, Antonin. *Collected Works: Volume Three.* Edited by Paule Thévenin. Translated by Alastair Hamilton. London: Calder and Boyars, 1972.

Augé, Marc. *Non-Places: Introduction to an Anthropology of Supermodernity.* Translated by John Howe. London: Verso, 2000.

Auslander, Philip. "The Performativity of Performance Documentation." *PAJ* 84 (2006): 1–10.

———. *Presence and Resistance: Postmodernism and Cultural Politics in Contemporary American Performance.* Ann Arbor, MI: University of Michigan Press, 1994.

Babias, Marius. "Subject Production and Political Art Practice." *Afterall* 9 (Spring/Summer 2004). Accessed June 23, 2017, https://www.afterall.org/journal/issue.9/subject.production.and.political.art.practice.

Baker, George. "An Interview with Pierre Huyghe." *October* 110 (Fall 2004): 80–106.

Bakhtin, Mikhail. *Rabelais and His World.* Translated by Helene Iswolsky. Bloomington, IN: Indiana University Press, 1984.

Banes, Sally. *Greenwich Village 1963: Avant-Garde Performance and the Effervescent Body.* Durham, NC: Duke University Press, 1993.

Barikin, Amelia. *Parallel Presents: The Art of Pierre Huyghe.* Cambridge, MA: MIT Press, 2012.

Baumgärtel, Tilman. "I am a Communication Artist: Interview with Nam June Paik." *Noem Lab,* February 17, 2001. Accessed April 5, 2017. http://noemalab.eu/ideas/interview/interview-with-nam-june-paik/.

Beech, Dave. "The Ideology of Duration in the Dematerialised Monument." In *Locating the Producers: Durational Approaches to Public Art,* edited by Paul O'Neill and Claire Doherty. Amsterdam: Valiz, 2011.

Benjamin, Walter. *Selected Writings, Volume 4 1938–1940.* Cambridge, MA: Harvard University Press, 2003.

Berardi, Franco "Bifo". *The Uprising: On Poetry and Finance.* Los Angeles, CA: semiotext(e), 2012.

Berardini, Andrew. "How to Start an Art School." *Momus: A Return to Art Criticism,* February 10, 2015. http://momus.ca/how-to-start-an-art-school/.

Bernes, Jasper. "Capital and Community: On Melanie Gilligan's Trilogy." *Mute*, June 23, 2015. Accessed June 24, 2017. http://www.metamute.org/editorial/articles/capital-and-community-melanie-gilligan%E2%80%99s-trilogy.

Beuys, Joseph. *Energy Plan for the Western Man: Joseph Beuys in America*. Compiled by Carin Kuoni. New York, NY: Four Walls Eight Windows, 1990.

Birchall, Michael G. "Socially Engaged Art in the 1990s and Beyond." *oncurating.org* 25 (2015): n.pag.

Bishop, Claire. "Antagonism and Relational Aesthetics," *October* 110 (Fall 2004): 51–79.

———. *Artificial Hells: Participatory Art and the Politics of Spectatorship*. New York, NY: Verso, 2012.

———. "The Social Turn: Collaboration and its Discontents," *Artforum* 44, no. 6 (February 2006): 179–85.

Blake, Aaron. "Kellyanne Conway Says Donald Trump's Team Has 'Alternative Facts'. Which Pretty Much Says It All." *Washington Post*, January 22, 2017. Accessed June 21, 2017. https://www.washingtonpost.com/news/the-fix/wp/2017/01/22/kellyanne-conway-says-donald-trumps-team-has-alternate-facts-which-pretty-much-says-it-all/?utm_term=.585f071c0dac.

Blinderman, Barry, ed. *Michelle Grabner*. Normal, IL: University Galleries, 2007.

Boulos, Mark. E-mail to the author. September 1, 2010.

Bourriaud, Nicolas. *Relational Aesthetics*. Dijon: Les Presses du réel, 1998. Translated by Simon Pleasance and Fronza Woods with Mathieu Copeland. Dijon: Les Presses du réel, 2004.

Boyd, Andrew, ed. *Beautiful Trouble: A Toolbox for Revolution*. New York, NY: OR Books, 2012.

Brecht, George. *The Ashgate Research Companion to Experimental Music*. Edited by James Saunders. Burlington, VT: Ashgate, 2009.

Brecht, George, and Robert Filliou. *Games at the Cedilla; or, The Cedilla Takes Off*. New York, NY: Something Else Press, 1967.

Brown, Lex. "Monument Time." In *Gramsci Monument*, edited by Thomas Hirschhorn. London: Koenig Books, 2015.

Bruguera, Tania. *La Biennale di Venezia/Prince Claus Fund for Culture and Development*. Chicago, IL: Lowitz & Sons, 2005.

Buchloh, Benjamin H. D. "Conceptual Art 1962–1969: From the Aesthetic of Administration to the Critique of Institutions." *October* 102, no. 55 (Winter 1990): 105–43.

Buckingham, Matthew. "Matthew Buckingham and Sharon Hayes." *DRINK THE NEW WINE*. Accessed June 21, 2017. http://creativetime.org/programs/archive/newwine/buckingham.php.

Byrt, Anthony. "Who's There: Ronnie van Hout and the Anti-hero Aesthetic." *Art New Zealand* 108 (Spring 2003). Accessed June 22, 2017. http://www.art-newzealand.com/Issue108/vanhout.htm.

———. *This Model World: Travels to the Edge of Contemporary Art*. Auckland: Auckland University Press, 2016.

Cage, John. *Silence: Lectures and Writings*. Middletown, CT: Wesleyan, 1973.

Cahill, Zachary, and Philip von Zweck. "The Artist as Double Agent." *Afterall* 36 (Summer 2014).

Carr, C. "Christine Hill Tapes Her Own TV Pilot, for Art's Sake: The Avant Late Show." *The Village Voice* (October 17, 2000): 59.

The Clash. *Sandinista*. Produced by Mikey Dread and The Clash. 2 x CD. Columbia – 495348
 2. New York: Columbia, 1999.

Cotter, Holland. "Refracting Race through the Comic Lens of Richard Pryor." *New York Times*,
 January 21, 2016. Accessed June 21, 2017. http://www.nytimes.com/2016/01/22/arts/de-
 sign/refracting-race-through-the-comic-lens-of-richard-pryor.html.

Critchley, Simon. *On Bowie*. London: Serpents Tail, 2016.

Dalton, David. *Who Is That Man? In Search of the Real Bob Dylan*. New York, NY: Hyperion
 Books, 2012. E-book.

Debord, Guy. *The Society of the Spectacle*. Detroit, MI: Black & Red, 1983.

DeLillo, Don. "Introduction: Assassination Aura." *Libra*. New York, NY: Penguin Books, 2006.

Dezeuze, Anna. "'Open Work,' 'Do-It-Yourself' Artwork and *Bricolage*." In *The "Do-It-Yourself"
 Artwork: Participation from Fluxus to New Media*, edited by Anna Dezeuze, 47–68. Man-
 chester: Manchester University Press, 2010.

———. *Thomas Hirschhorn: Deleuze Monument*. London: Afterall Books, 2014.

Díaz, Eva. *The Experimenters: Chance and Design at Black Mountain College*. Chicago, IL:
 University of Chicago Press, 2015.

Doherty, Claire. "In Search of a Situation." *Breaking Ground: Art in the Life World Research
 Papers*. Dublin: Ballymun Regeneration Art Commission Programme, 2008.

———. *Public Art (Now): Out of Time, Out of Place*. London: Art Books Publishing, 2015.

Drew, Jesse. "The Collective Camcorder in Art and Activism", In *Collectivism after Modern-
 ism: The Art of Social Imagination after 1945*, edited by Blake Stimson and Gregory
 Sholette, 95–114. Minneapolis, MN: University of Minnesota Press, 2007.

Dylan, Bob. *The Bootleg Series Vol. 6: Bob Dylan Live 1964, Concert at Philharmonic Hall*.
 Produced by Steve Berkowitz and Jeff Rosen. 2 x CD. Columbia – C2K 86882.
 New York: Columbia, 2004.

Elkins, James. *What Happened to Art Criticism?* Chicago, IL: Prickly Paradigm Press, 2003.

English, Darby. *How to See a Work of Art in Total Darkness*. Cambridge, MA: MIT Press, 2007.

Erlhoff, Michael, ed. *Das immerwährende Ereignis zeigt Robert Fillliou [sic] = the Eternal Net-
 work presents Robert Fillliou [sic] = la Fête permanente présente Robert Fillliou [sic]*.
 Hannover: Sprengel-Museum, 1984.

Felty, Heather. "Christine Hill." *Flash Art* 33, no. 215 (November–December 2000): 107–08.

Fialka, Gerry. "Insanity and Social Sculpture: A Conversation with William Pope.L." *Venice
 Wake*. Accessed June 17, 2017. http://www.venicewake.org/Articles/GF/04Insanity.html.

File under Sacred Music. http://www.fileundersacredmusic.com/making/index.html.

Filliou, Robert. *Teaching and Learning as Performing Arts*. Cologne and New York, NY: Verlag
 Gebrüder König, 1970.

———. *Mister Blue from Day-to-Day*. Hamburg: Lebeer Hossmann, 1983.

———. *Robert Filliou: From Political to Poetical Economy*. Vancouver: Morris and Helen
 Belkin Art Gallery, 1995.

———. *Toi par lui et moi*. Brussels: Lebeer Hossmann and Yellow Now, 1998.

———. *Robert Filliou: From Political to Poetical Economy (1977–79)*. Vancouver: Western
 Front Society and the Morris and Helen Belkin Art Gallery, 2006. DVD.

Fletcher, Harrell. *Blot Out the Sun* (2002). Video. Accessed June 21, 2017. http://www.ubu.
 com/film/fletcher.html.

Fluxus East: Fluxus Networks in Central Eastern Europe (2007). Accessed October 31, 2009.
 www.fluxus-east.eu/.

Foster, Hal. *Bad New Days: Art, Criticism, Emergency*. London: Verso, 2015. E-book.

Frascina, Francis. *Art, Politics and Dissent: Aspects of the Art Left in Sixties America.* Manchester: Manchester University Press, 1999.

French, Philip. "Synecdoche, New York." *The Observer*, May 17, 2009. Accessed June 21, 2017. https://www.theguardian.com/film/2009/may/17/synecdoche-new-york-film-review.

Friedman, Ken, Owen Smith, and Lauren Sawchyn, eds. *The Fluxus Performance Workbook*. Performance Research e-publications, 2002.

———. "The Case for Bengt af Klintberg." *Performance Research* ("Re-Received Ideas. A Generative Dictionary for Research on Research") 11, no. 2 (2006): 137–44.

———. *99 Events 1956–2009.* New York, NY: Stendhal Gallery, 2009.

———. E-mail message to the author. December 31, 2012.

Gagnon, Rachel. "Planning Social Practice: An Interview with Mary Jane Jacob." *art21 blog* (September/October 2014). Accessed June 21, 2017. http://blog.art21.org/2014/09/17/planning-social-practice-an-interview-with-mary-jane-jacob/.

Galloway, Bryce. *The Book of the Zine Incredibly Hot Sex with Hideous People.* Auckland: Clouds, 2011.

———. *Incredibly Hot Sex with Hideous People: The Comics Diary*. Melbourne: Pikitia Press, 2017.

Georg Kargl Gallery. "Arthur Köpcke". Accessed April 6, 2017. http://www.georgkargl.com/en/box/exhibition/arthur-koepcke.

Gerke, Greg. "The Rumpus Interview with John Jeremiah Sullivan." *The Rumpus* (April 24, 2012). Accessed June 21, 2017. http://therumpus.net/2012/04/the-rumpus-interview-with-john-jeremiah-sullivan/.

Gillam, Jenny. "Preface". *SHOW*. Auckland: Enzyme Publishing, 2009.

Gillick, Liam. "Contingent Factors: A Response to Claire Bishop's 'Antagonism and Relational Aesthetics.'" *October* 115 (Winter 2006): 95–106.

Gilligan, Melanie. "The Beggar's Pantomime: On Performance and Its Appropriations." *Artforum* 45, no. 10 (Summer 2007).

Godfrey, Mark. "Nikki S. Lee: Stephen Friedman Gallery, London." *Frieze* 52 (May 2000). Accessed June 21, 2017. https://frieze.com/article/nikki-s-lee.

Goetzman, Michael. "Pulp Nonfiction: An Interview with John Jeremiah Sullivan." *Los Angeles Review of Books,* March 28, 2012. Accessed June 17, 2017. https://lareviewofbooks.org/article/pulp-nonfiction-an-interview-with-john-jeremiah-sullivan/.

Gray, Spalding. "Morning, Noon, and Night." *National Public Radio: Weekend Edition Saturday*, September 18, 1999.

———. *The Journals of Spalding Gray*. Edited by Nell Casey. New York, NY: Knopf, 2011.

Greenfield, Robert. *Timothy Leary: A Biography.* New York, NY: Harcourt Books, 2006.

Gregory, Dick, with Robert Lipsyte. *Nigger*. New York, NY: Washington Square Press, 1986.

Gritz, Anna. "Political/Minimal." *Frieze* (January 2009).

Groys, Boris. "On Art Activism." *e-flux journal* 56 (June 2014). Accessed September 17, 2016. http://www.e-flux.com/journal/on-art-activism/.

Halliwell, Leslie. *Halliwell's Who's Who in the Movies.* New York: HarperPerennial, 1999.

Hansen, Eugene. "Re-Tard: David Cross." *SHOW*. Auckland: Enzyme Publishing, 2009.

Harren, Natilee. "*La cédille qui ne finit pas*: Robert Filliou, George Brecht, and Fluxus in Villefranche (deregulation version)." *The Getty Research Journal* 4 (2012): 127–44. Also online at *Art and Education*. http://www.artandeducation.net/paper/la-cedille-qui-ne-finit-pas-robert-filliou-george-brecht-and-fluxus-in-villefranche/.

Harris, Steven. "The Art of Losing Oneself without Getting Lost: Brecht and Filliou at the Palais Idéal." *Papers of Surrealism* 2 (Summer 2004): n.pag.

Haskell, John. *Out of My Skin*. New York, NY: FSG, 2009.

Haynes, Todd. *I'm Not There*. New York, NY: The Weinstein Company, 2008. DVD.

Heartney, Eleanor. "Re-Creating Sturtevant." *Art in America* 102, no. 10 (November 2014): 136.

Heathfield, Adrian, ed. *Live: Art and Performance*. London: Tate Publishing, 2004.

Hegarty, Paul. *Noise/Music: A History*. New York, NY: Continuum Books, 2007.

Hendricks, Jon, ed. *Fluxus Codex*. New York, NY: Harry N. Abrams, 1988.

Heti, Sheila. "Dave Hickey interviewed by Sheila Heti." *The Believer* 5, no. 9 (November/December 2007).

Higgins, Dick. "Statement on Intermedia." 1966. Accessed June 21, 2017. http://www.artpool.hu/Fluxus/Higgins/intermedia2.html.

———. *foew&ombwhnw: a grammar of the mind and a phenomenology of love and a science of the arts as seen by a stalker of the wild mushroom*. New York, NY: Something Else Press, 1969.

Higgins, Hannah. E-mail to the author. October 30, 2009.

———. *Fluxus Experience*. Berkeley, CA: University of California Press, 2002.

Higgins, Hannah B. "On Not Forgetting Fluxus Artist Ben Patterson." *Hyperallergic* (July 6, 2016). Accessed June 17, 2017. http://hyperallergic.com/309399/on-not-forgetting-fluxus-artist-benjamin-patterson/.

Hill, Chris, ed. *R E W I N D: A Guide to Surveying the First Decade: Video Art and Alternative Media in the U.S., 1968–1980*. Chicago, IL: Video Data Bank, 2008.

———. "Attention! Production! Audience! Performing Video in Its First Decade, 1968–1980." *Video Data Bank*. http://www.vdb.org/content/surveying-first-decade-video-art-and-alternative-media-us-1968-1980-attention-production-aud.

Hill, Christine. *Minutes: Work by Christine Hill*. Berlin: Hatje Cantz, 2007.

———. E-mail to the author. September 2012.

Hodgman, John. *Pilot* (typescript text courtesy of artist Christine Hill).

Hoffman, Jascha. "The Africana QA: Performance Artist William Pope.L." *The Artists Network of Refuse and Resist!,* December 18, 2002. Accessed June 17, 2017. https://web.archive.org/web/20150225220820/http://artists.refuseandresist.org/news3/news142.html#interview.

Hohaia, Te Miringa, Gregory O'Brien, and Lara Strongman, eds. *Parihaka: The Art of Passive Resistance*. Wellington: City Gallery, 2001.

Hopkins, Jerry. *Yoko Ono*. New York, NY: Macmillan, 1986.

Huberman, Anthony. "Talent is Overrated." *Artforum* 48, no. 3 (November 2009): 109–10.

Huddlestone, Toby. *Video Apathy* (2012). Accessed June 23, 2017. http://www.outcasting.org/video-apathy-toby-huddlestone/.

———. E-mail to the author. August 31, 2010.

Hutchinson, Mark. "Four Stages of Public Art." *Third Text* 16, no. 4 (2002): 429–38.

Illich, Ivan. *Tools for Conviviality* (1973). Accessed September 17, 2016. http://www.preservenet.com/theory/Illich/IllichTools.html.

Jackson, Matthew Jesse. "The Emperor of the Post-Medium Condition." In *12 Ballads for Huguenot House*, edited by Theaster Gates, 17–22. Köln: Walther König, 2012.

Jackson, Shannon. *Social Works: Performing Art, Supporting Publics*. New York: Routledge, 2011.

Jacob, Mary Jane, and Kate Zeller, eds. *Immersive Life Practices*; *Support Networks*; *Art against the Law*; and *Institutions and Imaginaries*. Chicago Social Practice Series. Chicago, IL: The School of the Art Institute of Chicago and University of Chicago Press, 2014–15.

Jones, Amelia. "'Presence' in Absentia: Experiencing Performance as Documentation." *Art Journal* 56, no. 4 (Winter 1997): 11–18.

———. "'The Artist is Present': Artistic Re-Enactments and the Impossibility of Presence." *TDR: The Drama Review* 55, no. 1 (Spring 2011): 16–45.

———. *Seeing Differently: A History and Theory of Identification and the Visual Arts*. New York, NY: Routledge, 2012.

Jones, Caroline A. "Staged Presence." *Artforum* 48, no. 9 (May 2010): 214–20.

Jones, Kellie. *EyeMinded: Living and Writing Contemporary Art*. Durham, NC: Duke University Press, 2011.

Joselit, David. "In Praise of Small." *Near Contact*, 4–21. New York, NY: Common Practice, 2016.

Jouannais, Jean-Yves. *Infamie.* Paris: Éditions Hazan, 1995.

Jouval, Sylvie, and Eric Corne. *Premiers mouvements–fragile correspondences*, (2002). FRAC Ile-de-France gallery Le Plateau. Accessed October 30, 2009. www.fracidf-leplateau.com/en/index.html.

Jouval, Sylvie, Jean-Hubert Martin, Heike Van den Valentyn, and Michel Collet. *Robert Filiou: Génie Sans Talent*. Villeneuve d'Ascq: Musée d'art moderne Lille Métropole, 2003. Exhibition catalog.

Judt, Tony. *Ill Fares the Land.* Victoria, Australia: Allen Lane/Penguin Books, 2010.

Kaplan, Janet A. with Bracken Hendricks, Geoffrey Hendricks, Hannah Higgins, and Alison Knowles. "Flux Generations." *Art Journal* 59, no. 2 (June 2000): 6.

Kaprow, Allan. *Essays on the Blurring of Art and Life*. Edited by Jeff Kelley. Berkeley: University of California, 2003.

———. *Untitled Essay and Other Works*, A *Great Bear Pamphlet*. New York, NY: Something Else Press, 1967. Accessed June 22, 2017. http://www.ubu.com/historical/kaprow/index.html.

Keenan, Danny. *Te Whiti O Rongomai and the Resistance of Parihaka.* Wellington: Huia Publishers, 2015.

Keller, Florian. *Andy Kaufman: Wrestling with the American Dream.* Minneapolis, MN: University of Minnesota, 2005.

Kelley, Jeff. *Childsplay: The Art of Allan Kaprow.* Berkeley, CA: University of California Press, 2004.

Kennedy, Randy. "Over and Over: Art that Never Stops." *New York Times*, June 3, 2009. Accessed June 26, 2017. http://www.nytimes.com/2009/06/04/arts/design/04icel.html?pagewanted=all&_r=0.

Kerouac, Jack. *Dharma Bums*. New York, NY: Signet Press, 1959.

Kester, Grant. *The One and the Many: Contemporary Collaborative Art in a Global Context*. Durham, NC: Duke University Press, 2011.

———. "On the Relationship between Theory and Practice in Socially Engaged Art." *A Blade of Grass*, July 29, 2015. Accessed June 17, 2017. http://www.abladeofgrass.org/fertile-ground/on-the-relationship-between-theory-and-practice-in-socially-engaged-art/.

Kiberd, Declan. *Ulysses and Us: The Art of Everyday Living*. London: Faber and Faber, 2009.

Klavans, Stuart. "The Dread of Failure: On Desplechin and Kaufman." *The Nation* (November 24, 2008). Accessed June 21, 2017. https://www.thenation.com/article/dread-failure-desplechin-and-kaufman/.

Knowles, Alison. *By Alison Knowles*. New York, NY: A Great Bear Pamphlet, 1965. Accessed June 21, 2017. http://www.ubu.com/historical/knowles/index.html.

Kostalanetz, Richard, ed. *John Cage: An Anthology*. Cambridge, MA: Da Capo Press, 1991.

Kubitza, Anette. "Fluxus, Flirt, Feminist? Carolee Schneemann, Sexual Liberation and the Avant-garde of the 1960s." *n.paradoxa* 15/16 (July/September 2001–July 2002): 15–29.

Kwon, Miwon. "One Place after Another: Notes on Site Specificity." *October* 80 (Spring 1997): 85–110.

Langston, Ingrid. "Sturtevant's Double Trouble." *Inside/Out* (January 6, 2015). Accessed June 21, 2017. http://www.moma.org/explore/inside_out/2015/01/06/sturtevants-double-trouble.

Larson, Kay. *Where the Heart Beats: John Cage, Zen Buddhism, and the Inner Life of Artists*. New York, NY: Penguin, 2012.

Laugh Factory. "Dave Chapelle – Kramer." YouTube video (December 20, 2010). Accessed June 21, 2017. https://youtu.be/Kth0UOU5a_M.

Law, Gretchen. *Turn Me Loose*. Directed by John Gould Rubin. New York, NY: Westside Theatre, May 19–July 17, 2016.

Leach, Maddie. *If You Find the Good Oil Let Us Know*. New Plymouth, New Zealand: Govett-Brewster Art Gallery, 2014.

Lee, Lisa, and Hal Foster, eds. *Critical Laboratory: The Writings of Thomas Hirschhorn*. Cambridge, MA: MIT Press, 2013.

Lee, Nikki S. "Interview with Gilbert Vacario." *Projects by Nikki S. Lee*. Edited by Russell Ferguson. Berlin: Hatje Cantz, 2001.

Lee, Patricia. *Sturtevant: Warhol Marilyn*. London: Afterall Books, 2016.

Léger, Marc James, ed. *Culture and Contestation in the New Century*. Bristol: Intellect, 2011.

———. "A Filliou for the Game: From Political Economy to Poetical Economy and Fluxus." *RACAR: revue d'art canadienne/Canadian Art Review* 37, no. 1 (2012): 64–74.

Lewallen, Constance. "The Eternal Frame, Hosted by Constance Lewallen." KADIST Vimeo video (November 17, 2012). Accessed June 21, 2017. https://vimeo.com/53734504.

Licht, Alan, ed. *Will Oldham on Bonnie "Prince" Billy*. New York, NY: Norton, 2012.

Ligon, Glenn. "Thomas Is a Trip." *Artforum* 52, no. 13 (November 2013): 228–32.

Lippard, Lucy. "A Different One Percent." *The Brooklyn Rail*, February 5, 2013. Accessed June 17, 2017. http://www.brooklynrail.org/2013/02/artseen/a-different-one-percent.

Lookofsky, Sarah. "Thomas Hirschhorn: Project in the Projects." *DIS Magazine*. Accessed June 21, 2017. http://dismagazine.com/disillusioned/47438/thomas-hirschhorn-on-his-project-in-the-projects/.

Lütticken, Sven, ed. *Life, Once More: Forms of Reenactment in Contemporary Art*. Rotterdam: Witte de With, 2005.

Lydén, Karl. "Ecstasy, Militancy, and Marxist Filmmaking." *Mousse Magazine* 24. Accessed June 21, 2017. http://moussemagazine.it/mark-boulos-kar-lyden-2010/.

Madoff, Steven Henry, ed. *Art School (Propositions for the 21st Century)*. Cambridge, MA: MIT Press, 2009.

Månsson, Erik and Susanne Ewerlöf, eds. *Verkstad: Rum för konst*. Norrköping: Verkstad Konsthall, 2015.

Marioni, Tom. *Beer, Art, and Philosophy*. San Francisco, CA: Crown Point Press, 2004.

———. E-mail to the author. January 2011.

Martin, Steve. *Born Standing Up*. New York, NY: Scribner, 2007.

Mattar, Mira, ed. *You Must Make Your Death Public: A Collection of Texts and Media on the Work of Chris Kraus*. London: Mute Publishing, 2015.

McCarthy, Tom. "Nests, Puke, Frames and Baby Faces." *File under Sacred Music*. Accessed June 23, 2017. http://www.fileundersacredmusic.com/reading/index.html.

———. *Remainder*. Richmond, VT: Alma Books, 2006.

———. *Transmission and the Individual Remix: How Literature Works*. London: Vintage Digital, 2012. E-book.

McCollum, Allan. "Harrell Fletcher." *BOMB* 95 (Spring 2006). Accessed June 21, 2017. http://bombsite.com/issues/95/articles/2800.

McKee, Yates. *Strike Art: Contemporary Art and the Post-Occupy Condition*. New York, NY: Verso, 2016.

McPherson, James. "The New Comic Style of Richard Pryor." *The New York Times Magazine*, April 27, 1975. Accessed June 25, 2017. http://www.nytimes.com/1975/04/27/archives/the-new-comic-style-of-richard-pryor-i-know-what-i-wont-do-says-the.html?_r=0.

Michaelson, Ruth. "Read, Browse, Yell! The Cairo Bookshop with a Screaming Room." *The Guardian*, October 30, 2016. Accessed June 17, 2017. https://www.theguardian.com/world/shortcuts/2016/oct/30/read-browse-yell-cairo-bookshop-screaming-room.

Miles, Barry. *Call Me Burroughs: A Life*. New York, NY: Twelve, 2014.

Miles, Malcolm. "Interrupting the Public Realm: Performative Excursions." *Research in Drama Education* 12, no. 1 (February 2007): 15–25.

Minissale, Gregory. "Problem Spaces in the Walters Prize." *Reading Room* 7 (2015): 126–46.

———. *The Psychology of Contemporary Art*. Cambridge: Cambridge University Press, 2013.

Mizota, Sharon. "Glenn Ligon Takes Apart a Richard Pryor Performance." *Los Angeles Times*, September 20, 2015. Accessed June 21, 2017. http://www.latimes.com/entertainment/arts/la-et-cm-glenn-ligon-at-regen-projects-20150914-story.html.

Mockus, Martha. *Sounding Out: Pauline Oliveros and Lesbian Musicality*. New York, NY: Routledge, 2008.

Molon, Dominic, and Barry Schwabsky. *Gillian Wearing: Mass Observation*. London: Merrell, 2002.

Montano, Linda. *Art in Everyday Life*. Los Angeles: Astro Artz, 1981.

———. *Letters from Linda Montano*. Edited by Jennie Klein. London: Routledge, 2005.

Moten, Fred. "Liner Notes for Lick Piece." In *Born in the State of FLUX/us*, edited by Valerie Cassel Oliver. Houston, TX: Contemporary Arts Museum, 2012.

———. "Remind." In *Gramsci Monument*, edited by Thomas Hirschhorn. London: Koenig Books, 2015.

Mouffe, Chantal. *Agonistics: Thinking the World Politically*. London: Verso Books, 2013.

Munroe, Alexandra, ed. *The Third Mind: American Artists Contemplate Asia, 1860–1989*. New York, NY: Guggenheim Museum, 2009.

Nancy, Jean-Luc. *Being Singular Plural*. Translated by Robert D. Richardson and Anne E. O'Byrne. Stanford, CA: Stanford University Press, 2000.

Nelson, Maggie. *The Art of Cruelty: A Reckoning*. New York, NY: Norton, 2011.

New York Press. "Best Confusion of Art and Life." September 27–October 3, 2000.

Nietzsche, Friedrich. *Twilight of the Idols* (1895). Translated by Walter Kaufmann. Reprint, *The Portable Nietzsche*. New York, NY: Penguin Books, 1977.

Obrist, Hans Ulrich, ed. *do it: the compendium.* New York: Independent Curators International/ Distributed Art Publishers, 2013.

O'Dell, Kathy. "Fluxus Feminus." *TDR: The Drama Review* 41, no. 1 (Spring 1997): 43–60.

O'Neill, Paul. *The Culture of Curating and the Curating of Culture(s).* Cambridge, MA: MIT Press, 2011.

O'Neill-Butler, Lauren. "Michelle Grabner and Brad Killam Talk about the Suburban's Tenth Anniversary." *Artforum* (Summer 2010). Accessed June 21, 2017. http://artforum.com/ words/id=26066.

O'Sullivan, Simon. "Academy: The Production of Subjectivity." In *A.C.A.D.E.M.Y*, edited by Angelika Nollert, Irit Rogoff, Bart de Baere, Yilmaz Dziewior, Charles Esche, Kerstin Niemann, and Dieter Roelstraete. Frankfurt: Revolver, 2006.

Our Literal Speed website. Accessed June 20, 2017. http://ourliteralspeed.com/.

Patterson, Ben. Video interview. *Fondazione Bonotto.* 2012. http://www.fondazionebonotto. org/fluxus/pattersonben/video/fxph1601.html.

Patterson, Benjamin. *Methods and Processes.* 2nd ed. Tokyo: Gallery 360°, 2004.

Paz, Octavio. *Marcel Duchamp: Appearance Stripped Bare.* Translated by Rachel Phillips and Donald Gardner. New York, NY: Arcade Publishing, 1990.

Peterle, Astrid. "Fluxus Scores and Instructions: The Transformative Years, 'Make a Salad.'" *Women & Performance: A Journal of Feminist Theory* 19, no. 3 (2009): 439–41.

Peterson, Michael. *Straight White Male: Performance Art Monologues.* Jackson, TN: University of Mississippi, 1997.

Phelan, Peggy. *Unmarked: The Politics of Performance.* New York, NY: Routledge Books, 1996.

Polit, Paweł. "Experiences of Discourse. Polish Conceptual Art 1965–1975." *Art Margins Online,* October 26, 2000. Accessed January 29, 2013. http://www.artmargins.com/index. php/2-articles/416-experiences-of-discourse-polish-conceptual-art-1965-1975.

Polit, Paweł, and Piotr Woźniakiewicz, eds. *Conceptual Reflection in Polish Art: Experiences of Discourse: 1965–1975.* Warsaw: Centre for Contemporary Art Ujazdowski Castle, 2000.

Pope.L, William. *William Pope.L: The Friendliest Black Artist in America.* Edited by Mark Bessire. Cambridge, MA: MIT Press, 2002.

———. *some things you can do with blackness….* London: Kenny Schachter Rove, 2005.

———. Artist's statement. "Reenactor: Excerpt." Vimeo video, March 6, 2012. Accessed June 18, 2017. http://vimeo.com/38058016.

———. *Distributing Martin.* Accessed June 17, 2017. http://www.distributingmartin.com/.

Preus, John. "Artslant Interview with Thea Liberty Nichols." *John Preus,* June 30, 2014. Accessed June 21, 2017. http://johnpreus.com/about/press/artslant-interview-with-thea-liberty-nichols/.

Prospect 2 Event: Collectively Blink 10/22. Accessed June 17, 2017. http://goinvade.com/prospect-2-event-collectively-blink-1022/

Quirk, Sophie. *Why Stand-up Matters: How Comedians Manipulate and Influence.* London: Bloomsbury, 2015.

Raymond, Yasmil. "Desegregating the Experience of Art: A User's Guide to *Gramsci Monument.*" In *Gramsci Monument,* edited by Thomas Hirschhorn. London: Koenig Books, 2015.

Rettberg, Jill Walker. *Blogging.* New York, NY: Polity Press, 2008.

Reynolds, Simon. *Retromania: Pop Culture's Addiction to Its Own Past.* New York, NY: FSG, 2011.

Richard, Sophie. "Conversation with Anny De Decker, Antwerp, November 16, 2004." In *Unconcealed: The International Network of Conceptual Artists 1967–77; Dealers, Exhibitions and Public Collections*, edited by Lynda Morris. London: Ridinghouse, 2009.

Rifkin, Jeremy. *The Third Industrial Revolution: How Lateral Power Is Transforming Energy, the Economy, and the World*. New York, NY: St. Martin's, 2013.

Robinson, Julia. "The Sculpture of Indeterminacy: Alison Knowles's Beans and Variations." *Art Journal* 63, no. 4 (Winter 2004): 96–115.

Rosler, Martha. "Take the Money and Run? Can Political and Socio-critical Art 'Survive'?". *e-flux journal* 12 (January 2010). Accessed June 17, 2017. http://www.e-flux.com/journal/12/61338/take-the-money-and-run-can-political-and-socio-critical-art-survive/.

Ruminjo, A., and B. Mekinulov. "A Case Report of Cotard's Syndrome." *Psychiatry (Edgmont)* 5, no. 6 (2008): 28–29.

Rumsby, Martin. "Chris Kraus #4: I Love Dick." YouTube video, July 21, 2008. Accessed June 21, 2017. https://www.youtube.com/watch?v=c2DDibS9jnI.

Ryan, Tim. "RT Interview: Charlie Kaufman on *Synecdoche, New York*." *Rotten Tomatoes*, October 22, 2008. Accessed June 19, 2017. https://editorial.rottentomatoes.com/article/rt-interview-charlie-kaufman-on-synecdoche-new-york/.

Saarikko, Petri. "Kallio Kunsthalle at Supermarket Art Fair, Stockholm." Accessed June 21, 2017. http://www.supermarketartfair.com/exhibitor/kallio-kunsthalle/2014.

———. *09-15*. Norköping: Werkstad Konsthall, 2015.

Sandford, Mariellen R., ed. *Happenings and Other Acts*. London: Routledge, 1995.

Saul, Scott. *Becoming Richard Pryor*. New York, NY: Harper, 2014. E-book.

Schaar, Elisa. "Spinoza in Vegas, Sturtevant Everywhere: A Case of Critical (Re-)Discoveries and Artistic Self-Reinventions." *Art History* 33, no. 5 (December 2010): 886–909.

Schavemaker, Margriet, and Mischa Rakier, eds. *Right about Now: Art and Theory Since the 1990s*. Amsterdam: Valiz Publishers, 2007.

Schickel, Richard. *Conversations with Scorsese*. New York, NY: Knopf Doubleday, 2011.

Schjeldahl, Peter. "House Philosopher." *The New Yorker*, July 29, 2013.

Schneider, Rebecca. *Performing Remains: Art and War in Times of Theatrical Reenactment*. New York, NY: Routledge, 2011.

Sholette, Gregory. "Delirium and Resistance after the Social Turn." *FIELD: A Journal of Socially-Engaged Art Criticism* 1 (Spring 2015). http://field-journal.com/.

———. *Delirium and Resistance: Activist Art and the Crisis of Capitalism*. London: Pluto Press, 2017.

Schrag, Anthony. "The Benefits of Being a Bit of an Asshole." *Journal of Arts & Communities* 6, nos. 2/3 (2014): 85–97.

———. *Lure of the Lost: Huntly to the Venice Biennale* (blog). Accessed September 17, 2016. https://theartpilgrimage.wordpress.com/.

Schwabsky, Barry. "Signs of Protest: Occupy's Guerilla Semiotics." *The Nation*, January 12, 2012. Accessed June 21, 2017. https://www.thenation.com/article/signs-protest-occupys-guerilla-semiotics/.

Scott, A. O. *Better Living Through Criticism: How to Think About Art, Pleasure, Beauty, and Truth*. New York, NY: Penguin Books, 2016.

Sell, Mike. *Avant-Garde Performance and the Limits of Criticism: Approaching the Living Theatre, Happenings/Fluxus, and the Black Arts Movement*. Ann Arbor, MI: University of Michigan, 2005.

Servin, Jacques, and Igor Vamos. "Congress Went after ACORN. Big Business Must Be Next!" *The Washington Post*, September 27, 2009. Accessed June 21, 2017. http://www.washingtonpost.com/wp-dyn/content/article/2009/09/25/AR2009092502016.html.

Shepard, Sam. *The Rolling Thunder Logbook*. New York, NY: Omnibus Press, 2010.

Shields, David. *Reality Hunger: A Manifesto.* London: Hamish Hamilton, 2010.

Silverman, Kenneth. *Begin Again: A Biography of John Cage*. New York, NY: Knopf, 2010.

Singerman, Howard. *Art Subjects: Making Artists in the American University*. Berkeley, CA: University of California Press, 1999.

Slade, George. "Garry Winogrand." In *Encyclopedia of Twentieth-Century Photography V. 3 O-Z*, edited by Lynne Warren, 1690–95. New York, NY: Routledge, 2006.

Smart Museum of Art, "Alison Knowles: Fluxus Event Scores." Vimeo video, February 14, 2012. Accessed June 17, 2017. https://vimeo.com/36770983.

Smith, Gavin. "Prisoners: Three Takes on Living in Lockdown." *Film Comment* (July–August 2008): 59.

Smith, Owen F. "Teaching and Learning about Fluxus: Thoughts, Observations and Suggestions from the Front Lines." *Visible Language* 39, no. 3 (2005): 219–34.

———. *Fluxus: The History of an Attitude.* San Diego, CA: San Diego State University Press, 1998.

Smith, Roberta. "Swagger and Sideburns: Bad Boys in Galleries." *New York Times*, February 12, 2010. Accessed June 21, 2017. http://www.nytimes.com/2010/02/12/arts/design/12boys.html.

Spieker, Sven. "Interview with Pawel Althamer." *Art Margins Online*, November 13, 2003. Accessed January 29, 2013. http://www.artmargins.com/index.php/5-interviews/304-interview-with-pawel-althamer.

Spoerri, Daniel, Robert Filliou, Emmett Williams, Dieter Roth, and Roland Topor. *An Anecdoted Topography of Chance*. London: Atlas Press, 1995.

Stedelijk Museum Amsterdam. "Mark Boulos – All That Is Solid Melts into Air." YouTube video, August 13, 2008. Accessed June 21, 2017. http://www.youtube.com/watch?v=BX6rYfN-zTJ8.

Stiles, Kristine. "Anomaly, Sky, Sex, and Psi in Fluxus." In *Critical Mass: Happenings, Fluxus, Performance, Intermedia and Rutgers University 1958–1972*, edited by Geoffrey Hendricks, 60–88. New Brunswick, NJ: Rutgers University Press, 2003.

Stiles, Kristine, and Peter Selz, eds. *Theories and Documents of Contemporary Art: A Sourcebook of Artists' Writings*. Berkeley, CA: University of California, 2012.

Stillman, Nick. "Clifford Owens." *BOMB Magazine* 117 (Fall 2011).

Stolk, Edwin. "Ragnar Kjartansson." *Strange Messenger*, November 4, 2011. Accessed January 24, 2013. http://strangemessenger.blogspot.co.nz/2011/11/ragnar-kjartansson.html.

Sullivan, John Jeremiah. *Pulphead*. New York, NY: FSG, 2011.

Szymczyk, Adam. "The Song of a Skin Bag: Interview with Artur Zmijewski, 1997." In *Pawel Althamer*, edited by Roman Kurzmeyer, Adam Szymczyk, and Suzanne Cotter. London: Phaidon, 2011.

Te Ao, Shannon. *Part Tree, Part Canoe*. Master of Fine Arts exegesis. Wellington NZ: Massey University, 2015.

———. "Reading While Driving: Speaking Poems in the Dark." In *Freedom Farmers: New Zealand Artists Growing Ideas*, 18. Auckland: Auckland Art Gallery, 2013.

Temporary Services, ed. *Group Work*. New York, NY: Printed Matter, 2007.

Temporary Services website. Accessed September 17, 2016. www.temporaryservices.org.

Thompson, Chris. "Responsible Idiocy and Fluxus Ethics: Robert Filliou and Emmanuel Levinas." *a-r-c* 5 (July 2001): 1–8.

———. *Felt: Fluxus, Joseph Beuys, and the Dalai Lama*. Minneapolis, MN: University of Minnesota Press, 2011.

Thompson, Nato, ed. *Living as Form: Socially Engaged Art from 1991–2011*. Cambridge, MA: MIT Press, 2012.

———. *Seeing Power: Art and Activism in the 21st Century*. New York, NY: Melville House, 2014.

Thornton, Sarah. *33 Artists in 3 Acts*. London: Granta, 2014.

Tilman, Pierre. *Robert Filliou; Nationalité poete*. Dijon: Les Presses du reel, 2006.

Tiravanija, Rirkrit. "In Another Country: Yoko Ono in Conversation with Rirkrit Tiravanija." *Artforum* 47, no. 10 (Summer 2009): 280–83.

Tolnay, Alexander. "Image Is Origin: On the Art of Sturtevant." In *Sturtevant: Shifting Mental Structures*, edited by Alexander Tolnay. Berlin: Hatje Cantz Publishers, 2002.

Trabant. Accessed June 20, 2017. http://www.myspace.com/trabantofficial.

Trebay, Guy. "Shadow Play." *New York Times*, September 19, 2004. Accessed March 5, 2017. http://www.nytimes.com/2004/09/19/magazine/shadow-play.html.

Tsong, Jane. *Myriad Small Things*. Accessed June 21, 2017. http://myriadsmallthings.org/.

Tuten, Frederic. "Tom McCarthy by Frederic Tuten." *BOMB – Artists in Conversation* 131 (Spring 2015). Accessed June 19, 2017. http://bombmagazine.org/article/276933/tom-mccarthy.

van Hout, Ronnie. "The Other Mother." In *The Artist's Cinema*. Wellington: CIRCUIT Artist Film and Video Aotearoa New Zealand, 2011. DVD booklet.

Voegelin, Salomé. *Listening to Noise and Silence: Towards a Philosophy of Sound Art*. New York, NY: Continuum, 2010.

Volk, Gregory. "William Pope.L: Animal Nationalism." In *Grand Arts*. Accessed January 29, 2013. http://www.grandarts.com/past_projects/2008/2008_09.html.

Walker, Hamza. "Double Consciousness, Squared." Chicago: Renaissance Society, 2013. Accessed June 21, 2017. http://renaissancesociety.org/publishing/481/forlesen-poster/

Wallace, David Foster. "E Unibus Pluram: Television and U.S. Fiction." *Review of Contemporary Fiction* 13, no. 2 (Summer 1993): 151–94.

Wang, Dan S. *Downtime at the Experimental Station: A Conversation with Dan Peterman*. Chicago, IL: Temporary Services, 2004. Accessed June 21, 2017. http://www.temporaryservices.org/downtime.pdf.

Westgeest, Helen. *Zen in the Fifties: Interaction in Art between East and West*. Zwolle: Waanders Publishers, 1996.

White, Anna-Marie. "Biography and Identity in the Work of Shannon Te Ao." *Shannon Te Ao: I Can Press my Face up Against the Glass*. Christchurch: The Physics Room, 2014.

White, Roger. *The Contemporaries: Travels in the 21st Century Art World*. New York, NY: Bloomsbury USA, 2016.

Whyte, Dick. "John Cage – 4' 33" [May '68 Comeback Special Edition]." *Circuit*. Accessed June 21, 2017. https://www.circuit.org.nz/film/john-cage-433-may-68-comeback-special-edition.

Wilde, Oscar. "Olivia at the Lyceum, *Dramatic Review*, 30 May 1885." *Complete Works of Oscar Wilde*. East Sussex: Delphi Classics, 2013. E-book.

Williams, Emmett. *My Life in Flux – And Vice Versa.* London: Thames and Hudson, 1992.

Wilson, Mick. "Curatorial Moments and Discursive Turns." In *Curating Subjects*, edited by Paul O'Neill, 201–16. Amsterdam: de Appel/Open Editions, 2007.

Wood, Gaby. "How Karl Ove Knausgaard and Elena Ferrante Won Us Over." *The Daily Telegraph*, February 28, 2016. http://www.telegraph.co.uk/books/what-to-read/how-karl-ove-knausgaard-and-elena-ferrante-won-us-over/.

Wood, James. "From Venice to Varanasi: Geoff Dyer's Wandering Eye." *The New Yorker*, April 20, 2009. Accessed June 21, 2017. http://www.newyorker.com/magazine/2009/04/20/from-venice-to-varanasi.

The Yes Men, directed by Dan Ollman, Sarah Price, and Chris Smith. Los Angeles, CA: MGM/DVD, 2003. DVD.

The Yes Men. *The New York Times*, July 4, 2009. Accessed June 20, 2017. http://www.ny-times-se.com/.

Yoshimoto, Midori, and Alex Pittman, eds. "An Evening with Fluxus Women: A Roundtable Discussion." *Women & Performance: A Journal of Feminist Theory* 19, no. 3 (November 2009): 369–89.

INDEX

Note: Page numbers in **bold** indicate an image.